THOMAS EAKINS

HIS LIFE AND WORK

AMS PRESS

NEW YORK

Reprinted from the edition of 1933, New York
First AMS EDITION published 1970
Manufactured in the United States of America
International Standard Book Number: 0–404–02863–2

Library of Congress Number: 71–138259

AMS PRESS INC.
NEW YORK, N.Y. 10003

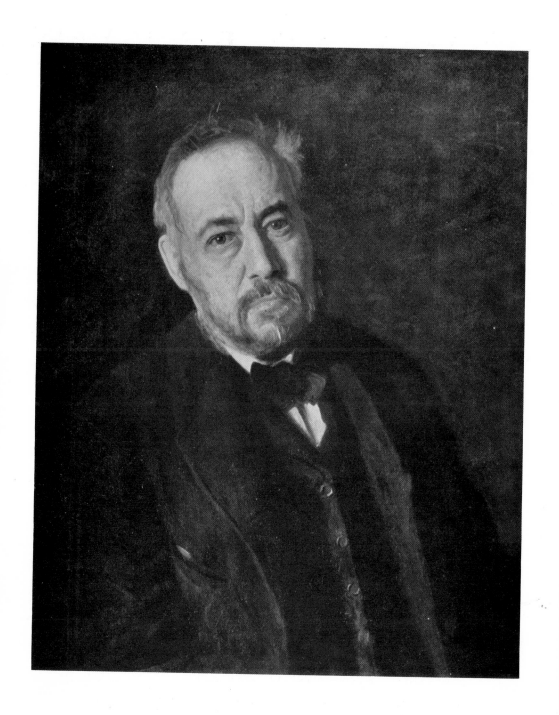

SELF-PORTRAIT

THOMAS EAKINS

HIS LIFE AND WORK

BY

LLOYD GOODRICH

NEW YORK

WHITNEY MUSEUM OF AMERICAN ART

1933

CONTENTS

FOREWORD

IN *presenting this first book on Thomas Eakins, I wish to express my gratitude to the Whitney Museum of American Art, and to its Director, Juliana R. Force, whose sympathetic and wholehearted support made the book in its present form possible, and whose generosity enabled me to spend the time necessary for research and writing, and enabled the work to be published in the most complete style.*

I also wish to acknowledge my deep indebtedness to others who have helped me:

To my friend Reginald Marsh, long an admirer of Eakins' work, who encouraged me to undertake the book and generously assisted me to do so, and whose keen artistic insight has been a constant stimulus to me in writing it.

To Mrs. Thomas Eakins for her invaluable cooperation in furnishing information about her husband and his work, and in placing at my disposal his correspondence, notebooks, manuscripts, and other biographical material which she had carefully preserved. Without her interest, her patient work, and her clear memory, the book could not have been written.

To others who have given me much valuable personal information, especially: Samuel Murray, Eakins' favorite pupil and intimate friend; Miss Mary Adeline Williams, close friend of the artist and Mrs. Eakins; his sister Mrs. William J. Crowell; his pupil Charles Bregler, who recorded his sayings and kindly allowed me to publish them; his pupils Thomas J. Eagan, James Wright, David Wilson Jordan, James L. Wood, Frank B. A. Linton, and Francis J. Ziegler; and his friends Mr. and Mrs. Nicholas Douty, Mrs. Stanley Addicks, Clarence W. Cranmer, Mrs. James Mapes Dodge, Mrs. Mary Hallock Greenewalt, Mrs. Lucy Langdon W. Wilson, Adolphe Borie, Ernest Lee Parker, and the late Professor Leslie W. Miller.

To the owners of pictures who have allowed me to see them or have furnished information about them, or have courteously permitted me to reproduce them.

To Henri G. Marceau, Curator of Fine Arts of the Pennsylvania Museum of Art, for assistance in gathering information for the catalogue; and to Forbes Watson, Editor of "The Arts," for permission to reprint Eakins' sayings.

And to Betty Burroughs and Katherine Schmidt, who listened patiently to many readings of the text, and made valuable suggestions.

<div align="right">L. G.</div>

I
BOYHOOD AND YOUTH

AMONG American artists of the last generation, Thomas Eakins was one of the strongest, leaving behind work of unescapable power, and exercising a widespread influence as a teacher. And yet less is generally known about his life and even his art, than about many of his minor contemporaries. Obscure during much of his career, and of a reserved nature, he preferred to be remembered by his work and through his pupils rather than by the printed word. But in recent years his name has taken on an increasing significance, until now his life, like his art, belongs to the world.

II

Thomas Eakins was born in 1844 in Philadelphia, the city in which almost his entire life was to be spent. His ancestry was Scotch-Irish, English, and Dutch, with a strain of Quaker. His immediate forebears, who had lived in America for at least a generation, were craftsmen—sturdy, hard-working, intelligent people, occupying respectable positions in their communities. His paternal grandfather, Alexander Eakins, was a Protestant Scotch-Irishman, who had come to this country from the north of Ireland with his wife, Frances Fife, about 1812, settling on a farm at Valley Forge, Pennsylvania, and pursuing his craft of weaving, in which he sometimes travelled by foot. His third child, Benjamin, the future father of the artist, was born on the farm in 1818 and as a young man came to Philadelphia, where he became a writing master, teaching the copperplate hand of the old style in the exclusive schools of the city, and engrossing documents such as deeds, diplomas, and testimonials. Throughout a long life filled with fine, patient work, he instructed more than one generation of Philadelphians, becoming a familiar figure in the city, commonly called "Master Benjamin" in Quaker style, although he was not a Friend. Kindly, sociable, of absolute integrity, he was beloved by all who knew him. His son was to perpetuate him in several pictures, notably in the

Writing Master: a sturdy figure, and a round head strongly Irish in character, with bald brow, shaggy eyebrows, patient gray eyes, a long clean-shaven upper lip, an old-fashioned fringe of whiskers below the chin, and an expression at once firm and benign, with a touch of humor; and strong, steady hands, used to years of exacting work.

In 1843 Benjamin Eakins married Caroline Cowperthwait. Her father, Mark Cowperthwait, a Quaker of Dutch and English blood, born in southern New Jersey, had been a forceful character, large and powerful physically, with a dark complexion which was to reappear in his children and grand-children. A cobbler by trade, he had moved to Philadelphia, accumulated real estate, and become a figure of some prominence in the city. Marrying Margaret Jones when he was in his thirties and she only fifteen, he had ten children, of whom Caroline was the youngest. The girl was not brought up as a Quakeress, her father dying when she was a child and her mother not being of that faith. In a daguerreotype of the 'fifties or 'sixties, from which her son was to paint a portrait after her death, she is shown with warm olive complexion, dark brown eyes, and almost black hair. The severe style of the period—the hair parted in the middle and drawn smoothly down to a knot behind, the plain black dress with a tight mannish collar—contrast with the direct, candid glance of the eyes, the wide, thick-lipped, sensitive mouth, and the firm chin; a face full of character, in which one divines a capacity for strong feeling.

The first child of Benjamin Eakins and Caroline Cowperthwait, a boy, was born on July 25th, 1844, in their house on Tenth Street below Green Street, and was named Thomas Cowperthwait Eakins. When he was about two years old the family moved to a house at 1729 Mount Vernon Street, which was to be his home for the rest of his life. In this quiet, tree-lined street of red brick houses, the Eakins home was much like the others, with white stone door-steps and tall downstairs windows whose blinds were kept closed against the heat of summer or the winter snow. The dark, high-ceilinged rooms were filled with rosewood and mahogany furniture, some old, from his mother's family, some mid-century, but all in the harmony of continuous tradition. Through

the back windows could be seen a yard paved and walled with red brick, in which green trees and shrubs grew; and over the wall a prospect of similar brick houses and backyards and trees, as in a picture by Pieter de Hooch. All of this still remains today as when Thomas Eakins was a boy, even the brass nameplate beside the door: "B. EAKINS."

His childhood was that of any normal American boy of the period. The family, while not affluent, was in comfortable circumstances, and lived simply but well. As the years passed three sisters were born: Frances, Margaret, and Caroline, five, ten, and fifteen years younger than he. The relations among all the members of the family were unusually close; especially between his father and himself there was an exceptional companionship, frankness, and mutual respect. The older man being an enthusiastic sportsman, the two led a healthy, active outdoor life in the country around Philadelphia. Never a shy dreamer, the boy formed many friendships, some of which were to last the rest of his life. The atmosphere of his home was liberal, and he was early remarkable for independent thinking and scientific curiosity. His mechanical ability and skill with his hands were marked, and he had a well-equipped workshop. His father's profession provided a natural background for a love of drawing, which showed at an early age.

His education was carried on in the Philadelphia public schools, first at the Zane Street Grammar School, where one of his best friends was the future painter William Sartain, son of the engraver John Sartain, a leading figure in the city's art world. In July, 1857, the two boys entered the Central High School of Philadelphia. This, the oldest high school in America outside of New England, was practically a college, with an exceptional group of teachers and a curriculum as advanced as most colleges of the time, unusual for its emphasis on science; and its pupils represented the pick of the city's young men in intelligence and talent. "Tom C. Eakins," as his name appeared on the school records, entered at the age of thirteen, about two years younger than the average. An excellent student, he was always near the head of his class, ranking fourth of forty-two the first year, and while not always keeping up

to this standard, graduating as number five of the fourteen who survived the four years' course. His marks were especially high in mathematics, sciences, and languages, particularly French; good in history, English, and Latin; and in drawing, which he studied all four years, he attained with unvarying regularity a rating of 100. This course, taught by Alexander Jay MacNeill, consisted largely of the study of perspective, geometrical forms, and mechanical drawing. Some of his school works still exist, among them pictures of complicated machinery, executed with no trace of childish weakness or fumbling, but with a precision and strength remarkable in a boy—a continuation of his father's fine and scrupulous craftsmanship. Even at this age he had mastered perspective with a thoroughness that most mature artists do not attain. Among these school works were also some copies of aquatints of romantic foreign scenes: operatic peasants lolling about ruins or fording mountainous torrents— such work as a drawing-master of the 'fifties would think proper for instilling the essentials of "art."

In July, 1861, not quite seventeen years old, he graduated, receiving a degree of A.B. Asked to make a graduation address, he refused, saying that he had nothing original to tell people, that all he had learned had been from books, where others could find it for themselves.

He had grown up to be a strong youth, taller than his father, whom he resembled in many ways, with the same round head and Irish cast of features: heavy eyebrows, high cheekbones, long upper lip and prominent mouth, with full, firm lips; but with his mother's dark complexion, dark brown eyes, and almost black hair. About five feet ten inches tall, he was built not heavily but powerfully, with strong legs and hips and a deep barrel of a chest; and extremely supple and lightfooted. His boyhood love of outdoor life had remained with him. This was a time of the renaissance of sports, after midcentury puritanism and other-worldliness, and he shared his generation's concern with the life of the body, as with science. His recreations were simple, natural, and close to the earth: hunting, fishing, walking, riding, skating, sailing, rowing, swimming. Both he and his father were beautiful skaters, the

older man remarkable for fancy figures, tracing calligraphic flourishes on the ice like those he made on paper; the younger for speed, power and endurance, being able to skate backwards as fast as others could forwards. Benjamin Eakins and some of his old friends owned a boathouse across the Delaware at Fairton on the Cohansie River, and father and son would go hunting for rail-birds in the marshes, where the river winds through the flatlands: Thomas in the stern of the skiff poling it through the winding creeks, Benjamin in the bow with a gun, waiting for the birds to rise—as the artist was to picture them later. The young man was unusually fond of animals, especially horses and dogs. He owned a small sailboat, and loved to go sailing on the Delaware, often being out on the river at four o'clock in the morning. Above all he enjoyed swimming; the water was a sort of passion with him, and he would strip and go in at every opportunity, without worrying about the sense of propriety of those who might see him, for he was as natural and unashamed about naked-ness as a child or a savage, liking to swim, sail, and bask in the sun nude.

Photographs of him at this time show a serious young man, with an ex-pression thoughtful, courageous, and imperturbable, and a gaze "from under" but direct and penetrating. Always tanned and weatherbeaten, he paid little attention to his personal appearance, liking to go around in old, rough clothes. Somewhat silent, he was frank and terse when he did speak, with a strain of broad, earthy humor. The unusual intimacy with his father had continued, as it was to all his life; and it extended to his father's friends, intelligent men, some of them fellow-teachers and artistically inclined. But while the older man was a conformist, Thomas was of a more independent and inquiring turn of mind, strong-willed, and indifferent to convention. Early an agnostic and a free-thinker, he was filled with the scientific enthusiasm of his time, his inter-ests being divided between art and science. An indefatigable student, he pur-sued his studies outside of school, borrowed scientific and practical books from the library, constructed a small steam engine, and studied languages by him-self, particularly French and Italian.

When he left high school the country was already shaken by the Civil War,

but because of his youth and perhaps also his Quaker blood and certain Copper-head sympathies (like his father, he was a Democrat), he did not enlist as did some of his classmates. For a time he helped his father teach penmanship; but the demand for fine writing was diminishing with the advent of a more machine-made age, so that even the older man realized that there was no future in the profession; and it was too routine and uncreative for Thomas' active mind. But its semi-artistic nature fostered the bent towards art which was manifesting itself with increasing force. Benjamin Eakins was an ama-teur and had several artistic friends, among them George W. Holmes, a painter and teacher, under whom many young Philadelphians received their first art instruction. The two men and the boy would go off on long Sunday rambles in the country, stopping now and then to sketch, and Thomas would make pencil drawings, one of them showing his two elders seated beneath a tree with a lunch basket and a bottle of wine. The boy also had artistic friends of his own: William Sartain, and Charles L. Fussell, a landscape painter of unusual sincerity and freshness, with whom he used to sketch. His father does not seem to have placed any obstacles in the path of his studying art, perhaps considering it a natural step up from his own profession.

His regular training began soon after he left high school, at the Pennsyl-vania Academy of the Fine Arts, the oldest art institution in the country, then located at Tenth and Chestnut Streets in a heavy Roman-Doric temple with a high dome, designed for impressiveness more than convenience. Its collec-tions consisted of casts from the antique, a few old masters of doubtful quality but imposing proportions, a group of early American portraits, and paintings in the grand "historic" style by Benjamin West, P. F. Rothermel, Christian Schussele, and other Philadelphia artists of the old school—the chief works of art which the young man had seen, for this was one of the few museums in America at the time. Visitors were infrequent, and there was little to disturb the drowsy peace. "Over it all there was a stillness," wrote a student of the time. "The smallest noise made an echo; it all seemed majestic."

The Academy had but meagre advantages to offer students. They were

permitted to draw from the casts, copy the paintings, and attend anatomical lectures; but there was no organized school with regular instructors. Whatever desultory teaching existed, was not of a high grade; one of the masters used to set his pupils to copying his own work. Everything was based on the antique, which one had to draw for months or even years before one was allowed to look at the living model. This outworn system was the stale remnant of the "classic" tradition of teaching, expressed by a seventeenth-century French academician who said that "students should be trained to know the antiques so well that they can draw them from memory; only after this is achieved should the master place his pupils before the living model, and then, compass in hand, the measurements should be corrected—i.e., from the antique." Through being forced to copy dusty plaster casts in these funereal halls, Eakins developed a lifelong hatred of drawing from the antique.

Life classes were irregular, being organized occasionally by the students and artists, who clubbed together and hired models, the Academy merely lending the room. There was little instruction, and most of the members drew instead of painting. The curator of the Academy was present to see that nothing indecorous occurred, and Rule No. 1 was that "no conversation is permitted between the model and any member of the class." The female models wore masks, thus hiding their identity and their shame from the world.

Edwin Austin Abbey, a pupil of the Academy a few years after Eakins, later recalled its atmosphere: "What a fusty, fudgy place that Philadelphia Academy was in my day! The trail of Rembrandt Peale and of Charles Leslie, of Benjamin West, and all the dismal persons who thought themselves 'Old Masters', was over the place, and the worthy young men who caught colds in that dank basement with me, and who slumbered peacefully by my side during long anatomical lectures, all thought the only thing worth doing was the grand business, the 'High Art' that Haydon was always raving about."

But Eakins was supplementing his artistic education outside this institution. Soon after entering the Academy he began attending anatomical courses at Jefferson Medical College under the famous surgeon Joseph Pancoast. Here

was no amateurish teaching of anatomy out of a book; he went through the regular anatomical training of a medical student, witnessed dissections and operations by a great physician, and himself dissected human and animal subjects. This was perhaps the most vital part of his education—learning the construction of men and animals, how they lived and moved and had their being. The study interested him profoundly and he continued it for several years with his characteristic thoroughness and concentration, so that before he was twenty his knowledge of anatomy was at least as great as that of the average physician and considerably greater than that of the average artist. Indeed, so absorbed did he become that he thought at one time of being a surgeon.

After four or five years of this kind of education, half artistic and half scientific, he possessed a thorough knowledge of perspective and anatomy and was able to do a strong drawing from the cast or model, but still had comparatively little experience of working from the nude and practically none of painting. Nor could better facilities for study be found elsewhere in America, for Philadelphia was one of the country's art centers and the Academy one of its best art schools. For any thorough professional training he realized that it was necessary to go abroad. His father did not oppose the plan but on the contrary did everything in his power to help, especially financially. It was not easy for Eakins to leave, for he was deeply attached to his family, his home, his friends, and his city. In late September, 1866, at the age of twenty-two, he sailed from New York, and after a miserable ten days during which he was so sea-sick that he "lost all account of time", he arrived in France.

II

FRANCE AND SPAIN

IN going to France to complete his artistic education, Eakins was in a sense a pioneer. Although the English influence on American art had waned and the French was in the ascendant, Paris was not yet the universal goal of art students. Relatively few American artists had studied there, in comparison to the horde of young men who in the next decade were to flock to the city and make her the capital of the art world. Of this invasion Eakins was one of the advance-guard.

French art in these final years of the Second Empire was dominated by the conservative Académie des Beaux-Arts, which ran the Ecole des Beaux-Arts, the École de Rome, and the Salons, distributed prizes and scholarships, and regulated museum purchases and the awards of public commissions. Its school, the most famous in the world, was the one which Eakins had made up his mind to enter. At that time this was not easy for a foreigner, who must have a proper introduction and credentials, and go through much red tape, including a formal call on the prospective instructor. In all of this Eakins was handicapped by the fact that his French was of the book variety, but being unusually free from the fear of ridicule, he plunged boldly in. At the end of October, almost a month after his arrival, he was admitted. For his master he chose Jean Léon Gérôme, foremost of academic teachers and dominating spirit of the Beaux-Arts.

Before he could get to work he had to go through the usual initiation of a *nouveau*, described in one of his first letters home: "When I got my card of admission the officers told me I could go now into the studio, and they seemed to have a little fun amongst themselves. Asking my way of the employees, I was passed along, and the last one, looking very grave, took me in. All the way that I went along I was making up a neat little address to Professor Gérôme explaining to him why I appeared so tardy. Unfortunately for French literature, it was entirely lost, as is every trouble you take to imagine what you ever are going to say when such and such a thing arrives.

"The man took me into the room and said, 'I introduce to you a newcomer,' and then he quickly went out and slammed the door. There was nobody in there but students. They gave a yell which would have lifted an ordinary roof up, and then crowded around me. 'Oh, the pretty child!' 'How gentle!' 'How graceful!' 'Oh, he is calling us *Musheers*, the fool!' 'Isn't he tall?' 'Give us twenty francs!' Half of them screamed, 'Twenty francs!' and the other half, 'The welcome breakfast!' When I could get them to hear me I asked what it was. Several tried to explain but their voices were drowned. They all pushed each other and fought and yelled all at once. . . . 'Where do you come from? England?' 'My God no, gentlemen, I'm an American.' (I feel sure that raised me a peg in their estimation.) 'Oh, the American!' 'What a savage!' 'I wonder if he's a Huron or an Algonquin?' 'Are you rich?' 'No.' 'He lies; he's got a gold mine.' They began at last to sit down one by one. I was invited by one to do the same thing. I did so, looking to see the stool was not jerked from under me. No sooner was I sat down than one of the students about thirty years old, a big fellow with a heavy beard, came and sat down with his face within a foot of mine and opposite me. Then he made faces, and such grimaces were never equalled. Zeph Hopper would be no-wheres . . . Each new contortion of course brought down the house. I looked pleasantly on and neither laughed nor got angry. I tried to look merely amused. Finally he tired himself out. . . . Then he insisted that I should put my bonnet on to see how I looked in it. Not being a model I resisted and wouldn't until I would be ready to go away. . . . I had determined to keep my temper even if I should have to pitch into them, and to stay there and have as much of it through with as possible. When they got not quiet but comparatively quiet, I took my leave. I thanked them for their kind attention, and giving warning to the big fellow that I was now about to put on my bonnet, I thanked him for his politeness and then left. I think the last was a good stroke, and the first thing I did next day was to go make friends with the big booby."

He had got off more easily than most, no doubt partly on account of his

physique. But until the next *nouveau* arrived he had to fag for the other students, running errands, keeping the stove going, which he did with imperturbable good humor. "They are an ill-mannered set when together," he wrote, "but easy to make friends with one at a time. I will be sorry if I ever have an enemy amongst them." For a while he was the sole American. "There is no one in all the school who knows English," he noted, "and I am glad of it." But soon appeared another young Philadelphian, Henry Humphreys Moore, a former fellow-student at the Pennsylvania Academy. He was deaf and dumb, and Eakins "explained to all the students his affliction and begged them not to amuse themselves at his expense. . . . I have no doubt my assuming the protection of Harry has in a measure protected me also." He learned the sign language so that he could talk with Moore, who became one of his closest friends.

The French students were no more tender with each other than with the *nouveaux*. "There was a dispute in the studio between two of the fellows as to which was the strongest. It was decided they should wrestle as soon as the model rested. So they stripped themselves and fought nearly an hour, and when they were done, they were as dirty as sweeps and bloody. Since then there has been wrestling most every day, and we have had three pairs all stripped at once, and we see some anatomy. The Americans have the reputation of being a nation of boxers. Max Schmitt taught me a little about boxing, which I have forgotten. A French student squared off at me, offering to box; I jumped in nothing loth for a little tussle, but another student jerked my opponent away, saying, 'My good man, let me give you a piece of counsel: never box with an American.'"

In this huge cosmopolitan school the young Philadelphian at first felt awed. The building, compared to the old Academy, was a "palace", and the students, some of the most brilliant talents of France and all the world, seemed formidable competitors. His early letters home were humble: "The studio contains some fine young artists, and it is an incalculable advantage to have all around you better workmen than yourself."

"I will never forget the first day that Gérôme criticized my work," he wrote. "His criticism seemed pretty rough, but after a moment's consideration, I was glad. I bought his photograph that very night. Gérôme is a young man. . . . He has a beautiful eye and a splendid head. He dresses remarkably plain. I am delighted with Gérôme. . . . He treats all alike, good and bad. What he wants to see is progress. Nothing escapes his attention. . . . The oftener I see him the more I like him."

Thus began an admiration which was to last all Eakins' life. And Gérôme seems to have noticed, beneath the provincial awkwardness of his new pupil, something out of the ordinary, for he remarked on first seeing his work that he would either be a good painter or would never be able to paint at all. In a few months, however, Eakins wrote that the master in his last criticism had "made no change in my work, said it was not bad, had some middling good parts in it, but was a little barbarous yet. If barbarous and savage hold the same relation to one another in French that they do in English, I have improved in his estimation. . . . Only once he told me that I was going backwards and that time I had made a poetical sort of an outline. The biggest compliment he ever paid me, was to say that he saw a feeling of bigness in my modelling."

At first he had to go once more through the grind of drawing from the cast, but after a few months he was promoted to the life class, for in the French schools the antique was merely a proving-ground. The foundation of the Beaux-Arts system was the nude, taught with relentless thoroughness. To paint a competent life study was the chief end of learning. The viewpoint was painstakingly naturalistic, modified by a pervading pseudo-classicism. A strict and narrow discipline, furnishing the most thorough technical training of the day, its most obvious deficiency was that it was based on draughtsmanship rather than painting. While the Munich students were learning to paint juicy pastiches of Frans Hals, with a liberal use of bitumen and broad brushes, and even in Paris the pupils of Carolus-Duran were taught to use the brush from the beginning, at the Beaux-Arts the dictum of Ingres, "Drawing is the

probity of art," was still gospel. The chief thing to strive for was an impeccable drawing, and painting was merely coloring it, beginning at the head and ending at the feet, finishing each part before another was started. True color, the full resources of the oil medium, the complex processes of transparent and opaque painting by which solid form and depth are achieved, or the study of the old masters' technique, were ignored.

These tendencies were intensified by the personality of the chief instructor. Gérôme in his teaching adhered to the literal truth literally rendered, tolerating no deviation from this straight and narrow path. Within limits his instruction was admirable: few masters have been so lucid in exposition, so rigorous in upholding a standard, so relentless in pointing out weaknesses, so just in recognizing honest endeavor. But his own works reveal his limitations. Nothing could be more perfect in their way than these little miracles of craftsmanship, creations of a vision that combined the properties of the camera and the microscope—in their perfection of detail and finish, the ultimate in photographic painting. If genius were really an infinite capacity for taking pains, he would still seem the genius that his contemporaries thought him. But in larger artistic qualities his work was deficient; small, cold, and dry, it concentrated on detail and local color at the expense of design and movement. Even his technique, with all its meticulous skill, was limited, having throughout the hard monotony that comes from uniformly opaque painting. He was essentially an exponent of academic draughtsmanship rather than of painting, and his students of any individuality had to discover for themselves the broader qualities of art.

In March, 1867, soon after he entered the life class, Eakins was allowed, much to his delight, to begin painting. Up to this time, when he was almost twenty-three, he had hardly handled a brush. His artistic evolution had been unusual: from a background of penmanship, mechanical drawing, perspective, and anatomy, he had advanced step by step, first learning how to draw geometrical objects and the human figure, and only then taking up color and the handling of paint. Construction had come first, representation later. The

process was logical and consistent, each stage being mastered before the next was begun. There was no going off on false scents; nor was there a trace of weakness in any phase; even his drawings as a boy had not been childish, and his student work, though awkward, was never vague or soft. His apparent backwardness in learning to paint arose from the fact that the things he was aiming at were more fundamental than with most students. Actually he was a fast learner, with great powers of concentration, so that when he finally began to paint he gained control of the medium in a comparatively short time, and his first pictures were to be remarkably mature. But into these few years of intense application he packed the struggles of an ordinary lifetime.

"I am working in color now," he wrote after a week or so, "and succeed in getting off some beastly things." He soon discovered that he would have to work out for himself the unfamiliar problems of color, light, and the handling of oil; and after a few months of painting in school, in the early fall of 1867, he rented a private studio, in order to paint independently as well as in class. "I practise composition and color," he wrote. "Gérôme told me before I left, to paint some bright-colored objects; lent me some of his Eastern stuffs, which are very brilliant, and I am learning something from them, faster than I could from the life studies. The colors are strong and near the ends of my scale of colors, such high and such low notes, and this has taught me a good many things that I might not have paid attention to, if I had only been painting flesh, where the colors are not strong but very delicate and clean. I remember many a trouble that I have got into from trying to play my tunes before I tuned my fiddle up."

"Gérôme is very kind to me," another letter said, "and has much patience because he knows I am trying to learn, and if I stay away he always asks after me. In spite of advice I always will stay away the antique week, and often I wish now that I had never so much as seen a statue, antique or modern, till after I had seen painting for some time."

A few months later he reported: "I am working now from memory and composing. I make very bad things but am not so downhearted as I have been

at times when I was making a drawing from the model, not good, not bad, but wishy-washy generally. When you make a thing mighty bad and see how bad it is, you naturally hunt to improve it, and sometimes find a way, but it keeps staring you in the face till you do. When after painting a model I paint it from memory, and then go back and do it again, I see things the second time I would not have seen if I had stayed at school painting on the same canvas all the week and maybe getting more and more tired.

"Color is becoming a little less of a mystery than it was and more of a study in proportion. When it ceases altogether to be a mystery, and it must be very simple at the bottom, I trust I will soon be making pictures. . . .

"Gérôme did not scold me that day you asked me about, but just painted my head right over again, and this I take as an insult to my work. . . . I had a clean canvas, clean brushes, clean outline, clean everything, but I am sure I would have learned more slathering around. . . . A beginner in skating may learn faster by rolling over rough ice, than by very slowly studying out a complicated turn, which he may never be able to learn, but which a good skater may easily do the first time he tries it."

He continued his anatomical studies; there was a dissecting-room in the school, and students could also work in the Paris hospitals. For a time he also took up sculpture under Dumont in the Beaux-Arts, not so much for itself as to supplement painting.

II

He concerned himself little with aesthetic matters. The nearest approach to them in his correspondence was a long letter in which, stimulated by his father's account of an artistic discussion, he expressed his philosophy of art, which in essentials was to remain the same all his life. The gist of his argument was that the painter must be faithful to nature, but nature seen and understood in the largest way—not slavishly copied but re-created. "The big artist," he wrote, "does not sit down monkey-like and copy a coal-scuttle or an ugly old woman like some Dutch painters have done, nor a dung pile,

but he keeps a sharp eye on Nature and steals her tools. He learns what she does with light, the big tool, and then color, then form, and appropriates them to his own use. Then he's got a canoe of his own, smaller than Nature's, but big enough for every purpose. . . . With this canoe he can sail parallel to Nature's sailing. He will soon be sailing only where he wants to, . . . but if ever he thinks he can sail another fashion from Nature or make a better-shaped boat, he'll capsize or stick in the mud, and nobody will buy his pictures or sail with him in his old tub. If a big painter wants to draw a coal-scuttle, he can do it better than the man that has been doing nothing but coal-scuttles all his life. . . . The big painter sees the marks that Nature's big boat made in the mud and he understands them and profits by them. . . . The big artists were the most timid of themselves and had the greatest confidence in Nature, and when they made an unnatural thing they made it as Nature would have made it, and thus they are really closer to Nature than the coal-scuttle painters ever suspect. In a big picture you can see what o'clock it is, afternoon or morning, if it's hot or cold, winter or summer, and what kind of people are there, and what they are doing and why they are doing it. The sentiments run beyond words. If a man makes a hot day he makes it like a hot day he once saw or is seeing; if a sweet face, a face he once saw or which he imagines from old memories or parts of memories and his knowledge, and he combines and combines, never creates—but at the very first combination no man, and least of all himself, could ever disentangle the feelings that animated him just then, and refer each one to its right place."

With such a purely naturalistic philosophy, he had no use for pseudo-classicism. His antipathy to it appeared in this letter: "Then the professors, as they are called, read Greek poetry for inspiration and talk classic and give out classic subjects, and make a fellow draw antique, not to see how beautiful those simple-hearted big men sailed, but to observe their mud marks, which are easier to see and measure than to understand. I love sunlight and children and beautiful women and men, their heads and hands, and most everything I see, and some day I expect to paint them as I see them, and even paint some

that I remember or imagine, . . . but if I went to Greece to live there twenty years I could not paint a Greek subject, for my head would be full of classics, the nasty, besmeared, wooden, hard, gloomy, tragic figures of the great French school of the last few centuries, and Ingres, and the Greek letters I learned at the High School, and my mud marks of the antique statues. Heavens, what will a fellow ever do that runs his boat, a mean old tub, in the marks not of Nature but of another man that run after Nature centuries ago?"

Seldom did he refer to the literary, romantic, or decorative aspects of painting, or to the art of others, either old masters or contemporaries. In America he had had few opportunities to see pictures; and even in Paris his visits to the Louvre and the Luxembourg were infrequent, and he left little record of his impressions. His letters reveal an artistic nature too close to reality and too intensely concentrated on the problem of depicting it, to be much interested in appreciation. His artistic curiosity extended only to works which, by successfully solving the problems that troubled him, had something definite to teach him; and his comments on them were limited almost entirely to their technique. When he called a picture "beautiful" he meant that it was a fine piece of naturalistic painting.

Among contemporaries, such preferences as he displayed were almost exclusively for the academic. He visited the Salons regularly, making notes in French on the pictures that particularly interested him. Gérôme he admired above all others; he spoke of a Fortuny as "*la chose la plus belle que j'ai jamais vu*"; he devoted several pages to an analysis of the color in Regnault's *Salome*; he spoke often of Bonnat. But his tastes though limited were his own. A provincial in the midst of the glittering shams of Second Empire art, he stuck to the things that represented realities to him. He admired the soundest and ablest academicians rather than the most fashionable, not being seduced by popular painters like Bouguereau and Cabanel, whose icily perfect *machines*, with their adroit combination of sentiment and nudity, were well calculated to appeal to the plutocracy and public of the Second Empire, and also of the new empire across the seas, being inevitably destined to adorn the Fifth Avenue

palaces of American railway kings or the still more glittering interiors of Broadway bars. Of this type of art he wrote: "I send by mail a catalogue of the Exhibition of Fine Arts. The great painters don't care to exhibit there at all; about twenty pictures in the whole lot interest me. The rest of the pictures are of naked women, standing, sitting, lying down, flying, dancing, doing nothing, which they call Phrynes, Venuses, nymphs, hermaphrodites, houris, and Greek proper names. The French court has become very decent since Eugénie had figleaves put on all the statues in the Garden of the Tuileries. When a man paints a naked woman he gives her less than poor Nature did. I can conceive of few circumstances wherein I would have to paint a woman naked, but if I did I would not mutilate her for double the money. She is the most beautiful thing there is—except a naked man, but I never yet saw a study of one exhibited. It would be a godsend to see a fine man painted in a studio with bare walls, alongside of the smiling, smirking goddesses of many complexions, amidst the delicious arsenic green trees and gentle wax flowers and purling streams a-running up and down the hills, especially up. I hate affectation."

Of any contemporary art outside the academic world he saw little. The 'sixties were a calm between storms, the romantic movement having subsided, the impressionist not begun. The Académie was in full control of affairs, and the few older independent artists still living were outlaws. Delacroix, who had died a few years before, was still anathema to the academicians; an opinion shared by Eakins, who wrote in his notebook: "*Ses tableaux sont abominables et généralement d'un dessin impossible. Ses hommes sont des singes. Il n'avait pas de procédé et ce sont les embus et les difficultés purement mécaniques qui l'ont toujours vaincu et parfaitement vaincu.*" But giving the devil his due, he added: "*On ne peut espérer sentir la couleur mieux que Delacroix,*" and concluded with the self-assurance of youth: "*Profitons par ses défauts pour aller beaucoup plus loin que lui.*"

Of all the independents the one most in the public eye was Courbet. In view of their realistic affinities, one might expect Eakins to have been attracted to

him. But Courbet was the arch-revolutionist of the day, the most violent antagonist of the academic world in which Eakins moved; and the romantic element in his realism would not have been to the younger man's taste at this time. While Eakins later admired him, as well as Millet, Corot, Degas, and Manet, if he noticed his work in Paris he left no record of the fact. Even when Courbet and Manet, having been refused at the Universal Exposition of 1867, caused a furore by showing their work in a wooden shed outside the grounds, Eakins' letters about the Exposition did not mention them; most of his space was devoted to the machinery, particularly the great American locomotive, "by far the finest there; I can't tell you how mean the best English, French and Belgian ones are alongside of it."

The impressionist movement was still in embryo. Manet he might have seen occasionally in the Salons, but the other impressionists were an obscure group of young eccentrics only slightly older than himself, who painted in the open air and argued in cafés about problems of sunlight, atmosphere, and pure color. They had not yet held an exhibition and the name "impressionist" had not been invented. And it is doubtful whether he would have cared for their work even if he had seen it, for his temperament was opposed to the more advanced tendencies of French art. While such sophisticated compatriots as La Farge and Whistler were strongly influenced by it, he went his own way, unmindful of the brilliant butterflies which lay in their chrysalises all around him.

III

In the beginning of his sojourn in Paris he had sometimes been lonely and homesick. But to a letter urging him to come home for a visit, he replied: "I do not know exactly what made me betray an uneasiness in my letter of which you speak. It was probably a rainy day or I had been seeing some disagreeable person or thing. But certainly it was a momentary affair like that and not a homesickness that could be dispelled by a momentary visit. I love my home as much as anybody and never see the sun set that I do not think of

it, and I often feel lonely, but I can learn faster here than at home, and stay content, and would not think of wasting the expense of a voyage for a few weeks' pleasure. You miss but one from the family. I miss all."

He kept up close contacts with home, writing long letters every week, particularly to his father. Once a month or so he sent the latter an account of his expenditures, scrupulously recording every item, and carefully explaining details out of the ordinary, such as the purchase of a volume by Rabelais, "a writer, priest, doctor of medicine, and hater of priesthood. He wrote a very fine book which I bought and am now reading." Of his expenses in general he said: "I have tried to act in moderation, without being liberal like a poor man or mean as a rich one. Spending your money, which came to you from hard work, I am touched by the delicacy of your not wanting the items but only the sum left, but I will nevertheless continue to give them as I have always done."

In spite of his father's generosity, he felt keenly the fact that he was still being supported, and lost no chance of assuring the older man that it was not a waste of money. "I could even now earn a respectable living in America, I think, painting heads," he wrote after a year and a half in Paris, "but there are advantages here which could never be had in America for study." A year later he spoke with more assurance: "One terrible anxiety is off my mind. I will never have to give up painting, for even now I could paint heads good enough to make a living anywhere in America. I hope not to be a drag upon you a great while longer."

His ideas about the financial side of painting, and his contempt for the type of artist who depended on social manœuvring to sell his work, instead of its own merits, were expressed in one letter. "Pickpockets are better principled than such artists," he said. Such tactics were bound to take up so much time that it would be impossible for the painter to bring his work up to the point where it was worth what he asked for it. "A good painting has a very high money value which it always brings, and beyond that a fancy price that runs up and down very irregularly. This fancy price is gambling, and an artist that pays attention to it instead of the real price, must lose in the end as sure as

insurance. The big painters understand this, and whether their aim is reputation or the comforts of money or even social position, they look on painting as their heaviest tool and work through it. A prince or anyone at all could not get in to Gérôme or Meissonier or Couture at work. No one but a student can ever get in to Gérôme. So everything I see around me narrows my path and makes me more earnest and hardworking. That Pettit or Read get big prices does not in the least affect me. If I had no hope of ever earning big prices I might be envious, and now worthy painting is the only hope of my life and study."

His daily life was serious and industrious, with little of the gay Bohemianism anticipated by young Americans. But he was no prig. His letters to his father commented with frank enjoyment on the broader side of Gallic life; in one he expressed amusement at an American friend who asked whether the outdoor *cafés chantants* on the Champs Elysées were "respectable", and why the police did not stop them. "Respectable. Dear me. Fine-looking old gentlemen stop there to rest and smoke their cigars, and have with them their daughters, and no married lady would hesitate an instant to stay there and applaud their wit. . . . If the man shut up his place he would be put in jail. The Government of France has authority over every place of amusement. It is its duty to see that its subjects shall be kept gay." He took part in the usual diversions and humors of the Latin Quarter, relished French cooking and wine, and appreciated student songs to the extent of copying down the more Rabelaisian of them before he left France. His amusements were simple: he went often to the opera, "principally to hear Adelina Patti, as it is not probable that I can ever hear such singing again," frequented the circus, and now and then the student masquerade balls or the races at Longchamps. Several days a week he visited a gymnasium, chiefly to wrestle.

Before he had been in Paris a year he could talk fluent French, including student slang; his notebooks and accounts were written in that language, and many of his letters, even to Americans. By this time he had firm friends among the French students, particularly Dagnan-Bouveret, Louis Cure, Paul Lenoir,

Achille Guedé—future pillars of the Académie. He knew Rosa Bonheur and her brother Auguste, and must have been delighted by Rosa's menagerie. The great influx of American students had not yet begun; of the few in Paris at this time, his closest friends were William Sartain, who had arrived about two years after himself, and Harry Moore.

In the summer of 1868 his father and his sister Frances came over for a trip. The latter wrote home an account of their meeting: "On the 4th of July we saw Tom; he was waiting at the station for us. He is much thinner than when he left home, but his complexion is clear and he looks right strong. The excitement of seeing us had kept him awake for a couple of nights and had made him pale, but by yesterday he had regained his color and looked fine. Anybody would take him for an Italian, his face and figure are so very Italian.

"Yesterday morning we went to his studio. He had not yet finished any of his paintings (that is lady's work, he says) and of course they are rough looking, but they are very strong and all the positions are fine and drawing good. He thinks he understands something of color now, but says it was very discouraging at first, it was so hard to grasp.

"He has changed very little, he's just the same old Tom he used to be, and just as careless looking. His best hat (I don't know what his common one can be) is a great big gray felt steeple, looks like an ashman's; his best coat is a brown sack, and his best pantaloons are light, with the biggest grease spot on them you ever saw. And then he most always wears a colored shirt. But he's the finest looking fellow I've seen since I left Philadelphia. We told him he was a little careless looking and he evinced the greatest surprise. 'Good gracious,' he said, 'why I fixed up on purpose to see you, you ought to see me other days.' You ought to see him bow; imagine Tom making a French bow. But I tell you he does it like a native."

School being closed for the summer, the three spent several happy months travelling through France and Switzerland into Italy, where they visited Florence, Rome and Naples. Eakins could talk Italian, and acquired a fondness for the people of that country that lasted all his life. Later they made a

short trip into Germany, as far as Munich. When the father and daughter sailed for America in September, he settled down again to work; but later in the year returned to Philadelphia for a short visit, arriving in time for Christmas. Two months were passed at home, and he was back in Paris by the middle of March.

IV

An increasing self-confidence appeared in his letters from about this time, when he had been two years in Paris. "My hard work is telling on me and my studies are good. Since I am learning to work clean and bright and understand some of the niceties of color, my anatomy studies and sculpture, especially the anatomy, comes to bear on my work and I construct my men more solid and springy and strong. . . . There is no doubt of the necessity of long studio work and that is the hardest of all work, but it is only one light and you ought no more to be accustomed to one light than to one model. Now I am going to give a great deal of my time to composition, working only after nature during the school hours. . . . So I am in good spirits." Again: "I think I can make my name as a painter, for I am learning to make solid, heavy work. I can construct the human figure now as well as any of Gérôme's boys, counting the old ones, and I am sure I can push my color further."

For a little more than a month, in the late summer of 1869, he worked in the studio of Léon Bonnat, where William Sartain was a student. Bonnat was still new as a teacher and uncertain in his methods, and at the end of the time Eakins wrote: "I am very glad to have gone to Bonnat and to have had his criticisms, but I like Gérôme best, I think."

Finally, in the autumn of 1869, he wrote his father: "I feel now that my school days are at last over and sooner than I dared hope. What I have come to France for is accomplished, so let us look to the Fourth of July, as I once looked for it before and for Christmas after. I am as strong as any of Gérôme's pupils, and I have nothing now to gain by remaining. What I have learned I could not have learned at home; for beginning, Paris is the best place. My

attention to the living model even when I was doing my worst work has bene-
fited me and improved my standard of beauty. It is bad to stay at school after
being advanced as far as I am now. The French boys sometimes do and learn
to make wonderful fine studies, but I notice those who make such studies sel-
dom make good pictures, for to make these wonderful studies they must make
it their special trade, almost must stop learning, and pay all their attention
to what they are putting on their canvas rather than in their heads, and their
business becomes a different one from the painter's, who paints better even a
study if he takes his time to it, than those who work in the schools to show off,
to catch a medal, to please a professor, or to catch the prize of Rome.

"I do not know if you understand. An attractive study is made from ex-
perience and calculations. The picture-maker sets down his grand landmarks
and lets them dry and never disturbs them, but the study-maker must keep
many of his landmarks entirely in his head, for he must paint at the first lick
and only part at a time, and that must be entirely finished at once, so that a
wonderful study is an accomplishment and not power. There are enough diffi-
culties in painting itself, without multiplying them, without searching what
it is useless to vanquish. The best artists never make what is so often thought
by the ignorant, to be flashing studies. A teacher can do very little for a pupil
and should only be thankful if he don't hinder him, and the greater the master,
mostly the less he can say.

"What I have arrived to I have not gained without any hard plodding work.
My studies and worries have made me thin. For a long time I did not hardly
sleep at nights, but dreamed all the time about color and forms, and often nearly
always they were crazinesses in their queerness. So it seems to me almost new
and strange now, that I do with great ease some things that I strained so hard
for and sometimes thought impossible to accomplish. I have had the benefit
of a good teacher with good classmates. Gérôme is too great to impose much,
but aside from his overthrowing completely the ideas I had got before at home,
and then telling me one or two little things in drawing, he has never been able
to assist me much, and oftener bothered me by mistaking my troubles. Some-

times in my spasmodic efforts to get my tones of color, the paint got thick, and he would tell me that it was the thickness of the paint that was hindering me from delicate modelling or delicate changes. How I suffered in my doubtings, and I would change again, make a fine drawing and rub weak sickly color on it, and if my comrades or my teacher told me it was better, it almost drove me crazy, and again I would go back to my old instinct and make frightful work again. It made me doubt of myself, of my intelligence, of everything, and yet I thought things looked so beautiful and clean that I could not be mistaken. I think I tried every road possible. Sometimes I took all advice, sometimes I shut my ears and listened to none. My worst troubles are over, I know perfectly what I am doing and can run my modelling, without polishing or hiding or sneaking it away to the end. I can finish as far as I can see. What a relief to me when I saw everything falling in its place, as I always had an instinct that it would if I could ever get my bearings all correct only once."

He realized, however, that while he was through with school he still had much to learn before he could paint pictures, and that he should remain longer abroad. When his family urged him to return to America for a visit, he replied: "I might come home again this winter. But I would not on any account, much as I want to see you all, for it would only put back a good deal further the big day that I am always looking to now, when I shall come home again to live; so a little more patience. I am all alone, and you are missing but one. Twenty days at least would have to be spent on the winter sea, and the thought of returning to France so soon, would not let me get regularly to work, and the work could not be of the kind that I am most needing now. I think maybe my best plan would be to work at school until the rain begins, and then go over to Algiers in the sunlight and paint landscape. Open air painting is now important to me to strengthen my color and to study light."

But he reckoned without the strain of hard work and the severity of Paris winters. He who had scarcely had a sick day in his life, fell ill at the beginning of winter. "I have a cold that set me coughing today," he wrote in early November. "I will try to get it well. It has been raining now for two weeks

every day, and sometimes it pours and is very dark, so that I feel anxious to get away. . . . Rain, dampness, and French fireplaces—no color even in flesh, nothing but dirty grays. If I had to live in water and cold mist I had rather be a cold-blooded fish and not human. . . . I have a good fire that warms my back and I hold my feet up on a chair to keep them from the draught that blows in from under the doors and sashes and up the chimney. The French know no more about comfort than the man in the moon."

Three weeks later he wrote: "I am going to Spain. I have been pretty sick here in spite of my precautions against the weather, and feel worn out." On the first of December, 1869, he arrived at Madrid, spent two or three days visiting the Prado, then resumed his journey southward to Seville, where he settled for the winter.

<h1 style="text-align:center">V</h1>

In Spain he discovered the sunlight of the south, southern life and character, and Spanish art. "I have seen big painting here," he wrote from Madrid. "When I had looked at all the paintings by all the masters I had known, I could not help saying to myself all the time, 'It's very pretty but it's not all yet. It ought to be better.' Now I have seen what I always thought ought to have been done and what did not seem to me impossible. O, what a satisfaction it gave me to see the good Spanish work, so good, so strong, so reasonable, so free from every affectation. In Madrid I have seen the big work every day and I will never forget it. I was sick when I left Paris. I think the good sunlight of Madrid set me up."

Spanish art, then as now, was difficult to know outside its native country. For centuries the proud, self-sufficient peninsula had kept it hidden from the rest of the world; and although it had been "discovered" in the 'thirties and 'forties, it was still little known at first-hand, for comparatively few artists had been to Spain. Not until the 'seventies did Velasquez begin to have the vogue that was to make the 'eighties and 'nineties resound with his name. Eakins was one of the first of his generation to see the art of Velasquez in its native setting,

and it burst upon him with a thrill of unexpectedness that would be impossible today. After the artificiality of the Salons, it must have seemed the very breath of reality. Of all the great masters whom he had seen, the closest to his own temperament was the Spaniard, with his naturalism, his concern with the facts of everyday life, his love of character more than ideal beauty, his scientific objectivity. The first great artist to concentrate on light and air and appearances, he had solved all the technical problems of realistic color, tone, and light, with which Eakins was still struggling. His consummate skill as a painter and his command of the brush must have seemed miraculous after the linear methods of the Beaux-Arts. Compared to the microscopic literalness of a Gérôme, his breadth of vision belonged to an ampler world; and his decorative tact, his reserved silvery harmonies, and his austere simplicity were a revelation of the meaning of style. Here was the world pictured as Eakins himself saw and felt it, but with a distinction and a grave splendor that he had never met before.

But he made no attempt to imitate Velasquez, even in the pictures he painted in Spain. His reaction was opposite to that of Whistler, who adopted the master's purely decorative qualities and adding a pinch of sentiment and *japonaiserie*, evolved his own faint, exquisite art. With Eakins it was less a matter of influence than of temperamental coincidence; his affinities to Velasquez were more fundamental, and the chief effect the master had on him was to confirm his disposition to paint his own world in his own way.

His other discovery among the Spaniards was the sombre, ferocious naturalist, Ribera, with his dramatic chiaroscuro, his delight in anatomy, and his strong, sober portraiture. In Eakins' notes the names "Ribera and Rembrandt" were frequently coupled—a judgment in accord with that of many of his contemporaries, particularly Bonnat. It is typical of his lack of aesthetic sophistication that he should not have gone back of Ribera to the fountainhead of naturalism, Caravaggio, of whom he did not seem to know. But the Neapolitan's work was difficult to see even in Italy, and the Spaniard was temperamentally closer to Eakins than an Italian could be.

To the other great painting in the Prado he paid less attention. Titian's

Danae was spoken of in his notes, but only with the comment that the paint in the shadows had not cracked. Indeed, most of his observations on the old masters had to do with their technique. The third of the trinity of the Prado, Rubens, he did not mention; it would be hard to imagine any points of contact between them. It is significant that between Rubens, the exuberant creator, the master of movement and design, and Velasquez, the austere naturalist, he chose the latter.

The old masters brought to him a clearer realization of the limitations of Beaux-Arts teaching. Although he was always to retain his admiration for Gérôme, he now saw how relatively limited his methods were. *"Il faut me décider de ne jamais peindre de la façon du patron,"* he noted. *"On ne peut guère espérer être plus fort que lui, et il est loin de peindre comme les Ribera et les Velasquez, quoiqu'il soit aussi fort qu'aucun frotteur."* His notes commented frequently on the limitations of direct, opaque painting, *"au premier coup,"* which to his mind resulted in *"faiblesse d'aspect."* Study of Velasquez, Ribera, Rembrandt, and Titian, had showed him the richer resources of the oil medium, towards which he had been working instinctively—the old method of successive paintings and glazes, partly opaque, partly transparent. From now on his own method was to dispense with a finished preliminary drawing and from the first to work directly in paint on the canvas, often covering it the first day, securing at once the main masses and chief tones, building the picture solidly by successive paintings, and allowing the details to take shape as the work progressed—*"la seule manière, à mon avis, qui puisse donner la délicatesse et la force en même temps . . . D'ailleurs, c'est là toujours que m'ont porté mes propres instincts."*

At this time his interest, as with most of his generation, was especially in light; having been used to the unchanging illumination of the studio, he was experimenting with other lights and with sunlight. His notebooks were full of speculations on such questions, which to him seemed as susceptible to logical solution as perspective or anatomy. The problem was to secure the utmost range of color and tone that the palette could offer, still keeping within nature's scale

of light; for example, one should not allow a white to appear in the light, as this would make it necessary to lower all the other values and thus restrict the luminosity of the picture. But he was not, like the impressionists, interested in light for itself, believing that its chief function in a picture was to reveal form, with which, like the old masters, he was most concerned.

VI

In Seville he had settled in a pension, where he was soon joined by Moore. "I am painting all the morning till three," he wrote his father. "Then I walk out into the country with Harry Moore. Then back to dinner, and then we sit in the dining-room by the fire and talk, for I am the only one that can talk with him. . . . I am very well, and it seems to me when I breathe the dry warm air, and look at the bright sun, that I never was so strong, and I wonder if I can ever be sick or weak again. The Spaniards I like better than any people I ever saw, and so does Harry Moore. He notices things, more than ordinary people, and remarks the absence of every servility and at the same time a great watching for the comforts or feelings of others. He can see farther out of the corner of his eye than anyone I ever knew, and he sees everywhere gentlemen repressing the curiosity of the little children at our queer motions.

"We walk out every day into the country. One day we went up along the river. At every quarter of a mile there would be little groups of men and women, much like our old picnic parties, family affairs, and they would be dancing. We stopped a long while with one party, the girls were so beautiful, and one man came with a little pigskin full of very fine wine and gave us all to drink, making us take first because we were strangers. How different a reception we would have got in England and even at home!"

A little later William Sartain joined them, and the three friends had festive days together in the early spring. "We take a day most every week to do nothing, working on Sundays," one of Eakins' letters said. "Then we get horses and gallop off into the country, and we mostly average forty miles, and that makes us sleep well. It is more pleasant than walking, for we go so fast and far, and

then rest all the middle of the day and look at the sky and eat our dinner." In this fashion they explored the country for miles around Seville, visiting all the small old towns, and on one occasion making an excursion of nine days to Ronda and the wilds of Andalusia.

Eakins, who had a deep affinity for the Latin temperament, loved the life of the ancient southern city. He had studied Spanish in Paris, thinking it "might be of use to him some day, or if of no use otherwise, a benefit to his mind," and had mastered it in his usual thorough fashion; and with his dark coloring, he was often taken for a Spaniard. "I am forming a very desirable acquaintance at Seville," he wrote. "I speak Spanish enough every day to kill or deafen a Spaniard if my whole conversation of the day could be addressed to one person. . . . Harry Moore, Billy Sartain and I are all three in fine health and spirits. It is warm and bright. I know ever so many gypsies, men and women, circus people, street dancers, theatre dancers and bullfighters. The bullfighters are quiet, gentle-looking men."

In Seville he started his first real picture, of a troupe of street entertainers, a "*compañia gymnastica*": a man and wife and their seven-year-old daughter. The girl is shown dancing in a sunlit street, while her father plays a flute and her mother beats a drum. The shadows of unseen spectators fall across the pavement; in a window, a woman with a child in her arms is watching; and over the wall behind can be seen the roof of a *palacio*, a palm tree, and the blue sky. With this first venture into the field of painting pictures, he took great pains, making innumerable drawings of the separate figures, and of the various details, even to the scrawl of a child on the wall. "My student life is over now and my regular work is commenced," he wrote his father. "I have started the most difficult kind of a picture, making studies in the sunlight. The proprietor of the hotel gave us permission to work up on top of the roof where we can study right in the sun. Something unforeseen may occur and my pictures may be failures, these first ones. I cannot make a picture fast yet, I want experience in my calculations. . . . Sometimes it takes me longer to do a thing than I thought it would, and that interferes with something ahead, and I have a good

many botherations, but I am sure I am on the right road to good work and that is better than being far in a bad road. I am perfectly comfortable, have every facility for work, especially sunshine, roof and beautiful models, good-natured natural people desirous of pleasing me. If I get through with what I am at, I want a few weeks of morning sunlight. Then I will make a bullfighter picture, and maybe a gypsy one."

But "something unforeseen" did happen, and six weeks later he was still working on the painting. "The trouble of making a picture for the first time is something frightful," he wrote. "You are thrown off the track by the most contemptible little things that you never thought of, and then there are your calculations all to the devil, and your paint is wet and it dries slow, just to spite you, in the spot where you are the most hurried. However, if we have blue sky, I think I can finish the picture and it won't be too bad if not too clumsy."

Two weeks later, excusing himself for not writing home oftener, he said: "I have been lately working very hard and often in much trouble. . . . If all the work I have put on my picture could have been straight work, I could have had a hundred pictures at least, but I had to change and bother, paint in and out. Picture-making is new to me; there is the sun and gay colors and a hundred things you never see in a studio light, and ever so many botherations that no one out of the trade could ever guess at."

A month later he was still at it; "but," he wrote, "I am not in the least disheartened, as your last letter feared. I will know so much better how to go about another one. My picture will be an ordinary sort of picture, with good things here and there, so that a painter can see it is at least earnest clumsiness."

His estimate of his first painting was too modest. Although a little awkward in handling and restricted in color, it had a largeness and strength remarkable in a young artist. No adventitious charms concealed the fundamental problems which the painter had attacked, and to a large extent solved. Few first attempts could show such courage, such freedom from outside influences, such a genuinely original vision.

At the end of spring, after six months in Spain, the three companions left

Seville and journeyed northward again, arriving in Paris at the beginning of June. Here Eakins lingered for a half-month, seeing his friends and visiting the Salon. About the middle of June he sailed for home, reaching Philadelphia in time for the Fourth of July, as he had promised.

Hardly had he left France when the Franco-Prussian War broke out—that cataclysm which was to destroy the world he had known and to introduce a new era, in art as in public life. And although he kept up contacts with his old friends abroad, he was never to return.

III

EARLY MANHOOD

EAKINS returned to an America which was entering a new epoch of material expansion and power. The stimulus of the Civil War, increased wealth and leisure, and wider international contacts, had produced a growing demand for luxury and art. The puritan plainness of the first half of the century was disappearing. A new architecture was developing, ostentatious and on an imperial scale, its most characteristic product being the solid rectangular respectability of the brownstone mansion; while Romanesque banks, Gothic railway stations, and brownstone Venetian palaces testified to a new eclecticism. The dark interiors were becoming crowded with bric-à-brac and curios; Turkish corners were appearing in the most respectable homes. Young ladies were ornamenting their cozy corners with crossed oars, fishnets, seashells, and gilded autumn leaves. The massive forms of the black walnut furniture were intricately carved, or concealed beneath red plush upholstery. Clothes were becoming heavy and voluminous, and evolving into strange shapes of bustles and sleeves, elaborate constructions of whalebone and velvet which swathed the female form from head to foot. Ornamentation, encouraged by the machine's cheap methods of reproduction, was spreading over every available inch of the simplest objects. It was an age of granite, cast iron, and oak, disguised by pretentious over-decoration; an age which concealed structural lines beneath what it fondly supposed to be an "artistic" surface.

A great wave of "Art" was spreading over the country. The comparatively simple and provincial art world of earlier America was breaking down before the new forces. The new millionaires were ransacking the galleries of Europe to enrich their new houses. The first great collections were being formed. Contemporary foreign art was being imported in increasing quantities, especially the modern French school: the Fontainebleau painters, and Bouguereau, Cabanel, Meissonier, Gérôme, Regnault, Bonnat—the last word in fashion. The appearance of the dealer, with his red plush galleries and his assortment of the

latest Salon prize-winners, marked the end of the old simple relations between artist and patron, and the coming of a more sophisticated day. Museums and art schools were being founded, art magazines were springing up, periodicals were devoting more space to art. More students than ever before were flocking to the art schools, including a large proportion of women; and henceforth the female influence in the American art world was to be powerful.

In this movement an important part was to be played by the Centennial Exhibition at Philadelphia in 1876, the first world's fair in this country— at once a result of the movement and a means of popularizing it. Bringing together for the first time a large collection of contemporary foreign art, it made the American people conscious of their own aesthetic limitations. A turning-point in American art, it inaugurated a new phase of foreign influence, particularly French.

When Eakins returned to this country, American painting was beginning to feel the new influences, but had not yet reached sophistication. In response to the pervading spirit of expansion and the new wealth's craving for "the biggest thing on earth", had appeared the grandiose products of the later Hudson River school, enormous panoramas by Church and Bierstadt and Thomas Moran, big in every way: in subjects, in size, in their massive gilt frames, in their impressive prices. The exhibitions of the National Academy of Design in New York and the Pennsylvania Academy in Philadelphia were filled with these productions, and with standardized portraits, sentimental or amusing anecdotes, picturesque "views" of the Alps or Venice, and works by the cow and sheep specialists. The nude was still practically a forbidden subject. The few attempts to portray American life realistically were over-literal or coated with sentimentality. In artistic qualities most of these works were old-fashioned and provincial. There were of course artists of genuine qualities among the older painters, as well as a few independent younger men, such as Homer, La Farge, Martin, Wyant, and Vedder; but these latter as yet played a minor part. The older academicians were in control; relatively prosperous and well satisfied with the rut into which they had fallen, they wanted nothing of the

strange new ideas which were beginning to drift over from Paris; to them even Corot was a revolutionary.

But with the 'seventies a movement was beginning among the younger artists, who were affected by the current urge for sophistication and foreign experience. The art of their elders seemed to them old-fashioned compared to foreign work. Teaching in this country was poor; they wanted to study at the center of things. The Centennial intensified the contrast; while a few had gone abroad before 1876, afterwards the exodus became general, the common goal being Paris. Entering the big official schools, they absorbed a naturalistic viewpoint and technique, and came to look with increasing scorn on artistic conditions back home.

Of this "New Movement", as it came to be called, Eakins was a forerunner, appearing in a pause between the two schools. While eight or nine years younger than the youngest independents of the old school, he was at the same time older than any of the new men, of whom the nearest to his age—Duveneck, Chase, Thayer, and Eaton—were four or five years his juniors, while the majority of them had been born in the 'fifties. He had gone abroad several years ahead of the earliest of them, and returned before most of them had even started. Closer in spirit to them than to the old academic school, he was for several years one of the few representatives of the "New Movement" in this country, and almost the only one in Philadelphia, where he and William Sartain came to be known, in the words of the latter's father, as "the two young firebrands from Paris."

II

Most young American artists returning from abroad in the 'seventies found life in this country, after that of Europe, hard and ugly, and had difficulty in adjusting themselves. But Eakins, being sturdier and more of a yea-sayer, fitted immediately and naturally into his old environment, whose comparative order and sense of tradition must have made the adjustment easier.

A studio was prepared for him on the top floor of the Mount Vernon Street

house, and he began at once painting the life he had known before he went abroad, his first pictures being of his own family. His sisters were all musical, and he painted Frances playing the piano and Margaret listening, or Margaret at the piano and Caroline lying on the floor studying, the background being the dark interior of their home. From the first these works had a seriousness and maturity unusual in a young painter. His aim was to present a true picture of the people he knew best, in their usual surroundings. None of these sitters, no matter how close to him, were flattered; he painted them as they were, with remarkable truth of character and sense of reality. Seldom has ordinary everyday life served as the raw material of an art so uncompromisingly objective. And yet in all these works, drastically honest and entirely free from sentimentality or banal story-telling, there was an undertone of intense feeling for family, friends, and home, a reserved but deep sentiment.

Next to his own family the Crowells appeared most often in these early pictures. One of his best friends in high school had been William J. Crowell, who was later to marry Frances Eakins. There were two Crowell sisters, Katherine and Elizabeth, and the young people of the two families became close friends. Between Thomas and Katherine, who was several years younger than himself, there was more than friendship, and soon after his return from abroad they became engaged. His first large portrait was of her, in a white dress, with a red fan in her hand, playing with a cat. But their love was cut tragically short by her death while she was still in her early twenties.

Another blow came in the death of his mother about the same time. During her last illness he exhausted himself nursing her, and photographs of him at this time show him hollow-cheeked, his emaciation emphasized by a thin beard, but his eyes seeming all the more alive.

The closest to him of his family, except his father, was now Margaret, who never married as did his other two sisters. Temperamentally she was like him in independence, hardiness, and mental vigor; and her love of music corresponded to his of art. While not conventionally pretty according to the feminine standards of the time, she was vivid and striking, with the dark coloring

of her mother's family, and a beautiful figure, strong and supple; "like an animal," said one who knew her. His comrade in outdoor activities, she could sail a boat and was an accomplished skater, she and Benjamin making a graceful pair on the ice; and it was in skating costume that her brother painted his best-known portrait of her. A favorite model of his, she appeared in many early works, and also helped him in practical affairs, appointing herself his business manager, keeping a record of his paintings, and seeing that they were sent out to exhibitions. There was an unusual and deep affection between them, as between himself and his father.

He had resumed his vigorous outdoor life, which supplied him with many of his earliest subjects: Benjamin Eakins and himself hunting in the marshes, whose flat expanse, golden-brown with autumn, stretched to the remote distance, where the sails of schooners appeared on the river; or two hunters in a sailboat on a hot, calm day, the sail hanging heavily, the river water lead-colored under the sun; or a negro crouching in a marshy meadow, whistling to decoy plover; or small sailboats, like the one he owned himself, racing on the Delaware. Rowing was one of the most popular sports of the time; the Schuylkill, lined with boat clubs, was always alive with shells. Eakins himself rowed, and was friendly with the champion oarsmen; and many of his early pictures were of rowers. One of the first shows his boyhood friend Max Schmitt resting on his oars in his shell *Josie*, while in the distance the artist himself is seen rowing; it is a still, sunny afternoon, with glassy water, and one can almost feel the heat. Other pictures showed rowers on practice spins, shooting under the darkness of bridges; or racing, with every muscle strained, their vari-colored uniforms brilliant in the sunlight, the river lined with excursion steamers and boats of all descriptions, the wooded banks crowded with spectators afoot, on horseback, or in carriages.

These were all virgin themes. Every picture was part of his daily life, every figure a portrait of someone he knew, every scene a familiar one. It was the material closest to him, presented with unconscious simplicity and truth. No trace of imitative style could be found in these works; they were

products of an essentially original vision. Keen first-hand observation appeared in the truth to character of these rough sportsmen, with their natural, unstudied gestures and attitudes, in the almost photographic sharpness of details, in the fidelity to the color and atmosphere of this country—the high, remote skies, the strong sunlight, the clear air, the brown bareness of grass and trees and fields for half the year. These were things he had never learned in Gérôme's studio. Among painters of the time only Winslow Homer approached the fresh authenticity of these records of American outdoor life.

III

Eakins' temperament was remarkable in its combination of artistic and scientific qualities. Next to painting, science was his chief interest. A fine mathematician, he delighted in mathematical problems and used to read logarithms and work out problems in calculus in order to relax his mind after work. This bent was consistent with his naturalistic viewpoint, concerned not at all with the literary or decorative aspects of art, but absorbed in the realities around him, in the physical existence of men and women and animals and things, their construction, action, and character. His whole approach to art was logical and reasoning rather than purely emotional. To him things must be understood rather than merely felt; one should know anatomy before painting the figure; space and form relationships should be figured out by perspective; even color was rationalized. In his notebook, after a discussion of how to fix the chief colors and tones in a picture, he wrote: *"Les mathématiciens n'ont pu mesurer le cercle qu'en commençant avec le carré dont on double continuellement le nombre de ses côtés."* This typified his method; fixing the definite, demonstrable points, and going on from them to more complex, unknown matters, like a surveyor mapping new country. When he came to teach he used to urge his students to study higher mathematics, which he said was "so much like painting"; and he once observed: "All the sciences are done in a simple way. In mathematics the complicated things are reduced to simple things. So it is in painting. You reduce the whole thing to simple factors. You establish

these, and work out from them, pushing them toward one another. This will make strong work. The old masters worked this way."

His chief interest, however, remained artistic. His studies were closely related to painting and to specific artistic problems. His concern was less with science *per se* than with science as it contributed to art. He was an artist absorbed in science, not a scientist practising art.

A few years after his return from abroad he resumed his anatomical studies at Jefferson Medical College, carrying still further the exhaustive researches he had already made, taking casts of human and animal subjects, and writing an illustrated treatise on anatomy, for his own information rather than for publication. By this time his anatomical knowledge was probably greater than that of any painter in the country; not the perfunctory affair of the average artist, but based on thorough, first-hand study, which was to continue a large part of his life. And his own physical activity, the feel of his own body, must have taught him much. His knowledge was not merely theoretical but deeply instinctive and sensuous. In his very first paintings his figures had a vitality possessed by few other artists of the time. But their anatomical aspect was never emphasized; it was entirely unobtrusive, having to do with essential life more than outward features. The same vitality appeared equally in his clothed figures.

His method of constructing these early pictures exemplifies his scientific bent. The main planes and the regular-shaped objects were built up in perspective, mathematically, everything being based on exact measurements and calculations, almost like the work of a mechanical draughtsman. Mechanical drawings were made of the ground-plan and the side and end elevations of the principal objects; the ground-plan of the picture was then laid out in perspective and on it the objects were erected, on the basis of the mechanical drawings. This method was applied only to the parts that lent themselves to mechanical treatment, not to the figures. A perspective drawing of a rowing picture, for example, would show the shell floating in the water, complete in all its details, the oars in correct position, the waves and reflections carefully

plotted, and perhaps a few regular objects such as the piers of a bridge; the figures being roughly blocked in in freehand. This was the framework of the picture. Drawn to the same scale, it was transferred to canvas with transfer paper. Sometimes the signature, written in a formal flowing hand that recalled his father's profession, was placed in perspective on the side of some object. These perspective drawings, some of which still exist, have a precise beauty of their own.

Little room was left for guesswork. Curved or irregular forms, for example, were not drawn freehand but were constructed by enclosing them in simple rectangular forms and then removing the superfluous parts, the transition from the mechanical to the perspective drawings being made by dividing the surfaces into checkerboards of small squares through which the lines were traced. In a lecture on perspective which he wrote in later years he said: "You need not imagine there need be any want of accuracy in this method of copying by eye from one set of little squares to the other set; for no matter if the eye itself should be so inaccurate that it would put a point in a little square as far as possible from its true place, yet by increasing the number of little squares and so diminishing their size, a possible error can be made less than any given amount."

An example of the method was given in his lecture: "I know of no prettier problem in perspective than to draw a yacht sailing. Now it is not possible to prop her up on dry land, so as to draw her or photograph her, nor can she be made to hold still in the water in the position of sailing. Her lines, though, that is a mechanical drawing of her, can be had from her owner or her builder, and a draughtsman should be able to put her in perspective exactly.

"A vessel sailing will almost certainly have three different tilts. She will not likely be sailing in the direct plane of the picture. Then she will be tilted over sideways by the force of the wind, and she will most likely be riding up on a wave or pitching down into the next one. Now the way to draw her is to enclose her in a simple brick-shaped form, to give in mechanical drawing the proper tilts, one at a time, to the brick form, and finally to put the tilted brick

into perspective and lop off the superabounding parts. . . . I advise you to take a real brick or a pasteboard box of similar shape, and letter the corners, and keep it by you while you draw it."

His own system, however, was more advanced than this, making use of higher mathematics; as he went on to say: "It is likely that an expert would not have got the tilts by drawing at all, but would have figured them out from trigonometric tables, but it is much easier for beginners to understand solid things than mere lines of direction."

These methods, so completely different from those of today, were not so unusual in his day. At this time the substitution of the photograph for the handmade picture—one of the outstanding facts in the artistic history of the last fifty years—had not yet robbed the artist of his most common function, that of making correct pictures of things for all kinds of purposes; accurate representation was still the *sine qua non* of painting and teaching. Eakins' methods were in line with those of the time. But he carried the scientific method further and applied it more thoroughly and consistently.

In spite of these seemingly cold scientific methods, there was no lack of vitality or warmth in the finished pictures. His mind was of such unusual clarity and steadiness that it worked easily in scientific terms, and delighted in them. The perspective method was simply the most natural way for him to draw objects whose properties must already have been present in his mind with extraordinary completeness. There was nothing slavish in his use of it; he dominated it instead of depending on it. If he had worked purely by instinct he might have secured the same results, but science was the channel through which his unconscious powers expressed themselves. He resembled certain artists of the Renaissance, who also lived in an age of scientific discovery, who had a burning interest in perspective and anatomy, and to whom science was an intellectual passion. With Uccello, he might have said: "What a delightful thing is this perspective!" By these methods he achieved form of a sureness, precision, depth, and power, of which few of his contemporaries were capable.

Of some early works he made several versions with varying details or in different mediums and sizes, as if having once established the structure he wished to play variations upon it, or as if these works were attempts to solve certain problems by approaching them from different angles or by placing the same elements in different combinations.

None of his pictures were painted outdoors. Small oil sketches were often made on the spot, merely color notes or indications of action; but the finished paintings were always done in his studio. For moving figures or those which he could not get to pose, he sometimes made small wax models—for example, the diving man in the *Swimming Hole,* the horses in the *Fairman Rogers Four-in-hand,* and the statues in *William Rush.* For the rowing pictures, as he told a pupil, he "made a little boat out of a cigar box, and rag figures with red and white shirts, and blue ribbons around the heads, and put them out into the sunlight on the roof and painted them, and tried to get the true tones." But the vitality of the finished work shows that he must have had an extraordinary visual memory.

Aside from his perspective studies he drew little. A strong draughtsman in the largest sense, he cared little for drawing itself; it was a means to an end, painting. Almost his only finished drawings were those made in school before he began to paint. Instead of preliminary drawings, he would make small oil sketches of individual figures or the whole composition, in full color, sometimes quite finished, more often giving merely the main masses, movement, and arrangement. These would be squared off and enlarged on to the canvas. Even for watercolors, of which he painted many in early years, he made studies in oil, an easier medium in which to feel one's way. His handling of watercolor was much like that of oil, with the same search for solidity rather than more fragile qualities.

The main constructive lines having been transferred to canvas from his sketches and perspective studies, he worked on the picture directly in paint, without any finished preliminary drawing on canvas—a method radically different from that of the Beaux-Arts. His technical processes, developed by

much original thought, assisted by study of the old masters in Spain, were considerably richer and more complex than those of Gérôme or of most of his contemporaries. While the artists of his time were increasingly using a relatively simple, direct, opaque technique, he adhered to the older tradition of building up his pictures by successive paintings and glazes, the solid forms being painted most heavily, the recessions more transparently—the opacity of the former creating solidity and projection, the transparency of the latter giving depth. He did not follow the system of the old masters to the extent of underpainting in monochrome, but first laid the picture in broadly in thin color, often covering the entire canvas at one sitting, establishing first the large masses and chief tones, then building more and more solidly. The heaviest painting was usually in the figures and especially the head and hands; the backgrounds were relatively transparent. But his impastos were seldom obtrusive, the surface in general being fairly smooth. In the beginning he experimented a good deal and his handling varied; and in general these early works were painted more heavily and with more evidence of struggle than his later ones were to be. But while sometimes even using a palette knife, in few cases did he load on pigment in an insensitive, opaque manner. His technique was always varied and subtle, combining firmness and refinement, and searching for solidity and depth rather than surface brilliancy.

From the first his color was dark and warm. He had grown up in a period when houses and clothes were sombre, when oil or gas light cast a limited illumination, amid the prevailing red brick of Philadelphia and her tree-shaded streets. Most of the paintings he had seen in his youth had been in a dark tradition. When he was abroad impressionism had hardly begun, and it would probably not have affected him much in any case, for he was not easily influenced. If he had had any inclination towards a more brilliant range he could have developed it independently, as did his contemporaries the impressionists; but his whole temperament inclined toward a darker key—his seriousness, reserve, lack of gay or decorative qualities, his preoccupation with form, the sombre emotional undertone of his art, his very complexion and coloring.

At its most high-keyed his color was powerful rather than brilliant, tend-ing always towards the browns and grays. Flesh tones were swarthy, almost Latin, with little rosy glow. Even the brightest of his outdoor pictures did not approach the impressionistic gamut. The fact that they were painted in his studio must have had much to do with their key, for the sketches were more brilliant than the finished pictures; and his most solidly painted works were often the lowest-toned, suggesting that as he worked on them, securing more body, they became darker.

But while in a dark and reserved tradition, he was a genuine and sensitive colorist, concerned not with mere charm or decorative quality, but with just-ness of relations and the coordination of color and form—a conception of color more profound than that of most of his contemporaries. And his color in itself, within its austere range, was powerful, deep, and mellow.

At this time his generation was becoming more and more preoccupied with light and atmosphere, but while sharing to some extent in this interest, he al-ways kept it strictly subordinated to considerations of form. While the im-pressionists were creating pictures in which light was the real subject, and ob-jects were bathed and softened by a luminous mist, the sunlight in his work, though low-toned, was clear and sharp, bringing out the solidity and charac-ter of objects, its direction and shadows plotted as precisely as the constructive lines of forms. He made little attempt to capture the evanescent moods and appearances of nature, concentrating on her structure and permanent realities.

His vision was almost photographic in its keenness of observation. He was himself an excellent photographer, as were several of his friends, although photography was still a matter for experts rather than the general public. But he never painted from photographs, except in a few cases of portraits of persons no longer living, a type of commission which he disliked to under-take. To him the camera was a useful instrument for gathering scientific data —a servant, not a rival. Whereas the competition of photography was to in-fluence many of his contemporaries toward a more purely "aesthetic" style, his vision was in harmony with it. In his pictures he sometimes included visual

phenomena which most painters disregard, such as the refraction of the side of a face as seen through glasses, or the slight blurring of objects in the background. In a lecture on the focus of the eye he said: "The character of depth is incompatible with that of sharpness, especially as you go out sideways from the point of sight, and one or the other characteristic must be sacrificed in a picture. If your picture is simply to convey an impression you will probably choose to give the depth, but if you were drawing a sloping-away bridge for an engineer you would sacrifice the feeling of depth, except what comes from correct perspective, to a conscientious reproduction of all the constructive details, whether far or near. Between these cases as extremes you will make your picture as it most strongly impresses you with its character and as you want to impress by it the spectators of your picture." In his own work he never rendered mere appearances, like the camera, but retained the solidity of forms.

One of his favorite problems in these early pictures was that of reflections in water, in which he was so much interested that he later wrote a separate lecture on it, explaining the laws of such phenomena as the varying reflections of the near side of a wave, the far side, and the top. These things to him were mathematical problems similar to those of perspective; and at the same time his remarks on them had a sober poetry, for the subject was close to his recreations and his love of the water. "There is so much beauty in reflections that it is generally well worth while to try to get them right," he said. An example of his observation was the following: "Everyone must have noticed on the sides of boats and wharves or rocks, when the sun is shining and the water in motion, never-ending processions of bright points and lines, the lines twisting into various shapes, now going slowly or in a stately manner, then dancing and interweaving in violent fashion. These points and lines are the reflections of the sun from the concave parts of the waves acting towards the sun as concave mirrors, focussing his rays now here, now there, according to the shifting concavities. They are called caustics, and may, by knowing the cause of them, the general character of the waves at the time, and direction of the sun, be sufficiently well imitated by guesswork."

IV

Although Eakins had worked hard in these early years, as proved by the number and variety of his pictures, he had made little attempt to exhibit. It was some time before he felt ready; and also there were few places in America for a young artist to show: the National Academy of Design in New York did not welcome newcomers, and the Pennsylvania Academy was closed for several years during the building of a new home.

As soon as he had done work which to some extent satisfied him, in the spring of 1873, he sent a specimen to Gérôme: a watercolor of a rower (prudently making a replica of it to keep and exhibit). The master replied: *"Mon cher Élève: J'ai reçu l'aquarelle que vous m'avez envoyé, je l'accepte avec plaisir et vous en remercie. Elle m'a été d'autant plus agréable que dans ce travail j'ai pu constater des progrès singuliers et surtout une manière de procéder qui ne peut vous mener qu'à bien. Je ne vous cacherai pas que jadis à l'atelier je n'étais pas sans inquiétudes sur votre avenir de peintre, d'après les études que je vous voyais faire. Je suis bien enchanté que mes conseils, appliqués quoique tardivement, aient enfin portés leurs fruits, et je ne doute pas qu'avec de la persévérance, dans la bonne voie où vous êtes maintenant, vous n'arriviez à des résultats vraiment sérieuses. Je passe à la critique après avoir constaté les progrès."* The figure, he continued, although well drawn in details, was immobile, a fault which he ascribed to the artist's having chosen to paint the middle of the stroke instead of the pause at either extreme. *"Il y a dans tout geste prolongé, comme l'action de ramer, une infinité de phases rapides. . . . Deux moments sont à choisir pour nous autres peintres, les deux phases extrêmes de l'action; . . . vous avez pris un point intermédiaire, de là l'immobilité."* But he concluded: *"La qualité générale du ton est très bonne, le ciel est ferme et léger, les fonds bien à leur plan, et l'eau est exécutée d'une façon charmante, très juste, que je ne saurais trop louer. Ce qui me plaît surtout, et cela en prévision de l'avenir, c'est la construction et l'établissement joints à l'honnêteté qui a présidé à ce travail, c'est pourquoi*

je vous envoie mes compliments avec mes encouragements, et cela je suis très heureux de le faire. Tenez-moi je vous prie en courant de vos travaux et consultez-moi toutes les fois que vous croirez devoir le faire, car je m'intéresse beaucoup aux ouvrages de mes élèves et aux vôtres en particuliers."

Eakins took this criticism to heart and painted another version in which the rower was at the end of the backward stroke, at a moment of relative pause between actions, instead of swift motion. This he sent to Gérôme next year through William Sartain, together with two oils of hunting subjects to be submitted to the Salon. This time the master wrote: *"Mon cher Eakins: J'ai reçu vos tableaux et j'ai trouvé un progrès très grand: je vous fais mes compliments. . . . Vous avez maintenant en main, le côté d'exécution, ce n'est plus qu'une question de choix et de gout. Votre aquarelle est entièrement bien, et je suis bien content d'avoir dans le Nouveau Monde un élève tel que vous qui me fasse honneur. . . . Je ne sais si cette espèce de peinture est commerciale, il me suffit de constater qu'elle est dans la bonne voie et l'avenir est là."* In the future he often asked after Eakins of new American students, and those who presented letters of introduction from his former pupil were assured of a cordial reception.

The two oils were accepted by the Salon, the height of a young artist's ambition in those days; and Goupil bought one of them—one of his earliest exhibitions and sales thus taking place in France.*

V

In the course of his anatomical work at Jefferson Medical College, he became acquainted with many of the leading physicians of the city. At this time the dominating figure in the college was Dr. Samuel D. Gross, one of the greatest surgeons in the country, a magnetic teacher, and a man of impressive appearance. Eakins saw him many times operating in his clinic

* In 1874 he had begun exhibiting watercolors at the American Society of Painters in Water Color in New York, and had sold one there that year. This was the first exhibition and sale of which there is any record.

before his students, and from this experience conceived the most ambitious
picture of his early years, the *Gross Clinic.*

The scene is a sombre amphitheatre into which cold daylight falls from
above, bringing the principal actors into dramatic relief. Dr. Gross has
paused in the operation, and scalpel in hand, stands talking to his students.
On the operating table lies the patient, surrounded by the assistants, one of
whom is probing the wound. Instead of the immaculate white of present-day
surgery, all the doctors wear dark, everyday clothes, characteristic of the days
before modern antisepsis. In the background the clinic clerk takes down the
great surgeon's remarks; and further back rise tier after tier of seats filled
with dimly seen figures of students absorbed in the operation, in every variety
of attitude. At one side, unnoticed, sits the patient's mother, covering her
eyes—a contrast to the scientific impersonality of everyone else.

While the picture represents a whole scene, it is at the same time the por-
trait of one man. Dr. Gross dominates it, with his silvery hair, fine brow, and
strong features catching the full force of the light—an imposing figure, with
the rugged force of a pioneer in his profession. Every detail in the picture
contributes to the dramatic value of his figure and the subordinate drama of
the group of assistants clustered around the patient. Every person is an indi-
vidual, whose character is depicted with a sure grasp, and each is doing his
work with absorbed intentness. The viewpoint is absolutely objective; the
hand that guided the brush was as steady as the hand that guided the scalpel.
But there is no lack of humanity; not the sentimentality that hides its eyes
and shrinks from the less pleasant aspects of life, but the robust understand-
ing of the scientist who can look on disease and pain, and record them truth-
fully. The work has the impersonality of science, and its humanity. It rep-
resents a drama of contemporary life, a phase of man's search for knowledge.
In its truth of characterization, its formal strength and balance of design, it
shows a power and completeness of realism that could be matched by no other
American painter of the time.

This picture, the masterpiece of Eakins' early manhood, was finished in

the latter part of 1875, when he was thirty-one years old. He had worked hard over it, persuading friends and fellow students, doctors, and the famous surgeon himself, to pose. Soon after its completion it was exhibited at the Haseltine Galleries on Chestnut Street—probably his first public exhibition of an oil in this country. It created a sensation; crowds visited the galleries, and long accounts of it appeared in the papers. "The public of Philadelphia now have, for the first time," wrote one critic, "an opportunity to form something like an accurate judgment with regard to the qualities of an artist who in many particulars is very far in advance of any of his American rivals. We know of no artist in this country who can at all compare with Mr. Eakins as a draughtsman, or who has the same thorough mastery of certain essential artistic principles. . . . To say that this figure is a most admirable portrait of the distinguished surgeon would do it scant justice; we know of nothing in the line of portraiture that has ever been attempted in this city, or indeed in this country, that in any way approaches it." But while a few other writers echoed these sentiments, the bulk of the criticism was unfavorable. Complaints were made about the darkness of the color, the strong lighting, the realistic style, diagnosed as "the modern French manner," the "puzzle" presented by the patient's body—even the perspective. The subject, however, was what condemned the picture utterly in the eyes of most writers, especially the fact that the artist had dared to show blood on the hands of the surgeon. One critic, after praising the principal figure, remarked regretfully: "If we could cut this figure out of the canvas and wipe the blood from the hand, what an admirable portrait it would be!" Another, on the occasion of its exhibition in New York a few years later, wrote: "The more one praises it, the more one must condemn its admission to a gallery where men and women of weak nerves must be compelled to look at it. For not to look at it is impossible." "The more we study it," said another, "the more our wonder grows that it was ever painted, in the first place, and that it was ever exhibited, in the second. . . . This is the subject of a picture of heroic size . . . that a society thinks it proper to hang in a room where ladies, young and old, young girls and boys

and little children, are expected to be visitors. It is a picture that even strong men find it difficult to look at long, if they can look at it at all; and as for people with nerves and stomachs, the scene is so real that they might as well go to a dissecting-room and have done with it. . . . No purpose is gained by this morbid exhibition, no lesson taught." Another wrote: "To sensitive and instinctively artistic natures such a treatment as this one, of such a subject, must be felt as a degradation of Art," while one of the country's leading critics, S. G. W. Benjamin, author of *Art in America*, said: "As to the propriety of introducing into our art a class of subjects hitherto confined to a few of the more brutal artists and races of the old world, the question may well be left to the decision of the public. If they demand such pictures, they will be painted, but if the innate delicacy of our people continues to assert itself there is no fear that it can be injured by an occasional display of the horrible in art, or that our painters will create many such works."

One remarkable fact about all the criticisms, however, was the amount of space that they gave the picture; even the writer who saw no reason "that it was ever painted, in the first place, and that it was ever exhibited, in the second," spoke of it before any other work in a large exhibition and devoted more than half of his review to it.

When painting it Eakins had had in mind the Centennial Exhibition, due to open in Philadelphia the following spring. But the art jury of the Centennial, while accepting five other works by him, rejected the *Gross Clinic*. He finally succeeded in getting it hung in the medical section. Commenting on this, a friendly critic remarked: "It is rumored that the blood on Dr. Gross' fingers made some of the members of the committee sick, but judging from the quality of the works exhibited by them we fear that it was not the blood alone that made them sick. Artists have before now been known to sicken at the sight of pictures by younger men which they in their souls were compelled to acknowledge were beyond their emulation."

Eakins had pinned high hopes on the picture, but they were not realized. There had been no order for it, and not until three years after it was painted

did the Jefferson Medical College buy it, for two hundred dollars; and then it was hung in the college where the art public seldom saw it. A few times during the years he borrowed it for important exhibitions, but only in 1904 did it receive an award.

The reception of the *Gross Clinic* must have been a blow to Eakins—the first of many he was to receive. But he showed no signs of discouragement, or of any attempt to compromise with popular taste.

VI

In the years following the Centennial, Eakins' younger colleagues who had gone abroad to study, began to return, and in 1877 occurred the historic exhibition at the National Academy in New York, in which a number of them, as well as himself, were represented for the first time—so well represented and hung, in fact, that the older academicians objected, leading to a revolt of the younger men and the formation of a radical new organization, the Society of American Artists, whose birth inaugurated the "New Movement." The young Society, unique at the time in that its exhibitions were open to all comers and that members were not exempt from the jury, at first had a hard struggle, but for many years held the liveliest exhibitions in the country. Chase, just back from abroad, speedily became one of the leaders of the Society and of the movement it represented.

Eakins had had his difficulties in being accepted by the National Academy, and in general was sympathetic with the younger men. He showed in the Society's first exhibition in 1878 and for several years thereafter, and in 1880 became a member—this being the only organization he was to join for many years. But he still continued to send to the Academy, supporting the new without abandoning the old. Although identified in the public mind with the new movement, he did not become as violent a partisan as the younger men. Not being an "organization" man, he went about his own work in his own way, bothering little with the politics of art, which was easy for him because in Philadelphia he was out of the main current of the movement.

At the Society in 1879 he exhibited the *Gross Clinic*. This was the first time it had been seen by the larger art public, and it was easily the most talked-of picture there. The show aroused such interest that the Pennsylvania Academy asked to include it in its annual exhibition, the agreement being that all the Society's pictures should be shown, as a unit. At this time Eakins had been represented at the Academy for several years, was a teacher in its school, and a member of the exhibition committee. But when the show came to be hung, the directors refused to give a place to the *Gross Clinic*, substituting an enormous canvas by Thomas Moran, *Bringing Home the Cattle*, which, although already rejected by the Society, was hung among its pictures, in the place of honor. Eakins at once protested in a letter in which he said: "I feel that the Academy will be greatly blamed for what will seem to the Society a direct insult." The Society also forwarded a written protest and followed this by sending a committee, including Chase, Carroll Beckwith, and William R. O'Donovan, to Philadelphia, to say that if the Moran picture was not taken down and the Eakins hung, they would withdraw their entire exhibition. The Academy officials, unused to having artists act in this manner, immediately complied; the *Gross Clinic* was hung, in the darkest part of the galleries. Thus was Eakins' most important work finally seen in an art exhibition in his native city.

VII

In the early 'seventies began his long career as a portrait painter. While in a sense all his work had been portraiture, for every figure had been a real person, he had painted comparatively few pure portraits, and only of his own family and friends. But soon he began to branch out. His first outside sitter was his old chemistry teacher in high school, Professor Benjamin H. Rand, whom he represented at a desk covered with books and shining scientific instruments, pausing in his work to stroke his cat. This was followed by two large portraits, one of the well-known surgeon Dr. George H. Brinton, the other of Archbishop James Frederick Wood, recently created first archbishop

of Philadelphia. None of these were commissions; the sitters were interesting people whom he knew and admired and asked to pose for him, afterwards presenting them with the paintings. Doubtless he hoped in this way to launch himself as a portrait painter.

In the spring of 1877 came his first portrait commission. The Union League of Philadelphia, one of the most influential clubs in the city, the stronghold of Republicanism and the pillar of the administration, gave him an order for a portrait of President Hayes, who had just been inaugurated; the price being the highest he had been offered so far, four hundred dollars. The League evidently wanted him to paint a conventional half-length figure from a photograph, for we find him writing the following letter to the chairman of the committee:

"It may at first sight seem ill befitting me to commence offering suggestions to those who have just gratified me so by their choice of me to paint the president, but I would nevertheless ask of you to represent to Col. Bell and your Committee one of my ideas with the excuse that I am even more anxious than they for the success of my portrait.

"I do not intend to use any photographs but the president must give me all the sittings I require. I will take a chance to watch him and learn his ways and movements and his disposition.

"If I find him pressed or impatient, or judge that he can ill afford a great number of sittings, I would like to confine myself to the head only, painting it with the greatest care, and this I could finish during a few hours in a week's time.

"If he is disposed, however, for a full-sized portrait similar to the Dr. Brinton composition, I would undertake it with equal spirit, but of myself I would not select the size you mentioned. A hand takes as long to paint as a head nearly, and a man's hand no more looks like another man's hand than his head like another's, and so if the president chose to give me the time necessary to copy his head and then each of his two hands (for I would not be induced to slight them), then it would seem a pity not to have the rest of him

when I know how to paint the whole figure. The price in either case can remain the same as you mentioned. In comparison with the importance of the work, the money and time do not count.

"So I would beg your influence with the gentlemen to urge postponement of the question of size only, until I can get acquainted with the president himself, and then I would want to consult with them before commencing. I wish very much to make them a picture which may do me credit in my city and which if I may be allowed to exhibit in France may not lessen the esteem I have gained there."

He had his way about not using photographs, although he was not allowed to realize his ambition of painting a full-length figure. Going to Washington, he presented himself to the President, who at first did not wish to pose, but finally consented on condition that he go ahead with his work, and the artist should sit in a corner out of the way. It was hot summer weather, and Hayes took off his coat and worked in his shirt-sleeves. In a pause of his labors he came over and expressed interest in what Eakins was doing; remarking that some time he would like to spend an afternoon looking into this business of art. At the times when he was out of the room, Eakins occupied himself by sketching the view from the White House window.

What the members of the Union League doubtless expected was something in the way of red velvet curtains with gilt tassels, a white marble column, and a noble attitude. What they received was a portrait of a dignified elderly gentleman with a patriarchal beard, dressed in ordinary clothes, and engaged in his everyday work—a portrait full of the rock-ribbed character that made Hayes one of the most dependable if not the most spectacular of the presidents, but with no trace of idealization or heroics. Moreover, he was perceptibly flushed with the heat, a fact that was particularly damaging in view of his and Mrs. Hayes' well-known teetotalism.* At first the League refused the picture, but some member more liberal than the rest finally persuaded them to accept it, and it was reluctantly hung among their more conventional presidential

* There is a legend that the portrait even showed the President in his shirt-sleeves, but this is unfounded.

portraits. But although the critic of one paper dared to say that it was the only good picture in the collection, it soon vanished, no one knows where; and a few years later an entirely innocuous and lifeless portrait by a second-rate artist was hung in its place. Of the Eakins work no trace remains but the memories of those who saw it, the newspaper account of it, and the sketch which the artist painted from the White House window while he was waiting for the President.

VIII

Eakins had always been intensely interested in the nude, and entirely natural about it. He enjoyed swimming, sailing, and taking his ease nude, and observing the bodies of others. With Walt Whitman he might have said: "Perhaps he or she to whom the free exhilarating ecstasy of nakedness in nature has never been eligible, has not really known what purity is—nor what faith or art or health really is." The human figure was the basis of his whole study, of his anatomical work, and later of his teaching.

Hence it at first seems curious that in early years he painted no nudes. This abstention from attempting a subject which interested him so profoundly, was no doubt due chiefly to his realism. The nude was to him, as he had said in an early letter, "the most beautiful thing there is," and the very foundation of learning, but his concern was less with "beauty" than with the truth of the life around him; and he could have seen few opportunities to picture the nude in the Philadelphia of his time. The puritanism of early America, which had objected to Vanderlyn's chaste *Ariadne* and had made it impossible to exhibit the icily idealized *Greek Slave* of Hiram Powers without the approval of the clergy, had always been especially strong in this city, with its heritage of Quaker modesty, where the casts in the Pennsylvania Academy had been swathed in muslin on ladies' days, and an English artist who had brought over a copy of the Venus de Medici was obliged to keep it locked in a chest in his own studio. Even in the 'seventies this prudery had not changed radically. The nude was still taboo, and comparatively few American artists had at-

tempted it; not until the younger painters of the new movement began to
return with their French ideas, did it commence to be acclimated in this
country. Professional models who would pose in the nude were difficult to
obtain and seldom good.

Even Eakins, with all his openness about such matters, seems to have shared
to some extent in the prevailing viewpoint of his environment. The puritanical
atmosphere in which he grew up must have conditioned his attitude, making
him conscious that his comparative freedom was a rebellion against the whole
spirit of his community. We may recall the letter to his father in which he
expressed his reactions to the nudes in the Salon, revealing his great admira-
tion for the nude (the male as much as the female), combined with an aus-
terely realistic attitude toward it, an insistence that it should be related to real
life, and a refusal to prettify it. "I can conceive of few circumstances wherein
I would have to paint a woman naked," he had written.

In early years he had confined himself to painting the semi-nude figures of
rowers, one of the few subjects in the life around him that offered an oppor-
tunity to see the human body. But in early 1877, soon after he began teaching
the life classes of the Pennsylvania Academy, he painted his first picture con-
taining a nude, and almost his only female nude—the small *William Rush
Carving his Allegorical Figure of the Schuylkill River*—which was also one
of his few historical subjects, not part of contemporary life. Rush, the first
native American sculptor, had been born and had lived most of his life in
Philadelphia, where his chief works were still found. Eakins admired him
as "one of the earliest and one of the best American sculptors," and liked the
story of his carving the allegorical figure, a piece of Philadelphia tradition
best told in the painter's own words:

"William Rush was a celebrated sculptor and ship carver of Philadelphia.
His works were finished in wood, and consisted of figure-heads and scrolls for
vessels, ornamented statues and tobacco signs, called Pompeys. When, after
the Revolution, American ships began to go to London, crowds visited the
wharves there to see the works of this sculptor.

"When Philadelphia established its water-works to supply Schuylkill water to the inhabitants, William Rush, then a member of the water committee of councils, was asked to carve a suitable statue to commemorate the inauguration of the system. He made a female figure of wood to adorn Centre Square at Broad Street and Market, the site of the water works,* the Schuylkill water coming to that place through wooden logs. . . .

"Rush chose for his model, the daughter of his friend and colleague in the water committee, Mr. James Vanuxem, an esteemed merchant.

"The statue is an allegorical representation of the Schuylkill River. The woman holds aloft a bittern, a bird loving and much frequenting the quiet, dark, wooded river of those days. A withe of willow encircles her head, and willow binds her waist, and the wavelets of the wind-sheltered stream are shown in the delicate thin drapery, much after the manner of the French artists of that day whose influence was powerful in America. The idle and unobserving have called this statue Leda and the Swan, and it is now generally so miscalled."

This story had a particular fascination for Eakins, being closely related to many of his interests: to the history of his native city, to American art, even to the Schuylkill River, scene of his recreations. An historic incident, it gave him an opportunity to picture the nude without departing from realism. And it had a close connection with his attitude toward the nude, and that of his community. Miss Vanuxem, who was "a celebrated belle," had created a scandal in Philadelphia by posing for Rush, even though, as the picture shows, a chaperon sat knitting beside her; and the statue itself, while draped, was denounced as indecent "through the fact that the draperies revealed the human form beneath." For Eakins the story must have had a symbolic value; he admired Rush's and the girl's naturalness and courage in defying convention,

* Charmingly pictured by the early nineteenth-century painter John Lewis Krimmel in his painting now in the Pennsylvania Academy, *View of Central Square on the Fourth of July*, which shows Rush's statue in its original position. The statue was carved in 1809. When the water-works were later established in Fairmount Park, the figure was moved there. A bronze cast of it now stands in the centre of a fountain there, the wooden original having been removed many years ago in a state of decay. For the full text of Eakins' statement, see the Catalogue of Works, NO. 109.

and felt an affinity between the old sculptor and himself, for in painting the picture he no more than Rush made use of a professional model; she was a young teacher, a friend of his and his sisters'. While her posing did not cause as much scandal as Miss Vanuxem's, the picture was looked at somewhat askance—one of his first conflicts with the prudery of his environment, which was to play so large and unfortunate a part in his career. Not only was the subject advanced for the time; whereas the few nudes which had been painted in this country had been "classical" and idealized, here was a realistic figure, pictured not in an imaginary setting but in a studio, and with all its grace, seen with the Northern realism of a Rembrandt; not an ideal creature, but a naked woman of flesh and blood.

He made unusually careful preparations for the picture, studying Rush's works, visiting the former site of his shop and getting a description of it from some old people, so that every detail was historically correct, even to the scrolls and drawings on the wall, which were from a sketch-book of the sculptor's preserved by an apprentice. He prepared small wax models of the figures, and painted several preliminary studies of the composition, making it at each stage more integrated and harmonious. The austere grace of the nude figure, the delicate precision of such details as the clothes on the chair, the depth and mellowness of color, and the unity and balance of the whole design, make this one of the most aesthetically satisfying of his works.

The Rush story interested him all his life, and in old age he was to essay it again.

IX

In the work of his early years outdoor pictures had predominated. But about the middle 'seventies he began to paint a larger proportion of indoor subjects, including portraits; and for a time his art seemed tending toward genre, with such themes as the *Chess Players*, the *Zither Player*, and the *Pathetic Song*. These more domestic scenes, with their undertone of grave sentiment, were linked to his first pictures of his own family; and indeed, the personages were

all members of his family or friends. The best known of these works was the *Chess Players:* two old friends of his father playing while Benjamin stood looking on. The three elderly men were observed with great understanding and sense of character, and the same loving care went into the portrayal of the dark room with its heavy walnut and mahogany furniture, plush upholstery, and such details as the black marble clock on the mantel and the decanter and glasses beside the players—a document of the period, as exquisite in its handling as one of the Dutch little masters.

Following *William Rush* came a series of small old-fashioned subjects, many in watercolor: women in early American costume, engaged in such household tasks as spinning or knitting. His sister Margaret posed for some of these, and he brought down old dresses from chests in the garret, and borrowed an antique chair from Dr. S. Weir Mitchell. These works, while revealing a new interest in scenes not part of the life around him, were in no sense storytelling pictures; his aim was not to illustrate anecdotes, but to portray truthfully some phase of the daily life of the past.

In these tendencies we can see the influence not only of his home life but also perhaps of his teaching at the Pennsylvania Academy, where he had many women students. After the exclusively masculine outdoor scenes of his earlier years he was developing an increasing interest in the more social, domestic, and even feminine aspects of life. His healthy preoccupation with the human body and physical activity was changing into a more penetrating interest in character, in the human being as an individual—sign of a less youthful viewpoint.

In outdoor work his former strenuous sporting subjects were succeeded by more pastoral scenes, with an intimate feeling for the country and rural occupations. In the early 'eighties he often used to cross the Delaware to Gloucester, New Jersey, where there were shad fisheries, to watch the fishermen pull in the nets, to sketch, and to eat planked shad. A number of fishing pictures resulted, the best known being *Mending the Net*, with its acute observation of the distinctly native types of the fishermen, and its austere grayed landscape,

with soft sunshine and pale blue sky and water. None of his early works had
been pure landscape; nature was subsidiary, the setting for human activities.
But now he showed a greater interest in nature for herself, making many
sketches of fields, beaches, and water in the sunlight; and his only landscape,
The Meadows, dates from this time. All the work of this period was more
atmospheric than formerly, with a subtler sense of outdoor light and color.

A year or so later he painted the *Swimming Hole*, a group of naked men
and boys, including himself and his friends and pupils, and his dog, swimming
in a secluded spot. In its theme, its free use of the nude, and its fine landscape,
this picture while entirely realistic was one of the most poetic of his works.
The numerous sketches he made outdoors for it, and his careful planning of
the composition, show that it was a subject that attracted him strongly. Com-
pared to the rowing and sailing pictures of a decade earlier, it marked the cul-
mination of his outdoor work; the forms filled the space of the picture most
fully, the movement was freest, the design most highly developed—less severe
and geometrical, more complex and varied, with a greater sense of pictorial
unity. The muscular nude bodies built up a rhythmical design which recalled
some work of the Renaissance.

About the same time he attempted a few Arcadian subjects, idyllic nude
figures outdoors in the sunlight—a more purely poetical strain than he had
ever displayed before, though combined with his usual realistic observation.
None of these pictures were finished, and the vein ceased almost as soon as it
had begun. Almost his only excursion into the fanciful, it probably represented
a temporary inclination toward a more pagan, imaginative type of subject,
which in the end proved not natural to him, being too far removed from the
life around him. If there was a conflict here between his paganism and his
realism, it was realism which conquered. He was too much the portraitist of
his surroundings to paint such subjects with much conviction.

It is significant that his few pictures of the nude, of landscape, and of imag-
inative themes, were all painted within a few years of one another. These ten-
dencies, manifesting themselves about the same time, were all to come to an

end in the middle 'eighties, when his earlier varied subjects and outdoor scenes were to cease, and his work was to become almost entirely portraiture.

X

Eakins had been interested in sculpture since studying it at the Beaux-Arts, and made it part of his teaching at the Pennsylvania Academy. The problem of relief absorbed him particularly, and he prepared a lecture on it, the manuscript of which still exists, bearing a note: "I believe this paper to be entirely original." "There are very few who understand the law that governs bas-relief, even good sculptors," he once remarked. "Relief," his lecture said, "holds a place between a painting or drawing on a flat surface and a piece of full sculpture." To him it was not a conventionalized, flat medium, but a representation of round forms and deep space by means of forms not entirely round. It was thus subject to the same laws as plane perspective, with one added element: the depth of relief. The process was like that of constructing a picture in perspective, except that in addition one had to select the slope of the floor line and calculate the depths and projections.

"The frieze of the Parthenon by Phidias is the highest perfection of relief," he said. "Those things by Phidias, with very little imagination you feel that they stand out full—yet when you get around to the side you see that they are very flat. . . .

"Where the subject of relief becomes complicated, as in the gates of Ghiberti at Florence, and distant landscape, architecture and other accessories are shown, the simple plan above is departed from. The near figures which are of the greatest interest are in full or nearly full relief, and the distant parts have a very flat relief. . . . A great disadvantage in such relief as Ghiberti's is that when viewed in the light most favorable for showing the form, the near figures throw shadows on the distant landscape and other parts. This change of scale is a departure from the simplicity of the Greek frieze. The Greeks chose subjects for their reliefs exactly suited to their means of expression. . . .

"Modern sculptors do not generally understand the beauty of relief, and

I have often seen an ear in a profile head as deep as all the rest of the head. . . .

"If you make the least error in a relief it won't look right. There is a limit in relief; if you keep inside of it, it is a powerful instrument to work with. As soon as you do wild things, like the Fighting Gladiator coming toward you, it no longer has that strength."

His first original sculptures were two small oval reliefs of women in old-fashioned costume, knitting and spinning, commissioned in 1882 by a wealthy Philadelphia art patron as ornaments for a chimney-piece in his luxurious new house. The architect, as Eakins said, "easily induced me, for the work was much to my taste." He spared no pains with them, even having his model take spinning lessons; as he later wrote his client, "after I had worked some weeks, the girl in learning to spin well became so much more graceful than when she had learned to spin only passably, that I tore down all my work and recommenced." The completed panels showed the result of his thought on the problems of relief: the possibilities of the medium were understood better than by many professional sculptors. Through the artist's mastery of the scale of projection and recession, the forms stood out round and full, contrasting with the relatively flat and linear character of much relief.

But when he submitted the clay originals, from which stone panels were to be carved, the art patron objected to the price, four hundred dollars each, agreed on beforehand, and indicated that he might not accept them. Eakins wrote reminding him that the work had been commissioned, detailing the labor expended, and continuing: "Nor am I an obscure artist. Relief work too has always been considered the most difficult composition and the one requiring the most learning. The mere geometrical construction of the accessories in a perspective which is not projected on a single plane but in a variable third dimension, is a puzzle beyond the sculptors whom I know.

"My interest in my work does not terminate with the receipt of my bill. Thus I have heard with dismay that a stone-cutter had offered to finish those panels each in a week's time. I have been twenty years studying the naked figure, modelling, painting, drawing, dissecting, teaching. How can any stone-

cutter unacquainted with the nude, follow my lines, especially, covered as they are, not obscured, by the light draperies? How could the life be retained? "

On the client's suggesting that they be left unfinished, he replied: "I do not agree with you that a less finished work would do almost as well. If you will stop at the Academy of Fine Arts, you can examine there casts of the most celebrated reliefs in the world, those of the frieze of the Parthenon. Now this frieze, just twice as large as mine (linear measure), was placed on the temple nearly forty feet high, while my panel is not I think more than three feet above the eye. Hence to view the frieze at as favorable an angle as my panel you would have to go twelve times as far off. To make an analogy then, my panels should be finished $\frac{12}{7}$, just six times as much, as the Phidias work. But the fact is that no one has ever yet equalled in finish the modelling of those frieze surfaces. . . .

"Unfinished sketches by a good artist . . . would be appropriate in an artist's studio or his home, but hardly in a fine house like yours. If sketches were placed there you would come to wish them completed and so would your friends; and if you hung pictures on your walls I do not think you would choose unfinished studies."

The art patron, however, refused not only to have the panels cut in stone, but also to pay the artist for the work already done. After trying for several years to collect his bill, Eakins suggested that the matter be submitted to arbitration; but although by the referee's decision he received part payment, the reliefs were left on his hands. Thus his first excursion into sculpture received small encouragement.

XI

Eakins was fond of animals, particularly horses, and liked to ride. One of his best friends was Fairman Rogers, member of a prominent and wealthy Philadelphia family, an engineer and an art patron, at whose house a group of scientific friends, including the painter, used to meet every Sunday night. A

leading sportsman and horseman, Rogers owned a large stable and was one of the first in Philadelphia to have a four-in-hand coach. In 1879 he commissioned the artist to paint him driving the coach in Fairmont Park. Eakins made extensive studies for the picture, having the coach driven before him again and again, painting many sketches of each separate horse, and modelling small wax figures of them. In the finished picture their movements were observed with almost photographic keenness and truth, as were the characters of the passengers, the sunlight reflecting from the horses' sleek coats and harness, and the color and light of a fresh May morning.

Equine anatomy interested him almost as much as that of human beings, and he carried on extensive anatomical studies of horses, as well as of dogs and cats, dissecting them and making casts from them. He was especially absorbed in the problem of animal locomotion, which was receiving much attention in both artistic and scientific circles at this time. The traditional idea of the gallop, with all four legs of the animal symmetrically extended, was giving way to a more naturalistic vision. In France, Meissonier was having controversies with his colleagues about the question. The possibilities of instantaneous photography in analyzing motion were being discovered. Zoetropes and other similar devices were popular; Eakins made one himself. It was the day of the first unconscious stirrings of a new art, the motion picture.

Out in California Governor Leland Stanford was engaged in disputes with his sporting friends about the gait of the horse, and having made a bet of twenty-five thousand dollars, had employed the photographer Eadweard Muybridge to prove his point with the camera. This was before the days of flexible film, and photographers had to use glass plates, fragile, heavy, and hard to move. Muybridge, with the technical assistance of Stanford's engineers, devised a battery of twenty-four cameras ranged side by side along a track, and set off in rapid succession as the horse moved past, resulting in a series of photographs of successive phases of the motion.

Eakins and Fairman Rogers, both good photographers, were keenly interested in these experiments, and the artist kept in touch with Muybridge by

correspondence, offering suggestions.* In the early 'eighties, when head of the Pennsylvania Academy schools, he had Muybridge lecture there twice. In 1884 the latter began further researches at the University of Pennsylvania, using not only horses but human beings, animals, and birds; the necessary funds being guaranteed by several anonymous wealthy Philadelphians, of whom Fairman Rogers was probably one. It is likely that Eakins played a part in this arrangement; and he was appointed a member of the supervising committee, together with some of the University's leading scientists.

With his knowledge of both anatomy and photography, he took a prominent part in the experiments. But he soon differed with the methods of Muybridge. The latter was less a scientist than an expert photographer, whose technical methods were largely due to Stanford's engineers, and who had improved on them little. In his elaborate system each photograph was taken from a different viewpoint, so that any correct scientific comparison of them was difficult; moreover the separate cameras could never, except by coincidence, exactly follow the speed of the object, and the intervals between exposures were not absolutely regular. Eakins began experiments of his own to devise some more simple and accurate method.\ He was interested in the idea of photographing from a single camera, so that, the viewpoint remaining the same and the time intervals being regulated exactly, the successive images could be compared with mathematical precision. The French physiologist E. J. Marey had been using a single camera with a disk, pierced by several openings, revolving in front of the lens. Eakins adopted this principle and designed a camera which in many respects was an improvement over Marey's.†

* For example, about May, 1879, Eakins wrote Muybridge suggesting a more accurate method of including a scale of measurements in the photographs. Muybridge had placed measurement lines behind the horse, which Eakins felt were misleading, necessitating a calculation in perspective; he suggested that instead, after the animal had been run, a measure be held over the center of the track and photographed.

† A description of the apparatus and method is given in *Animal Locomotion: The Muybridge Work at the University of Pennsylvania: The Method and the Result*, published for the University by J. B. Lippincott Company, Philadelphia, 1888, and written by various members of the faculty. The description, forming part of an essay by Professor William D. Marks, was written by Eakins himself, the manuscript being now in the possession of Mrs. Eakins. Eakins' chief improvement was the use of two smaller disks, one revolving eight times as fast as the other, thus greatly reducing the dimensions of the apparatus. Marey in his book

This gave a series of about nine or ten images on one plate. When the object was moving from one spot to another, like a man walking or jumping, the images cleared each other enough to distinguish them. For movement taking place on one spot, as that of a man throwing a ball, when on a stationary plate the images would be superimposed, he devised a second camera in which the plate was revolved, thus giving separate images.* Every detail of this mechanism he designed himself, and built parts of it, even calculating the correct refractions for the lenses.

With this apparatus he commenced in August, 1884, a series of experiments independent of Muybridge's, but also under the auspices of the University, photographing horses in motion and nude athletes running, jumping, walking, swinging weights, and throwing baseballs. Dr. Harrison Allen cooperated with him, and the committee became interested, allowing him a small fund to erect a studio of his own on the University grounds. In the spring of 1885 he gave a lecture at the Pennsylvania Academy on the motion of the horse, illustrated with the zoetrope—perhaps the first demonstration in this country of motion pictures in the sense of photographs of actual motion taken from a single viewpoint, and one of the earliest in the world.† In a book based on

Le Mouvement (1894) described a somewhat similar arrangement of two disks turning in opposite directions; it is not clear when he evolved this. Eakins may have anticipated him; in any case, judging by his and Professor Marks' statements in *Animal Locomotion*, the artist was not aware of Marey's use of two disks, and developed the idea independently. Other improvements included an ingenious instantaneous shutter, a moving diaphragm to exclude extraneous light, and a chronograph to record the times and durations of exposures, the latter designed by Professor Marks.

* A similar principle was embodied in Marey's "photographic gun" for recording the flight of birds, designed in 1882, but being a portable apparatus it did not have the completeness of Eakins' and could give only very small images. Marey himself realized its limitations and about this time or later was experimenting with a larger machine based on the same principle; but he found the heavy glass plate difficult to move and stop intermittently (a stationary condition during exposures being necessary for clearness), and finally abandoned the idea. Judging from Eakins' description of his own apparatus, he was not aware of Marey's experiments along this line, and developed the idea independently. In his description there was no mention of the revolving plate being brought to rest during exposures—a feature which he probably would have found essential, if he had continued longer with his researches.

† The 79th Annual Report of the Academy states that on May 22nd, 1885, Eakins "lectured on the Zoetrope, and illustrated the movement of the horse." (The same report says that the school had been presented with a fine stereopticon for illustrating lectures on perspective and anatomy by the Director.) Muybridge for several

Muybridge's and his work, subsequently published by the University, Professor William D. Marks said: "It is to be regretted that Professor Eakins' admirable work is not yet sufficiently complete for publication as a whole. . . . The advantages arising from this method of photography would seem to render its further prosecution desirable, as yielding a means of measurement as near scientifically exact and free from sources of error as we can hope to reach."

But although he was intensely absorbed in these experiments and had devoted much time and labor to them, they were not continued after the summer of 1885. While the definite reasons are not now known, he probably cared more about developing his method and establishing its superior accuracy, than applying it, which would have meant an enormous amount of routine work. And the authorities may not have been sufficiently interested, for while it was generally agreed that his principle was more exact than Muybridge's, no essential change was made in the latter's experiments, which continued at the University for eight more years. There was too much invested in the older method to alter it radically, whereas Eakins' work was experimental and the results less impressive.

When the Muybridge photographs were published in sumptuous volumes, arousing great interest among scientists and artists throughout the world, Eakins received little credit for his labors. But although Muybridge's name bulks large in the history of the motion picture and Eakins' has never been mentioned in connection with it, the former's methods were in a short time to be discarded as antiquated, whereas Eakins' system of photographing from a single viewpoint was the path which the motion picture was to follow. It is not my intention to enter into the complicated and controversial question of "who invented the motion picture." Muybridge and Edison in America,

years had illustrated his lectures, including two at the Academy in 1883, with a projecting machine called the "zoöpraxiscope" or projecting zoetrope; and it seems almost certain, although I have been unable to discover any direct proof of the fact, that Eakins in lecturing to an audience would not have been content merely to exhibit the zoetrope, but would have availed himself of some projecting device, perhaps that of Muybridge or one similar to it. If so, this would be probably the first projection in this country of motion pictures in the sense of photographs (or silhouettes drawn from them, which Muybridge usually used) of actual motion taken from a single viewpoint; and one of the earliest of such projections in the world.

Marey and Lumière in France, Friese-Green and Evans in England, all have their champions, whose arguments to an impartial observer seem equally one-sided. The general truth seems to be that no one man was the "inventor", but a long line of individuals in several countries, sometimes paralleling one another, sometimes building on one another's work. In this progress Eakins was well in the forefront, for while adopting Marey's principle, he had carried it further; and during the short time that he worked on the problem, his methods were as advanced as any of the day. A few years later came the flexible film, which revolutionized the whole question and made possible the achievements of Edison and others. Eakins' chief purpose, like that of Marey, had been the purely scientific one of analyzing motion, rather than of synthesizing the resulting images into moving pictures; but in the long evolution of the cinema he played an unconscious part.

His interest in the anatomy of the horse always remained strong, and in the 'nineties he wrote a paper on a special point which had long absorbed him, "The Differential Action of Certain Muscles Passing More than one Joint," which he had first observed in horses pulling horse-cars.* Constructing a simple mechanism to demonstrate his conception of the action, with elastic bands representing muscles, he took it to the famous zoologist Edward Drinker Cope, who at first, thinking that no artist could contribute anything original about anatomy, refused to look at it, but then became interested. The paper was submitted to the Academy of Natural Sciences of Philadelphia, accepted, and published in its *Proceedings* in 1894. Eakins told a friend that it was a piece of presumption for him to write it, as he "didn't know anything about science"; and he began the paper: "It is not without diffidence, that I, a painter, venture to communicate with a scientific body upon a scientific subject; yet I am encouraged by thinking that nature is so many-sided that the humblest observer may, from his point of view, offer suggestions worthy of attention."

He had long been dissatisfied, he continued, with the orthodox system of

* Probably his work on the equestrian statues for the Memorial Arch in Prospect Park, Brooklyn, in 1892 and 1893, stimulated him to write this paper.

classifying muscles principally as flexors or extensors, working and resting alternately, especially when applied to muscles passing over two or more joints, flexing one while extending another. His observation had been that actually both sets were used at once, in a differential action, by which when both were contracted the limb would shoot forward, and when they were at rest the limb was locked and would sustain weight without muscular action. "To investigate the action of a muscle," he wrote, "I believe it necessary to consider it, not only with reference to the levers to which it is attached, but with relation to the whole movement of the animal. Then it will be seen that many muscles rated in the books as antagonistic, are no more so than are two parts of the same muscle. . . . The least action anywhere is carried through the whole animal. The differential action of the muscles secures to the scapula from which the horse's body hangs, a much longer and swifter throw, a concurrent and auxiliary movement of great muscles, generally supposed to be antagonistic, a grace and harmony that any less perfect system of coordination would surely miss." His conclusion brought the subject back into his own field: "On the lines of the mighty and simple strains dominating the movement, and felt intuitively and studied out by him, the master artist groups, with full intention, his muscular forms. No detail contradicts. His men and animals live. Such is the work of three or four modern artists. Such was the work of many an old Greek sculptor."

XII

After the middle 'seventies Eakins had been represented fairly regularly in the leading exhibitions of the country. At the Pennsylvania Academy, except for the year following the difficulty about the *Gross Clinic*, he showed several new works every year; and he was now being accepted by institutions in other cities, including the National Academy, the Society of American Artists, and the American Water Color Society. At this time there were comparatively few channels through which an artist could reach the public, but he made diligent use of all of them, sending not only to regular art exhibitions but to fairs and

industrial shows. It was at one of these, the Massachusetts Charitable Mechanics' Association, that he received in 1878 his first award, which was to be the last for fifteen years.

Sales and commissions, however, were still few. A notebook in which he recorded all such transactions up to the year 1880, when he was thirty-six, shows that in these first ten years of his professional career he had sold only eight paintings and that his total income from art, aside from teaching, had been a little over two thousand dollars. Fortunately, there was the family home to live in, and his father stood ready to help. And he had too strong a will, too much confidence in his own powers, and too genuine a love of his art, to allow neglect, or even opposition and abuse, to discourage him or affect the character of his work.

In spite of his lack of financial success, his reputation was growing. The novelty of his art, its uncompromising realism, and its power, which no one could escape, had given him a considerable *succès de scandale*. A few critics were favorable and really understanding; but even those who were hostile recognized his seriousness and ability and gave him a full share of attention. By the beginning of the 'eighties he was generally recognized as one of the leaders of the new school, and the most important of the younger artists of Philadelphia.

IV

TEACHING

EAKINS was a born teacher. The teaching instinct was in his blood, from his father; in the spirit of his age; in his temperament, always searching for knowledge and eager to impart it. Feeling strongly the inadequacy of the instruction he had received in this country, he had returned from abroad full of revolutionary ideas. His opportunity soon came. In the spring of 1876 the Pennsylvania Academy moved into its new building on North Broad Street, the last word in fashionable design and up-to-date equipment, and opened a regular school.

The Academy differed from most institutions of its kind in that it was controlled not by artists but by the "leading citizens" of Philadelphia, who managed most of the city's cultural activities. While in New York the National Academy was run by its academicians and the Art Students' League by its students, the Philadelphia institution was managed by a board of directors representing the city's social and financial élite. These gentlemen supported it liberally, but in return kept the reins in their own hands; it was "their" Academy, and the artists were allowed little voice in its affairs. The school committee was composed entirely of laymen, and even the exhibitions were run by them. Most of the directors, naturally, were extremely conservative and had little understanding of artists and their problems.

An exception was Eakins' friend Fairman Rogers, who was chairman of the school committee. Progressive and democratic, he was willing to entrust the guidance of affairs to professionals. With his combination of scientific and artistic interests he was a man after Eakins' own heart, and during their years of association in the school they worked perfectly together.

The instructor was a survivor of the old régime—Christian Schussele, an Alsatian painter who occupied a respectable position in the local art world. An exponent of old-fashioned academic training, he believed in drawing from the antique, careful copying of nature, and minute finish—a conservative pro-

gram which suited the taste of his superiors. He was now old and half-para-
lyzed and had to be helped around his classes, but this did not injure his value
in the eyes of the directors, one of whom wrote: "The time would not be far
distant when he would be unable to paint, but he would not be incapacitated
for teaching."

When the school started, Eakins, who had known Schussele for years, vol-
unteered to help him out by taking over the life classes; and for the first two
seasons he was not a recognized member of the faculty and received no salary.
Even so there was some objection on the part of the directors, who distrusted
this young "radical"; but Schussele's increasing feebleness changed their at-
titude, and at the end of the second term Eakins received a vote of thanks for
"valuable services given freely." The next season he became an accepted
teacher, and when Schussele died in the summer of 1879, Eakins was ap-
pointed his successor, with the title of "professor of drawing and painting."
An assistant was given him (from 1881 on, this position was held by Thomas
Anshutz), but he did most of the teaching himself.

Schussele had always been a figurehead. Even while he was alive it was
Eakins who ran the school and remodelled it on new and radical lines. Amer-
ican art education at this time was still based on the antique; life classes were
few and hard to get into, and even in them only drawing was taught. The sole
approach to foreign standards was at the new Art Students' League in New
York, but the latter was still poor and struggling, with no such financial back-
ing or official position as the Pennsylvania Academy. Eakins was one of the
first in this country to subordinate the antique and base his teaching on the
nude. Schussele and most of the directors were against him, but with the sup-
port of Fairman Rogers and the large majority of the students, he had his
own way.

While he admired the art of Greece and Rome, talked about it often to his
pupils, kept casts in his studio, and in New York always made a point of visit-
ing the collection of casts in the Metropolitan Museum, his objections to
drawing from the antique were expressed in an interview with the critic

William C. Brownell:* "Mr. Eakins did not say 'the antique be hanged,' because though he is a radical he is also contained and dispassionate; but he managed to convey such an impression. 'I don't like a long study of casts,' he said, 'even of the sculptors of the best Greek period. At best, they are only imitations, and an imitation of imitations cannot have so much life as an imitation of nature itself.† The Greeks did not study the antique; the *Theseus* and *Illysus* and the draped figures in the Parthenon pediment were modelled from life undoubtedly. And nature is just as varied and just as beautiful in our day as she was in the time of Phidias. You doubt if any such men as that Myron statue in the hall exist now, even if they ever existed? Well, they must have existed once or Myron would never have made that, you may be sure. And they do now. Did you ever notice, by the way, the circus tumblers and jumpers? . . . They are almost absolutely beautiful, many of them. And our business is distinctly to do something for ourselves, not to copy Phidias. Practically, copying Phidias endlessly, dulls and deadens a student's impulse and observation. He gets to fancying that all nature is run in the Greek mold; that he must arrange his model in certain classic attitudes and paint its individuality out of it; he becomes prejudiced, and his work rigid and formal. The beginner can at the very outset get more from the living model in a given time than from study of the antique in twice that period. That at least has been my own experience; and all my observation confirms it.' "

His policy was to keep students in the antique as short a time as possible— sometimes no more than a week—and as soon as they showed any promise, to promote them to the life class. There he started them right in painting in full

* *Scribner's Monthly Illustrated Magazine*, September, 1879; "The Art Schools of Philadelphia," by William C. Brownell; giving a very full account of the school and its methods, largely in Eakins' own words. Another full discussion of the subject is "The Schools of the Pennsylvania Academy of the Fine Arts," by Fairman Rogers, in *The Penn Monthly*, June, 1881. A more recent account, "Thomas Eakins as a Teacher," by one of his students, Charles Bregler, appeared in *The Arts*, March and October, 1931.

† The same idea was expressed in different words in Fairman Rogers' article: "The present professor of painting has a strong feeling that a really able student should go early into the life class, and, if he deems best to do so, go back to the antique, from time to time, later, to compare his work with it, on the principle that work from nature is more useful than that from a copy of nature, however great. That is, in fact, the key-note of all the present instruction."

color, without preliminary drawing—another radical step. In his interview with Brownell, in response to the question: "Don't you think a student should know how to draw before beginning to color?" he said: "I think he should learn to draw with color. The brush is a more powerful and rapid tool than the point or stump. Very often, practically, before the student has had time to get his broadest masses of light and shade with either of these, he has forgotten what he is after. Charcoal would do better, but it is clumsy and rubs too easily for students' work. The main thing that the brush secures is the instant grasp of the grand construction of a figure. There are no lines in nature, as was found out long before Fortuny exhibited his detestation of them; there are only form and color. The least important, the most changeable, the most difficult thing to catch about a figure is the outline. The student drawing the outline of that model with a point is confused and lost if the model moves a hair's-breadth; already the whole outline has been changed, and you notice how often he has had to rub out and correct; meantime he will get discouraged and disgusted long before he has made any sort of portrait of the man. Moreover, the outline is not the man; the grand construction is. Once that is got, the details follow naturally. And as the tendency of the point or stump is, I think, to reverse this order, I prefer the brush. I don't at all share the old fear that the beauties of color will intoxicate the pupil, and cause him to neglect the form. I have never known anything of that kind to happen unless a student fancied he had mastered drawing before he began to paint. Certainly it is not likely to happen here.

"The first things to attend to in painting the model are the movement and the general color. The figure must balance, appear solid and of the right weight. The movement once understood, every detail of the action will be an integral part of the main continuous action; and every detail of color auxiliary to the main system of light and shade. The student should learn to block up his figure rapidly, and then give to any part of it the highest finish without injuring its unity. To these ends, I haven't the slightest hesitation in calling the brush and an immediate use of it, the best possible means."

It can be seen how far he had diverged from the Beaux-Arts methods.

Another novel feature was modelling, taught chiefly as an aid to painting, and practised not only by prospective sculptors but by most of the painting students. "When Mr. Eakins finds any of his pupils painting flat, losing sight of the solidity, weight and roundness of the figure," wrote Brownell, "he sends him across the hall to the modelling-room for a few weeks."

The most radical feature of the Academy, which set it apart from any other school not only in America but also abroad, was the emphasis on anatomy. The subject, when taught at all, was usually taught in an amateurish way and without actual demonstration. But Eakins said: "To study anatomy out of a book is like learning to paint out of a book. It's a waste of time." Anatomical lectures, open to all students, were given by one of the leading surgeons of the city, Dr. William W. Keen; for Eakins, although better versed in the science than any other painter in the country, characteristically deferred to the expert. The lectures were thorough, many forms of demonstration being used: the skeleton, the manikin, and the living model, who was put through his paces, his muscles being called into play by weights, suspended rings, and other apparatus. Electricity was used to show the action of the muscles, and there were times, as Joseph Pennell recalled, "when a skeleton, a stiff, a model, and the negro janitor Henry all jerked and jumped when the battery was turned on."

The lectures were illustrated by dissections performed in the school's dissecting-room by the advanced students under the direction of Dr. Keen and the chief demonstrator of anatomy, a position filled for the first few years by Eakins. The other life class pupils were admitted to the room to study the parts and make drawings of them. Casts were taken, and of one particularly beautiful male subject Eakins took casts of the entire body in various stages of dissection, painting the muscles red, the tendons blue, and the bones white. Although no one was required to study dissection, a large majority of the students, including women, did so.

A live horse served as a model in the modelling class for several weeks each

season, being sometimes succeeded by a cow. Animal anatomy was also stud-ied; horses were dissected in the school and in a bone-boiling establishment; and in summer Eakins took students to Fairman Rogers' farm, where they studied the living, moving animal.

Eakins' ideas about this exhaustive study of anatomy were given in the in-terview with Brownell, who asked: "Don't you find this sort of thing [dis-secting] repulsive? At least, do not some of the pupils dislike it at first?"

"'I don't know of anyone who doesn't dislike it,' is the reply. 'Every fall, for my own part, I feel great reluctance to begin it. It is dirty enough work at the best, as you can see. Yes, we had one student who abstained a year ago, but this year, finding his fellows were getting along faster than himself, he changed his mind and is now dissecting diligently. . . .'

"'And don't you find your interest becoming scientific in its nature, that you are interested in dissection as an end in itself, that curiosity leads you be-yond the point at which the aesthetic usefulness of the work ceases? I don't see how you can help it.'

"'No,' replies Mr. Eakins, smiling, 'we turn out no physicians and sur-geons. About the philosophy of aesthetics, to be sure, we do not greatly con-cern ourselves, but we are considerably concerned about learning how to paint. For anatomy, as such, we care nothing whatever. To draw the human figure it is necessary to know as much as possible about it, about its structure and its movements, its bones and muscles, how they are made, and how they act. You don't suppose we pay much attention to the viscera, or study the functions of the spleen, I trust.'

"'But the atmosphere of the place, the hideousness of the objects! I can't fancy anything more utterly—utterly—inartistic!'

"'Well, that's true enough. We should hardly defend it as a quickener of the aesthetic spirit, though there is a sense in which a study of the human organism is just that. If beauty resides in fitness to any extent, what can be more beautiful than this skeleton, or the perfection with which means and ends are reciprocally adapted to each other? But no one dissects to quicken

his eye for, or his delight in, beauty. He dissects simply to increase his knowledge of how beautiful objects are put together to the end that he may be able to imitate them. Even to refine upon natural beauty—to idealize—one must understand what it is that he is idealizing; otherwise his idealization—I don't like the word, by the way—becomes distortion, and distortion is ugliness. This whole matter of dissection is not art at all, any more than grammar is poetry. It is work, and hard work, disagreeable work. No one, however, needs to be told that enthusiasm for one's end operates to lessen the disagreeableness of his patient working towards attainment of it. In itself I have no doubt the pupils consider it less pleasant than copying the frieze of the Parthenon. But they are learning the niceties of animal construction, providing against mistakes in drawing animals, and they are, I assure you, as enthusiastic over their "hideous" work as any decorator of china at South Kensington could be over hers. As for their artistic impulse, such work does not affect it in any way whatever. If they have any when they come here they do not lose it by learning how to exercise it; if not, of course, they will no more get it here than anywhere else. . . .

"'Of course, one can waste time over anatomy and dissection. I did myself, when I began to study; I not only learned much that was unnecessary, but much that it took me some time—time that I greatly begrudged—to unlearn; for a time, my attention to anatomy hampered me.'"

His interest was always in character; even a life study was a portrait to him. Brownell testified of his students' work: "I saw a sketch of no model that was not individual, none whose ugliness was characterless. . . . 'We change the model as often as possible,' explained Mr. Eakins, 'because it is only by constant change that pupils learn that one model does not look at all like another. There is as much difference in bodies as in faces, and the character should be sought in its complete unity. On seeing a hand one should know instinctively what the foot must be. . . . Nature builds harmoniously.'" And to his pupils he once said: "Get the character of things. I detest this average kind of work. There is not one in the class that has the character; it is all a medium between

the average model and this one. If a man's fat, make him fat; if a man's thin, make him thin; if a man's short, make him short; if a man's long, make him long."

Regular models were varied occasionally with athletes, trapeze-performers, and the like. The poses, however, were simple, usually standing, as they were easy to hold, and taught the student to look for construction and character rather than more spectacular qualities. Photographs were taken of especially fine or interesting models, and a collection of these photographs was gradually built up.

Eakins stressed the study of perspective, delivering a course of lectures on it, the manuscript of which still exists, an example of his terse, lucid handling of a complicated subject. The system was essentially that which he used himself, simplified. Students were given concrete problems to work out, using regular mechanical drawing instruments. The final problem was his favorite one of a yacht sailing. "A boat is the hardest thing I know of to put into perspective," he said. "It is so much like the human figure, there is something alive about it. It requires a heap of thinking and calculating to build a boat." Students were constantly urged to study higher mathematics, one of them being told: "You are young yet and ought to learn it—it is so much like painting." He always delighted in pointing out analogies between science and art. Lectures were also given on his pet problem of reflections in water, on sculptured relief, another favorite subject, and on the focus of the eye.

He advised students to paint small studies of simple objects, such as eggs, oranges, or lumps of sugar, trying to get the color, tone, and texture. "You know the form, and it's only painting," he said. "These things can be gained with paint. To get these things is not dexterity or a trick. No—it's knowledge. These simple studies make strong painters." He told them that he himself had made some wooden eggs, coloring one red, one black, and one white, and "painted these in sunlight, in twilight, indoors—working with the light, and the light just skimming across them."

The whole tendency of his teaching was against mere surface naturalism.

"Strain your brain more than your eye," he said; and again: "You can copy a thing to a certain limit. Then you must use intellect." Increase of knowledge meant more to him than immediate results, intelligence more than industry. "A few hours' intelligent study is better than a whole day of thoughtless plodding," was one of his sayings. Pupils were always urged to work intensely, to "paint hard." "Picture-making ought not to be put off too long," he said. "There are men in Paris in the schools, they paint day after day from the model. They never try to paint anything else. They are waiting until they know something. They are now old men. They cannot paint as well as they could twenty years ago." Boldness was one of the keynotes of his teaching; the way to learn a thing was to do it. "You notice a little boy learning to skate," he observed. "He plays, he pitches into a thing, and he learns much quicker than a big fellow."

Although he would seldom work on students' pictures, he was not at all precious of them; those that showed surface finish without sound construction were sometimes demolished in the process of pointing out weaknesses. One young man who had obtained a certain effect and had been afraid to touch his study for fear of spoiling it, was asked: "What have you been doing? Get it—get it better, or get it worse. No middle ground of compromise."

No prizes were offered. He did not believe in such extraneous stimulants; if a student was incompetent or lazy, the sooner he gave up the study of art, the better; and for the serious student increasing knowledge and skill were sufficient rewards, and prizes only distractions. The only honor was that the master selected and initialed the best studies, which were kept by the Academy; but even this was abandoned in his later teaching.

He was not a severe critic, rarely praising, but never sharp or sarcastic. He did little unnecessary talking in the classroom. Sometimes he would sit down in front of a student's work and study it long and intently, then rise without a word and go on to the next easel. On occasion this would happen to half the class, and some individual member might not receive a criticism for weeks on end. Silence was sometimes sufficient comment; and also he felt that students

were frequently better off working things out for themselves. His function
was to present them with facts and natural laws; what they did with this
material was their own affair. They were continually encouraged to think and
feel for themselves. "His methods made one very self-reliant," said one of
them.

When he did speak it was to the point. Many of his sayings have been pre-
served by a pupil, Charles Bregler, who used to write them down soon after
he heard them, so that they retain their fresh, graphic quality:

"There is too much of this common, ordinary work. Respectability in art
is appalling."

"Don't copy. Feel the forms. Feel how much it swings, how much it slants
—these are big factors. The more factors you have, the simpler will be your
work."

"Get life into the middle line. If you get life into that, the rest will be easy
to put on."

"Get the foot well planted on the floor. If you ever see any photograph of
Gérôme's works, notice that he gets the foot flat on the floor better than any
of them."

"Always think of the third dimension."

"You can't compare a flat thing with a round thing. You have to get it
round as quickly as possible."

"The more planes you have to work by, the solider will be your work. One
or two planes is little better than an outline."

"Think of the cross-sections of the parts of the body when you are painting."

"Get the profile of the head, then see how far back the cheekbone is, then
paint the eyesocket, then the eyeball, then the thin eyelashes on top of the eye-
ball. Always think of things in this way and you will do good work."

"Think of the weight. Get the portrait of the light, the kind of day it is, if
it is cold or warm, gray or sunny day, and what time of the day it is. Think of
these separately, and combine them in your work. These qualities make a
strong painter."

"Get the thing built up as quickly as possible before you get tired. Get it standing and in proportion in the first two days. Don't go at it as if you had four weeks ahead of you. Then model up a part as far as you can and take up another part. If you don't do this you keep going on correcting this part by that, and you get no further. You keep going around a ring."

"When finishing, paint a small piece, then don't go and finish another beside it. If you do you lose your drawing. But finish a piece some distance from it and then keep working the two points. For example, if I were painting an arm I would finish the elbow and then the wrist, then I would finish in between until the two ends met. Joints are always a good thing to start from."*

Little of his talk was about aesthetics or the art of others. If a picture was mentioned, it was usually because it solved some specific technical problem. Of the old masters he spoke most often of Velasquez, Rembrandt, and Ribera, and among moderns of Gérôme. His teaching was naturalistic, concentrating on the reality in front of the student—the nude human figure. Learning to paint it seemed to him to present problems enough for years of study. No attempt was made to inculcate wider artistic principles; these were up to the student himself. While recognizing their existence and importance, he did not believe that they could be taught. The most that a master could do was to furnish a naturalistic training, not wide but deep and thorough. As Fairman Rogers wrote, evidently expressing Eakins' viewpoint also: "The objection that the school does not sufficiently teach the students picture-making, may be met by saying that it is hardly within the province of a school to do so. It is better learned outside, in private studios, in the fields, from nature, by reading, from a careful study of other pictures."

His naturalism, however, was not the superficial affair of the average academic instructor of the day, concerned with appearances and brushwork; it was a thorough, profound study of fundamental natural principles. Thus it actually had a deeper aesthetic content than the teaching of more supposedly

* These and other of Eakins' sayings preserved by Mr. Bregler were published in *The Arts*, March and October, 1931. Many of those given elsewhere in this chapter were also recorded by him.

"artistic" contemporaries. His masculine insistence on form stood almost alone at the time.

A large part of his time and labor was devoted to the school—not for pecuniary reasons, for the salary was small—and for a time his own production declined. In his students he aroused enthusiasm and devotion. "It was an excitement to hear his pupils talk of him," said Robert Henri. "They believed in him as a great master, and there were stories of his power, his will in the pursuit of study, his unswerving adherence to his ideals, his great willingness to give, to help, and the pleasure he had in seeing the original and worthy crop out in a student's work." His relations to them were close and informal; many posed for portraits or figures in other pictures.

After two or three years of his management, in 1882, the school was changed from a free to a pay basis, becoming almost self-supporting, and other innovations were made which show that he was having his way against the more conservative directors: promotion to the life class was made still easier, his own title was changed to Director, and a statement of the school's objects, probably written by him, was published in the catalogue, reading in part: "The course of study is believed to be more thorough than that of any other existing school. Its basis is the nude human figure."

During his remaining years as director, the school reached a position unrivalled in America, being widely known as the most progressive in the country. Students from many states journeyed to Philadelphia to study under Eakins, and for a time the city became a center of art education approaching New York. As a painter he was also in the high tide of his prominence in Philadelphia, showing more at the Academy than anywhere else.

II

But beneath the surface opposition was growing. Most of the directors, in spite of their public approval, still distrusted his "radicalism," their conception of art being a polite avocation that would give them a standing in the community, ornament their houses, and keep their daughters out of mischief

until marriage. Eakins was too energetic, too full of new ideas, and too strong-willed and outspoken for them. They realized with consternation that the school was becoming a one-man affair. Only Fairman Rogers was always on his side, intelligent, urbane, smoothing out difficult spots. But in the latter part of 1883 Rogers retired to private life, writing his ally: "I leave the Academy with regret, as I have many pleasant associations with my work there—not the least among them the hours spent with you." His successor, Edward Hornor Coates, was a less progressive person.

There was also discontent among certain factions of the students. A few of the older and more conservative, whom he had promoted to positions of responsibility, but who disagreed with his ideas, were eager to get in and run the school themselves. At this time women were entering art in increasing numbers. The Academy had been one of the first to admit them under the same conditions as men, and they now formed half the number of students. The more conventional of them disapproved of Eakins' methods. Young ladies who wanted to learn such genteel accomplishments as china-painting, pyrography, or watercolor sketching, were asked instead to attack the most difficult artistic problems, to take up higher mathematics, to study anatomy and dissection, to use horses and cows as models. Eakins made art too strenuous for them. In other schools the tendency was away from this insistence on structure towards easier methods and more spectacular results.

His emphasis on the nude, however, caused the most opposition. There was nothing like it elsewhere in the country. The nude was still too recent a subject of study for it to seem altogether proper. In these middle 'eighties women's clothes were voluminous and protective, allowing not so much as an ankle to appear. But where the tendency of the age was to cover up, Eakins' was to strip bare, to get down to the natural and essential. His innate frankness, his training in medical schools and life classes, and his teaching of anatomy and figure-painting, had given him a comparatively free attitude towards the nude. Even though his realism kept him from painting it more than a few times, it was to him the embodiment of fundamental artistic principles, the

basic subject for the artist and the most thorough training for the student; and he had no more sense of shame about it than a physician. His disregard of ordinary taboos when they interfered with scientific or artistic truth, and his freedom of speech, offended conventional students. From time to time there were incidents which caused complaints, and friction between himself and the directors. Once when a model in the women's class had not appeared, and he was explaining an anatomical point about the female back, he asked one of the young ladies to take off her clothes so that they could see her back; but instead she burst into tears and went home and told her father, who caused a commotion which was with difficulty smoothed over. Further scandal resulted when some of the more liberal female students posed nude and were photographed, and when professional models of both sexes were posed together for comparison. Then in demonstrating anatomy he dared to lay his hands on the model and manipulate the muscles. But the culminating incident occurred in the early part of 1886, when in pointing out to the women's class the action of the pelvis in a male model, he removed the loin-cloth. His reasons for this were made clear in a letter written several years later to a school which had asked him to lecture on anatomy:

"In lecturing upon the pelvis, which is in an artistic sense the very basis of the movement and balance of the figure, I should use the nude model. To describe and show an important muscle as arising from some exact origin to insert itself in some indefinite manner under the breech clout, is so trifling and undignified that I shall never again attempt it.

"I am sure that the study of anatomy is not going to benefit any grown person who is not willing to see or be seen seeing the naked figure, and my lectures are only for serious students wishing to become painters or sculptors.

"Adverse criticism could be avoided by announcement of when I should use the naked model. Those not wishing to come to such lecture could stay away or withdraw and lose nothing they could make use of, but would not hinder others wishing to learn."

The incident was a trivial one, but in such an explosive atmosphere a spark

was sufficient. A few proper females complained to the directors. A special committee was formed, which after hearing both sides ruled that Eakins must exercise restrictions in posing the model, or resign. His reply was that he would remain only on condition that he was not hampered in his teaching. On February 13th, 1886, his resignation was presented to the directors and accepted.

But the Academy officials reckoned without the students. The complaints had come from a few women; the large majority of the pupils had had no hand in the matter, and were with their master, the men almost unanimously. As soon as it was known that he had resigned, an indignation meeting of the male students was held, at which a petition was drawn up and signed by all present, requesting the directors to persuade him to return; and there was talk of seceding from the Academy if he did not. "The class as a whole is perfectly satisfied with Mr. Eakins," a spokesman told newspaper reporters afterwards. "The disaffection is confined to a comparative few who have exhibited a prudery that is, to say the least, unbecoming among those who pretend to make a study of art." Following the meeting, at ten o'clock at night, the students marched down Chestnut Street from Seventeenth to Eakins' studio just below Broad. "Each man," reported a newspaper, "wore a large E on the front of his hat as a symbol that he was for Eakins first, last and all the time. On reaching this point they came to a halt and cheered lustily for their head instructor. After waiting a reasonable length of time for him to appear, and seeing no signs of his appearance, they dispersed to their homes." Next morning the women students met and drew up a similar petition, which was signed by all but twelve.

But their hopes of having a voice in the affairs of the school were rudely shattered. "We will not ask Mr. Eakins to come back," one of the directors announced to the press. "The whole matter is settled, and that is all there is about it. The idea of allowing a lot of students to run the Academy is ridiculous. All this talk about a majority of them leaving the school amounts to nothing. Let them leave if they want to. If all left we could close the school

and save money. Why, we have an annual deficiency of about $7,000. . . .
The school is not self-supporting. This very fact makes it presumptuous on
the part of the students to tell us what to do. If any of them left it would be
their loss, not ours." With this amiable and enlightened statement the Acad-
emy closed its side of the controversy.

The answer of the petitioners was to call another meeting for the following
night, to decide whether they should secede.

In all this agitation Eakins had taken no part, saying to reporters: "I could
not give them the same advantages they have at the Academy. Of course, if a
new school was organized, and I was requested to take charge, I would take a
businesslike view of the matter and probably accept. But I would take no
steps to organize such a school. That I can say positively, and I don't believe
any will be organized."

At the meeting of the rebels, attended by between forty and fifty students,
mostly men, the decision was made to withdraw from the Academy and found
a new school, to be called the Art Students' League of Philadelphia, and it
was announced that Eakins would give his services free for the first year.
Tuition was fixed at about half that of the Academy.

The conservative judgment on the affair was summed up in a leading edi-
torial in the *Evening Bulletin*, reading in part: "Mr. Eakins' resignation and
the foolish proposition of some of the young men of the School to form an in-
dependent class under that gentleman's tuition . . . grow out of a failure to
appreciate the fact that the Life School of the Academy is a benefaction es-
tablished by the directors for the good of the students and absolutely under
the directors' control. . . . It is their school and nobody's else. . . .

"The general facts which have led to the present difficulty are these: Mr.
Eakins has for a long time entertained and strongly inculcated the most 'ad-
vanced' views, as they are often called, regarding the methods of study in life
schools. Teaching large classes of women, as well as of men, he holds that,
both as to the living model in the drawing-room and the dead subject in the
anatomical lecture and dissecting room, Art knows no sex. He has pressed this

always-disputed doctrine with much zeal and with much success, until he has impressed it so strongly upon a majority of the young men that they have sided with him when he has pushed his views to their last logical illustration by compelling or seeking to compel the women entrusted to his direction to face the absolute nude. . . .

"That the women of the Life School should have revolted at the tests forced upon them was inevitable. They appreciate the value of the privileges afforded by the Academy so highly that there is probably not one among them who would have made open protest against any of its methods if there had been any legitimate room for two opinions on the subject. A woman is never entitled to any special praise for following her womanly instincts, as she is never entitled to much consideration when she ignores them. With a few abnormal exceptions the women at the Life School recognized the fact that much as they might risk in coming in conflict with the Academy authorities, they would risk infinitely more by accepting the conditions that Mr. Eakins proposed to force upon them. As things have turned out, they have lost nothing by their attitude. The directors have stood by them and made it understood that the same limitations are to be preserved in the work of the Life School in Philadelphia that are observed in the schools of the same class in other parts of this country and generally among the best schools in Europe. To have done anything else would have been to drive these ninety* women out of the School and to have put the Academy of the Fine Arts in a position which it would have found it very difficult to occupy."

The Academy did not appear to regret the loss of its best teacher and the city's leading artist. After he left, the instruction was divided among several teachers of more mediocre quality, some of them former pupils of his; the directors tightened their own grip on the management; and each year after his resignation one after another of his innovations was dropped, until the in-

* Ninety was the total number of women students enrolled in all classes for the first five months of the season. The number of women in the life class at this time must have been considerably below this figure. Of these "all but a dozen" signed the petition for Eakins' return, according to the *Evening Bulletin* of February 16th, 1886.

stitution was once more a conventional academic school, of which Eakins wrote in later years to a student: "My advice would be contrary to nearly all the teaching there."

The whole affair was one of the severest blows of his career. The school had meant much to him; for ten years it had played a large part in his life. Even the loyalty of so many of his pupils could not compensate for the loss of his official position, with its power and opportunities. The publicity had been unpleasant; an unfortunate reputation grew up around him, and after this he was ostracized to a certain extent by the more respectable element of Philadelphia society. The break with the Academy meant a loss of prestige as an artist, a portrait painter, a power in the art world, and a social being. Thenceforth he was always, consciously or unconsciously, a rebel against the ruling forces of his community.

III

The Art Students' League of Philadelphia, which stated in its prospectus that "the basis of study is the nude human figure," held its first session on the evening of Washington's Birthday, 1886, in temporary quarters at 1429 Market Street, about thirty members being present, mostly men. The first model was the newsboy on the corner. The school began with a lurid reputation, all sorts of rumors being current about the immorality of master and pupils. One enterprising New York newspaper sent a reporter to enroll as a student and get the inside scandal; but after struggling with art for a few days and witnessing no orgies, the unfortunate man confessed his purpose and was allowed to depart in peace.

The League was a cooperative affair run entirely by the students, who paid for rent, light, heat and models. The first estimates of costs were found to have been over-optimistic, and tuition had to be increased, although still remaining less than at the Academy. Membership never rose much above the original number, and sometimes fell far below. Periods of comparative prosperity alternated with more frequent hard times; often the students, being too poor

to hire models, would pose for each other: first the president, to set the example, then the vice-president, the secretary, the treasurer, the curator, and so on. The school led a more or less wandering existence, occupying four or five different premises. Its equipment was scanty, but arrangements were always made to carry on anatomical work in the laboratories of regular medical institutions.

No antique or drawing classes were included; only painting and modelling from life. Eakins gave criticisms two mornings, one afternoon and one evening a week, delivered lectures on anatomy, perspective, and other subjects, and superintended the dissecting. For all this he refused to accept any salary during the years of the school's existence; indeed, he assisted some of the poorer students financially, often under the guise of paying them for posing for him.

At the League he could give his pupils more personal attention than at the Academy, and the relationship between them, cemented by the revolt, was close. They were like part of his family—"the boys," as he was "the Boss." He would often invite them to his house, and his studio was always open to them; and sometimes they would help him, laying in the simple parts of large pictures—a relation like that of a mediaeval master and his apprentices. The connection did not stop with the end of school; he always took a keen interest in their work, and would visit their studios to advise them. Among the most sympathetic of his portraits were the many he painted of them, and they appeared constantly in his large compositions. Time has not lessened their devotion to him; more than one has said: "He was my best friend."

The atmosphere was more free-and-easy and democratic than that of the Academy. Most of the students were men, from all walks of life, including many Irish, for whom Eakins always had a fondness. Every Washington's Birthday, the school's anniversary, there was a costume party, the usual feature of which was a burlesque concert; on one occasion the printed program, full of excruciating youthful humor, announced that "the entire Opera of Faust will be given, with an augmented orchestra, and Chorus of 1000, on a

scale of magnificence never before attempted north of South Street." It is recorded that Eakins appeared at one of these parties as Little Lord Fauntleroy, and again as an Italian organ-grinder, when the program stated that "by special request the 'Boss' will give an organ recital, supported by the whole orchestra, and connived at by the audience."

Out of the League grew one of Eakins' closest friendships, with Samuel Murray, a young sculptor of Irish descent who soon became his favorite pupil, and after a few years began to work in his studio, helping with the preliminary laying-out of pictures. In return Eakins taught the younger man the craft of sculpture, launched him on his career, and even assisted him with his first commissions. Murray became like a son to Eakins, sharing his studio for more than ten years, seeing him every day, working with him, joining in his outside life; and even after they took separate studios they kept up their close relation, which ended only with Eakins' death. The younger man also had an influence on the older, stimulating his interest in sculpture, leading him more toward the life of the people, showing him the world of prizefighting which he was to picture later, and introducing him to many of his Catholic sitters.

In the meantime Eakins was teaching elsewhere. Widely recognized as the most learned anatomist in American art, he was engaged as lecturer, within a year or two after the Pennsylvania Academy break, by some of the leading art schools of the country, particularly in New York.* At the height of his teaching activities, in the late 'eighties and early 'nineties, he would commute to New York sometimes twice a week, giving several lectures a day.

After the affair at the Pennsylvania Academy, he was careful to have it understood in advance how he purposed to show the model in certain lectures, and in most cases there was no trouble. But there were some unfortunate incidents. At the National Academy of Design there was a complaint in the latter part of 1894, and he did not lecture after that season. At the Drexel Institute

* He lectured on anatomy at the National Academy of Design from 1888 to 1895; at Cooper Union from 1891 to 1898; and for varying periods during the late 'eighties and early 'nineties at the Art Students' League of New York, the Art Students' League of Washington, the Brooklyn Art Guild, and Drexel Institute, Philadelphia.

in Philadelphia, where he was teaching in 1895, he announced before his lecture on the pelvis that the male model would be completely nude, and that any women students who objected could stay away. "About twenty women did go to the lecture," reported a newspaper, "and their monitor told him she had assured them that some slight drapery would be used. He asked her to get them out of the room, or let them understand distinctly that the man would be totally nude, but he found them all there when he went with the model, he said, and when the sheet was dropped only one girl got up to go. The lecture went on quietly." But someone complained, a newspaper played up the story, stating that all the girls had left in a body, and he was dismissed. His friend Riter Fitzgerald, critic of the *Philadelphia Item*, came to his defense: "Thanks to the enterprise of one of our journals, that talented artist and very modest gentleman, Professor Thomas Eakins, is the center of attraction. He is accused of having, during his lectures on artistic anatomy at the Drexel Institute, displayed a nude model before the horror-stricken gaze of the innocent male and female students, who had come there to study the nude. . . . There are always timid people and foolish people. In this class I include the trustees of the Drexel Institute. . . . If they are going to 'play propriety' with art, what kind of artists do they expect to turn out? If these gentlemen were to put it to vote amongst the art students of the Drexel Institute, I am positive that Professor Eakins would be sustained by a large majority. As it is, his dismissal was a very silly and unjust thing. . . . Professor Eakins tells me positively that there was never any arrangement with him forbidding the introduction of the nude model. 'I would not have consented to deliver the lectures had such a proposition been made,' he said. 'I have never discovered that the nude could be studied in any way except the way I have adopted. All the muscles must be pointed out. To do this all drapery must be removed.'"

A more politic person would have waived the point; but policy was not in his make-up, and when it came to scientific or artistic matters in which he believed, he was unswerving; either he taught in the way he thought right, or not at all. If the official world did not want to accept him on these terms, it did

not need to. In the end the action perhaps came to have a symbolic meaning—
a gesture of revolt against the prudery of his day and generation: a gesture
which in the end may have had a note of defiance, and a foreknowledge of
defeat.

Partly because of the opposition to his methods, most of his lecturing ceased
about the middle 'nineties. And the Art Students' League of Philadelphia had
not been long-lived. With no outside support, and struggling against the offi-
cial art of the city, it had been held together entirely by the force of his per-
sonality. When the older students who had been through the battle with the
Academy began to drop out, its fortunes declined, and after an existence of six
or seven years it died a natural death. Thus as he entered his fifties, his teach-
ing, which had taken so much time and labor for over twenty years, came to
an end, although he always continued to give younger men and former pupils
the benefit of his advice.

The fashionable trend of the day was against his kind of teaching; and he
had collided with the prevailing prudery. His place was taken by others who
taught more acceptably and had official backing. One of the greatest teachers
of the time was not wanted by the time.

His influence, though wide-spread, was less conspicuous or sharply defined
than that of more "brilliant" and superficial instructors, such as Chase, Shir-
law, or Duveneck. The things he taught were too fundamental to leave a read-
ily recognizable impress. His students received a thorough, profound natural-
istic training; what they made of it depended on their innate gifts. Most of
them, as was inevitable, absorbed the smaller truths but missed the larger
qualities which made his own art living, but which were instinctive with him
and could not be imparted. No teacher can create geniuses. But a large pro-
portion of the younger generation passed under him, and his influence on them
was the soundest and most vital in the American teaching of the time.

In his own life, teaching had played an important part. While taking some
time and energy from his painting, it had given him a position of power and
responsibility, many human contacts and enduring friendships, a constant

stimulus and outlet for his conscious thought, and fresh material for his art. It answered a fundamental need of his nature. It would be as difficult to imagine him not a teacher—not studying natural laws and imparting them to others, not being surrounded by young men and women—as to imagine Winslow Homer not a solitary on a stormy coast, or Ryder not a hermit in the midst of crowds.

MIDDLE LIFE AND OLD AGE

ASIDE from his active teaching career, Eakins' life in middle years was quiet externally.

About 1882 his sister Margaret died while still in her twenties— one of the greatest griefs of his life. His relation to her, as to his father, had been unusual; and even years later he could not speak of her without deep feeling. His sisters Frances and Caroline were married and had families of their own, and only his father and himself and an aunt were left in the house on Mount Vernon Street.

This condition did not last long, for in January, 1884, in his fortieth year, he married Susan Hannah Macdowell, an artist and a former pupil. The daughter of an engraver, William H. Macdowell, she had a background of fine craftsmanship, like himself; indeed, before their fathers knew each other, the engraver had often drawn the documents which the writing master engrossed with names. The atmosphere of her home had been even freer than his, her father being a free thinker, fond of new ideas and lively argument, who had passed on a liberal viewpoint to his daughter. Meeting Eakins when the *Gross Clinic* was first exhibited, she was so impressed by it that she studied with him at the Academy and soon became one of his most brilliant pupils. Although after their marriage she was unable to paint as much, he considered her the best woman painter in the country and valued highly her opinion on his own pictures. A close community of tastes and interests existed between them. Believing whole-heartedly in his art, she gave him the constant support of her understanding and faith, and devoted herself untiringly to his comfort and to sparing him petty annoyances. Musical, and gifted with a lively sense of humor, she furnished a foil to his temperament.

The first year of their married life was spent in a studio at 1330 Chestnut Street, but next year they moved to the old home on Mount Vernon Street, Eakins keeping the studio for himself. His father continued to live with them,

and while they had no children of their own, the house was always full of
nephews and nieces. Fortunately, in view of Eakins' lack of financial success,
his father owned some Philadelphia real estate which paid a small but steady
income. They lived simply and frugally, seldom leaving the city even in sum-
mer, contenting themselves with short excursions to the country. Aside from
such holidays and his periodical visits to New York and other cities to lecture
or paint portraits, he travelled little. In spite of the urgings of his cosmopoli-
tan friend William Sartain, he was not interested in going abroad again just
for "foolishness," saying that his favorite spots in the world were Philadelphia
and Spain. Except for his student days, practically his whole life was lived in
the same city, the same street, the same house.

He had a gift for friendship, being interested in all kinds of people and able
to meet them on common ground; and the circle of his and Mrs. Eakins' ac-
quaintance was wide, including men and women of many classes and occupa-
tions. A person's social, financial, or cultural status never concerned him;
people who knew things or could do things, such as scientists and artists and
athletes, interested him more than the wealthy or fashionable. A large propor-
tion of his friends were entirely outside the artistic field—intelligent men of
the professional class, especially physicians, surgeons, and anatomists. He
moved almost as much in scientific as in artistic circles, being one of an in-
formal club, mostly professors of the University of Pennsylvania, which met
every Sunday night in one another's homes for talk. This was his only club
until his election in old age as honorary member of the Philadelphia Art Club.

In the fashionable artistic activities of Philadelphia he played little part.
While he knew most of the artists and had taught many of them, he was re-
garded in official circles as an outlaw, and his artistic intimates were mostly old
friends or pupils who had remained loyal. Among New York painters his
friends were almost as numerous, especially in the Society of American Artists.
Chase, when head of the Pennsylvania Academy school, would often drop in
at his studio, where, both being expert shots, they had rigged up a shooting
gallery. They painted portraits of each other, and Eakins gave Chase several

pictures; although his opinion of the brilliant New Yorker as an artist had reservations. For Sargent he had a more unqualified admiration, which was reciprocated, and when the younger man visited Philadelphia in the early nineteen-hundreds, the two were often together, and were about to paint each other when Sargent had to return to England. With brother artists he was unfailingly kind and generous; and no trouble was too much for him in helping a younger painter or a student.

There was nothing of the hermit in him; he liked to be with people and enjoyed social gatherings. Visitors to his studio were frequent, but with his great powers of concentration he could work with people all around talking and making comments. When painting a picture crowded with figures he would say to visitors: "Stay a while and I'll put you in"; so that every figure was a portrait.

Like many artists who can express themselves well in their own medium, he was inclined to be silent. Gossip and small talk were contrary to his nature, and being interested in facts and things more than in opinions, he was not given to artistic discussion. But he was a good listener, enjoying intelligent conversation; and in sympathetic company or when the talk was on concrete subjects, he would express himself, directly and tersely, using few words and making his meaning entirely clear. His choice of words had a bare simplicity: "workshop" rather than "studio," "painter" rather than "artist," "naked" rather than "nude." An accomplished linguist, talking almost perfect French, and Spanish, Italian, and some German, he nevertheless avoided the use of foreign terms, considering it an affectation when there were good English words for the same things. When the occasion required it, he could be devastatingly frank. But he disliked quarrelling, and turned a deaf ear to abuse. While physically courageous he was never pugnacious, his various difficulties being due to his indifference to convention and unswerving adherence to his principles. If a quarrel was forced on him he would not argue but would simply have no more to do with the other person, or if some expression was necessary, would write rather than talk. When angry the only sign he gave was to whistle softly to

himself. In all these characteristics one may perhaps discern the Quaker strain in his ancestry.

The seriousness of his conversation was leavened with shrewd, homely humor. He loved Rabelaisian jokes and had a remarkable memory for them, and his Elizabethan freedom of speech often scandalized the ultra-proper. His sense of fun was natural and rather boyish; he entered thoroughly into the amusements of his students, and having a remarkable gift for mimicry, could play the clown with enormous success.

Publicity was distasteful to him; he mistrusted writers or newspaper men, except a few personal friends, and avoided giving interviews. An artist's life and character, he often said, were of no concern to the public. In answer to a request for information about himself from a publisher of a biographical dictionary, in 1893, he wrote:

"I was born July 25, 1844. My father's father was from the north of Ireland of the Scotch Irish. On my mother's side my blood is English and Hollandish. I was a pupil of Gérôme (also of Bonnat and of Dumont, sculptor). I have taught in life classes, and lectured on anatomy continuously since 1873. I have painted many pictures and done a little sculpture. For the public I believe my life is all in my work. Yours truly, Thomas Eakins."

A lady who asked him to give a talk before a workingman's club, about the Pennsylvania Academy exhibition of 1897, received the following reply:

"With regard to the matter of your letter of the 2d., I do not see my way very clear to comply.

"The artist's appeal is a most direct one to the public through his art, and there is probably too much talk already.

"The working people from their close contact with physical things are apt to be more acute critics of the structural qualities of pictures than the dilettanti themselves, and might justly resent patronage.

"In my own case, I have not yet found time to examine the Academy exhibit, and would be puzzled indeed to tell anybody why most of the pictures were painted.

"I have however the greatest sympathy with the kindly and generous spirit which prompts the action of your Club."

A hard worker, he went to bed usually about nine o'clock and rose early, often at four or five in the summer, painting many of the portraits of his pupils in the early morning. His powers of sleep were great and at dull parties he would sometimes doze off. He drank no coffee or tea and little spirituous liquor, although liking a good bottle of wine. Smoking he disliked, even the smell of tobacco that clung to his clothes after a social evening. His appetite was hearty, and he relished good cooking, sometimes practising the art himself.

In middle years he kept up his active outdoor life, and while becoming stouter and more bowed, remained a powerful figure. His general appearance was rough and a little formidable—"like a bear," it has been said. His round massive head was covered with close-cropped, disorderly iron-gray hair, and his sparse moustache and beard were grizzled. His face was now heavier and deeply lined, with a determined mouth and full, scornful underlip. His dark eyes were his most eloquent feature — penetrating, ironical, intensely alive, looking at one without fear or sentiment, but not unsympathetically, and lighting up when he was interested or angry. He had a habit of observing people, "painting" them, as his friends said; once when a woman at a party, disconcerted by the directness of his gaze, asked: "Mr. Eakins, why do you look at me like that?" his reply was equally direct: "Because you are so beautiful." His hands, as shown in a cast made by himself, were not large, but extremely vital and sensitive. In contrast to the rest of his physical presence, his voice was high and gentle.

His personal appearance received little attention. In a day when men's clothes were sombre, stiff, and formal, he wore soft colored woolen shirts, a suit rarely pressed, baggy trousers with a belt, and shoes with no heels, shunning anything starched or tight. In this there was no studied Bohemianism, but a simple preference for comfort over style. His working costume was even less formal—usually an old pair of trousers and an undershirt. "I remember seeing him in summertime," wrote a friend, "almost a study in the nude as he

modelled or painted in his attentive way." He never cared much whether he wore clothes or not, especially boating or swimming—a habit which shocked many proper Philadelphians.

The same obliviousness to outward appearances applied to his studio, which showed no trace of the Oriental luxury affected by his more fashionable colleagues. A large bare room on the top floor of a business building, up four flights, it was in a state of chronic disorder, littered with canvases, painting materials, and clay. "Chase's studio is an atelier; this is a workshop," he remarked. This unadorned simplicity showed also in his choice of frames—not the massive gilded affairs of the day, but entirely plain, and covered with dull gold.

While hard-working, he did not believe in mere industry but in working intensely and then getting a complete change. "Don't paint when you are tired," he told a pupil. "A half an hour of work that you thoroughly feel will do more good than a whole day spent in copying." His recreations were mostly physical and boyishly simple. With his father and friends he still kept up the sports of hunting, boating, and swimming, on the other shore of the Delaware. In middle age he was still a powerful skater. When the bicycle craze began in the late 'eighties, he became an enthusiastic cyclist, going off with Murray on trips of several days through Pennsylvania or taking a train to Washington and riding on into Virginia and further south. In the summer he and Mrs. Eakins were frequent visitors at his sister Frances' farm in Avondale, in the rich, rolling country of Chester County, where there was a large and lively family of children. He loved horses, and often rode bareback.

His fondness for animals being shared by Mrs. Eakins, their house contained a small menagerie: dogs, cats, rabbits, birds, tame rats and mice, and a turtle, which can still be seen wandering around the backyard. The favorite pet was a red setter, "Harry," who figured in many pictures. He and his master were inseparable; he would accompany Eakins to school and lie in a corner of the classroom during criticisms. For a time there was a monkey, "Bobby," which at first was kept in the studio, much to the annoyance of sitters, then

allowed to run around the house until he made such a nuisance of himself that he had to be confined in a cage. Eakins was indulgent with the animal, allowing him to climb on his shoulder and pound his head with a coin; and consented to part with him only on the insistence of friends. A favorite haunt of the artist was the Zoological Gardens, which his pupils were also urged to visit. He was exceedingly patient and gentle with animals, and when Harry once killed a rabbit, he administered a whipping with tears streaming down his face. But his love of animals did not interfere with his scientific interest in their anatomy, both being manifestations of a healthy naturalism and a curiosity about all living things.

The summer of 1887 he spent in the West. The disturbance of the break with the Academy, the end of his work with Muybridge, and financial worries, must have resulted in staleness and discouragement; in the preceding years he had painted fewer pictures than at any time in his career. Three months were passed on a ranch near Dickinson, Dakota—his most extended stay away from Philadelphia since the years abroad. The primitive outdoor life, spent largely in the saddle, in this vast expanse of open country, was exactly to his taste. Bunking with the cowboys and helping in their chores, he got on well with them, delighting in their skill on horseback and with gun and lariat, their songs, accompanied with banjo and mouth-organ, and their humor. He bought a white horse, "Billy," and a brown Indian pony, "Baldy," and spent a large part of every day riding.

The time for return drawing near, he wrote his wife: "I think the children might know now that I am going to bring them an Indian pony. The contemplation will give them perhaps almost as much happiness as the pony itself. I know how happy it makes me to think of giving it to them. I will come riding down Mount Vernon Street and you will be looking out for me, and then I will bring the two horses into the yard, and Harry will smell at them as soon as he finds time to get away from me, and on Saturday you will go down in the morning train to the farm, and I shall ride down . . . Next day the children will have lots of fun and you will too, riding the little rocking-chair pony. . . .

Harry will soon see me again. Don't tell him about me till I am almost home."

The journey as far as Chicago was made on a cattle train. Arriving in Philadelphia, he rode up from the station through the quiet streets, dressed in full cowboy regalia, mounted on one horse and leading the other. After his return he threw himself with renewed energy into his work, painting a series of western subjects, for which his students posed, while Billy and Baldy were the equine models.

The horses were kept at his sister's farm. Harrison Morris, managing director of the Pennsylvania Academy, tells of visiting Eakins there, getting off the train in formal city clothes, and being met by the artist in cowboy costume, riding "a lean western pony, leading a white one by the bridle. Before I knew it, I was mounted on this led broncho and Eakins started off on the other. I protested that I knew little about riding . . . but he took for granted that anybody ought to stick on a horse, and he looked back without a flicker of sympathy at my plight . . . He galloped off under the trees, and I, like John Gilpin, galloped after . . . We must have galloped miles, Eakins entirely satisfied that I could take care of myself—which was far more than I was— hardly ever looking back, enjoying the breakneck pace."* The same thing happened to others, who in spite of their protests that they could not ride, were told that the best way to learn was to do it.

In the late 'nineties he became interested in prizefighting, to which he was introduced by Murray and a sports-writer friend, Clarence Cranmer. Like rowing in earlier years, the ring gave him an opportunity to see the human body in action; and a number of boxing pictures resulted. Pugilism was not yet a fashionable sport proper for gentlemen and ladies to attend, and he was one of the first artists to touch this unregenerate side of life. Into this world he entered as wholeheartedly as into everything else, attending fights several times a week, and watching them with such intensity that he would go through all the motions. At polite parties he would draw friends aside to discuss the latest bouts. The fighters were persuaded to come to his studio to pose, and

* *Confessions in Art*, by Harrison S. Morris. New York, 1930. Pp. 33–34.

became so friendly that they would drop in now and then and practise, so that for a time the place became a sort of gymnasium.

He went little to the theatre, but enjoyed taking his young nephews and nieces to the circus. The foreign sections of the city fascinated him, especially the Italian—the little restaurants, and the marionette shows. Knowing the language well enough to talk it and to read Dante, he had several good Italian friends, particularly an impresario of a small theatre, Enrico Gomez d'Arza, whose wife he painted—one of his most intense portraits of women, showing a deep affinity for the Latin temperament. Some of his closest friends in Philadelphia were French. He often talked with pleasure of his student days, could sometimes be heard singing snatches of student songs, and delighted in teaching them to sitters.

His childhood and youth with three musical sisters had fostered a love of music. He himself could play no instrument and had been given up in despair by a singing teacher, but Mrs. Eakins was an accomplished pianist, and they had many musical friends, and evenings of music were often held in their home. His taste, while not highly educated, was sound and rather conservative, his favorite composer being Beethoven. He once said that he liked to *see* the musicians play and sing; and this pleasure in the visual side of music was manifested in many paintings.

He read comparatively little, mostly scientific and mathematical works, scarcely ever art books or fiction, having a particularly fine scorn for French novels; but what reading he did was of the best, and his tastes were independent and sure, such as his admirations for Rabelais, Dante, and Whitman. While not prone to social theories or political discussion, he was a shrewd observer of current events. His viewpoint on the whole was liberal; a genuine democracy, a sympathy with the working classes, and an antipathy to war, were qualified by scientific skepticism. He voted the Democratic ticket.

While in later years he did less active research than earlier, science still remained his chief avocation. Sitters would frequently find him reading a mathematical book, as others might a novel. In his diningroom hung a blackboard on

which could be illustrated any point that might come up in conversation. From the sciences related to his own artistic problems, his interest extended to others, which absorbed the outside mental activity that with most artists goes into aesthetic fields. But his science remained concrete; when a friend tried to interest him in the fourth dimension, he refused to take stock in any such "poetical mathematics," saying: "You can't tie a knot in the fourth dimension." He enjoyed working with his hands and was an expert craftsman; the top floor of the house contained a complete workshop, with a cabinet-maker's bench and lathes for turning wood and metal.

In religion he was an agnostic, belonging to no church. In painting his version of the *Crucifixion*, he seems to have been actuated partly by a desire to attempt a subject done by all the old masters, but still more by scientific interest, saying that he had never seen a picture in which the figure was really hanging or seemed to be in the open air. His pupil, John Laurie Wallace, himself an anatomist, posed for it, strapped to a cross out-of-doors. A dying Jew, deserted, hangs on a cross in a desolate rocky landscape, in the sunlight of every day, against an impersonal blue sky. There is still some life in the body and one feels the painful strain of its weight on the nailed hands and the feeble effort of the legs to relieve the strain. The work is an objective study of a human being in his last moments; the irony is probably unconscious; of religious feeling there is hardly a trace.

But although his agnosticism caused a certain amount of scandal, he was not actively opposed to religion; in fact some of his warmest friends could be found among the Catholic clergy, with whom he came in contact partly through Murray. His relations to them were human rather than religious; they appealed to him because they were not too other-worldly, because many of them were intelligent men—scholars, writers, teachers—because some were Italians, because of the splendor of their vestments. In the early nineteen-hundreds he painted a series of portraits of prelates, many of high rank, all done at his own request, and including some of his most ambitious and finest works. For several years he and Murray used to bicycle on Sundays out to St.

Charles Seminary at Overbrook, where they would spend the day. Eakins liked the monastic atmosphere, and painted some of the priests, also loaning them the *Crucifixion*. Once when a group of Chinese priests was present, he astonished his companions by talking to them—as it turned out, in Latin. He loved to compose Latin inscriptions for his pictures.

The artistic viewpoint and tastes expressed in his letters as a student, remained with him all his life, though somewhat broadened. In a period when "beauty" was on the tongue of every critic, he seldom referred to that quality. When a well-known woman painter of a sentimental type showed him a picture, he commented: "That's *beautiful*"; and from his tone she gathered that it was not meant as a compliment. Little given to artistic discussion, having few aesthetic theories and small concern with the literary or decorative aspects of art, he was interested chiefly in the technical qualities of other painters, in what they could teach him—an attitude typical rather of the creator than the appreciator. His tastes were not wide, but they were independent, and strongly held. He did not accept any man's work whole, finding some things he liked, others he did not; nor was he afraid to say so.

His preferences were almost entirely for realistic art. Above all he admired the Spanish painters—Velasquez, and next to him Ribera—who he said had succeeded best in the kind of painting he believed in. Among the Dutch he admired particularly Rembrandt, as well as Vermeer. Spanish and Dutch painting appealed to him more than Italian or Flemish. The Greek sculptors, especially Phidias, held a special place in his estimation. At the Metropolitan Museum in New York he spent most time with the works of Velasquez and Rembrandt, and the Greek casts. He had retained his admiration for certain of the French academicians: Laurens, Bonnat, Regnault, and above all Gérôme. His temporary differences with his master were now forgotten, and there remained only a lifelong devotion to him as a man and an artist, "the greatest painter of the nineteenth century," he often said. Others whose work he respected were Millet, Corot, Barye, Courbet, Manet, Degas, Forain, Fortuny, Sargent, and Winslow Homer; and in his old age, Bellows.

His life as a whole was a simple, centered one, rich in work, study, friendship, and physical activity, but with little vicarious living in art or literature. His was a powerful, penetrating intellect, but not of the type commonly known as cultured. His mental powers were concentrated with great intensity on the realities around him. While such contemporaries as La Farge and Kenyon Cox worked from culture and taste in towards art, he worked from the core of reality out into art. He did not need to go far afield, as others did; the material that satisfied him lay all around. The world he knew was not a wide one, but he knew it deeply.

II

In the early 'nineties Eakins' mind turned for a time in the direction of sculpture—stimulated no doubt by teaching the craft to Murray and helping him on his first commissions, such as the colossal figures of the prophets on the Witherspoon Building in Philadelphia. In 1891 his friend William R. O'Donovan secured a commission for two bronze equestrian statues of Lincoln and Grant for the Memorial Arch in Prospect Park, Brooklyn.* Knowing Eakins' familiarity with equine anatomy, O'Donovan arranged for him to do the horses. The works were to be life-sized, and in high relief, almost in the round—about the same scale of relief as the metopes of the Parthenon, which Eakins probably studied beforehand.

The artists, both realists, decided from the first not to picture ideal horses, but to select actual animals of the right type and make portraits of them. The choice of a model for Lincoln's mount was simple, for the President rode little and never cared for showy horses; for him they picked Eakins' Billy. Grant presented a more difficult problem, as he was an expert rider and owned fine mounts, whose descriptions and photographs had been preserved. But all the General's horses were dead, and Eakins wished to model from the living animal; so a search was started for a horse of exceptional strength and fine proportions. They visited West Point, and while not finding what they wanted,

* See *McClure's Magazine*, October, 1895: "Grant and Lincoln in Bronze," by Cleveland Moffett.

observed the cadets being put through their paces, Eakins making instantan-
eous photographs of them. The search was continued at horse shows, circuses,
and fashionable resorts, until the choice finally lighted on "Clinker," a heavy
charger owned by A. J. Cassatt of Philadelphia, who loaned him to Eakins.

The work was done at his sister's farm at Avondale. Mounted on Baldy, he
rode around a field for days, studying one or the other of the horses, and work-
ing on a small wax model which he held in his hand. A quarter-sized model
was then made, also in the field, and from this was constructed a life-sized
frame, on which the final version was once more modelled from life.

These two horses were Eakins' most successful achievements in sculpture.
While unpretentious compared to the spectacular baroque of the rest of the
monument, they have a power and vitality that place them among the finest
animal figures in American art. It is unfortunate that they were associated
with O'Donovan's over-literal figures of the riders, which they dwarf.

His only other sculpture commission came a year or two later, for two re-
liefs on the Trenton Battle Monument — practically his last work in this
medium. With more encouragement he might have continued, for like a
Renaissance artist he seemed equally at home in sculpture and painting. But
having no gift for the politics of art, he was even less fitted to achieve worldly
success as a sculptor than as a painter.

His works were too few and too limited by external restrictions, to give a
complete idea of his ability. All were in relief, sometimes very high, but never
in the complete round; in this sense they were the sculpture of a painter. His
realism, and his concentration on fundamental form instead of surface stylisms,
set his work apart from that of most sculptors of the time. The austere power
of his best sculpture indicates that if he had had the inclination or the encour-
agement to continue with the medium and had practised it enough to gain
fuller freedom and mastery, he might have achieved results as important in
this field as in painting.

III

In spite of Eakins' great interest in the human figure and anatomy, he painted few nudes. Aside from the half-naked figures of rowers, his only works containing nudes had been *William Rush*, the *Crucifixion*, the *Swimming Hole*, the unfinished *Arcadia*, and a few life studies—a small production compared to that of the average Salon painter or even of some of his younger American colleagues. Among these the male figure had appeared more often than the female, who was represented only in *William Rush* and *Arcadia*. His version of the nude was austerely realistic, without romanticism or idealization; his figures were real people, with little conventional grace or voluptuousness, but intense vitality. They were painted with a knowledge, a constructive sense, a sculptural largeness, and a deep sensuousness that made him, in spite of the small number of his nudes, one of the strongest figure painters of the time in this country.

All of these few nudes dated from the period when he was teaching in the life classes of the Pennsylvania Academy, the first of them being *William Rush*, which in a sense symbolized the artist's attitude towards the nude and towards women posing, in contrast to that of his community. His painting of the nude was evidently linked to teaching it, to seeing models, to having sympathetic students, some of whom consented to pose—all of which was consistent with the close relation between his life and his art.

After the middle 'eighties he painted no more nudes (with an exception spoken of later), aside from semi-nude prizefighters. This was undoubtedly due in large part to the affair at the Pennsylvania Academy and the repulse of his teaching the nude. While he still had many sympathetic students at the League, few of them were women; and the sting of the Academy fight must have lasted; and there were recurring troubles in other schools—all of which would be enough to make him sensitive on the subject of the nude, and little inclined to attempt it. And then he was a realist, the portraitist of his time and place; and there could have been few times and places when paganism was

less in evidence than in Philadelphia from 1870 to 1910. A more idealistic or imaginative artist would not have been affected by this; but he painted what he saw in the life around him. To him the nude was not a pretty artistic convention, but a living, breathing actuality.

His interest in the nude had come up against the prudery and meagreness of his environment, and had been defeated. There had been a conflict between his freer instincts and the restraining influence of his surroundings; and between his paganism and his realism; and in the end his realism and the external restraints conquered. His environment acted upon him not only directly, through such restrictive measures as those of the Academy, but in a broader sense, by not furnishing him with a freer type of subject. One of the greatest themes for the artist, which he was magnificently qualified to paint, was denied him, by the limitations of his time and place, combined with his own temperament.

In later years he liked to paint women in evening dress, the costume which, in that day of protective clothes, presented the fullest opportunity to see the body. He often asked women who were posing for their portraits if they would pose for him nude—evidently not being interested in professional models, feeling a lack of reality in them, and wishing to find this freedom in his actual surroundings. But few of his feminine sitters, even the most liberal, would consent, though he persisted, told them their attitude was unnatural, and in some cases even went to see their mothers and tried to enlist them on his side. One sitter who posed for him at the age of about twenty said that one day "he remarked: 'You have a nice back—much like that of a boy. I would like to paint you nude.' His manner was so simple, so honest, that I said: 'Well, I shall ask my mother and see.' My mother did not forbid it, but said it would be better not to on the whole, and that Tom Eakins was somewhat hipped on nudes." This habit increased his scandalous reputation.

In old age, a year or two before he stopped painting, he took up again the theme which had interested him so in early manhood, the story of William Rush and his model—painting three versions of it, in one of which Nancy

Vanuxem was posing for Rush as in the earlier painting; and two more in which the sculptor (who bore a curious resemblance to himself) was helping her down from the stand, with every mark of respect. These works seem to have been a conscious attempt to symbolize what the nude meant to him—its beauty, and the artist's respect for it and the woman who would consent to lend it to him, in defiance of convention.

IV

In his middle life Eakins' subjects changed. His early work had pictured varied aspects of the life around him, including many outdoor scenes, which expressed his love of open air and sunlight, of physical activity, of a natural, free life, of the human body in the midst of nature—an element of paganism, if of an austere and Spartan kind. In the later 'seventies and early 'eighties he had turned also to portraiture and domestic themes; and in *William Rush* he had handled for the first time an historical subject, in the *Crucifixion* he had essayed an imaginative theme, in the *Swimming Hole*, one of the most poetic of his works, he had used the nude with the greatest freedom, and he had even attempted, though he did not complete, a few Arcadian scenes, of a more purely idyllic type than anything he had done before. An interest in the nude, landscape, and imaginative subjects, had been manifesting itself at this time.

About the middle 'eighties these varied subjects ceased, and his work became almost entirely portraiture. He painted practically no more outdoor scenes, genre, figure compositions, or nudes. He had always painted portraits, and in a sense all his work had been portraiture; but from now on he devoted himself almost exclusively to it.

This change in subjects was probably due to a combination of causes: the coming of middle age, with its slowing of physical activity; the death of his sister Margaret, his companion in outdoor life and his model for several genre pictures; his whole relation to the nude, and the starving of the freer, pagan side of his nature; the opposition or indifference which most of his early work

had met; his lack of financial success (he may have hoped to be able to make his living by portraiture, whereas he could not by figure-painting). And through misfortune he was perhaps finding his essential self: in temperament he had always been primarily a portraitist, interested in humanity more than nature, in character more than "beauty," in the heads and hands and bodies of men and women, more than in the general spectacle of the outside world. He had reached a stage in his development when the external scene attracted him less than the human being—a less youthful, more mature viewpoint. His art had retired indoors, and all his powers were now concentrated on the individual. But this mature self had been shaped by his experiences; in a freer environment he might have painted a freer type of subject, might have gone on to create even more ambitious figure compositions.

<div align="center">V</div>

Never a successful portraitist in the worldly sense and receiving few commissions, he painted mostly his family, students, and friends. Among his sitters were many scientific acquaintances, especially physicians, including some of the leading figures of the day—famous surgeons like Gross, Agnew, Brinton, J. William White; physicians like Horatio C. Wood or J. M. Da Costa; Thomson the ophthalmologist, Leonard the X-ray pioneer, Spitzka the brain specialist; the physicists Rowland and Barker, Rand the chemist, Marks the engineer, Cushing and Culin, ethnologists; and teachers, churchmen, musicians, and many brother artists. These men were almost all Philadelphians and friends of his, whose personalities and accomplishments he admired enough to ask them to pose. In some cases he sought out individuals who interested him particularly: for example, Rowland, one of the most brilliant of American scientists, although little known to the public, he considered "ought to be painted." Besides these he painted scores of people not especially distinguished, but who were part of his daily life—friends, neighbors, pupils. The only types who hardly ever appeared in his work were the millionaire and the society lady, the chief support of the average portraitist. His sitters were intellectual

and artistic workers, remarkable for intelligence and character rather than wealth, social position, or beauty. Between them and the artist, who shared many of their qualities, there was a close rapport.

To him a man's work was an essential part of his individuality, and he liked to show his sitters working or in their everyday surroundings: surgeons operating, professors lecturing, physicians in their consulting rooms, teachers at their desks, musicians playing or singing. Rowland was pictured in his laboratory, holding one of his famous diffraction gratings for spectrum analysis, while his assistant worked at a lathe in the background; and even the frame was "ornamented with lines of the spectrum and with coefficients and mathematical formulae relating to light and electricity, all original with Professor Rowland and selected by himself." When shown at their work, his sitters were intensely absorbed in it, quite unconscious of an audience. Never was there an attempt to display elegant leisure or pretentious luxury.

His chief interest was in character, for which he had a powerful instinct. He was never afraid to push it to its limits; as he said to a student: "I'd rather see exaggeration, although it is a weakness, than not enough. Go to the full extent of things." This bent was never as broad as caricature, which implies a romanticism alien to his temperament; he remained within the austere limits of realism, but within them secured the utmost in character. While the average tendency is to soften and reduce to the normal, his was the opposite: to concentrate on the individual traits that made the sitter a person like no other in the world, and picture them with uncompromising saliency and boldness. His likenesses lay below the surface, in the construction of the head and the shape of the skull, which is always felt beneath the flesh; while the features, even the texture of the skin, were depicted with the same unerring accuracy. Few artists have had such a mastery of the head. And the hands interested him as much, and were as individual and fully realized.

In this search for character he disregarded conventional beauty. He was incapable of flattery; no woman ever emerged under his brush prettier than she was, or any man more handsome. Whatever he saw in a face came out on

the canvas, with a terrible candor. As he would say: "That's the way it was." His people were pictured with none of the rosy glow, the glamor, the imperceptible idealization, of the more conventional portraitist. His vision had a mordancy like that of a powerful acid, eating away surface graces and leaving only the irreducible nucleus of character. Sometimes he went beyond simple honesty, making his sitters homelier and more serious than they actually were. This unsparing revelation was especially strong in his later years; in painting certain types like the hard-headed, close-fisted business man or the starved female, he gave us portraits which without being satires were devastating in their bitter truth.

Maturity and experience interested him even more than youth; he liked to paint people who had been seasoned and worn by life. Like Rembrandt he had a strong feeling for old age, and often asked old people to pose for him, remarking once to a friend: "How beautiful an old woman's skin is—all those wrinkles!" "One of the few times when I ever heard him speak of anything that he thought of as beautiful," said another friend, "was when he spoke of my wife's hair as he painted it in her portrait. It was just turning gray." Sometimes he made sitters look older than their age. In one case, after asking if he might take liberties and do a work of art rather than a likeness, since "in fifty years nobody would know the difference," he made the subject, a middle-aged man, twenty years older. But, as was said of another portrait, "it was getting to look more and more like the sitter every day"; he had painted the essential character, which time does not change but accentuates.

In his portraits of women these tendencies were especially noticeable. Although he chose many of his female sitters for their beauty, sometimes following one around at a party and gazing at her so intently as to make her uncomfortable, before asking her to pose, he endowed them with little obvious prettiness or surface bloom. Instead of the ideal creatures of light and ether painted by the average portraitist, they were human beings, portrayed as relentlessly as men, but with a penetrating sympathy and a sense of inner life that made his feminine portraits among his most intense works—documents of the social life

of the time, often revealing the frustration and defeat to which society condemned so many women in his day.

His sense of character extended also to clothes, which became an expression of individuality as much as the rest of the sitter's person. His feeling for the style of a time, even of a place, was unerring; one could date his works by this. He liked to picture women in their finest dresses, which he painted with loving care and an appreciation of their sensuous qualities of design, color, and texture. But he gave them little of the flattering chic of the fashionable portraitist; indeed, his fidelity to truth often exposed the grotesqueness of fashions, such as the voluminous, over-decorated feminine styles of the 'eighties and 'nineties, or the ungainly sombreness of male attire. Even the gorgeous ceremonial robes of priests and scholars were pictured with no trace of the pretentious or over-picturesque. And no matter how formal the clothes, there was always a body beneath for which they were merely elaborate coverings. They showed the shape of the body, and looked as if they had been lived in. "When he painted my portrait," wrote Professor Leslie W. Miller, "he not only wanted me to wear some old clothes but insisted that I go and don a little old sack coat —hardly more than a blouse—that he remembered seeing me in in my bicycle days, and which I certainly never would have worn facing an audience, which the portrait represented me as doing. He did much the same thing with Dean Holland. He made the poor Dean go and put on a pair of old shoes that he kept to go fishing in, and painted him shod in this way when he faced a distinguished audience on a very impressive occasion."

His sitter's surroundings—the dark interiors with their heavy carved walnut and mahogany furniture and red plush upholstery—were portrayed with the same feeling for character; few artists have conveyed so intensely the taste of the period. Often the objects, such as the professional apparatus of a scientist, played an important part. There was never a trace of the gilt and satin of the fashionable portraitist; the most commonplace objects, such as roll-top desks or swivel chairs, were used without fear of "vulgarity," but with a healthy acceptance of the surroundings of everyday life.

With all his drastic realism, stripping away glamor, youthfulness, and fashion, his portraits were profoundly human. He painted not dolls or shadows or the stylishly-dressed shells of people, but men and women of flesh and blood. His people were real, alive, with an extraordinary vitality. Neither idealizing nor satirizing them, he presented them as he saw them, in the complete round, with entire objectivity, but with a depth of understanding that made most of his contemporaries seem cold and superficial. In the end one feels about them as one does about real people, that one can never get to the bottom of even the most commonplace of them, that there always remains some unfathomable element of essential humanity. And when he was fortunate enough to have sitters of genuine distinction, with what magnificent force of character he endowed them!—portraits which challenge comparison with those of the old masters. In such subjects, worthy of his gifts, he proved his title as one of the strongest of American portrait painters—certainly the strongest of the last generation.

His differences from the fashionable portrait painter—his inability to flatter, his concentration on character, his love of the old and worn, his lack of femininity or chic, the darkness of his color—all unfitted him to be a successful portraitist. Few persons are strong or broad enough to stand an unflattered version of themselves. The average sitter dislikes character, his conception of a good portrait being an idealization with just enough likeness to make it recognizable. Edwin A. Abbey expressed the common viewpoint when, being asked why he did not sit for Eakins, he replied: "Because he would bring out all the traits of my character that I have been trying to hide from the public for years." Most of Eakins' sitters were people of mediocre tastes, and even the more distinguished were usually outside the artistic field—scientists who knew and cared less about art than he did about science. Many sitters and their families, repelled by his portraits, protested that they were poor likenesses, although to outsiders they seemed excellent. "No soul," was a frequent complaint; or it was explained that "mother was sick when this was painted" or "father was having business troubles." Women particularly objected to his

versions of themselves. In some minds they seemed to arouse positive hatred.

His disregard of his personal appearance and that of his studio contrasted unfavorably with the velvet jackets and exotic luxury of the fashionable portrait painter. "This was one of the things that alienated the inclinations, to put it mildly, of some of the sitters," wrote a friend. "Mrs. G——, for instance, refused to go near him again after he received her one blistering hot day in his studio up three or four flights of stairs, dressed only in an old pair of trousers and an undershirt. He wanted her to give him one or two more sittings but she not only refused them but wanted me to destroy the portrait after it came into my possession." And the hints of scandal that clung to him made conventional sitters hesitate to pose. Another deterrent was the length of time he took compared to the more perfunctory portraitist.

Commissions were few and far between. Occasionally a college would order a portrait of a professor, or a wealthy man (hardly ever a woman) would have himself painted. But the large majority of his sitters were friends, students, members of his family, or others whom he asked to pose. In most cases he presented them with the portraits (except those he kept to exhibit); hence the frequent inscription: "To my friend ——." Even then some sitters would not continue posing, so that many works were unfinished. Others to whom portraits were given did not bother to take them away from his studio, so that they accumulated year by year until he had a houseful of them, hung on every available wall-space and stacked in odd corners. Of those that were accepted, many were hidden away in garrets or cellars, lost, or destroyed.

A typical incident was that of a lady of one of Philadelphia's leading families, who had given a collection of fans to a museum in the city. Eakins conceived the idea of a large portrait of her surrounded by fans—a companion piece to his picture of Mrs. Frishmuth, collector of musical instruments. He asked her to pose, and she consented; but after a few sittings a note arrived from her saying that it was too much of an inconvenience, she could not spare any more time, but her maid would pose for her. She evidently thought that a little money would smooth the whole matter over, but he replied:

"I cannot bring myself to regard the affair in the light of a business transaction. The commission was sought by me, because even long before I was presented to you I felt that a worthy and beautiful composition picture could be made of the giver of fans to the Museum, but a portrait of you that did not resemble you, would be false, have no historic value, and would not enhance my reputation.

"Your other alternative is not agreeable. I cannot accept money for which I give no equivalent. I would much prefer to look upon my attempt as an unfortunate one and a trespass upon your complacency.

"I enjoyed my visits to you very much, and beg your pardon sincerely. May I ask that your people will at their convenience send to me my belongings?"

His rare clients sometimes refused to accept their portraits, or asked him to repaint them, one of them proffering a photograph "which gives a more natural expression and pose." Even so cultured a person as Dr. J. M. Da Costa, whose portrait had been adversely criticized by newspapers and friends, suggested that it be done over. In this case the artist wrote:

"It is, I believe, to your interest and to mine that the painting does remain in its present condition . . . I do not consider the picture a failure at all, or I should not have parted with it or consented to exhibit it.

"As to your friends, I have known some of them whom I esteem greatly to give most injudicious art advice and to admire what was ignorant, ill-constructed, vulgar and bad; and as to the concurrent testimony of the newspapers, which I have not seen, I wonder at your mentioning them after our many conversations regarding them.

"I presume my position in art is not second to your own in medicine, and I can hardly imagine myself writing to you a letter like this: Dear Doctor, The concurrent testimony of the newspapers and of friends is that your treatment of my case has not been one of your successes. I therefore suggest that you treat me a while with Mrs. Brown's Metaphysical Discovery."

He had little sense of money in relation to his art. His chief pleasure was in the work itself, and what became of the picture afterwards was of less concern

to him. Many of his paintings, not only portraits but earlier works, were given away to those who were discriminating enough to admire them; and if asked about prices, he would be apt to say: "Well, I don't know; what do you think it's worth?" The few sales that were made during his lifetime were for extremely low figures: even at the height of his reputation his average price was only a few hundred dollars, and only two or three times in his career did he receive over a thousand. All of this doubtless contributed to the poor opinion of his work in the minds of the hard-headed people he had to deal with. In spite of the remonstrances of friends, these tendencies grew stronger year by year; whereas in youth he had confidently expected to be able to make his living, in later years he evidently abandoned any such hope.

Once, at the age of sixty, he ventured to ask fifteen hundred dollars for a full-length, life-sized portrait of a wealthy New York merchant. The price had not been agreed on beforehand, and the sitter, who did not like the portrait, paid it only under protest, at the same time offering to return the picture to the artist "with his compliments." Eakins wrote him a long letter, reading in part: "I remember speaking to you very frankly of my affairs, telling you that a very large proportion of my important works had been given away or sold at nominal prices. My work has been so divergent in character and so novel, and so much of it has gone directly to institutions, that its commercial value is indeterminate, and I admit I was sorely puzzled to know just what to charge you. I asked some of the best figure painters and reduced considerably the sum mentioned by them. I also learned the prices of Madrazo and Chartran, both painting in New York. They get $6,000 for full-lengths, and certainly do not paint better than I do. My reputation among artists is very good. I am a member of the National Academy and have had awards by international juries in the last three World's Fairs, including Paris. . . . May I suggest what I think to be your duty? It is to inform yourself at your leisure as to the value of large portraits. The best painters in the country belong to your club, the Century, and there are many picture stores along Fifth Avenue which would take orders for portraits. If after consultation you still believe

I have overcharged you, I will give you back so much of the money as will bring the sum within your own opinion of propriety and honesty."

Not only individuals but also institutions treated his work in this way. He had many close friends in the faculty of the University of Pennsylvania, and some of his finest portraits were of them—in every case painted at his own request—yet the University gave him only one commission (the *Agnew Clinic*, ordered by the students). When he offered to make them a present of his portrait of Professor George F. Barker, one of their most distinguished scientists, they refused to accept it. For many years he loaned the picture of Mrs. Frishmuth to their museum, where it hung in her collection of musical instruments; but when he wished to show it in an exhibition, he was informed that if he removed it from their walls he could never return it. Naturally he took it away immediately, as well as the portrait of Frank Hamilton Cushing which he had also loaned them.

There were of course others who appreciated his portraits or at least treated them with more courtesy. Outside of his family, there were his pupils, who treasured his pictures of themselves; a few fellow-painters who realized their power; friends who, while not understanding their artistic merits, were pleased to be asked to pose, grateful to him for giving them the portraits, and found them, if not flattered, very "like"; and a few sitters—usually men—large-minded enough to value genuinely his versions of them. This appreciation, comforting as it must have been to him, was limited, and did not result in the solid support of commissions. While such a brilliant contemporary as Sargent had an international reputation and a waiting-list of the wealthy and fashionable, Eakins was merely an obscure artist painting portraits of his friends.

Fortunately he did not have to live by portraiture, and was able to paint more or less the people he wanted to. Indeed, with some commissions he was less successful than with sitters chosen by himself, more closely related to his own life. The career of a fashionable portraitist would never have suited him; he did not suffer from the lack of the mundane reputation and financial success of a Sargent. More important was the absence of a wider appreciation of

his portraiture for its own qualities, and commissions worthier of his gifts.

The strength of his character was shown in the fact that he displayed little personal bitterness at the treatment given his work, never attempted to make his style more acceptable, and as the years passed continued to paint as many portraits, even larger and more ambitious, of the people who interested him, purely for the love of it.

VI

A different kind of sitter was Walt Whitman. In the late 'eighties the poet, now an old man, was living in Camden across the Delaware and was a familiar figure in Philadelphia. Eakins, although not a member of the adoring circle which surrounded him, had admired him for some time, and in 1887 asked him to pose.

There were fundamental affinities between the two men. In their ancestry appeared some of the same strains: Dutch and English Quaker. Physically they were both powerful men, lovers of the outdoors, of the natural and free. The art of both was founded on a superb health and a belief in the life of the body and the earth. Eakins must have responded to:

> *I think I could turn and live with animals, they are so placid and self-contain'd,*
> *I stand and look at them long and long.*
>
> *They do not sweat and whine about their condition,*
> *They do not lie awake in the dark and weep for their sins,*
> *They do not make me sick discussing their duty to God,*
> *Not one is dissatisfied, not one is demented with the mania of owning things,*
> *Not one kneels to another, nor to his kind that lived thousands of years ago,*
> *Not one is respectable or unhappy over the whole earth.*

Both were realists, dealing directly with the life around them, alive to the significance of the ordinary and familiar.

> *Will you seek afar off? You surely come back at last,*
> *In things best known to you finding the best . . .*

Both were democrats, despising forms and conventions which hid the essential human being. Whitman's belief in the sacredness of the individual had its counterpart in Eakins' penetrating search for individual character. The poet expressed some of the artist's philosophy when he said to his biographer, Horace Traubel: "Be sure to write about me honest; whatever you do, do not prettify me; include all the hells and damns." Both were deeply at home in their own country and yet in rebellion against its puritanism; and both had suffered for their frankness. They were both masculine artists in an artistic milieu largely feminine.

With this deep-seated affinity went wide differences. There was nothing in Eakins of the expansive, philosophical, or mystical sides of Whitman, just as there was little in Whitman of Eakins' science, objectivity, sense of character, or intense concentration on reality.

The two men had a deep respect for each other. When a mutual friend, the singer Weda Cook, who wrote music to *O Captain, My Captain!* was posing for Eakins' *Concert Singer*, the artist talked much to her about Whitman and would sometimes quote his verses. It was the concrete, realistic side of the poet, his observation, and his feeling for the body, that appealed most to the painter, who used to say: "Whitman never makes a mistake." And one day after Eakins had come over to Camden to call on Whitman, the latter, who was too ill to receive anyone, said: "You can imagine how I must have felt at the time to refuse to see Eakins. He is always welcome."

Eakins' portrait gives us Whitman the lover of the earth—a genial, ruddy old man, who seems to have lived all his life in the open and seen the world in every aspect. There was no trace of idealization, as in John W. Alexander's version. For this reason the picture did not meet with entire favor from Whitman's admirers. Traubel wrote that the artist "seems to me to have caught Whitman rather as he said, 'I have said that the soul is not more than the body,' than as he said, 'I have said that the body is not more than the soul.'" Whitman himself preferred photographs to the work of the numerous artists who pictured him, and preferred the bust by Sidney H. Morse to any of the

paintings; but of all the latter he liked Eakins' best. Many were the discussions reported by Traubel between the poet and his friends regarding the relative merits of the various portraits, Whitman standing up staunchly for the Eakins. "The portrait is very strong," he observed once, "it contrasts in every way with Herbert Gilchrist's, which is the parlor Whitman. Eakins' picture grows on you. It is not all seen at once—it only dawns on you gradually. It was not at first a pleasant version to me, but the more I get to realize it the profounder seems its insight."

On another occasion, he compared the Eakins and Gilchrist portraits with two pictures of Napoleon crossing the Alps, one mounted "on a noble charger, uniformed, decorated," the other by an artist who investigated the facts and found "that Napoleon rode on a mule—that the mule was led by an old peasant—that the journey was hard, the manner humble. . . . Well, Herbert painted me—you saw how: was it a success? . . . Then Tom Eakins came along and found Walt Whitman riding a mule led by a peasant."

"I never knew of but one artist, and that's Tom Eakins," he said another time, "who could resist the temptation to see what they thought ought to be rather than what is."

"Does it look glum?" he inquired once. "That is its one doubtful feature: if I thought it would finally look glum I would hate it. There was a woman from the South here the other day: she called it the picture of a jolly joker. There was a good deal of comfort to me in having her say that—just as there was when you said the other day that it made you think of a rubicund sailor with his hands folded across his belly about to tell a story."

Again he pointed out the reasons for Eakins' lack of popular appeal: "Look at Eakins' picture. How few like it. It is likely to be only the unusual person who can enjoy such a picture—only here and there one who can weigh and measure it according to its own philosophy. Eakins would not be appreciated by the artists, so-called—the professional elects: the people who like Eakins best are the people who have no art prejudices to interpose."

Regarding Alexander's portrait Whitman felt strongly. "Alexander came,

saw—but did he conquer?" he said. "He was here several times, struggled with me—but since he left Camden I have heard neither of him nor of his picture, . . . which, indeed, I never liked. I am not sorry the picture was painted, but I would be sorry to have it accepted as final or even as fairly representing my showdown. I am a bit surprised too—I thought Alexander would do better, considering his reputation. Tom Eakins could give Alexander a lot of extra room and yet beat him at the game. Eakins is not a painter, he is a force. Alexander is a painter."

A year before Whitman's death, Eakins was one of thirty-two friends who gathered for dinner at the poet's house to celebrate his seventy-second birthday. Admirers from all over the world had written or telegraphed their greetings, and these were read, interspersed with speeches by the guests. Traubel reports the following dialogue: "*Whitman:* 'And Eakins—what of Tom Eakins? He is here. Haven't you something to say to us, Eakins?' *Eakins:* 'I am not a speaker—' *Whitman:* 'So much the better—you are more likely to say something.'" The artist then said a few complimentary words.

After Whitman's death, Eakins and his pupil Schenck made a death mask of the poet. The singer Weda Cook remembers being in the studio when a group returned from the funeral, including Robert Ingersoll and Eakins; the artist picked her up, stood her on a table, and commanded her to sing *O Captain, My Captain!*

VII

The best-known work of Eakins' middle life, and the most important commission he ever received, was the *Agnew Clinic*. Dr. D. Hayes Agnew, one of the greatest surgeons and anatomists in the country, who for many years had taught at the University of Pennsylvania, where he was idolized by his students, was about to retire in the spring of 1889. In accordance with custom, the students arranged to have his portrait painted for presentation to the University, and gave the commission to Eakins. It was assumed that the picture would be a single figure of the conventional type; but the painter was led by

his admiration for Agnew to embark on his largest composition, showing the great surgeon at work, like Gross. He told the students, however, that the price first agreed on—seven hundred and fifty dollars—would remain the same; all he asked was that they should come and pose for the figures in the background.

The conception of the picture is similar to that of the *Gross Clinic*. Here also the surgeon has paused in the operation and his assistants are busy with the patient; and behind, the benches are filled with students absorbed in the spectacle. But in many ways the two pictures belong to different ages. In the fourteen years since Dr. Gross posed in his brown frock-coat, surgery has changed; now all the costumes are antiseptic white, there is less blood in evidence, none of the family are present, and a woman nurse appears in the background; the whole spirit being that of the immaculateness and tense, white-hot skill of modern surgery. The grouping is less formal than in the Gross picture, with a seemingly casual naturalism which conceals a careful balance of the various elements. Agnew has retired to one side, away from the group of assistants around the patient, and stands leaning against the rail of the pit, scalpel in hand; but although far from the geometrical center of the picture, he is still the center of interest. His figure in its white garments, with the strong cold light full on it, standing out in startling relief against the dark background, has a reality and power that make it one of Eakins' finest achievements. His face, a striking likeness, is concentrated, showing in its frown and in the firm lines around the mouth the marks of a life lived at high pressure; but calm, with a steely steadiness quite different from the marmoreal imperturbability of Dr. Gross—a face of a more high-strung, modern age. So intense is the life in this magnificent head that it dominates the entire picture.

This large composition had to be finished in three months, during part of which the artist was ill with grippe, but did not interrupt his work. Some of the most important sections being in the foreground and the canvas being too large to put on an easel, he would sit on the floor to work; and when he became tired he would lie back and sleep for an hour or so, and then go on painting.

One of his pupils recalls coming into the studio late one night and finding him stretched out in front of the picture, dead asleep from exhaustion.

Dr. Agnew's biographer tells us that the doctor, noticing that he was being pictured with blood on his hands, "at once objected most strenuously, and, despite the artist's protests for fidelity to nature, ordered all the blood to be removed." His scruples, however, must have finally gone unheeded, or Eakins painted the blood in afterwards, for it is there at the present day, although less prominent than in the *Gross Clinic*. The public reception of the picture was much like that of its predecessor. Exhibited only once—at the Haseltine Galleries—for several years after it was painted, it aroused no such widespread comment as the *Gross Clinic*, and little written criticism, but in the polite art circles of Philadelphia it created a scandal. The favorite phrase which went around was: "Eakins is a butcher"—an attack which seems to have affected the artist more than most, for he repeated it to a friend, with feeling.

VIII

After the break with the Pennsylvania Academy his relations with it had been strained; but while sometimes talking bitterly about it, he headed no rival faction, being too absorbed in his art and teaching to play politics. For several years he did not exhibit in its shows. But in the 'nineties, with the election of Edward Hornor Coates as president, the directors attempted to establish closer relations with the artists of Philadelphia, placing the annual exhibitions in the hands of a jury of artists who, it was announced, were to control them "absolutely." In 1891 this jury invited Eakins to contribute, requesting particularly the *Agnew Clinic*, which he sent together with five other works. But as the artists were about to hang them, they received a letter from the chairman of the directors' exhibition committee, "requesting" them not to include the *Agnew Clinic* on the grounds that its having been shown at the Haseltine Galleries had rendered it ineligible, in accordance with an obscure regulation, seldom invoked. No exception, however, was taken to works by other painters already shown in the city, or to another picture by Eakins

which had been on view at the galleries longer than the *Agnew Clinic*. The directors, it was rumored, privately gave other reasons for their action; some thought the picture "not cheerful for ladies to look at."

After considerable argument between artists and laymen, the chairman of the jury replied that although the artists did not agree in this interpretation of the rules, "nevertheless, in deference to your wishes and to your supreme authority in such matters, they are willing to withdraw the picture." At the same time he wrote Eakins: "Every member of the artists' committee of selection for this year's exhibition regrets that your portrait of Dr. Agnew was not hung, particularly as we had decided before soliciting the picture that its having been seen in the Haseltine Galleries was not to render it ineligible for our exhibition."

Eakins immediately called on Coates and protested. Their conversation was confirmed by the president in a meticulously worded letter. Eakins was right, he said, in stating that the exhibition was "absolutely" in charge of the artists' jury; but "it was with no thought or desire of *interference*, and in my judgment, quite properly," that the directors had made their "request." "With this request . . . the hanging committee thought proper to comply. At the same time it was clearly within their power to have declined doing so, had they thought proper."

Eakins' reply was more direct: "I thank you very much for putting into writing your conversation with me. I still beg leave to say that in order to call the hanging committee's notice to a fact already well-known, it was hardly necessary to have a controversy extending over many days, until wearied with the great labor of hanging pictures, the artists in a moment of weakness ceded to the importunity, and asked to be relieved of a responsibility they had no right to surrender."

His own copy of this letter contains a postscript quoting a passage from Rabelais in which Panurge recounts to Pantagruel how a nun who had sinned with a monk, justified not having confessed it by saying that she had done so immediately afterwards to her partner in sin, who had bound her to silence;

and to reveal a confession was such a heinous offence that it might have brought down fire from heaven upon the abbey. The quotation ended with Pantagruel's comment: *"Vous ja ne m'en ferez rire. Je sçai assez que toute moinerie moins craint les commandements de Dieu transgresser, que leurs statutes provinciaulx."*

Thus the history of the *Gross Clinic* was strangely repeated: the most important work of Eakins' maturity, like that of his youth, was rejected by the "artistic" authorities of his own city.

For the next two years he did not show at the Academy. But in the meantime Harrison Morris, who knew and admired him, had been made managing director. As Morris wrote in later years: "A city with Eakins living in it detached from its Fine Arts Academy was a Hamlet-less farce. You might as well try to run a wagon on three wheels . . . I felt at once the lost motion of the Academy without Eakins, and I set out to win him back; not to the classes —prejudice and superior virtue were too thick for that—but to have the favor of his presence, to see him often, and to feel his passive influence."* Whether or not because of these efforts to draw him out of his isolation, the artist began to exhibit again at the Academy in 1894, and from this time on was represented in every annual exhibition, showing more there than anywhere else. As far as outward appearances went, the breach was more or less healed as the years passed; and in later years he occasionally served on the Academy juries. In 1897 the institution purchased the *'Cello Player*—his first work that it had acquired and his first purchase by a leading museum. Of the small amount which he received from the sale, he gave half to the musician who had posed for the picture. But while he used the Academy as an exhibiting medium, his attitude towards it remained the same, and the attitude of its directors towards him. There was no possibility of his again having any share in the affairs of the institution or its school. To teach the painting classes the Academy imported Joseph DeCamp all the way from Boston once a week, and later Chase from New York.

* *Confessions in Art*, by Harrison S. Morris. New York, 1930. P. 31.

In the Philadelphia art world Eakins' position in middle life was that of an outlaw. The respectable portion of the city's art public, the wealthy backers of the Academy, and the academic artists, had little to do with him. The nearest approach to a patron of his work had been Fairman Rogers, who had gone abroad in the 'eighties to live. Collectors bought none of his pictures, being interested in acquiring Cabanels, Bonnats, Bouguereaus, Fortunys, and Meissoniers, more than the work of any artist in their midst, particularly one who had proved rebellious. From only a handful of figures in the local art world, outside of his small circle of friends and pupils, did he receive any recognition. Sargent, visiting Philadelphia in the early nineteen-hundreds and being lavishly entertained, was asked by his hostess what Philadelphia artists he would like to have at a dinner, and said: "There's Eakins, for instance," to which the reply was: "And who is Eakins?"

IX

In the wider art world of America, the comparative fame of his early years was succeeded in the late 'eighties by increasing obscurity. The leading tendencies of American painting were away from almost everything that he stood for. The impressionism of Monet, the brilliant naturalism of Sargent, and the aestheticism of Whistler, were the most widespread influences of the time. Light, atmosphere, pure color, and "technique" were becoming the chief issues. Form and construction were of less importance than an eye for appearances, a clever brush, a gift for pattern, a gay color sense, or pleasing sentiment. The world of art was pursuing evanescent visions of sunlight and shade and pretty faces—adolescent ideals which contrasted with Eakins' mature, masculine realism. To his contemporaries his art seemed increasingly severe, sombre, indoors, and ugly, lacking "beauty" or "poetry." So much of his subject-matter lay outside the charmed circle of "Art"—ungraceful portraits of doctors, professors, and other "Philistines," and of ordinary people in ordinary settings, and commonplace themes like sports, prizefights, surgical operations, and scenes from everyday life. His draughtsmanship and knowledge of anat-

omy and perspective elicited a perfunctory respect, but seemed dull, old-fash-
ioned virtues, while his "neglect of the beauties and graces of painting," as a
leading academic critic put it, were deplored. Once a pioneer of the "New
Movement," he was now passé. While in youth he had had to contend with
opposition and abuse, in middle life he suffered the worse fate of indifference
and neglect.

During these years the Society of American Artists, the embodiment of the
"New Movement," had become more and more popular, and more and more
conventional, and was now hardly distinguishable from its former rival the
National Academy. Now occupying a respectable financial position, it was
building an imposing new home in New York. Eakins, as we have seen, had
been one of its earliest members and had exhibited with it from the first. But
when his two reliefs, *Spinning* and *Knitting*, had been rejected in 1884, he
had evidently thought of resigning, and we find Augustus St. Gaudens, one
of the moving spirits of the Society, writing him agreeing that he had been
unjustly treated, but urging him not to resign "so long as there is any hope in
the organization." For several years thereafter, with one exception, his work
when he sent it was rejected, the final blow being the refusal of the *Agnew
Clinic* by the Society which little more than a decade earlier had fought so
valiantly to have the *Gross Clinic* shown in Philadelphia. In May, 1892, he
wrote the Society:

"I desire to sever all connection with the Society of American Artists.

"In deference to some of its older members, who perhaps from sentimental
motives requested me to reconsider my resignation last year, I shall explain.

"When I was persuaded to join the Society almost at its inception, it was a
general belief that without personal influence it was impossible to exhibit in
New York a picture painted out of a very limited range of subject and narrow
method of treatment.

"The formation of the young Society was a protest against exclusiveness
and served its purpose.

"For the last three years my paintings have been rejected by you, one of

them the Agnew portrait, a composition more important than any I have ever
seen upon your walls.

"Rejection for three years eliminates all elements of chance; and while in
my opinion there are qualities in my work which entitle it to rank with the
best in your Society, your Society's opinion must be that it ranks below much
that I consider frivolous and superficial. These opinions are irreconcilable."

When a few months later the Society's new building was opened with a
retrospective exhibition, he showed a group of early works, doubtless for old
times' sake; but thereafter he sent only once for ten years.

His resignation, at the moment of the Society's triumph, was a more radi-
cal gesture than it would be today, for academicism had a vitality which it has
not now, and the Society and the National Academy included practically all
the best artists of the country. But he was not a revolutionary against academic
art. While playing little part in artistic politics, he was not opposed to institu-
tions, and took advantage of any legitimate opportunity to bring his work be-
fore the public. Although he attached little value to prizes and medals, he
had no objection to serving on juries, and on the few occasions that he was
asked to do so, was a tolerant juror. In such matters he was independent and
commonsense, guided by the realities of the situation rather than by prejudices
or theories. It was only when forced by what he considered injustice, that he
revolted.

In the late 'eighties and the 'nineties his obscurity was at its deepest. A pro-
vincial, living in Philadelphia out of the main current of art, he had few of
the contacts which he would have had in New York. He did not exhibit as
widely in middle years as in youth, showing mostly at the Pennsylvania Acad-
emy, and being represented at the National Academy and the Society of Amer-
ican Artists only at long intervals. Having no dealer in New York, he never
held a one-man exhibition there; and only one even in Philadelphia, at the
Earle Galleries about 1896, which aroused no more than ordinary interest.
Many of his most important works, such as the *Gross* and *Agnew Clinics*,
were hidden away in institutions where the artistic public seldom saw them,

or were in the hands of owners who did not appreciate their artistic merits. The end of his teaching in the middle 'nineties added to his obscurity.

One could name a half hundred painters who were more in the public eye; not only the "leading American artists" of the time—Whistler, Homer, Inness, La Farge, Sargent, Chase, Duveneck, Alexander, Cox, Weir, Thayer —but many of lesser rank. The art books and reviews of the time gave him only passing mention. He was seldom asked to serve on juries or committees and played little part in the game of prizes and commissions. The only organization which had elected him to membership was the Society of American Artists. He was represented in few museums.* At the World's Fair in 1893 —a milestone in American art almost as important as the Centennial, but this time marking the triumph of the "New Movement" as 1876 had marked its beginnings—he was not asked to take part in any of the elaborate artistic preparations, although many less-known Philadelphians were; nor to help with the decorations which turned the theatrical pseudo-Roman buildings of "The White City" into realizations of the common man's ideal of "Art." In these halcyon days of American mural painting he received none of the numerous commissions which were given out, although a far-sighted committee might have perceived in him one of the few really monumental painters of the time. At the World's Fair he received his first award for many years, a bronze medal for a group of his most important works; but since this honor was shared by fifty-six other American painters, it was scarcely outstanding. This was his last award until 1900.

There was of course some appreciation, else it is doubtful whether even he, with all his strength and self-sufficiency, would have been able to keep on painting. He was not a solitary. He had the constant faith and encouragement of Mrs. Eakins; and then there was Murray, his devoted pupil, fellow-

* During his lifetime he was represented in only three museums, by six pictures, half of which were purchased from him. The Smith College Museum of Art purchased *In Grandmother's Time* from him in 1879; he presented the *Chess Players* to the Metropolitan Museum in 1881; the Pennsylvania Academy purchased the *Cello Player* from him in 1897, purchased *Walt Whitman* from another owner about 1908, and was presented with the portrait of *Charles E. Dana* in 1913; and the Metropolitan Museum purchased *Pushing for Rail* from him in 1916.

worker, and companion; his students, who worshipped him as a man and an artist; a few colleagues, seldom the most prominent, who respected his strength; a few supporters in the local art world; and his friends, some of whom genuinely admired his work, while others, being fond of him, were at least kind to it. Most of this appreciation was personal, coming not from official institutions, fashionable patrons, leading artists, critics, the public—in other words, the larger art world—but from people close to him. It undoubtedly meant much to him, far more than it would have to a more cosmopolitan artist; but he must have felt its limitations.

It was fortunate that he did not have to depend upon painting for his living, and was free to paint his own subjects in his own way. Financial success or fashionable reputation meant little to him, and might even have been a hindrance. But while more than ordinarily independent, he was not indifferent to appreciation, being in fact sensitive as well as strong-willed. An integral part of his environment, sharing fully in its life, he would have liked to take his place in it, to be able to make his living, to feel that he was fulfilling a needed function; would have welcomed public response, and worthier opportunities to exercise his gifts. In younger years he had been ambitious, had hoped and tried for fame, believing in his simplicity that he need only produce the best that was in him and the public would make a path to his door. Only when even a modest share of recognition was denied him, did he become more indifferent to success, but this indifference covered profound disappointment. The depth of his disillusionment appeared in a letter written in 1906 to a young man who had asked his advice about studying art:

"I am sorely puzzled to answer your letter. If you care to study in Philadelphia, you could enter the life classes of the Pennsylvania Academy of the Fine Arts and I could give you advice as to your work and studies, or you might go to Paris and enter some life classes there. Nearly all the schools are bad here and abroad.

"The life of an artist is precarious. I have known very great artists to live their whole lives in poverty and distress because the people had not the taste

and good sense to buy their work. Again I have seen the fashionable folk give commissions of thousands to men whose work is worthless.

"When a student in your evident state of mind went to Papa Corot for advice, the old man always asked how much money he had. When the boy offered to show his sketches and studies, the old man gently pushed them aside as being of no consequence."

Of him in later life, one who knew him well said: "He was a sad man." In these years his thoughts seem to have returned frequently to his youth and France; he often spoke of his student days, and hearing in 1907 of the death of his old schoolmate Guille, he wrote Louis Cure: "*Je suis vivement touché de la mort de ce pauvre Guille. Il était toujours si gentil, si spirituel. Je pense toujours à lui et à toi, quand je pense à la France, ce qui m'arrive très souvent.*" His self-portrait, painted when he was approaching his sixties, was a revealing document, showing the face of a man who had been through much, saw things with a minimum of illusion, and yet retained an essential courage and equanimity, and a touch of ironic humor.

Fortunately he had a realization of his own power that was not shaken by the treatment he received. From the time in school when he had written that he was doing "solid, heavy work," he always spoke of the worth of his art as an indisputable fact. Even when he realized most bitterly the meagre rewards that society gave a genuine artist, he never lost his faith in his own work or his delight in painting. A weaker man would have made opposition and neglect an excuse for surrender; but Eakins continued to paint as many, in fact more pictures, on an even larger scale, as uncompromisingly realistic and as free from any attempt to make them more acceptable. There was no loss of vigor; indeed, his style became constantly broader, freer, more masterly. In his disillusioned later years even more than in his hopeful youth, he revealed the deep soundness and vitality of his character.

X

On December 30th, 1899, as the century was closing, Benjamin Eakins died—a loss which his son felt profoundly. All his life he had had a deep love and respect for the older man—simple, untroubled, part of that sense of unbroken continuity which was an essential part of his nature.

The next year the artist gave up his studio on Chestnut Street and built a new one on the top floor of the Mount Vernon Street house. Murray took a studio of his own, but the two continued to see each other almost as much as before. At this time also Miss Mary Adeline Williams, a childhood friend of Eakins and his sister Margaret, came to live in the household, and became a close friend and companion to the artist and his wife.

With the opening of the new century, as Eakins was approaching his sixties, he began to emerge somewhat from the obscurity that had enveloped him in middle life, and to receive a measure of recognition. He had reached an age when any artist may expect some honor; he had been painting long and consistently, and was now doing some of his most important work; he could no longer be ignored. By the mellowing action of time, the public had become more accustomed to the asperities of his style. A new generation of "younger painters" was turning toward a realism somewhat akin to his own. He was beginning to be thought of as one of the old masters of American art.

The recognition came first from outside of his native city. The Carnegie Institute in Pittsburgh, which started its international exhibitions in 1896, invited him from the first, and from 1899 asked him to serve on the international jury of awards for five consecutive shows. In 1900 came his first award since the World's Fair—an honorable mention at the Paris Universal Exposition; and next year a gold medal at the Pan-American Exposition in Buffalo. In March, 1902, the National Academy of Design unanimously elected him an associate, and two months later, by a large majority, an academician —an unusual procedure. The gesture was tardy, for most of his friends and contemporaries had long been members; but he had exhibited little at the

Academy or anywhere in New York for some years. After this he showed there regularly, as well as at the Society of American Artists until the two were merged in 1906.

A succession of awards followed, including the Temple gold medal at the Pennsylvania Academy in 1904, the Proctor prize at the National Academy in 1905, and the second prize at the Carnegie International in 1907.* To none of these did he attach much importance, leaving his medals lying around the studio among his painting materials. When he was awarded the Temple gold medal, he and Murray appeared at the Pennsylvania Academy on bicycles and in cycling costume, and his only comment on receiving it from the president, Edward Hornor Coates, was that the Academy had "a heap of impudence to give him a medal"; and he immediately rode up to the Mint and turned it in for its equivalent in money—about seventy-five dollars.

In these years he began to receive more recognition from critics. Sadakichi Hartmann in his *History of American Art*, published in 1902, singled out him and Winslow Homer as the foremost realists and native artists of the older generation—the first estimate of him from a modern viewpoint. Commenting on his so-called "brutality," Hartmann wrote: "Our American art is so effeminate at present that it would do no harm to have it inoculated with just some of that brutality. Among our mentally barren, from-photographs-working, and yet so blasé, sweet-caramel artists, it is as refreshing as a whiff of the sea, to meet with such a rugged, powerful personality . . . His work may here and there be too severe to be called beautiful, but it is manly

* The complete list of Eakins' awards is as follows: a silver medal at the Massachusetts Charitable Mechanics' Association, Boston, 1878, for two watercolors, *Negro Boy Dancing* and *Young Girl Meditating*; a bronze medal at the World's Fair in Chicago, 1893, for a group of ten paintings including the *Gross* and *Agnew Clinics*; an honorable mention at the Paris Universal Exposition, 1900; a gold medal at the Pan-American Exposition in Buffalo, 1901, for the portrait of *Professor George F. Barker*; a gold medal at the Louisiana Purchase Exposition, St. Louis, 1904, for the *Gross Clinic*; the Temple gold medal at the Pennsylvania Academy of the Fine Arts, 1904, for the portrait of *Archbishop Elder*; the Thomas R. Proctor prize for the best portrait in the eightieth annual exhibition of the National Academy of Design, 1905, for the portrait of *Professor Leslie W. Miller*; the second prize at the eleventh annual international exhibition of the Carnegie Institute, Pittsburgh, 1907, for the portrait of *Professor Leslie W. Miller* (the first prize was given to Gaston La Touche); the gold medal of the American Art Society, Philadelphia, 1907.

throughout—it has muscles—and is nearer to great art than almost anything we can see in America." A few years later Charles H. Caffin followed suit in his *Story of American Painting:* "He has the qualities of manhood and mentality that are not too conspicuous in American painting." These opinions, however, were still confined to a few radical critics. The average academic judgment was expressed by Samuel Isham, who in his monumental *History of American Painting* dismissed Eakins as an example of the "inelegant" results of Beaux-Arts training. Critics in general paid little more attention to him; not a single article was published on him during his lifetime.

Even at the time of his greatest recognition he was not nearly as popular as the "leading American artists" of the day. His best work was still liable to be rejected by juries, or if accepted to be hung in the "morgue." Commissions and sales were as rare as ever, he still had difficulties with clients about portraits, and his pictures continued to accumulate in his house. The flurry of awards must have seemed to him an empty honor. It was at this time that his letters expressed the deepest disillusionment with worldly success.

But that he was far from indifferent to even this recognition, was shown by the fact that in the decade of 1900 to 1910 he painted almost twice as many pictures as in any corresponding period, his production being highest in the years 1903 and 1904, following the first of his honors. The work of this decade included some of his most important pictures: the *Thinker, Mrs. Frishmuth, Professor Miller, Signora d'Arza, Music, Professor Forbes, Dr. Thomson,* the *Old-fashioned Dress,* the later versions of the William Rush theme, the magnificent portraits of Catholic prelates. In this culminating phase of a productive period of over forty years, he showed a superb vitality.

XI

In 1910 his health, always so robust, began to decline; kidney trouble developed, he became lethargic, could hardly get around without assistance, and his eyes began to fail. After this he did little painting. Once he started a large portrait of the brain specialist Edward A. Spitzka, holding a cast of a

human brain; but he had great difficulty with it, and finally asked Mrs. Eakins to try her hand on the cast, which was the only part finished, for he was unable to continue. This was his last work.

But his interest in painting still remained strong, and he often spoke of the work he intended to do when he should be well again, continued to exhibit, and still visited the studios of friends and former students to watch them and offer criticisms. At times he would fall into a melancholy mood, sometimes quoting Dante. His enjoyment of music was a consolation, and his friend Nicholas Douty, the tenor, frequently came to the house to sing for him.

A modest honor came to him in these years. In 1912 an exhibition of historic portraits was held in Lancaster, the old capital of Pennsylvania; and Dr. Agnew having been a native of the county, the *Agnew Clinic* was borrowed and hung in the place of honor. In spite of his illness the painter insisted on making the trip to attend the opening. A critic who was present recalled "how Mr. Eakins, supported by his faithful and lifelong friend, Samuel Murray, made the heroic effort of being present on this occasion. There was a great crush of provincial folk, for the affair was warmly supported by the Lancastrians, many of whom had lent family portraits. Eakins entered the room with Samuel Murray and spent a happy hour in the exhibition looking at the old American portraits there assembled, and seemed gratified with the conspicuous placing of his own great picture. No one recognized him, and it was only after the authorities had been informed of his presence that he received an ovation and departed early for the long trip back to Philadelphia in the night."* He always looked back upon this occasion with special pleasure, and once when asked by reporters what honors he had received, replied that he had been given a reception at Lancaster.

In 1914 came another mark of recognition; a study for the figure of Dr. Agnew, which had lain around his studio for years, was purchased by the collector of modern art, Dr. Albert C. Barnes, for a price which while not

* *The Philadelphia Inquirer*, November 11, 1917.

over five thousand dollars was still three times as much as the artist had ever received. This transaction, involving a respectable sum of money, at once became news, and Eakins found himself, at the age of seventy, a nine days' wonder. The veracious press informed the public that "the price paid for the painting, may, when revealed, prove sensational. One rumor makes it $50,000." Reporters hurried up to the quiet house in Mount Vernon Street to interview "the dean of American painters." To a request for his opinion as to "the present and future of American art," he replied:

"If America is to produce great painters and if young art students wish to assume a place in the history of the art of their country, their first desire should be to remain in America, to peer deeper into the heart of American life, rather than to spend their time abroad obtaining a superficial view of the art of the Old World. In the days when I studied abroad conditions were entirely different. The facilities for study in this country were meagre. There were even no life classes in our art schools and schools of painting. Naturally one had to seek instruction elsewhere, abroad. Today we need not do that. It would be far better for American art students and painters to study their own country and portray its life and types. To do that they must remain free from any foreign superficialities. Of course, it is well to go abroad and see the works of the old masters, but Americans must branch out into their own field, as they are doing. They must strike out for themselves, and only by doing this will we create a great and distinctly American art."

Asked whom he considered the greatest American painter of his time, he replied, "Winslow Homer." "Whistler," he added, "was unquestionably a great painter, but there are many of his works for which I do not care."

As he entered the last year of his life there were a few more signs of increasing appreciation. The Art Club of Philadelphia elected him an honorary member, an early sporting picture was purchased by a private buyer, and the Metropolitan Museum bought another small early work. Eakins' gratification at this was tempered by disappointment: "Why didn't they buy the *Thinker?*" he asked one of the museum curators.

An unexpected pleasure came when his old friend Harry Moore, whom he had not seen since the days in Paris and Spain, returned to Philadelphia, seeking a quieter atmosphere than wartime France. When the two elderly men met after so many years, they threw their arms around each other; and thereafter were almost constantly together, talking as before in the sign language.

He was now scarcely able to walk, but would still insist on going out, accompanied by Mrs. Eakins or Murray. Once at his request Murray took him to New York, where he went through the Metropolitan Museum in a wheelchair, seeing little but enjoying the adventure.

He was confined to his room only for ten days, in the latter part of June, 1916. Uncomplaining, he sometimes talked to Murray about the prizefights they had seen. On the morning of June 25th he became unconscious, breathed more and more slowly, and died peacefully about one o'clock.

In accordance with his own wishes, there were no religious services and no flowers; his friends merely gathered at the house to say farewell; and afterwards his body was cremated.

XII

Hardly had he died before there began that wider recognition which he had lacked all his life. His friends in Philadelphia, and especially Gilbert S. Parker, director of the Pennsylvania Academy, wished to hold a memorial exhibition, but were unable to secure enough official support; but in New York the curator of paintings of the Metropolitan Museum, Bryson Burroughs, who had long appreciated his work, was not hampered by such restrictions. With the assistance of Mrs. Eakins and Parker, he selected the best pictures from the houseful that the painter had left behind, supplementing them with other outstanding examples, and in November, 1917, opened in the large gallery of the museum an exhibition which for the first time showed the artist's work in the proper scale.

The New York art world at this time was in a state of ferment, having been stirred to its depths a few years before by its first extensive contact with mod-

ernism in the Armory Exhibition. The older American school was passing,
and its place being taken by a new "New Movement." Here, among the radi-
cals, Eakins' work found its warmest supporters, particularly in the group of
new realists of whom Robert Henri was the leading spirit, many of whom
had come from Philadelphia. To them he seemed a precursor. Henri in par-
ticular talked of him enthusiastically to his own students, saying: "Look at
these portraits well. Forget for a moment your school, forget the fashion. Do
not look for the expected, and the chances are that you will find yourself,
through the works, in close contact with a man who was a man, strong, pro-
found, and honest, and above all, one who had attained the reality of beauty
in matter as it is; who was in love with the great mysterious nature as mani-
fested in man and things, who had no need to falsify to make romantic, or to
sentimentalize to make beautiful. Look, if you will, at the great *Gross Clinic*
picture for the real stupendous romance in real life, and at the portrait of
Miller for a man's feeling for a man. This is what I call a beautiful portrait;
not a pretty or a swagger portrait, but an honest, respectful, appreciative man-
to-man portrait."*

It was also the critics who had welcomed modernism who gave the exhibi-
tion its warmest reception. Henry McBride especially devoted much space to
it in the *New York Sun*, writing: "Eakins is one of the three or four greatest
artists this country has produced, and his masterpiece, the portrait of Dr.
Gross, is not only one of the greatest pictures to have been produced in Amer-
ica but one of the greatest pictures of modern times anywhere."

The Philadelphia papers, in reporting the exhibition, showed a realization
of the neglect of Eakins by his native city. "This is the Philadelphian whom
Philadelphians have never thought it worth while to honor!" wrote one critic.
"New York, the first to realize the unappreciated genius of which death last
year deprived America, has spared no pains to make of the atoning memorial
exhibition a just and fitting tribute to the man who, through long years of the
most conscientious work, labored with no tribute but his own satisfaction. For

* *The Art Spirit*, by Robert Henri. New York, 1923. P. 86.

the great artist whom Philadelphia could have claimed, the great teacher of art who, in an age of art silliness and sophistry, could have held Philadelphia pupils firm in the immortal traditions, . . . was set aside and ignored in this city." But New York having showed the way, Philadelphia was now ready to follow, and due mostly to the enthusiasm of Gilbert Parker, the Pennsylvania Academy opened in December, 1917, the largest exhibition of Eakins' work ever held, including the entire New York group and almost as many more pictures from owners in the city.

After these memorial activities ensued a quieter period in Eakins' reputation. The exhibitions had had rather a *succès d'estime* than a popular one, and appreciation was still confined to a limited number of artists and critics. But unlike most of his contemporaries, his reputation grew steadily if slowly after his death. About 1923 began a series of exhibitions in New York galleries, starting at the Whitney Studio Club, which aroused a growing interest. Freed from the personal friendships or hostilities of his lifetime, critics wrote more thoughtfully and understandingly of his art, and in a few years more was published than had appeared during his entire life. Led by the Metropolitan Museum, the museums of the country began to purchase his pictures. While this was going on, not a single work was acquired by any public institution in Philadelphia, in spite of sporadic efforts to interest the authorities. Finally, in the early part of 1930, Mrs. Eakins presented to the Pennsylvania Museum of Art over sixty of the most important works still in her hands—a gift for which there were few parallels in American art, and which gave his native city a permanent and worthy memorial of one of her chief artists. A few months later the contemporary estimate of his work was expressed by the Museum of Modern Art in New York, which exhibited him, together with Homer and Ryder, as the three American painters of the last generation who are of most significance to the present age.

VI

THE ARTIST

SELDOM has there been so consistent a realist as Eakins—one whose art was such a direct outgrowth of reality. He used the material that lay closest around him. Every figure he painted was a portrait, every scene or object a real one—always the particular rather than the generalized, the individual rather than the type, the actual rather than the ideal. His whole philosophy was naturalistic, with little bent towards the romantic, the exotic, or the literary.

His vision was close to familiar visual reality. He saw reality steadily, with penetrating observation, and seemed to get entire satisfaction from it, feeling no need to idealize it. He painted what he saw, with almost terrible candor; anything that appeared in the subject, and that seemed to him significant, re-appeared in his work, regardless of conventions. He distorted little; the liberties he took with nature consisted rather in the omission of non-essentials, the concentration on fundamentals. There was hardly a trace of conscious stylism or decorative intent.

His art was essentially original. Most artists of any sensitiveness see reality partly through their memories of other art, but he had the rare ability to face it without the need of anything to soften its hard outlines or make it more acceptable. His eye was as innocent as that of a primitive, observing things as if they had never been painted before—as indeed many of his subjects had not been. Few artists have been so little influenced by others, or have shown so few signs of a borrowed style.

The viewpoint set forth in his work was as near complete objectivity as is possible for a creative artist. He presented the external world as he saw it, without trying to express his subjective emotions about it. His impersonality was like that of a scientist. Even the people closest to him were painted entirely without glamor. But there was nothing cold in his attitude; underlying his relentless realism were deep humanity and intense personal emotion,

revealing themselves not in subjective emotionalizing but in the creation of a powerful and penetrating record of things as he saw them.

He differed from the ordinary naturalistic painter in that while the latter presented the surface facts, he gave the vital, essential truths. He was no plodding copyist, piling detail on detail to achieve a lifeless verisimilitude; he might be called a creative realist. Disregarding small truths, he concentrated on the most significant elements of reality, searching always for essential structure, character, and action.

The commonest complaint about his art has been that it lacked "beauty" and "poetry." Those who make this criticism are apt to mistake prettiness for beauty, sentimentality for poetry. With most of his "poetic" contemporaries, one exhausts their work when one has felt its mood, for there is little else. Eakins on the other hand presented the thing itself—the person, object, or scene—and thereby created something more enduring than those who merely painted their emotions about the thing. And the austere poetry which did appear in many of his works, being inherent in the things portrayed, was genuine.

Although his aim was not "beauty" as that shopworn word is commonly understood, but truth, his work nevertheless attained aesthetic qualities more permanent than that of most of the beauticians of his time. These qualities were probably largely unconscious—by-products of his search for truth.

II

The thoroughness shown in other aspects of his art appeared in his painting methods. Every figure, object, or scene was carefully studied from its original in nature. When painting the *Concert Singer*, each day before starting work he asked the model, Weda Cook, to sing "O rest in the Lord" from Mendelssohn's *Elijah*, so that he could observe the action of mouth and throat; and while she was singing he would watch her "as if under a microscope." For the orchestra leader's hand which appeared in the foreground, a famous conductor was asked to pose.

He was always particular to have the model posed in exactly the same position, in one case tracing squared lines on a tapestry in the background, so that the sitter's head could be located against it exactly, and on the opposite wall drawing a square with diagonals on whose intersection the sitter was supposed to keep his eyes fixed. In another case colored ribbons were pinned on salient points of the figure, and ribbons of corresponding colors on the background where these points came against it. The canvas had to be perpendicular and at right angles to the eye, and when the picture was life-sized he would sometimes place it alongside the model for comparison.

Intensely absorbed in his work, he was not easy on sitters, who often complained of the length of time they had to pose, some refusing to continue. Aiming at qualities more fundamental than the average portraitist, he took longer, especially when there was some problem or subtlety which interested him particularly, as in the *Concert Singer*, on which he worked for two years, the first year fairly steadily. Several times when a painting was almost finished he became dissatisfied with it, laid it aside, and started over again. But considering what he put into a picture, he was a fast rather than a slow worker. There was nothing niggling or tortured in his methods; he worked firmly and surely, with intense concentration. The first painting was very swift, in many cases achieving the main features in a single sitting. Some of the head-and-bust portraits of his later years, presenting no particularly new problems, were finished in a few sittings of a few hours each. His total known production, about three hundred and twenty paintings and watercolors, aside from studies, and ten pieces of sculpture, was not small, considering the size and complexity of many of them, as well as the time he spent in teaching and scientific research.

His perspective studies, so thorough in early years, were not continued to the same extent in later life, when he trusted his eye more; and his later works, being mostly portraits, did not call for them. But in large pictures he still laid out the ground-plan and the regular-shaped objects in perspective; in the case of a seated figure the floor and the chair would be constructed first.

He still made few drawings, doing instead small oil studies, which were enlarged on to the canvas, the main masses sometimes being blocked in before the sitter posed again. In many cases, such as the head-and-bust portraits, even these preliminary sketches were dispensed with.

In technique the tendency of his time was away from traditional processes towards more direct, summary, and "brilliant" methods, whose aim was to secure effects and appearances; such as the impressionists' mosaic of pure colors, or the flowing brushwork of the Sargent school—alike in that they were relatively opaque painting, *au premier coup*. Eakins' technique was in an older tradition, richer and more complex, whose aim was the creation of solid form and depth; essentially the old masters' method of successive paintings and glazes, in which the opacity of the solid forms built up body and projection, and the transparency of the recessions gave depth. Every form was modelled instead of being merely indicated, the textures were varied, and the whole work was carried to a higher finish than with the "brilliant" school. "There is no intermediate between the highest finish and a start," he once said. As a technician in the broadest sense—not of surface brilliancy but of firmness, richness, and depth—he was one of the most accomplished of his generation.

As he matured his handling became increasingly free, broad, and transparent, with no loss of solidity. But he seldom used the Sargent brushstroke, flowing in the direction of the form and indicating it with summary skill; his brushwork was more sober and solid, although no less able. As a master of the brush he was superior to Sargent in power, if not in pyrotechnic brilliancy. But he despised mere cleverness. In one portrait a passage along the cheek was painted with particular skill; a friend praised its "cleverness"; but the next time he saw the picture the passage had been scraped down and painted over. Eakins' reasons were opposite to those of Sargent, who would do a part over and over until it gave the desired effect of "effortless skill."

A dark and reserved colorist, powerful rather than brilliant, he was affected little by the general tendency of his time towards a higher gamut. He did not, like his contemporaries the impressionists, try to rival the brilliancy of nature,

but to create within the pictorial range an equivalence to her tonal relations, transposed to a lower key. The important thing to him was not the key but the justness of relations. The merely decorative or emotional aspects of color interested him less than its coordination with form, which was always right, every note taking its place in depth or relief, so that color became form, form color. His color seemed inherent in the objects, part of their very substance. It had a depth, body, and mellowness that could result only from a profound understanding of its function. His pictures possessed a unity of tone, out of which individual colors emerged. And in itself his color held a strong sensuous appeal—warm, full-blooded, resonant. His feeling for harmony was sensitive and true, and within his austere range he secured deep and powerful effects.

While he always remained a dark painter, his palette broadened throughout the years, becoming lighter and cooler. Flesh tones were clarified; and the prevailing warm browns of his early indoor work were varied with light grays and golden tones, terracotta reds, olive-greens, and blues.

With all his limitations in range, he was one of the most genuine colorists of his time in this country. In comparison, the greater brilliancy and charm of many of his contemporaries seemed shallow or saccharine. Even Homer's masculine robustness, though wider in its range, was not as deep; and Whistler's sensitive harmonies seemed a matter of charming decoration without vital relation to form. Only Ryder shared Eakins' profound conception of the form-building function of color, having more feeling for its poetic and emotional value, if less realistic force.

While interested in light, like others of his generation, he was never as exclusively concerned with it as most. With the impressionists it tended to become the whole subject of the picture, and figures and objects lost much of their intrinsic value; but for him its chief function was to reveal form. His greatest interest remained in the object, with its physical properties of substance, weight, hardness or softness, and texture. His light, though low-toned, was clear and revealing; it never broke up forms, but brought out their body

and relief. His objects were surrounded by air, but even in his most atmospheric work none of their solidity was sacrificed. While in early pictures the light had sometimes been so realistic that it did not permit the forms to be seen at their fullest, he later displayed an increasing sense of the light which brings out the plastic qualities of form; although he did not depart from naturalistic illumination.

While his vision was close to familiar reality, he was not a merely "photographic" painter. He never attempted to render mere appearances, like the camera, but preserved the integrity of his forms. He differed from most of his naturalistic contemporaries in that while they were concerned with light and atmosphere and appearances, he was interested in things, objects, forms. Many of them were cleverer painters of superficial facts, but their work now seems a consummately skillful solving of problems that are no longer important. Their naturalism was of the eye, his of a more fundamental kind. The permanent realities of nature meant more to him than her passing aspects.

III

His art was completely three-dimensional. His forms were in the full round, absolutely solid, to their very cores, and convincing in tangibility, hardness, and weight. There was no sense of his having to strain after these qualities; he simply felt the physical existence of things with almost primitive integrity; it would have been impossible for him to paint otherwise. Everything was definite and thoroughly understood, with no trace of vagueness; art which left too much to the imagination, he called "cowardly." The character of forms was stated without softening or idealization, but with uncompromising boldness and saliency.

He was concerned less with the surface than the core of forms, so that they seemed the result of building up from within rather than tame accumulation of external facts; they had the dynamic inner life that marks the creative formal artist. His austerity and his desire to reduce things to their simplest factors, led him to strip forms to their bare fundamentals, to eliminate superflu-

ous details or decoration, to get down to the elements that embodied essential power. He saw things as wholes, combining intense development of parts with a comprehensive sense of their relations. This largeness of vision gave his forms a sculptural quality. Where they came to critical points, they were chiselled with extreme fineness and precision. His drawing was entirely free from formulas or easy curves; it showed a searching honesty, a sensitiveness to subtleties, that recalled the Dutch masters.

His figures possessed vitality. Painted not only with anatomical knowledge but with an instinctive sensuousness, they arouse sensations of muscular tensity or relaxation, capacity for action, essential energy; they are alive. His art, like that of most strong artists, was founded on the sound basis of a deeply physical feeling for the human body.

Several of his early works had represented motion. In these the figures were springy and seemed capable of moving, and the action was observed with unconventional truth (as was natural considering his scientific studies of human and animal locomotion). But especially in the swifter phases, the feeling was that of arrested motion rather than of movement in the sense in which it was depicted by a Rubens, who created forms that have the property of motion in themselves. His researches had been scientific rather than aesthetic, and his conception of motion remained naturalistic.

We may recall Gérôme's criticism of one of his rowing pictures as immobile, a fault which the master ascribed to the fact that the rower was shown at the height of the action instead of in the pause at either extreme (indicating Gérôme's aesthetic limitations, for according to this theory it would be impossible to express motion at all); and we may remember that Eakins painted another version of the subject to conform to this restriction.

Later he evidently came to realize in what direction his strength lay (a process in which Gérôme's criticism may have played a part), for most of his later subjects were of a type, portraiture, which did not call for the representation of motion, and in his few figure compositions he chose more or less stationary subjects. As he matured, his forms themselves developed more in-

trinsic motion and became more free and flowing; but his art always remained relatively static, its characteristic qualities being power in reserve, monumentality. These qualities, in harmony with the slow-moving, leisurely spirit of his time and place, were also consistent with his temperament — reserved, unexpansive, intensely concentrated on the object. And they were linked to his limitations in the field of figure-painting; his paintings of the nude or semi-nude body, such as the *Swimming Hole*, were the most moving, and if he had attempted it more often his sense of motion might have developed further.

Design never consciously absorbed him as did naturalistic problems. Aside from his innate realism, his environment and training no doubt played a part in this. The America in which he grew up had little great art in museums and had created comparatively little of its own. By the time he reached France his predilections had already crystallized; and he was not easily influenced. He gave little study to the supreme masters of design, Raphael, Michelangelo, Titian, and Rubens; his admiration for Rembrandt was largely for his realism; and of all the great painters he chose as his particular ideal the one with the slightest sense of design, Velasquez. And these tastes remained essentially unchanged throughout his life.

But while not highly conscious or articulate about such matters, an instinct for design showed in his work from the first. Without theories or help from other art, and in opposition to prevailing trends, he dealt with the material of life in the most highly developed formal and plastic way of which he was capable. His instinct sought expression through such studies as perspective and anatomy—the sciences of space relationships and of the structure of living organisms. To him the human body was the most interesting of nature's forms, and his sense of its structure, and that of the head, was strong. From this feeling for the design of individual figures and objects, he worked more or less unconsciously towards design of the whole picture; his efforts being revealed in his sketches and studies, and in succeeding versions of similar subjects, which became progressively more organized.

His instinct for design showed in elimination of unnecessary details, and concentration on fundamental constructive elements. A sensitiveness to the relation of part to part extended in his most complete works to a sense of the balance and harmony of the whole. From the first his design was austere, composed of relatively few elements, rather than complex. His early rowing and outdoor pictures showed a fine understanding of the use of geometrical forms and the play of simple forces. In the more crowded figure subjects, such as the *Gross Clinic* or the *Pathetic Song*, the composition was of a more or less traditional, pyramidal type, building up stable, monumental forms, which reached a point of high development in the heads. In the few works containing nudes, such as *William Rush* and the *Swimming Hole*, a less formal, more rhythmical and poetic type of design was manifest. Comparing his earliest works with those of a decade or so later, we observe a steady progress: the forms were larger, the movement freer, the composition less severe and geometrical, more varied and subtle.

His later works, being almost entirely portraits, included few examples of complex design. Most of them were head-and-bust portraits, varying little in arrangement or even size, and sometimes casual in composition. But in his larger portraits, while confining himself to a relatively simple type of design, he practised it with increasing mastery. Everything was on a grander scale, and the forms filled the space of the picture more satisfyingly, and were seen more broadly, felt more sensuously, handled more freely, with a greater sense of plasticity and movement. And the whole picture had more unity. There was a more austere economy of means; nothing non-essential was allowed to detract from the figure, whose sculptural forms dominated the picture. Particularly in the head was concentrated a vitality so intense that it filled the whole space. Few modern painters have shown such a mastery of the head, such a feeling for it as the central piece of design in nature. Details and accessories, while rich in themselves, were subordinated to a more unified pictorial rhythm, a more intense concentration on the leading motif. The unity he had achieved was that of powerful central elements, intensely realized,

rather than of the organization of complex forces—the unity of simplicity rather than of multiplicity.

In his few later works containing several figures, while individual parts were stronger than ever, the whole was often less integrated. The early version of *William Rush*, for example, possessed more unity than that of thirty years later. *Taking the Count*, the first of the prize-ring pictures of the 'nineties, was awkwardly composed; but the next, *Salutat*, was more successful, while the last, *Between Rounds*, was one of his most unified designs. He evidently realized the incompleteness of his first attempts and was able to improve on them; but through lack of practice in this more complex type of design, he only rarely carried it further than in early years.

His design was strong within limits. Few artists have realized individual figures and objects with more power; but he did not always go beyond their naturalistic aspect and conceive of them as elements in a total formal organization. In design centering around the single figure he attained a completeness equalled by few of his contemporaries; but his ability to handle more complex themes remained relatively undeveloped. The strength of his design lay not in complexity or movement, but in simplification, concentration, monumental power.

These characteristics were a natural result of his artistic temperament. His close contact with reality was at once a source of strength and a limitation, in that he remained bound to the object, to a naturalistic conception of form, and to a comparatively limited field of subjects. While in early years he had showed an interest in many types of themes—the nude, landscape, genre, figure compositions—he later devoted himself almost entirely to portraiture. This restriction can be ascribed not only to his innate proclivities, but to the way that the world he lived in had reacted on him and his art, through the rejection or neglect of his work, the suppression of his interest in the nude, the starving of the pagan side of his nature, and the general effect of the narrowness and meagreness of his surroundings. He was strong; but no individual is strong enough to withstand the pressure of an entire environment; though he battled

stubbornly against it, in the end he was unconsciously moulded by it. If he had been a more imaginative artist, having less sense of solidarity with his community, he might have freed himself more fully from its limitations; but he was the portraitist of his time and place, drawing his sustenance from the life around him. Thus the influence of his environment, added to his own character, restricted his subject-matter, and this in turn determined the aesthetic limitations of his art.

His relation to the nude undoubtedly played a vital part. In spite of his intense interest in it, his realism and the prevailing prudery had combined to keep him from painting it more than a few times. The few works in which the nude or the semi-nude appeared, such as *William Rush*, the *Swimming Hole*, and the rowing and boxing pictures, were among his most complex, free, and moving compositions. His feeling for the design and movement of the body was closely linked to his sense of pictorial design and movement, and called forth aesthetic powers of a different order from those shown in his portraits. If he had painted the figure more often, these potentialities might have developed further. As it was, his design evolved towards a simpler and more austere type, expressing his concentration on individual character. Of their own kind many of these works were more complete in design than the earlier; but it was a different evolution from that which he might have followed in a more liberal and responsive environment, where he might have gone on to be an even greater designer of figure compositions.

With all his limitations, he was the strongest formal composer among the American painters of his generation, and one of the strongest anywhere. Others had a more pleasing gift for pattern and decoration, but few had his sculptural sense of form or his instinct for three-dimensional design. In this country only Ryder shared these qualities, having more sense of movement and rhythm and a more complete conception of the whole picture, while Eakins dealt with more powerful elements, and created forms of greater solidity, precision, and force, on a more monumental scale.

IV

In the art of his period Eakins stands out as an isolated figure, belonging to no school, having few ancestors or descendants. It would be difficult to trace any influences in his work. The nearest approach to one, his admiration for the Spanish masters, was a matter of temperamental coincidence rather than imitation. In histories of American art he has been classified as an example of French influence; but this is a superficial view. His viewpoint was opposed to much in French painting—its formalism, classicism, and remoteness from the primordial realism of the Spaniards and Dutch. In spite of his training in France, as soon as he returned to this country he had begun painting native subjects, in a style entirely his own. His admiration for the Salon painters was largely for their technical ability; in other respects his art differed fundamentally from theirs.

His affinities were closer to the independent French artists, such as Courbet, Corot, Degas, or Manet; but here again the parallels were those of coincidence rather than influence. He has been called a disciple of Courbet, but he saw little if any of the French painter's work until after his own style had been formed; later he admired him, but not more than other contemporaries. In spite of obvious affinities between them, there were deep differences. Courbet was a less pure naturalist, being at bottom a child of romanticism in revolt against his parentage.

Most of the leading tendencies of French art passed Eakins by completely; impressionism, the cult of the exotic and Oriental, the return to the primitive, the increasing subjectivism, the decorative bent, the trend towards abstraction, the restless search for new forms and colors.

The American artist of his time, in fact any American of sensitiveness and culture, was prone to regard this country as an aesthetic wilderness, and either to turn his back on it and become an expatriate, or to draw a veil of pretty sentiment over its crudities. But Eakins lived in an ordinary American community, shared deeply in its life, and extracted from it the raw material of art.

Like Whitman, he was deeply at home in his native land, although revolting against its puritanism. Few of his contemporaries accepted their environment with such a robust affirmation, or pictured it with such understanding.

His whole life and art were at the opposite extreme from the viewpoint set forth in Whistler's *Ten O'Clock*, the creed of the aesthetes of the 'nineties. The contrast between Whistler's aestheticism and Eakins' naturalism could hardly be greater: between an art exclusive, self-conscious, deliberately aiming at "beauty," and one growing directly out of the common life, its aesthetic content a largely unconscious result of the desire for truth.

Among American artists of the latter part of the nineteenth century, he emerges as one of those whose work has the most enduring qualities. Others might surpass him in certain respects: Sargent was a more brilliant and gracious portraitist, Whistler a more sophisticated stylist, La Farge a more learned aesthetician, Homer a more picturesque recorder of the epic of outdoor life; but few approached his humanity, understanding of character, penetration into the heart of truth, or formal power.

Strangely enough the two Americans of the time who seem temperamentally at opposite poles—Eakins the realist and Ryder the romanticist—are now seen to have the deepest affinities. While most of their generation were pursuing shadows, these two had in common the fact that the worlds they created, different as they were, possessed depth and substance. The dream world of Ryder was as real as the naturalistic world of Eakins. Their minds, directed in the one case outward, in the other inward, were the most profound in the American painting of the last generation.

Eakins' influence, like that of Ryder, would be difficult to trace, aside from that which he exercised directly on his students. His work had few elements to make it popular; and it called for too fundamental a knowledge to attract imitators; so that he established no such following as Sargent or Whistler. But as the years pass his art is coming more and more to seem the solid core of his period, and a substantial part of our inheritance. Time, like a river, washes away sand; it leaves the rock standing.

CATALOGUE OF WORKS

A NOTE ON THE CATALOGUE

THE *information for this catalogue has been secured from the following sources: from Mrs. Thomas Eakins, whose very full and clear memory of her husband's work has been invaluable; from his friends and pupils, particularly Samuel Murray; from two record books kept by Eakins himself in early years, listing most of his pictures of the 'seventies and early 'eighties (continued later by Mrs. Eakins); from catalogues of exhibitions and other contemporary documents; from the sitters and owners of the pictures. While it would be impossible to state definitely that the catalogue includes all his works, as there may have been some, especially in early years, which were never recorded or shown, it includes everything now known through these various sources.*

The question of authenticity has been comparatively simple, as there is ample external evidence for practically every picture, and it has not been necessary to depend merely on stylistic qualities. These qualities, however, are readily recognizable and not easily duplicated; the few "fakes" which have come to light have been obvious.

I have been able to examine a large majority of the works. Where this was not practicable, the owners have very kindly furnished me with information.

Works whose present whereabouts are unknown but which may still be in existence, have been included. Of some, particularly early ones, nothing is known except that they were listed in Eakins' records or in exhibition catalogues; in other cases the last owners are known but I was unable to trace them. Separate lists are given at the end, of pictures probably or definitely no longer in existence.

Watercolors are listed along with oils, as Eakins' handling of the two mediums was not essentially different, and he often made oil studies for his watercolors. His few drawings, all student work, are also listed with his paintings. His studies for pictures were usually in the form not of drawings but of small oil sketches. These, which form almost a fourth of the items listed, have been placed immediately after the pictures for which they are studies, without being described except when they differ essentially from the finished works. A separate list of his sculpture is given at the end.

The order is chronological. Many pictures are dated; the dates of others have been fixed by external evidence; of some the dates are only approximate.

In a few cases I have changed the titles to those given originally by the artist, especially when the later titles were inaccurate or undescriptive.

All the works shown as being owned by the Pennsylvania Museum of Art, unless otherwise stated, were part of the generous gift of Mrs. Eakins and Miss Mary Adeline Williams to the Museum in 1930.

The pictures are in oil unless otherwise stated. The size is given in inches, height first, width second. The measurements do not include the frame. In the case of watercolors which could be measured only with the mat on, the words "mat size" appear. "Right" and "left" are from the standpoint of the spectator, except when I speak of the sitter's right arm, left hand, etc. The type used in the signatures corresponds to that used by the artist: Roman small capitals representing Roman capitals in the signature; italic upper and lower case representing script, small and large letters.

Abbreviations: u.l.=upper left; u.r.=upper right; l.l.=lower left; l.r.=lower right; Penna. Museum=Pennsylvania Museum of Art, Philadelphia; Met. Mus. Mem. Exh.=Metropolitan Museum Memorial Exhibition; Penna. Acad. Mem. Exh.=Pennsylvania Academy Memorial Exhibition.

CATALOGUE OF WORKS

DRAWINGS FROM LIFE

Probably done before Eakins went abroad and at the Beaux-Arts before he began to paint. They are all in charcoal on paper about 24 x 18; none are signed by him.

The following are owned by the Penna. Museum (signed by Mrs. Eakins):

1 Nude woman, seated, wearing a mask. (Plate 1.)
2 Nude woman, back turned. (Reproduced in *The Arts*, December 1923, p. 306.)
3 Nude boy. (Reproduced in *The Arts*, December 1923, p. 314.)
4 Nude man, seated.
5 Nude woman reclining, back turned.
6 Nude woman reclining, seen from the front.
7 Head, bust and arm of a child.
8 Arm resting on the back of a chair.

The following are owned by Mrs. Eakins:

9 Nude man with a beard, seated on the floor. On the back, the middle section of a nude man.
10 Nude man standing.
11 Legs of a seated model.
12 Legs of a standing model.
13 Head and bust of an Arab with a turban.
14 Torso and arm of a nude man.
15 Nude woman reclining on a couch.
16 Nude woman reclining, wearing a mask.
17 Nude woman standing.
18 Nude man seated. On the back, a warrior's head from the antique.

19 ANTIQUE STUDY
Female head from the antique, leaning against a pile of books. Oil on heavy paper, 13½ x 10¾. Unsigned. Owned by Mrs. Eakins. This and the next eleven items (Nos. 20 to 30) were probably painted in Paris in 1867, 1868 or 1869.

20 ANTIQUE STUDY
Roman male head; almost monochrome. Canvas, 21½ x 18. Unsigned. Owned by Mrs. Eakins.

21 STUDY OF A LEG
Oil on heavy paper, 13¼ x 10¾. Unsigned. Owned by Mrs. Eakins.

22 STUDY OF A RAM'S HEAD
Canvas, 18 x 14¾. Unsigned. Owned by Mrs. Eakins.

23 STUDY OF A GIRL'S HEAD
Head and bust of a nude girl, full face, with dark brown hair tied up with a red ribbon. Dark green background. On the back, a study of a man's arm. Canvas, 18 x 15. Unsigned. Owned by Walter Pach, New York.

24 STUDY OF A GIRL'S HEAD
Head and bust of a nude girl, in profile right, her head bowed, her right hand to her face. Brown hair; dark green background. Canvas, 21½ x 18. Unsigned. Owned by Mrs. Eakins.

25 STUDY OF A GIRL'S HEAD
Head and bust of a nude girl, in profile right, her head bowed. Dark brown hair; dark green background. Reproduced in *The Arts*, December, 1923, p. 302. Canvas, 17¾ x 14½. Unsigned. Owned by the Penna. Museum.

26 THE STRONG MAN
Head and bust of a nude man, in profile left, holding a staff in his right hand. Black hair, brown beard. Dark green background. Canvas, 21½ x 17¾. Signed on back: "T. E." Owned by the Penna. Museum.

27 BUST OF A MAN
Head and bust of a nude man, in profile right, with his right arm raised. Long dark hair and beard. Gray-brown background. Canvas, rebacked, 21½ x 18¼. Signed on back: "T. E." Owned by the Penna. Museum.

28 STUDY OF A STUDENT'S HEAD
A man with long black hair, moustache and beard, wearing a smock, in profile left. Canvas mounted on cardboard, 9¼ x 9⅜. Unsigned. Owned by Mrs. Eakins.

29 STUDY OF A STUDENT'S HEAD
The same, in profile right. Canvas mounted on cardboard, 7½ x 6⅜. Unsigned. Owned by Mrs. Eakins.

30 A NEGRESS
Nude negress, seen to the waist, body half right, face almost in profile right, wearing a many-colored scarf around her hair, and coral ear-rings; greenish-gray background. Canvas, rebacked, 22¾ x 19½. Signed on back: "T. E." Owned by Mrs. Eakins.

31 SCENE IN A CATHEDRAL (STUDY)

Figures of bare-headed women in bright-colored clothes, standing or kneeling by the pillar of a cathedral. Probably suggested by a scene in the Cathedral of Seville. Unfinished. Canvas, 21¼ x 18. Unsigned. Owned by Mrs. Eakins.

32 CARMALITA REQUENA

Spanish street-dancer. Eakins wrote in a letter from Seville to his little sister, at Christmas, 1869: "Some candy given me, I ate a little and then gave the rest to a dear little girl, Carmalita, whom I am painting. . . . She is only seven years old and has to dance in the street every day. But she likes better to stand still and be painted. She looks down at a little card on the floor so as to keep her head still and in the right place, and when we give her the goodies she eats some and puts the nicest ones down on the card so she would be looking at them all the time while she poses."

Head and bust, almost in profile right, looking down. Red and black cap and dress; brown background. Reproduced in *Parnassus*, January 1931. Canvas, rebacked, 21 x 17. Unsigned. Owned by the E. C. Babcock Art Galleries, New York.

33 A STREET SCENE IN SEVILLE
(Plate 2)

Eakins' first completed picture, painted in Seville in the spring of 1870. The models are the Requena family—Augustin, Angelita, and Carmalita—"*compañia gymnastica*"; the picture was painted in the sunlight on the roof of his hotel. Canvas, rebacked, 63 x 42½. Signed on back: "EAKINS 1870". Owned by Mrs. Eakins.

34 A SPANISH WOMAN

Head and bust, almost in profile left, of a dark, rather plump middle-aged Spanish woman; black hair, dark eyes; low-necked white dress with a small rose stripe; light gray background. Also called *Dolores*. Canvas, about 22 x 18. Owned by Walter Pach, New York.

35 FRANCES EAKINS

Eakins' sister, later Mrs. William J. Crowell. Three-quarters length, playing a grand piano, in profile right. In her early twenties, she has dark brown hair and wears a white dress with low neck and long sleeves, a scarlet ribbon around her neck, and a scarlet sash. Golden brown background. Canvas, 24 x 20. Unsigned. One of the first pictures he painted after returning from abroad; probably late 1870 or early 1871. Owned by Mrs. William J. Crowell, Avondale, Pa.

36 AT THE PIANO

Frances Eakins playing the piano, her younger sister Margaret listening; the former half-length, turned right a little beyond profile; the latter leaning on the further side of the grand piano, facing the spectator, looking down at her sister. Frances has dark brown hair bound up with a red ribbon, and wears a deep red dress; Margaret has dark brown hair and wears a black dress. Golden brown background. Canvas, 22 x 18¼. Unsigned. Probably late 1870 or early 1871. Owned by Mrs. William J. Crowell, Avondale, Pa.

37 HOME SCENE
(Plate 3)

Margaret Eakins, seated at a piano, turning to look down at her younger sister Caroline, who lies on the floor drawing on a slate. Margaret has dark brown hair and wears a black dress with a gray jacket trimmed with red; with her right hand she plays with a brown kitten on her shoulder; an orange rests on the piano rack. Caroline wears a plaid dress, predominantly red. Canvas, rebacked, 21¾ x 18. Signed l. r.: "*Eakins*", and on back: "EAKINS". Probably late 1870 or 1871. Owned by Mrs. Eakins.

38 BENJAMIN EAKINS

Father of Thomas Eakins; writing master. Head, shoulders and right hand, in profile right; bending over writing, with his glasses near the end of his nose; ruddy complexion, grayed hair. A sketch. Watercolor on paper, 3½ x 3½. Unsigned. Probably about 1870. Owned by Mrs. William J. Crowell, Avondale, Pa.

39 MARGARET IN SKATING COSTUME
(Plate 4)

Portrait of Margaret Eakins. Black hair, dark brown eyes, dark skin; black hat with a red feather, red tie, buff corduroy jacket; brown background. Canvas, rebacked, 24 x 20½. Signed l. r.: "T. E. 1871"; and on back: "EAKINS". Owned by the Penna. Museum.

40 MARGARET (STUDY)

Study of Margaret Eakins. Head and bust, body half right, head full-face, leaning back against a chair cushion and looking at the spectator. Strong light on left side of face, right side in shadow. Gray dress, brown background. Canvas, 19¼ x 16. Unsigned. Probably about 1871. Owned by Francis W. Sheafer, New Milford, Conn.

41 MARGARET (SKETCH)

Sketch of Margaret Eakins. Head and bust, half right, head bent over, looking down. Gray-blue dress, dark brown background. Canvas, 18 x 15. Unsigned. Probably about 1871. Owned by Mrs. Eakins.

42 HIAWATHA

Hiawatha standing in a cornfield, silhouetted against a sunset sky containing clouds in the shapes of a bear, a buffalo, an antelope and a turkey; the cornshocks have the forms of human beings. One of Eakins' few essays in the fanciful; painted soon after he returned from abroad. Watercolor on paper, 15 x 26. Unsigned. Owned by Mrs. Eakins.

43 HIAWATHA. Oil, unfinished. Canvas, 20 x 30. Unsigned. Owned by Mrs. Eakins.

44 MAX SCHMITT IN A SINGLE SCULL (Plate 5)

Eakins' boyhood friend Max Schmitt in his shell *Josie*, on the Schuylkill River above Girard Avenue Bridge. In the middle distance is Eakins himself rowing. A still, sunny afternoon; blue sky with one or two very white clouds. Also called *On the Schuylkill above Girard Bridge*. Canvas, 32¼ x 46¼. Signed on Eakins' shell: "EAKINS 1871". Given by the artist to Max Schmitt; purchased in 1930 from his widow, Mrs. Louise S. M. Nache, by Mrs. Eakins, the present owner.

45 KATHERINE (Plate 6)

Katherine Crowell, Eakins' first fiancée. She has brown hair, wears a white dress with a cerise ribbon at the throat, holds a red fan, and is playing with a brown kitten in her lap. The chair is upholstered in red plush; the rug is prevailingly light gold, the cabinet behind a mahogany red, and the wall at the left a deep golden brown.

Canvas, 62½ x 50. Signed on the floor, l. r.: "*Thomas Eakins, 1872*". Owned by Stephen C. Clark, New York.

46 ELIZABETH CROWELL AND HER DOG

Sister of Katherine Crowell; she also appears in *Elizabeth at the Piano* (No. 87). She is here shown as a girl, seated on the floor, her schoolbooks beside her, holding up her right hand to a brown poodle with a red ribbon around his neck, who is sitting up balancing a cookie on his nose. She is a little left of center, the dog a little right. She wears a bright red blouse trimmed with bands of black velvet, a black skirt, a white fur turban; her hair hangs below her shoulders. Part of a grand piano shows at the left; against the wall at the right is a carved high-backed armchair. Canvas, 13¾ x 17. Unsigned. Painted in the early '70s. Owned by the sitter's daughter, Mrs. Ruth S. Vorce, Perris, Cal.

47 MRS. JAMES W. CROWELL

Mother of Katherine, Elizabeth, and William J. Crowell (the last-named married Eakins' sister Frances). Head and bust of a woman of about sixty, with gray hair parted in the middle, wearing a black lace cap and a black silk dress with white ruching at the throat. The light falls on the left side of the face, particularly the left ear and the nose. Dark brown background. General tone dark. Canvas, 27 x 22. Unsigned. Painted in the early '70s. Owned by the sitter's granddaughter, Mrs. Fred Cox, Point Loma, Cal.

48 "GROUSE"

A brown and white setter dog belonging to Henry Schreiber, well-known photographer of animals; sitting, facing right. Canvas, 20 x 24. Signed l. r.: "E. 1872". Owned by Miss Anne C. Schreiber, Aldan, Delaware County, Pa.

49 THE PAIR-OARED SHELL (Plate 7)

The professional oarsmen Barney and John Biglen on the Schuylkill River under the old Columbia Bridge. They wear blue scarves around their heads, white shirts edged with blue, and blue trunks. General tone brownish. Also called *The Biglen Brothers Practising, The Biglens under the Bridge*, and *The Oarsmen*. Canvas, rebacked, 24 x 36. Signed on stone pier

at right: "EAKINS 1872". Owned by the Penna. Museum.

50 PERSPECTIVE DRAWING. Pencil and ink on paper mounted on cardboard, 32 x 48. Owned by Mrs. Eakins.

51 PERSPECTIVE DRAWING. Figures, shell and reflections blocked in in watercolor. Paper mounted on cardboard, 32 x 48. Owned by Mrs. Eakins.

52 THE BIGLEN BROTHERS TURNING THE STAKE
(Plate 8)

The professional oarsmen Barney and John Biglen racing on the Schuylkill River. They have just turned the stake with a blue flag in the foreground, while their competitors in the middle distance are about to turn the red flag at the left. The Biglens wear blue scarves around their heads, white shirts edged with blue, black trunks; their competitors wear red scarves, white shirts, red trunks. In the stakeboat at the left sits Eakins himself, his arm upraised. A sunny day, with clear blue sky and calm blue water. Canvas, 40 x 60. Signed on side of shell, at left: "EAKINS 73", and on back: "EAKINS". In the Hinman B. Hurlbut Collection, Cleveland Museum of Art.

53 PERSPECTIVE DRAWING. Pencil and ink on paper mounted on cardboard, 32 x 48. Owned by Mrs. Eakins.

54 THE PAIR-OARED RACE—JOHN AND BARNEY BIGLEN TURNING THE STAKE

Watercolor, present whereabouts unknown, exhibited at the 7th Annual Exhibition of the American Society of Painters in Water Colors, New York, spring 1874. Priced at $200., more than the average in the exhibition, hence probably large and detailed. Probably a watercolor version of the preceding. Not given in Eakins' records.

55 A ROWER

Watercolor, present whereabouts unknown, given to Gérôme, who acknowledged it May 10, 1873, in a letter reading in part as follows: "*J'ai reçu l'aquarelle que vous m'avez envoyé, je l'accepte avec plaisir et vous en remercie. . . . Je passe à la critique. . . . Le personnage qui est bien dessiné quant aux morceaux manque*

de mouvement dans l'ensemble, il est immobile et comme fixé sur l'eau; son attitude n'est pas je crois portée assez en avant, c'est-à-dire à la limite extrême du mouvement dans ce sens-là. Il y a dans tout geste prolongé, comme l'action de ramer, une infinité de phases rapides, une infinité de points depuis le moment où le rameur, après s'être porté en avant, se ramene le haut du corps en arrière. Deux moments sont à choisir pour nous autres peintres, les deux phases extrêmes de l'action, soit quand il est porté en avant, les rames étant en arrière, soit quand il est penché en arrière, les rames en avant; vous avez pris un point intermédiaire, de là l'immobilité. La qualité générale du ton est très bonne, le ciel est ferme et léger, les fonds bien à leur plan, et l'eau est exécutée d'une façon charmante, très juste, que je ne saurais trop louer. Ce qui me plaît surtout, et cela en prévision de l'avenir, c'est la construction et l'établissement joints à l'honnêteté qui a présidé à ce travail. . . ."

From this description it is evident that the rower was represented in the middle of the stroke; perhaps in an attitude similar to that of John Biglen (the rear rower) in *The Biglen Brothers Turning the Stake.*

56 JOHN BIGLEN *or* THE SCULLER

Watercolor, present whereabouts unknown, exhibited at the 7th Annual Exhibition of the American Society of Painters in Water Colors, New York, spring 1874; "No. 8. The Sculler". The marked copy of the catalogue notes that it was sold to C. T. Barney for $80. Evidently the same picture as that given in Eakins' records as: "John Biglen (Single Scull). Watercolor. Exhibited at New York in the Watercolor Exhibition. Sold, $80." Probably it was a replica of the preceding, just as the following seems to have been a replica of another watercolor presented to Gérôme.

57 JOHN BIGLEN IN A SINGLE SCULL

Duplicate of a watercolor presented by Eakins to Gérôme; probably of a second one, as the description in Gérôme's letter acknowledging the first does not fit this. The rower, wearing a red scarf around his head, white shirt trimmed with red, and black trunks, is rowing toward the right, almost in profile; he is bending forward,

the oars almost at the end of the backward stroke (evidently Eakins had changed the attitude in accordance with Gérôme's criticism). The bow of another shell appears at the left. Shore and boats in the distance; blue sky, blue water. Reproduced in the Met. Mus. Mem. Exh. catalogue. Watercolor on paper, 16¾ x 23 (mat size). Unsigned. Probably 1873 or early 1874. Owned by the Metropolitan Museum of Art, New York.

58 PERSPECTIVE DRAWING. Reproduced in *The Arts*, October, 1931, p. 33. Pencil and ink on paper mounted on cardboard, 32 x 48. Owned by Mrs. Eakins.

59 JOHN BIGLEN IN A SINGLE SCULL
Study in oil for the watercolor. Reproduced in *The Arts*, May, 1930. Canvas, 24 x 16. Signed on back: "*Eakins 1874*". In the Whitney Collection of Sporting Art, presented in 1932 by Francis P. Garvan to Yale University, New Haven, Conn.

60 JOHN BIGLEN IN A SINGLE SCULL
The second watercolor presented to Gérôme, who acknowledged it September 18, 1874, excusing himself for his delay, and saying: "*Votre aquarelle est entièrement bien.*" Present whereabouts unknown.

61 THE BIGLEN BROTHERS RACING
John and Barney Biglen, wearing blue scarves around their heads, white shirts trimmed with blue, and black trunks, rowing towards the right, almost in profile; they are bending forward, their oars almost at the end of the backward stroke; John (the rear rower) is in the same attitude as in the watercolor *John Biglen in a Single Scull*; Barney is looking down to his left, as he does in *The Biglen Brothers Turning the Stake*. The bow of another shell appears in the foreground. In the distance, steamboats are following the race, and the banks are crowded with spectators. Reproduced in *The Art News*, December 20th, 1930, p. 68. Also called *The Biglen Brothers Ready to Start the Race*. Canvas, rebacked, 24 x 36. Unsigned. Probably 1873. Owned by Mrs. Eakins.

62 PERSPECTIVE DRAWING. Pencil and ink on paper mounted on cardboard, 32 x 48. Owned by Mrs. Eakins.

63 OARSMEN ON THE SCHUYLKILL
The champion Pennsylvania Barge Club Four on the Schuylkill River. They are rowing diagonally away from the spectator toward the left. Late afternoon sunlight; blue sky with a few clouds, calm water; shore in the distance. Canvas, 27 x 47½. Signed on the side of the shell: "EAKINS". About 1873. Discovered in 1929 in a boat club on the Schuylkill; now owned by the Brooklyn Museum. Reproduced in the Museum *Quarterly*, October, 1932.

64 OARSMAN IN A SINGLE SCULL (SKETCH). Evidently a study for the preceding, similar except for the number of rowers. Canvas, 10 x 14⅜. Unsigned. Owned by the Penna. Museum.

65 OARSMEN (STUDY)
A sketch of two rowers in a pair-oared shell, with red scarves around their heads, white shirts and blue trunks, rowing under a bridge, toward the right and diagonally away from the spectator; on the stone bridge-pier behind a man sits fishing. Canvas, 14 x 18. Unsigned. Probably about 1874. Owned by Mrs. Blanche Hersey Hogue, Portland, Ore.

66 THE SCHREIBER BROTHERS
Henry Schreiber, the well-known photographer of animals, and one of his brothers, rowing a pair-oared shell under a bridge, toward the left, diagonally away from the spectator. They wear red scarves around their heads, white shirts and blue trunks. Behind them, a rowboat with people fishing, the stone bridge-pier, and in the distance to the left, the shore with trees. Composition somewhat similar to that of *A Pair-Oared Shell* (No. 49). Reproduced in *The Arts*, October, 1929, p. 72. Canvas, rebacked, 15 x 22. Signed right center: "EAKINS 1874". Owned by John Hay Whitney, New York.

67 PERSPECTIVE DRAWING. Pencil and ink on paper mounted on cardboard, 32 x 48. Owned by Mrs. Eakins.

68 THE ARTIST AND HIS FATHER HUNTING REED-BIRDS
(Plate 9)
Benjamin Eakins wears a dark shirt, khaki trousers, brown hat and high boots; Thomas wears a red hat, dark shirt and dark brown trousers. The marshes are rusty red, the sky

yellowish. Canvas, rebacked, 18 x 27. Signed on bow of boat: "BENJAMINI EAKINS FILIUS PINXIT", and on back: "EAKINS". About 1874. Owned by Mrs. Eakins.

69 PERSPECTIVE DRAWING. Pencil and ink on paper mounted on cardboard, 32 x 48. Owned by Mrs. Eakins.

70 PUSHING FOR RAIL
Three hunters standing in skiffs being punted by their "pushers" through the reeds of a marsh, waiting for the rail-birds to rise. Canvas, 13 x 30. Signed l. r.: "EAKINS 74". Exhibited at the Paris Salon in 1875, under the title of *Une chasse aux Etats-Unis*. Purchased from Eakins in 1916 by the Metropolitan Museum of Art, New York, the present owner. (See also No. 151.)

71 WHISTLING FOR PLOVER
A negro with a shotgun, crouching in a flat marshy meadow, whistling to decoy plover; around him lie dead birds; in the middle distance, another hunter is lying; in the far distance, sails of ships on a river. Reproduced in *The Brooklyn Museum Quarterly*, April, 1927, p. 40. Watercolor on paper, 16½ x 11. Signed l. r.: "EAKINS 74". Eakins presented it to Dr. S. Weir Mitchell in the '70s; the latter's son Langdon Mitchell sold it about 1910 to a Philadelphia book-dealer; later it turned up in a second-hand store. Now owned by the Brooklyn Museum.

72 WHISTLING FOR PLOVER
An oil painting, present whereabouts unknown, sold through Goupil in Paris, probably in 1874 (information from Eakins' records). Possibly one of two paintings shown at the Salon in 1875, both under the title of *Une chasse aux Etats-Unis* (the other being *Pushing for Rail*). Possibly similar to the preceding, as Eakins in his early years several times made both oil and watercolor versions of the same subject.

73 HUNTING (SKETCH)
A hunter with a gun, crouching, facing the spectator, slightly left of center; a white setter dog, tail in air, behind and to the right. Canvas mounted on cardboard, 9 x 11¾. Unsigned. Probably about 1874. Owned by Mrs. Eakins.

74 STUDIES OF GAME-BIRDS
Plover, standing and flying. Canvas mounted

on cardboard, 9⅝ x 13¾. Unsigned. Owned by Mrs. Eakins.

75 LANDSCAPE WITH A DOG
A green field, with trees in the distance. A white setter with red spots, in the right foreground. Unfinished. Canvas, 18 x 32. Unsigned. Date unknown. Owned by Mrs. Eakins.

76 SAILBOATS (HIKERS) RACING ON THE DELAWARE
(Plate 10)
The men wear bright red or dark blue shirts. Sunny day, blue sky with a few faint clouds, brownish water. Canvas, rebacked, 24 x 36. Signed on side of boat at right: "EAKINS 74", and on back: "T. E." Exhibited at Goupil's in Paris, probably in 1874. Owned by the Penna. Museum.

77 SAILING
(Plate 11)
Gray-blue sky, brownish water with lead-colored reflections. Painted almost entirely with a palette-knife. Canvas, 32 x 46⅜. Inscribed l. r.: "*To his friend William M. Chase. Eakins*". Painted about 1874. Given to Chase about 1900; bought at the Chase sale in 1917 by Alexander Simpson, Jr., and given by him to the Penna. Museum.

78 STARTING OUT AFTER RAIL
A small sailboat with two men, almost identical with the preceding; but this picture is upright, other boats appear in the distance, the sky is clear blue, the color throughout more brilliant, and the handling more finished and detailed. Canvas, 24 x 20. Unsigned. Exhibited at Goupil's in Paris about 1874. Purchased from Eakins in 1915 by Miss Janet Wheeler, Phila., the present owner.

79 STARTING OUT AFTER RAIL
Watercolor, present whereabouts unknown, exhibited at the 7th Annual Exhibition of the American Society of Painters in Water Colors, New York, spring 1874, under the title of *Harry Young, of Moyamensing, and Sam Helhower, "The Pusher", going Rail Shooting.* Priced at $200., more than the average in the exhibition, hence probably large and detailed. Eakins' records list a watercolor, *Starting out*

after Rail, which seems to be this one; it was exhibited at the 52nd Annual Exhibition of the Pennsylvania Academy in 1881 as owned by J. C. Wignall, a boat-builder and friend of Eakins. I have been unable to trace him or his family. The picture was probably similar to the two preceding.

80 SHIPS AND SAILBOATS ON THE DELAWARE

A two-masted schooner and a three-masted square-rigger, anchored in the Delaware, surrounded by small sail- and row-boats. Calm day. General blue-gray tone. Formerly called *Becalmed*. Canvas, rebacked, 10 x 17. Signed l. r.: "T. E." and on back: "T. E. 1874". Owned by Mrs. Eakins.

81 STUDY. Canvas mounted on cardboard, 7 x 10¾. Unsigned. Owned by Mrs. Eakins.

82 SHIPS AND SAILBOATS ON THE DELAWARE

Similar to the preceding, except that the two ships are at the left instead of the center, and the general tone is warmer. Formerly called *Becalmed on the Delaware*. Canvas, 10⅛ x 17¼. Signed l. r.: "EAKINS 74", and on back: "T. E." Owned by the Penna. Museum.

83 DRIFTING

Watercolor, present whereabouts unknown, painted about 1874; also called *No Wind—Race-boats Drifting* and *Waiting for a Breeze*. Exhibited at the American Society of Painters in Water Colors, February, 1875; and elsewhere. Eakins' records state that it was contributed in February, 1880, to the sale for the benefit of the family of Christian Schussele, painter and professor at the Pennsylvania Academy; the purchaser is not recorded.

84 MRS. BENJAMIN EAKINS

Mother of Thomas Eakins. Painted from an old photograph after her death. Head and bust, half left; dark brown hair, parted in the middle and drawn down smoothly to a knot behind; dark brown eyes, dark skin, wide, thick-lipped mouth. Narrow band of white collar around the throat, plain black dress. Style of hair and dress of about the '60s. Dark red-brown background. Bottom part of canvas unpainted. Canvas, 24 x 20. Unsigned. About 1874. Owned by Mrs. Eakins.

85 PROF. BENJAMIN HOWARD RAND

1827–1883. Chemist; professor of chemistry at Franklin Institute and Central High School and later at Jefferson Medical College; dean of the College for four years; secretary of the Academy of Natural Sciences of Philadelphia for twelve years; author of several textbooks. Eakins probably studied under him at Central High School. This seems to have been the artist's first portrait of anyone outside of his family and friends, and his first portrait of a scientist. He asked Prof. Rand, then at Jefferson, to pose for it. Full-length, seated facing the spectator at a desk covered with papers and scientific instruments, stroking his cat who stands on the desk. Reproduced in the Met. Mus. Mem. Exh. catalogue. Canvas, 60 x 48. Signed l. l.: "EAKINS 74". Owned by Jefferson Medical College, Phila.

86 BASEBALL PLAYERS PRACTISING

A batter, facing left; behind him a catcher, crouching, hands on knees; in the background, bleachers with a few spectators. Watercolor on paper, 9⅜ x 10½ (mat size). Signed on wall near batter's hand: "EAKINS 75". After disappearing for years, it turned up in 1929 in an antique shop in Maine. Owned by Mrs. Herbert E. Thompson, Boston.

87 ELIZABETH AT THE PIANO

Portrait of Elizabeth King Crowell (see No. 46). Full-length, seated at a grand piano, in profile right. Reproduced in the Met. Mus. Mem. Exh. catalogue. Canvas, 72 x 48. Signed l. r.: "*Eakins 75*". Owned by the Addison Gallery of American Art, Phillips Academy, Andover, Mass.

88 THE GROSS CLINIC

(Plates 12 and 13)

Portrait of Dr. Samuel David Gross in his clinic at Jefferson Medical College. Dr. Gross (1805–1884) was one of the greatest surgeons, teachers and writers on surgery that this country has produced; a pioneer in his profession in America, author of the monumental *System of Surgery*, translated into many foreign languages; for many years professor of surgery at Jefferson Medical College.

He is shown during an operation on a young man from whose thigh a piece of dead bone is

being removed. He has paused in the operation, and, scalpel in hand, stands talking to his pupils. Dr. James M. Barton, on the other side of the operating table, is probing in the incision, which is being held open with a tenaculum by Dr. Daniel Apple, seated at his left; Dr. Charles S. Briggs, seated directly in front of Dr. Gross, is holding the patient's legs; the anæsthetist is Dr. W. Joseph Hearn, later professor of clinical surgery at the College. The patient's mother, seated behind Dr. Gross, is hiding her eyes. Behind, the clinic clerk, Dr. Franklin West, is taking down the great surgeon's remarks. The latter's son, Dr. Samuel W. Gross, who later occupied his father's chair of surgery, is leaning against the wall of the entrance to the amphitheatre; and behind him appears "Hughie", the janitor, in his shirt-sleeves.

Canvas, 96 x 78. Signed on the operating table, l. r.: "EAKINS 1875". Submitted to the art jury of the Centennial Exhibition of 1876, but rejected; finally hung in the Medical Department. Exhibited at the Society of American Artists, 1879; Pennsylvania Academy, 1879; World's Fair, Chicago, 1893; Pan-American Exposition, Buffalo, 1901; Louisiana Purchase Exposition, St. Louis, 1904 (Gold Medal). Purchased from Eakins in 1878 for $200. by the Jefferson Medical College, Phila., the present owner.

89 SKETCH. Canvas, 24 x 20. Signed l.r.: "T. E. 75", and on back "T. E." Owned by the Penna. Museum.

90 DR. GROSS (STUDY). Head and bust; same position as in the large picture. Painted almost entirely with a palette-knife. Reproduced in the *Bulletin of the Worcester Art Museum*, January 1930. Canvas, 24 x 18. Signed on back: "EAKINS". Owned by the Worcester Art Museum.

91 BLACK AND WHITE VERSION. Eakins, wishing to have photogravure reproductions of the *Gross Clinic* made by Braun in 1876, made this black-and-white copy to be sent abroad. He later exhibited the reproductions. India ink on cardboard, 23⅝ x 19⅛. Signed on the operating table, l. r.: "EAKINS 1875". Reproduced in the catalogue of the Homer-Ryder-Eakins Exhibition at the Museum of Modern Art, New York, 1930. Owned by the Metropolitan Museum of Art, New York.

92 DRAWING OF TWO HEADS. The heads of Dr. Gross and Dr. Barton, drawn separately in India ink on paper, with pen and brush. Evidently a study for the preceding. 11¾ x 14¾. Squared off. Inscribed l. l. by Mrs. Eakins: "*Drawing in India Ink by Thomas Eakins 1876*". Owned by the Penna. Museum.

93 ROBERT C. V. MEYERS (STUDY)
1848–1917. Writer and poet, author of short stories, one-act farces, novels, popular biography, and poems, of which the best known is *If I Should Die Tonight*. He is one of the audience in the *Gross Clinic*, the second from the right in the last row. This study is in the same position: almost half-length, seated, full-face, looking down, his chin resting in his left hand, his right arm on his knee. Light from the left; most of the face in shadow. Reproduced in the *Pennsylvania Magazine of History and Biography*, April 1931. Oil on brown paper, 9x8½. Squared off for enlarging. Unsigned. On the back of the frame is a label in Meyers' handwriting: "Study of R. C. V. Meyers, for picture for Centennial Exhibition, painted by Thomas R. Eakins and presented by him to R. C. V. M. Dec. 25, 1875. Sitting of Oct. 10, 1875". From the sitter it passed to his literary executor Joseph F. A. Jackson, from whom it was purchased in 1930 by Seymour Adelman, Chester, Pa., the present owner.

94 THE ZITHER PLAYER
(Plate 14)
Two of Eakins' boyhood friends, Max Schmitt and William Sartain the painter (1843–1924); the former playing the zither, the latter listening. Watercolor on paper, 10¾ x 8 (mat size). Signed l. r.: "*Eakins 76*". Owned by Miss Mary Adeline Williams, Phila.

95 HARRY LEWIS
Boyhood friend of Eakins. Head and bust, full-face, looking at the spectator; dark brown hair, moustache and goatee, ruddy complexion; dark suit; dark background. Reproduced in the Met. Mus. Mem. Exh. catalogue. Canvas, rebacked, 24 x 20. Signed l. r.: "EAKINS 76". Owned by the Penna. Museum.

96 THE CHESS PLAYERS
(Plate 15)

Two old friends of Benjamin Eakins, M. Gardel, teacher of French (to the left), and George W. Holmes, painter and teacher (to the right), playing a game of chess, while Benjamin stands watching. All are gray-haired and wear black suits. The Oriental carpet is reddish, the chairs are upholstered in green. Wood, 11¾ x 16¾. Inscribed on the drawer of the table, in small, exquisitely accurate letters: "BENJAMINI. EAKINS. FILIUS. PINXIT. 76". Eakins first loaned it, and in 1881 presented it, to the Metropolitan Museum of Art, New York.

97 PERSPECTIVE DRAWING. Pencil and ink on paper. Owned by Mrs. Eakins.

98 M. GARDEL (SKETCH). Head and shoulders, his right hand up to his chin. Oil on paper mounted on cardboard, 12 x 10. Signed l. r.: "T. E." Owned by the Penna. Museum.

99 BABY AT PLAY

Ella Crowell, child of Eakins' sister Frances (Mrs. William J. Crowell) playing in the sunlight in the back yard of the Eakins Mount Vernon Street house. She is about two years old. Full-length, seated on the red brick pavement, her head toward the left, leaning on her right arm and with the other hand playing with lettered blocks. Light brown hair; white embroidered dress, red and white striped stockings, black shoes. A toy white horse with a bright red wagon stands at the left; at the right a doll lies on its face near a flower-pot; heavy green shrubbery in the background. Canvas, 32¼ x 48. Signed on the brick pavement, l. r.: "Eakins 76". Owned by Mrs. William J. Crowell, Avondale, Pa.

100 STUDIES OF A BABY. For the preceding. On both sides of the panel. Oil on cardboard, 13¾ x 10¾. Unsigned. Owned by Mrs. Eakins.

101 DR. JOHN H. BRINTON
(Plate 16)

1832–1907. Well-known surgeon; Major of Volunteers in the Civil War, and medical director of Grant's army; gathered the nucleus of the Army Medical Museum, and edited the *Medical and Surgical History of the War of the Rebellion*; taught for many years at the Jefferson Medical College, where he succeeded to the chair of Dr. Gross. Eakins asked him to sit for this portrait. He has dark brown hair and beard and wears a dark suit; his chair is upholstered in red; the Oriental rug is red and dark blue; the background brown. Canvas, about 81 x 60. Signed l. r.: "Eakins 76". Owned by the sitter's son, Dr. Ward Brinton, Phila.

102 MRS. SAMUEL HALL WILLIAMS

Friend of Eakins' mother. Eakins painted this after her death, from a photograph, to give to her daughter, Miss Mary Adeline Williams. Head and bust, full-face; dark brown hair parted in the middle, white collar, with a scarlet bow, simple dark dress, dark background. Wood, 9 x 6. Unsigned. About 1876. Owned by Miss Mary Adeline Williams, Phila.

103 COLUMBUS IN PRISON (STUDY)

Study for a composition never carried out. Columbus, with white hair and beard, is seated on a bench, turned half left, legs crossed, leaning his head on his left hand, and studying a sphere which he holds on the bench with his right hand. Canvas mounted on cardboard, 5⅝ x 7⅜. Unsigned. About 1876. Owned by Mrs. Eakins.

104 WILL SCHUSTER AND BLACKMAN GOING SHOOTING

Two men in a hunting skiff in a marsh. The skiff is headed toward the left and away from the spectator; amidships stands a hunter with a beard, aiming a shotgun toward the left; in the stern stands a negro with a punting-pole. High reeds behind, with a few trees in the distance. Canvas, not large, wider than high. Signed on a post at the right: "EAKINS 76". Present whereabouts unknown. It was contributed in the late '70s to the sale for the benefit of the painter George W. Holmes, and bought by George D. McCreary, prominent Philadelphian (1846–1915); but Mrs. McCreary does not know its present whereabouts. The above description was made from a photograph of the painting owned by Mrs. Eakins, and from a reproduction in *Scribner's Magazine*, July 1881 (see No. 150). Also known as *Rail Shooting*.

105 RAIL SHOOTING

Oil similar to the preceding, but upright, about 20 x 16. Loaned by Eakins about 1892

to the sculptor, William R. O'Donovan (see No. 477). Present whereabouts unknown. Samuel Murray describes it: "Painted in higher key than usual with bright blue sky and shifting feathery clouds indicative of strong wind. The reeds were semi-dry and a light Naples yellow in color. The figures were larger than in most of his gunning pictures; I would say about nine inches in height."

106 IN GRANDMOTHER'S TIME

An elderly woman spinning; full-length, seated, half right, at a spinning-wheel, wearing a white lace cap and gray old-fashioned dress. A child's toy horse and cart at the left; a red apple on the floor at the right (now faded so as to be almost indistinguishable). Rag carpet; dark background. Canvas, 16 x 12. Signed on side of spinning-wheel: "EAKINS 76". Purchased from Eakins in 1879 for $100 by President Seelye of Smith College for the Smith College Museum of Art, Northampton, Mass., the present owner.

107 ARCHBISHOP JAMES FREDERICK WOOD

1813–1883. First Archbishop of Philadelphia. Born a Protestant but converted to Catholicism; as bishop coadjutor of Philadelphia, he restored the finances of the diocese, completed the Cathedral, laid the foundations of St. Charles Seminary at Overbrook, and built up the diocese to a point where it was changed into an archdiocese in 1875, with himself as Archbishop. Eakins knew him and asked him to sit for this portrait, in the latter part of 1876. Full length, seated in a high-backed chair, half right. White hair, round, clean-shaven, kindly face; violet robes, edged with red, red buttons, lace apron. Bright green carpet on floor; dark brown background. Canvas, 82 x 60. Signed l. r.: *Eakins 77*". In bad condition, much darkened, when the writer examined it. Owned by St. Charles Seminary, Overbrook, Pa.

108 STUDY. Quite finished. Canvas, rebacked, 16⅛ x 12½. Signed u. r.: "EAKINS 1876", and on back: "T. E. 1876". Owned by Mrs. Eakins.

109 WILLIAM RUSH CARVING HIS ALLEGORICAL FIGURE OF THE SCHUYLKILL RIVER
(Plate 17)

William Rush (1756–1833) was the first native-born American sculptor. The story of his carving the allegorical figure is told in a statement in which Eakins wrote: "William Rush was a celebrated Sculptor and Ship Carver of Philadelphia. His works were finished in wood, and consisted of figure-heads and scrolls for vessels, ornamented statues and tobacco signs called Pompeys. When, after the Revolution, American ships began to go to London, crowds visited the wharves there to see the works of this Sculptor.

"When Philadelphia established its waterworks to supply Schuylkill water to the inhabitants, William Rush, then a member of the Water Committee of Councils, was asked to carve a suitable statue to commemorate the inauguration of the system. He made a female figure of wood to adorn Centre Square at Broad Street and Market, the site of the water-works, the Schuylkill water coming to that place through wooden logs. The figure was afterwards removed to the forebay at Fairmount where it still stands. Some years ago a bronze copy was made and placed in old Fairmount near the Callowhill Street bridge. This copy enables the present generation to see the elegance and beauty of the statue, for the wooden original has been painted and sanded each year to preserve it. The bronze founders burned and removed the accumulation of paint before moulding. This done, and the bronze successfully poured, the original was again painted and restored to the forebay.

"Rush chose for his model the daughter of his friend and colleague in the water committee, Mr. James Vanuxem, an esteemed merchant.

"The statue is an allegorical representation of the Schuylkill River. The woman holds aloft a bittern, a bird loving and much frequenting the quiet dark wooded river of those days. A withe of willow encircles her head, and willow binds her waist, and the wavelets of the wind-sheltered stream are shown in the delicate thin drapery, much after the manner of the French artists of that day whose influence was powerful

in America. The idle and unobserving have called this statue Leda and the Swan, and it is now generally so miscalled.

"The shop of William Rush was on Front Street just below Callowhill, and I found several very old people who still remembered it and described it. The scrolls and drawings on the wall are from sketches in an original sketch book of William Rush preserved by an apprentice and left to another ship carver.

"The figure of Washington seen in the background is in Independence Hall. Rush was a personal friend of Washington and served in the Revolution. Another figure of Rush's in the background now adorns the wheel house at Fairmount. It also is allegorical. A female figure seated on a piece of machinery turns with her hand a water wheel, and a pipe behind her pours water into a Greek vase."

Canvas, rebacked, 20⅛ x 26⅛. Signed l. r.: "EAKINS 77", and on back: "T. E." Owned by the Penna. Museum. For the wax models, see No. 498. Eakins painted three more versions of this theme in 1908 (Nos. 445, 451, and 453).

10 STUDY. An early study for the composition. The chaperon is seated at the model's left. Painted over a landscape, on cardboard, 10 x 13½. Inscribed on back, by Mrs. Eakins: "Composition for Rush carving allegorical figure. Thomas Eakins". Owned by Clarence W. Cranmer, Phila.

11 STUDY. A study of the whole composition, evidently from life. The model is heavier than in the finished picture; the statue is turned in the same direction as the model; the chaperon is at the model's right but has her back turned; both she and Rush are in modern dress; and the chair with the model's clothes is missing. A more accidental, less unified composition than the final version. Only the model's figure is carried very far. Canvas, 20 x 24. Signed l. r.: "T. E. 76", and on back: "EAKINS 76". Owned by the Penna. Museum.

12 INTERIOR OF RUSH'S SHOP (SKETCH). Canvas mounted on cardboard, 8⅝ x 13. Unsigned. Owned by Mrs. Eakins.

13 THE MODEL (STUDY). Back turned more towards the spectator; holding a large book on her shoulder. Canvas mounted on cardboard, 14¼ x 11¼. Unsigned. Owned by Mrs. Eakins.

114 SEVENTY YEARS AGO

A middle-aged woman, full-length, seated, half left, knitting, wearing a lace cap and a gray old-fashioned dress. Behind, a spinning-wheel at the left and part of a round tip-table at the right. The same model as the chaperon in *William Rush* and in a similar position, but seen from a different angle. Watercolor on paper, 12 x 9 (mat size). Signed u. r.: "EAKINS 77". Purchased from Eakins in 1878 for $135 by R. D. Worsham; turned up about 1928 at an auction at Silo's, New York, and was bought by Prof. Frank Jewett Mather, Jr., Princeton, N. J., the present owner. Eakins made a basrelief similar to this (No. 505).

115 SKETCH. The sketch on the back is not by Eakins. Oil on canvas mounted on cardboard, 12½ x 9¼. Unsigned. Owned by Charles Bregler, Phila.

116 YOUNG GIRL MEDITATING

A girl of about eighteen, full-length, standing, half left, hands clasped in front, looking down at some geraniums in pots; behind her a round tip-table turned up. She wears an old-fashioned high-waisted olive-green dress. Dark brown background. Eakins also called it *Fifty Years Ago, A Young Lady admiring a Plant*, or *Reminiscence*. Awarded a silver medal at the Massachusetts Charitable Mechanics' Association exhibition, Boston, 1878. Watercolor on paper, 8¾ x 5½ (mat size). Signed on wooden stool, l. r.: "EAKINS 77". Owned by the Metropolitan Museum of Art, New York.

117 SKETCH. Oil on canvas, 12¾ x 7½. Unsigned. Squared off for enlarging. Owned by Mrs. Eakins.

118 IN WASHINGTON

Sketch of the view from the White House window, painted when Eakins was working on his portrait of President Hayes (No. 475). Wood, 10½ x 14½. Signed l. r.: "T. E." Owned by the Penna. Museum.

119 THE COURTSHIP
(Plate 18)

The model for the girl was Miss Nannie Williams, who posed for *William Rush*. She has light brown hair and wears a white old-fashioned dress; the young man wears a dark blue coat, cream-white trousers, high black boots

with tan tops, and holds a black cap. Dark gray background. The figure of the man and the background are not quite finished. Canvas, 20 x 24. Unsigned. About 1878. Purchased from Eakins soon after it was painted, by Dr. Horatio C. Wood, and now owned by his son James L. Wood, Phila.

120 SKETCH. The whole composition. Canvas, rebacked, 14¼ x 17. Unsigned. Owned by Mrs. Eakins.

121 THE SPINNER (SKETCH). Reproduced in the Met. Mus. Mem. Exh. catalogue (No. 22). Canvas, 30 x 25. Signed on back: "T. E." Owned by the Worcester Art Museum.

122 THE SPINNER (SKETCHES). Two studies, one in a white dress, the other nude. On the back, a sketch for a portrait of a man. Wood, 14½ x 10½. Unsigned. Owned by Mrs. Eakins.

123 THE YOUNG MAN (SKETCH). Canvas, about 30 x 18. Unsigned. Given by Eakins to Miss Elizabeth R. Coffin (No. 343), and now in the possession of her niece Mrs. Helen Coffin Buchanan, Scarsdale, N. Y.

124 NEGRO BOY DANCING
 A negro boy, at the right, dancing; at the left a young negro seated in a chair playing a banjo; behind, an old negro standing watching the boy. Reproduced in the Met. Mus. Mem. Exh. catalogue. Exhibited originally under the title of *The Negroes*. Awarded a silver medal at the Massachusetts Charitable Mechanics' Association exhibition, Boston, 1878. Watercolor on paper, 18⅛ x 22⅝. Signed on bench at right: "EAKINS 78". Owned by the Metropolitan Museum of Art, New York.

125 STUDY. The figure of the young negro playing the banjo. Oil on canvas mounted on cardboard, 19⅝ x 15. Squared off. Unsigned. Owned by Charles Eddy, Westfield, N. J.

126 MRS. JOHN H. BRINTON
 (Plate 19)
 Née Sarah Ward; wife of the surgeon (No. 101). She has dark brown hair and wears a black silk dress with a white bow at the throat and white lace cuffs; the fan with which she is playing is red; the high-backed carved chair is upholstered in dark red plush; the background is dark brown. Canvas, 24¼ x 20⅛. Signed l. r.:

"EAKINS 78". Owned by the sitter's son, Dr. Ward Brinton, Phila.

127 "THE SPELLING BEE AT ANGEL'S"
128 Two illustrations for *The Spelling Bee at Angel's*, poem by Bret Harte, published in *Scribner's Magazine*, November 1878. One represents a group of miners sitting in a country store, listening to a man standing talking; the other represents a man in torn clothes shooting through an open door, with a body lying across the threshold. Present ownership of either unknown.

129 "MR. NEELUS PEELER'S CONDITIONS"
 Illustration for *Mr. Neelus Peeler's Conditions*, short story by Richard M. Johnston, published in *Scribner's Magazine*, June 1879. A woman, poorly dressed, with bare feet, seated at the left sewing; at the right her husband seated at a table, leaning forward and talking to her; a child lying on the floor. Black ink and chinese white on paper, 10⅜ x 11½ (mat size). Unsigned. Turned up in a second-hand store recently; now owned by the Brooklyn Museum.

130 SKETCH. Study of the man, in color. Squared off. On the back, a study of a negro boy on a bay horse. Wood, 14½ x 10½. Unsigned. Owned by Mrs. Eakins.

131 A QUIET MOMENT
 Watercolor (present whereabouts unknown) of an elderly woman sewing; the model was Mrs. King, who posed for Nos. 106, 114, 505, and for the chaperon in *William Rush*. Listed in Eakins' records as painted in early 1879 and exhibited frequently, the last recorded occasion at the Providence Art Club, December 5–19, 1883. The oil sketch below is probably a study for it.

132 SEWING (SKETCH). An elderly woman sewing, full-length, seated, half left, in a high-backed chair. Gray hair, black dress of about 1880, white collar, glasses; dark background. The model was Mrs. King. On the back, a sketch of an interior. Wood, 14⅜ x 10⅜. Unsigned. Owned by Mrs. Eakins.

133 THE FAIRMAN ROGERS FOUR-IN-HAND
 (Plate 20)
 Fairman Rogers (1833–1900) was a civil

engineer, an enthusiastic sportsman and horse-man, and one of the first in Philadelphia to drive a four-in-hand; also a director of the Pennsylvania Academy, chairman of its com-mittee on instruction, and an intimate friend of Eakins. In 1879 he commissioned the latter to paint his four-in-hand coach being driven in Fairmount Park, paying him the highest price he had received up to that time, $500. Eakins made careful studies for the picture, visiting Rogers' summer estate at Newport, painting several sketches of each horse and of the land-scape background, and modelling wax figures of the horses (see No. 503).

On the box seat are Fairman Rogers, in top hat, black coat and gray trousers, and Mrs. Rogers; on the seat behind, Mr. and Mrs. Franklin A. Dick and Mrs. Rogers' brother and sister-in-law, Mr. and Mrs. George Gilpin; on the back seat, two grooms in dark green coats. The horses are all bays; the wheels of the coach are red; the parasol is bright red. One of Eak-ins' most brilliant works in color. Originally called *A May Morning in the Park.* Canvas, 24 x 36. Signed on the stonework, l. l.: "EAK-INS 79". From Fairman Rogers it passed to William A. Dick of Philadelphia, who in Jan-uary 1931 presented it to the Penna. Museum. For the black-and-white version, see No. 320.

34 SKETCHES. On one side of the panel, the coach being driven across the picture, left to right; in the background, a bare, rugged hill-side, probably Newport. On the back, a study of Mrs. Rogers, head and shoulders, in profile left. Both reproduced in the *Pennsylvania Mu-seum Bulletin,* January 1931, with an article by Henri Gabriel Marceau. Wood, 10¼ x 14½. Signed l. r.: "T. E." Owned by the Penna. Museum.

35 SKETCH FOR THE LANDSCAPE. On the back is a sketch of a river bank, and a sketch of a man, and one of a woman, both outdoors. Wood, 10⅜ x 14½. Unsigned. Owned by Mrs. Eakins.

36 SKETCH FOR THE LANDSCAPE. Part of the landscape at the left. Wood, 14½ x 10¼. Signed, l. r.: "*Fairmount Park. T. Eakins*", and on back: "*Study in Fairmount Park. T. E*". Owned by the Penna. Museum.

37 STUDIES OF A HORSE. On one side, the body without the head; on the other, the head

and forelegs. Wood, 14½ x 10¼. Unsigned. Owned by Mrs. Eakins. Other studies of horses appear on the backs of Nos. 165, 181, 182, 199, and 201.

138 GEN. GEORGE CADWALADER
1806–1879. Lawyer and soldier. Com-manded the forces which quelled the Native American riots of 1844 in Philadelphia. In the Mexican War, was brevetted Major-General for gallant conduct. Major-General of Volun-teers in the Civil War. He was considered one of the handsomest men in the army. For many years chairman of the board of trustees of the Mutual Assurance Company. In February, 1878, about a year before he died, he was in-vited by the board of the Company to sit for his portrait. Eakins' first portrait, however, was not finished until 1880, and he may have been as-sisted by a photograph in finishing it; it is known that he was in painting the second. Which was the first is not certain, but the order is probably as given below. Eakins received $250. for each portrait from the Company.

Half-length, standing, full-face, in the uni-form of a Major-General, holding his hat in his left hand. Black hair, slightly grayed, flowing back from his forehead, black side-whiskers, and clean-shaven lips and chin. Plain dark brown background. Canvas, 38½ x 24½ (inside frame). Unsigned. In December, 1883, this portrait passed from the Company to the Gen-eral's family, and is now owned by his grand-nephew, John Cadwalader, Phila.

139 GEN. GEORGE CADWALADER
Head and bust, full-face; black hair and side-whiskers, only slightly grayed; black stock and black double-breasted coat of the style of the mid-century. Plain mahogany-colored back-ground. The label under the picture says: "Thomas Eakins 1880". This was probably the second portrait, painted from a photograph or daguerreotype. Canvas, 30 x 25. Unsigned. Owned by the Mutual Assurance Co., Phila.

140 RETROSPECTION
(Plate 21)
Study of a Mrs. Perkins wearing an old-fash-ioned dress, sitting in an old chair belonging to Dr. S. Weir Mitchell. Light brown hair, white dress, golden brown background. Originally ex-

hibited by Eakins under the titles of *Study* or *Meditation*. Wood, cradled, 14⅜ x 10¼. Signed u. r.: "EAKINS 1880". Owned by Bryson Burroughs, New York.

141 RETROSPECTION (WATERCOLOR). Started after the oil; unfinished. Paper, 14⅝ x 10⅝. Signed l. r.: "*Thomas Eakins*". Squared off, with two very faint lines. Owned by the Penna. Museum.

142 THE CRUCIFIXION
 (Plate 22)
 Eakins made studies for this painting outdoors, his pupil, J. Laurie Wallace (see No. 206) posing for him, strapped to a cross in the sunlight. The picture itself, however, was painted in his studio. Grayed tonality; pale sunlight, clear grayish blue sky, gray-brown rocky landscape. Canvas, 96 x 54. Inscribed on back: "CHRISTI EFFIGIEM EAKINS PHILADELPHIENSIS PINXIT MDCCCLXXX". Eakins loaned it for many years to St. Charles Seminary, Overbrook, Pa. Now owned by the Penna. Museum.

143 SKETCH. The head, part of the arms, and the bust; evidently painted outdoors. Canvas, 22 x 18. Unsigned. Owned by Samuel Murray, Phila.

144 SPINNING
 (Plate 23)
 The model is Margaret Eakins. Dark hair, white old-fashioned dress. Watercolor on paper, 11 x 8 (mat size). Signed on side of spinning-wheel: "EAKINS 1881". Owned by Mrs. Eakins.

145 SKETCH. The same model, turned more left. At the right, the head of a red-and-white setter dog lying on the floor. Oil on wood, 14½ x 10¼. Unsigned. Owned by Mrs. Eakins.

146 SPINNING
 The model is Margaret Eakins. Full-length, seated on a stool at a spinning-wheel; turned slightly beyond profile right, bending over. Brown hair, white old-fashioned dress with low neck and short sleeves. Behind at the left, a cupboard with dishes and pots. Originally called *Homespun*. Eakins made a bas-relief similar to this (No. 504). Watercolor on paper, 14 x 10⅞. Signed u. r.: "EAKINS 81". Owned by the Metropolitan Museum of Art, New York.

147 SKETCH. On the back, an unfinished sketch of the same subject. Oil on wood, 14 x 10¼.

Unsigned. Owned by David Wilson Jordan, New York.

148 THE PATHETIC SONG
 (Plate 24)
 The singer is Miss Harrison, sister of Alexander and Birge Harrison; the pianist is Susan H. Macdowell, later Mrs. Thomas Eakins. Canvas, 45¼ x 32½. Signed l. l.: "*Eakins 1881*". (The last two numbers are now illegible, but this is the date given in Eakins' records.) Owned by the Corcoran Gallery of Art, Washington.

149 SKETCH. On the back, a sketch of a rocky shore. Wood, 11⅜ x 8½. Unsigned. Owned by David Wilson Jordan, New York.

150 RAIL SHOOTING
 Drawing after the painting, No. 104. This and the following item were used as illustrations for an article in *Scribner's Magazine*, July 1881. Eakins' records show that he made separate drawings for them, receiving $50. for the two. Present whereabouts of either unknown.

151 A PUSHER
 Drawing of the negro at the left in *Pushing for Rail* (No. 70). See the preceding.

152 SHAD-FISHING AT GLOUCESTER ON THE DELAWARE RIVER
 (Plate 25)
 Scene at the shad-fisheries at Gloucester, N. J. The group on the beach includes Benjamin Eakins, one of Eakins' sisters, and their dog, Harry. Clear sky, calm blue water. Also called *Taking up the Net*. Canvas, 12⅛ x 18¼. Signed on back: "T. E." 1881. Owned by the Penna. Museum.

153 SHAD-FISHING AT GLOUCESTER ON THE DELAWARE RIVER
 A group of fishermen on a flat scow loaded with net, others standing in the water helping to pay it out. Similar in general arrangement to the preceding, except that the group occupies a larger part of the picture, is different in individuals, and there are no spectators on the shore. Clear sky, calm blue water. Also called *Taking up the Net*. Reproduced in Met. Mus. Mem. Exh. catalogue (No. 20). Watercolor on paper, 9½ x 14⅛. Signed on boat at right: "EAKINS 81". Owned by the Metropolitan Museum of Art, New York.

54 SHAD-FISHING AT GLOUCESTER ON THE DELAWARE RIVER

Oil painting, present whereabouts unknown, listed in Eakins' records as being painted in June, 1881, and shown at various exhibitions in 1881 and 1882. No other record of it. Probably similar to the preceding, without the group of spectators in No. 152; in his record of the latter, Eakins mentioned the group, but not in Nos. 153 or 154.

55 MENDING THE NET
(Plate 26)

Scene at the shad-fishing grounds at Gloucester, N. J. Sunny day, but quiet color: gray-blue sky, pale blue water at the right, gray-green trees and grass; touches of more brilliant color in the figures. Canvas, 32 x 45. Signed on lumber at right near center: "EAKINS 81". Owned by the Penna. Museum.

56 A FISHERMAN. Sketch of the head and shoulders of the fifth fisherman from the left. On the back, a sketch of a beach and water, with a sailboat. Oil on cardboard, 4 x 5¾. Unsigned. Owned by Mrs. Eakins.

57 THE TREE. Study of the lower part of the tree, with the pile of lumber, the capstan, and a glimpse of the river. On the back, a small sketch of the whole tree. Wood, 10¼ x 14½. Unsigned. Owned by Mrs. Eakins. Another similar sketch appears on the back of No. 162.

58 MENDING THE NET

A fisherman mending a net, standing in a flat field, in the middle distance, with his back turned, in an attitude similar to the second figure from the left in the preceding. At his left, another man is seated on the ground. In the distance, at the right, a strip of blue water, with shore beyond. Soft sunlight, blue sky with light pinkish clouds. Watercolor on paper, 9½ x 16½ (mat size). Signed l. r.: "EAKINS 82". Purchased from Eakins by Dr. Horatio C. Wood, and now owned by his son, James L. Wood, Phila.

59 DRAWING THE SEINE

Fishermen at Gloucester, N. J., drawing in a seine with a capstan, assisted by a horse. They are in the middle distance, slightly to the left, on a point of land with water to the right and beyond; a small sailboat rides at anchor further

out to the right; in the extreme distance is the opposite shore. A barrier of logs lies along the near bank. Pale sunlight, sky filled with clouds, choppy grayish water. Also called *Lanascape, Gloucester*. Watercolor on paper, 8 x 11. Signed on log, l. r.: "EAKINS 82". Presented by Eakins in 1887 to John G. Johnson, and now in the John G. Johnson Collection, Phila.

160 HAULING THE SEINE

Fishermen at Gloucester, N. J., hauling a seine up on a beach by hand. The river is at the left; the beach extends from the lower left back toward the right; fishermen in yellow oilskins are strung along it. Further back, at the right, a line of trees; in the distance the shore goes out again toward the left. Weak sunlight, sky filled with clouds; general warm gray tone. Also called *Drawing the Seine on a Windy Day*. Canvas, 12⅛ x 18. Signed on stone wall, l. r.: "EAKINS 82". Owned by Mrs. Eakins.

161 THE MEADOWS, GLOUCESTER, N. J.

Green meadows, with a stream winding through them, cows in the middle distance, and beyond, a house in a group of green trees. Blue sky with thin clouds. Eakins' only large pure landscape. Also called *Landscape, Gloucester*. Canvas, rebacked, 32¼ x 45¼. Originally signed on back: "T. Eakins". About 1882. Owned by the Penna. Museum.

162 SKETCH. On the back, a sketch of the tree, lumber pile and capstan in *Mending the Net* (No. 155). Wood, 10½ x 13¾. Unsigned. Owned by Mrs. Eakins.

LANDSCAPE SKETCHES

Sketches made outdoors, mostly around Gloucester, N. J., and the shores of the Delaware River, probably in the early 'eighties. Some are fairly finished, others no more than color notes. None are signed. All belong to Mrs. Eakins.

163 A meadow, with trees beyond; foreground in shadow. Quite finished. Sometimes called *In the Country*. Canvas mounted on cardboard, 10⅝ x 14⅜.

164 Flat fields. Sometimes called *Near the Sea*. Canvas mounted on cardboard, 9⅜ x 13⅜.

165 A meadow, with woods beyond; autumnal coloring. On the back, study of a horse in the

Fairman Rogers Four-in-Hand (No. 133). Wood, 10¼ x 14½.

166 Shore scene; tree-trunk at left, shore in right middle distance, river beyond, with schooner, and distant shore. Canvas mounted on cardboard, 5½ x 6½.

167 River scene; beach in foreground, river with long boat at left, shore beyond, with house and factories at right. Strong sunlight reflected in water at left. Canvas mounted on cardboard, 6½ x 9¼.

168 Four sketches of marshes and river, on one panel, each framed with light lines. Inscribed, l. r. (not by Eakins): "*Studies by Thomas Eakins.*" Canvas mounted on cardboard, 10¼ x 10½.

169 Two sketches of meadows and trees, on two sides of a cardboard panel, 8¾ x 13 (sketches themselves 4½ x 7 and 4¾ x 6½).

170 Three sketches of shore, fields and trees, in oil on one sheet of heavy paper, 10⅝ x 13¼.

171 Water in foreground, high shore beyond, and sky. Oil on heavy paper, 9¾ x 13½.

172 Water and meadow in foreground; two trees in middle distance. Canvas mounted on cardboard, 5 x 7⅞.

173 Water in foreground, high shore beyond, and sky. Canvas mounted on cardboard, 4½ x 10⅜.

174 Sunset scene; green meadow in foreground, river with ship, further bank with trees. Canvas mounted on cardboard, 4¾ x 6⅝ (mat size).

175 Shore scene; sand at left, water at right. On the back, color notes of a blue sky with clouds. Cardboard, 4 x 5¾.

176 Water in foreground, in the distance a point of land projecting from right. Canvas mounted on cardboard, 3⅝ x 6½.

177 A steep-roofed cottage surrounded by trees. Cardboard, 5¼ x 6½.

MISCELLANEOUS SKETCHES

I have grouped here sketches which I have been unable to connect with any particular pictures. Unless otherwise noted, none are signed. All belong to Mrs. Eakins.

178 An old man, half-length, full-face, with bald head, white hair, and long beard, and large gnarled hands hanging in front of him. Canvas mounted on cardboard, 13 x 9¾. Squared off.

179 A man, half-length, full-face, wearing a hat, his hands resting on a cane. Canvas mounted on cardboard, 14½ x 10½.

180 A girl seated beneath a tree, in dappled shade. On the back, two sketches of shore scenes. Cardboard, 4 x 5¾.

181 Head of a girl, probably same model, against dappled green foliage. On the back, forelegs of a horse in the *Fairman Rogers Four-in-hand* (No. 133). Wood, 10¼ x 14½. Initialed: "T. E." on both sides.

182 Man wearing a cap, outdoors; sometimes called *Boatman*. On the back, hind legs of a horse in the *Fairman Rogers Four-in-hand* (No. 133). Wood, 14⅝ x 10⅜.

183 The red setter dog Harry, lying down. Cardboard, 5¼ x 6½.

184 Several sketches of the head and shoulders of Benjamin Eakins, in his shirt-sleeves; also of still-life; in oil on one sheet of heavy paper mounted on cardboard, 10 x 13½.

185 Studies of various objects; vegetables, a rosebush, colored objects. Canvas, 13¾ x 10⅜.

186 A head in right profile, bending over; unfinished. Oil on heavy paper, 13¾ x 10¾.

187 A woman seated in a chair, broadly indicated. Canvas mounted on cardboard, 4 x 2¾.

188 THE WRITING MASTER
(Plate 27)

Portrait of the artist's father Benjamin Eakins, writing master. Gray hair and chin beard, ruddy complexion; black coat, black bow tie; mahogany-colored background. Canvas, rebacked, 30 x 34¼. Signed on edge of table, l. r.: "EAKINS 82". Owned by the Metropolitan Museum of Art, New York.

189 SKETCH. Wood, 8¼ x 10⅛. Unsigned. Owned by the Penna. Museum.

190 THE SWIMMING HOLE
(Plate 28)

The models were friends or pupils of Eakins; the artist himself appears swimming at the lower right; the dog is his red setter Harry. Canvas, 27 x 36. Signed on rock at outer end of pier: "EAKINS" (date illegible). Signed on back (by Mrs. Eakins): "*Swimming Hole, Thomas Eakins, 1883*". Owned by the Fort Worth Museum of Art, Fort Worth, Texas.

191 SKETCH. Study of the whole composition. Wood, 8¾ x 10¾. Unsigned. Owned by Mrs. Eakins.

192 SKETCH OF LANDSCAPE. Wood, 10¼ x 14½. Signed l. r.: "T. E." Owned by Mrs. Eakins.

193 SKETCHES. The wooded background, with part of a reclining figure at the left, in sunlight. On the back, the head of the dog Harry. Cardboard, 10½ x 14½. Unsigned. Owned by Mrs. Eakins.

194 SKETCHES. On one side, the landscape; on the back, a nude figure standing in the sunlight. Cardboard, 4 x 5¾. Unsigned. Owned by Mrs. Eakins.

195 SKETCH. On one side, the landscape. On the back, the hand of a fisherman in *Mending the Net* (No. 155). Cardboard, 4 x 5¾. Unsigned. Owned by Mrs. Eakins.

196 ARCADIA

Three nude figures in a green glade beside a brook, with trees in the background. At the right a youth stands playing the pipes; at the left, another youth reclines, also playing the pipes; still further left, a girl, reclining, listens.

One of Eakins' few excursions into the idyllic; not entirely finished. He also did three reliefs of similar subjects (Nos. 506, 507, and 508). Canvas, rebacked, 38¾ x 45. Signed on back: "*T. Eakins Pinxit*". About 1883. Given by Eakins to William M. Chase; now owned by Thomas E. Finger, New York.

197 SKETCH. Same general arrangement, except that the woman at the left is seated. Wood, 5⅝ x 7¾. Unsigned. Owned by Mrs. Eakins.

198 YOUTH PLAYING PIPES (STUDY). The standing figure. On the back, a landscape sketch. Wood, 10¼ x 14½. Unsigned. Owned by Mrs. Eakins.

199 BOY RECLINING (STUDY). The middle figure, evidently painted outdoors. On the back, a sketch of one of the horses in the *Fairman Rogers Four-in-hand* (No. 133). Wood, 10¼ x 14½. Owned by Mrs. Eakins.

200 AN ARCADIAN

A young woman, half-nude, draped in white, seated in a green meadow, her back to the spectator, leaning on her right hand and looking toward the right. She is at the left; at the right Eakins intended to add the figure of a nude youth playing the pipes (judging by faint chalk marks now obliterated). Behind, a clump of willows. Canvas, 14 x 18. Signed l. r.: "*Eakins*". About 1883. Owned by Lloyd Goodrich, New York.

201 STUDY. Sketch of the seated figure, in sunlight. On the same side of the panel, and on the back, sketches of parts of a horse, for the *Fairman Rogers Four-in-hand* (No. 133). Wood, 10¼ x 14½. Unsigned. Owned by Mrs. Eakins.

202 A WOMAN'S BACK (STUDY)

The back of a nude woman, from just below the shoulders to just above the knees, the weight on the left hip, the arms at the sides. Wood, 10⅜ x 14⅝. Unsigned. Probably painted in the early '80s. Owned by Mrs. Eakins.

203 FEMALE NUDE (STUDY)

Full-length, standing, seen from behind, a little more of her right than her left side showing; her weight resting on her left hip; her hands in front. Dark background. Canvas, 24 x 20. Unsigned. Probably painted in the early '80s. Owned by Mrs. Eakins.

204 FEMALE NUDE (STUDY)

Full-length, standing, beyond profile right, seen somewhat from behind; her head bent, her hands in front; her weight resting on her right hip. Dark background. Study for the watercolor below. Oil on canvas, 24 x 20. Squared off. Unsigned. Probably painted in the early '80s. Owned by Mrs. Eakins.

205 FEMALE NUDE (WATERCOLOR). In the same attitude. The figure is fairly finished, but occupies only part of the paper, the rest being blank. Eakins may have intended to add other figures. Watercolor on paper, 17 x 9; painted portion 11 x 3½. Unsigned. Owned by Mrs. Eakins.

206 J. LAURIE WALLACE

Painter, pupil of Eakins at the Pennsylvania Academy, and chief demonstrator of anatomy there in 1882 and 1883. He also posed for *The Crucifixion* (No. 142). Three-quarters length, standing, half right, his right hand on his hip, his left holding a straw hat. Black hair, moustache and thin beard, dark skin, slender figure. Black suit, deep golden brown background. Reproduced in the Met. Mus. Mem. Exh. catalogue. Canvas, 50 x 32. Signed l. r.: "EAKINS". About 1883. Owned by Mrs. Eakins.

207 PROFESSIONALS AT REHEARSAL

Two young men, one playing a zither, the other a guitar. The model for the former was John Laurie Wallace; for the latter, William L. MacLean, pupil of Eakins and later his chief demonstrator of anatomy. Wallace is seated at the right, bending over his zither, which rests on a round-topped table; MacLean sits at the left and further back. A bottle of wine and two glasses are on the table; books are piled on the floor. Reproduced in the Penna. Acad. Mem. Exh. catalogue. Canvas, rebacked, 16 x 12. Signed u. l.: "EAKINS". About 1883. At one time in the Thomas B. Clarke Collection; now owned by Mrs. John D. McIlhenny, Germantown, Phila.

208 IN THE STUDIO

One of Eakins' girl pupils seated, center, with his red setter dog Harry lying on the floor beside her, lower left. Full length, half right, her right arm at her side; brown hair, white evening dress; dark brown background. Unfinished; squared off; evidently a study for the watercolor below. Canvas, rebacked, 22¼ x 18¼. Signed l. r.: "T. E. 1884", and on back: "T. E". Owned by Mrs. Eakins.

209 IN THE STUDIO (WATERCOLOR). Same as the preceding, but only the upper part of the figure is painted, the rest unfinished. Paper, 21 x 17. Unsigned. Owned by Mrs. Eakins.

210 A. B. FROST

1851–1928. Illustrator and caricaturist, known especially for his drawings for Uncle Remus and Rudder Grange. Although largely self-taught, "he attributed his first acquirements in 'solid drawing' to his evening studies in the Pennsylvania Academy of Fine Arts under Thomas Eakins". Head and bust, slightly left of full-face, looking at the spectator. Reddish brown hair, red moustache and beard, black stock, black coat buttoned high. Dark gray-brown background. Reproduced in the catalogue of the Homer-Ryder-Eakins exhibition at the Museum of Modern Art, New York, 1930. Canvas, 27 x 22. Signed on back: "T. E." About 1884. Owned by the Penna. Museum.

211 THE VETERAN

(Plate 29)

Portrait of George Reynolds, cavalry captain

in the Civil War, landscape painter, pupil of Eakins at the Pennsylvania Academy, one of the leaders in the founding of the Art Students' League of Philadelphia, and its first curator. He appears also as the diving figure in The Swimming Hole (No. 190). Black hair, dark chestnut brown moustache and beard, old rose scarf, dark brown coat mottled with gray, deep brown background. Canvas, 23⅛ x 17. Signed l. r.: "EAKINS". About 1884. Owned by Henry Sheafer, Pottsville, Pa.

212 MRS. WILLIAM SHAW WARD

Sister-in-law of Mrs. John H. Brinton (No. 126). This portrait, a commission, was started in May, 1884; but as Mrs. Ward could not continue the sittings, it was not entirely finished. Half-length, seated in a chair, somewhat left of full-face, her hands in her lap; dark brown hair, blue eyes, warm olive-green dress; light warm olive-green background. Reproduced in the Art News, December 20, 1930, p. 66. Canvas, rebacked, 40 x 30. Unsigned. Owned by the E. C. Babcock Art Galleries, New York.

213 A LADY WITH A SETTER DOG

(Plate 30)

The artist's wife, Susan Macdowell Eakins, with her red setter Harry. She wears a light blue silk dress, red stockings and black slippers, and holds a Japanese picture book in her lap. The Oriental rug is prevailingly warm red, the secretary light brown, the hangings warm golden ochre with touches of light red, the walls gray. One of Eakins' most brilliant works in color. Canvas, 30 x 23. Unsigned. 1885. Owned by the Metropolitan Museum of Art, New York.

214 PROF. GEORGE F. BARKER

1835–1910. Well-known chemist and physicist; professor of physics at the University of Pennsylvania; the first in America to exhibit radium in radio-active bodies. He was associated with Eakins on the Muybridge Committee, and remained a good friend. Standing, three-quarters length, full-face, his arms at his sides. Iron-gray hair, reddish moustache and side-whiskers; pince-nez, black suit. Dark golden brown background. Reproduced in the Met. Mus. Mem. Exh. catalogue. Canvas, 60 x 40. Signed l. r.: "EAKINS 1886". Owned by Mrs. Eakins. The artist at one time offered to present

it to the University of Pennsylvania, but it was refused.

215 SKETCH. Oil on cardboard, 12½ x 10⅛. Unsigned. Squared off for enlarging. Owned by the Penna. Museum.

216 PROF. WILLIAM D. MARKS
(Plate 31)
1849–1914. Engineer; Whitney professor of dynamical engineering at the University of Pennsylvania. He was associated with Eakins on the Muybridge Committee, designed some of the mechanism for the experiments, and wrote an essay in which he devoted considerable space to Eakins' apparatus. One of the artist's closest scientific friends. Dark brown hair and moustache, ruddy complexion, black suit. Canvas, 76 x 54. Signed on side of table at right center: "EAKINS 86". Owned by the sitter's daughter, Miss Jeannette Marks, Mount Holyoke College, South Hadley, Mass.; loaned to the Dwight Hall Art Gallery of the College.

217 PROF. MARKS (FIRST VERSION). Unfinished; without the objects on table and floor, or the book-case behind. Canvas, 76 x 54. Signed on back: "T. E." Owned by Mrs. Eakins.

218 FRANK MACDOWELL
Brother of Mrs. Eakins. Head and bust, slightly right of full-face; black hair and long moustache, heavy eyebrows, dark brown eyes; low collar, dark gray coat buttoned up high, dark brown background. Reproduced in the Penna. Acad. Mem. Exh. catalogue. Canvas, 24 x 20. Signed on back: "EAKINS". About 1886. Owned by his niece, Mrs. John Randolph Garrett, Roanoke, Va.

219 FRANK MACDOWELL (FIRST VERSION). Same, except that he wears a high collar widely separated in the middle. Not entirely finished. Canvas, 24 x 20. Unsigned. Owned by Mrs. Eakins.

220 WALT WHITMAN
(Plate 32)
American poet; 1819–1892. Gray hair, moustache and beard; ruddy face; light gray suit, white collar edged with lace, brown background. Canvas, 30 x 24. Signed u. r.: "EAKINS 1887", and on back: "WALT WHITMAN PAINTED FROM LIFE by THOMAS EAKINS 1887". (Actually finished in the spring of 1888.) Al-

though Eakins told Whitman that they could each have a half-interest in the picture, he left it with the poet, after whose death it passed to his executor Dr. Bucke, from whom it passed to H. C. Pope, Moose Jaw, Canada, from whom it was purchased by the Pennsylvania Academy, the present owner.

221 SKETCH. The head alone; eyes closed. Wood, 5¼ x 5¼. Unsigned. Owned by the Museum of Fine Arts, Boston.

222 MRS. LETITIA WILSON JORDAN BACON
(Plate 33)
Sister of David Wilson Jordan (No. 329). Eakins saw her at a party in this dress and asked her to pose for him. Black hair, brown eyes; black evening dress, scarlet ribbon around her neck, long buff gloves, blue-gray scarf over her arm, old gold fan; deep mahogany red background. Canvas, 59 x 39½. Inscribed l. r.: "TO MY FRIEND D. W. JORDAN. EAKINS. 88". Owned by the Brooklyn Museum.

223 SKETCH. Oil on cardboard, 14 x 11. Unsigned. Squared off for enlarging. Owned by the Penna. Museum.

224 COWBOYS IN THE BAD LANDS
(Plate 34)
Cowboys with their horses, reconnoitreing in the Bad Lands of Dakota, where Eakins spent the summer of 1887. The cowboy at the left, mounted on a brown horse, wears khaki clothes and a red bandanna; the other wears a blue shirt and khaki chaps. The models for the horses were Eakins' white "Billy" and his brown Indian pony "Baldy". Pale blue sky, with a few thin clouds; the grassy parts of the landscape are light warm green, the hills sand-color. Canvas, 32½ x 45½. Signed l. r.: "EAKINS 88". Owned by Stephen C. Clark, New York.

225 SKETCHES. Three sketches: one of the cowboys and their horses; one of a saddle; and one of a stirrup; on canvas, mounted on one piece of cardboard, 10 x 18. Unsigned. Owned by Mrs. Eakins.

226 SKETCH. The right-hand cowboy and his horse. Canvas, 24 x 20. Inscribed l. r.: "Study for picture 'Cowboy in Bad Lands'. Eakins". Signed on back: "T. E." Squared off. Owned by the Penna. Museum.

227 THE BAD LANDS. Landscape sketch. Canvas mounted on cardboard, 10½ x 14½. Unsigned. Owned by the Penna. Museum.

228 THE BAD LANDS. Landscape sketches on both sides of the panel. Canvas mounted on cardboard, 10½ x 14½. Unsigned. Owned by Mrs. Eakins.

229 COWBOY RIDING (SKETCH). He is riding across the picture towards the right; the rear of another horse at the right. Canvas mounted on cardboard, 10½ x 14½. Unsigned. Owned by Mrs. Eakins.

230 COWBOY (SKETCHES). Head of Edward W. Boulton (No. 232); also sketches of bridle, quirts, and other cowboy accoutrements. On the reverse, a cowboy mounted on a brown horse (the canvas is cut so that the rider is seen only to his waist). Canvas mounted on cardboard, 10 x 14. Owned by Mrs. Edward W. Boulton, New Preston, Conn.

231 COWBOY (SKETCH). Head of Edward W. Boulton in cowboy costume; also small sketch of a bust statue of a man. Canvas mounted on cardboard, 14½ x 10¾. Owned by Mrs. Edward W. Boulton, New Preston, Conn.

232 EDWARD W. BOULTON
Painter, pupil of Eakins at the Art Students' League of Philadelphia, and its president for several years. Head and bust, life size. About 1888. Badly damaged in an accident. Owned by Mrs. Edward W. Boulton, New Preston, Conn.

233 DOUGLASS M. HALL
(Plate 35)
Pupil of Eakins at the Art Students' League of Philadelphia; son of Dr. Andrew Douglass Hall, prominent ophthalmologist; died at the age of twenty-seven. Brown hair, fine blond moustache, blue eyes; white shirt; dark brown background. Canvas, 24 x 20. Unsigned. About 1888. Owned by his sister Mrs. William E. Studdiford, New York.

234 GIRL IN A BIG HAT
Portrait of Lillian Hammitt, pupil of Eakins. Head and bust, half right, head tilted to the right, eyes fixed on the spectator. Light reddish-brown hair, dark blue eyes, round face, ruddy complexion, steel-rimmed spectacles. Wide-brimmed black hat and black coat with black fur collar. Light grayish gold background. Canvas, 24 x 20. Signed on back: "EAKINS". About 1888. Owned by Mrs. Eakins.

235 THE AGNEW CLINIC
(Plates 36 and 37)
Portrait of Dr. D. Hayes Agnew in his clinic at the Medical School of the University of Pennsylvania. Dr. Agnew (1818–1892) was one of the greatest surgeons and anatomists of his time. For twenty-six years he was professor of surgery at the University, where he was idolized by his pupils. This portrait was commissioned by the students on the occasion of his resignation in 1889, the price agreed on being $750. Instead of painting a conventional single figure, Eakins was led by his admiration of Dr. Agnew to paint his largest and most ambitious composition. It was completed in three months, and was presented to the University by the undergraduate classes of the Medical School at the annual commencement, May 1st, 1889.

Dressed in white surgical costume, like his assistants, and holding his scalpel in his left hand (he was ambidextrous), Dr. Agnew is talking to the class about the operation he has just performed, for cancer of the breast, while his assistant Dr. J. William White (1850–1916), himself later a famous surgeon, applies a dressing to the wound, Dr. Joseph Leidy II holds a sponge to wipe the blood, and the anaesthetist, Dr. Ellwood R. Kirby, stands at the patient's head. In the entrance to the amphitheatre, at the extreme right, appears the artist himself (painted by Mrs. Eakins); Dr. Fred H. Milliken is whispering to him. The students, dressed in dark street clothes, are all portraits and have been identified, their names being given in the *Old Penn Weekly Review* of October 30th, 1915.

The picture was exhibited in the Haseltine Galleries in Philadelphia soon after it was finished; rejected by the Society of American Artists; solicited by the artists' jury of the Pennsylvania Academy in 1891 but not allowed by the officials to be hung; not seen in any large exhibition until the World's Fair in Chicago in 1893, where, together with other pictures by him, it received a bronze medal.

Canvas, 74½ x 130½. The frame is inscribed: "D. HAYES AGNEW M.D. CHIRURGUS

PERITISSIMUS. SCRIPTOR ET DOCTOR CLARISSI-MUS. VIR VENERATUS ET CARISSIMUS. MDCCC-LXXXIX". Canvas inscribed on back: "AGNEW CHIRURGI EAKINS PHILADELPHIENSIS EFFIGIEM PINXIT". Owned by the University of Pennsylvania.

236 SKETCH. Canvas mounted on cardboard, 10⅜ x 14½. Unsigned. Owned by Samuel Murray, Phila.

237 DR. AGNEW (STUDY). The Doctor's figure alone. Reproduced in *The Arts*, January 1923, p. 26. Canvas, 50⅜ x 32. Signed l. r.: "*Study for the Agnew Portrait. Eakins*". Purchased from the artist in 1914 by Dr. Albert C. Barnes, and now in the Barnes Foundation, Merion, Pa.

238 SAMUEL MURRAY
(Plate 38)

Sculptor; born 1870. Entering the Art Students' League of Philadelphia about 1887, he soon became Eakins' favorite pupil, worked with him and shared his studio for over ten years, and remained like a son to him until his death. He is well-known for his public monuments, portraits, and statuettes. Brown hair, black suit, soft collar and loose purplish necktie; dark brown background. Canvas, 24 x 20. Signed on back: "THOMAS EAKINS 1889". Owned by Samuel Murray, Phila.

239 DR. HORATIO C. WOOD
1841 – 1920. Well-known physician and naturalist, especially noted as a therapeutist. Taught for over forty years at the University of Pennsylvania, as professor of materia medica and pharmacology, of general therapeutics, and clinical professor of nervous diseases. Author of *A Treatise on Therapeutics*, a landmark in its field; and of many works on neurology. A friend of Eakins, and owned two of his pictures. Full-length, seated, half left, at a mahogany table covered with books and papers, holding a pen to his mouth. Dark hair, moustache and beard; dark blue velvet jacket, black trousers. Oriental rug; golden drapery behind. Reproduced in the Met. Mus. Mem. Exh. catalogue. Canvas, 64 x 50. Signed l. r.: "EAKINS". About 1889. Owned by the Detroit Institute of Arts.

240 PROF. GEORGE W. FETTER
(Plate 39)
1827–1909. Principal of the Girls' Normal School, Philadelphia, 1865–1894. This portrait was commissioned by his pupils in honor of the twenty-fifth anniversary of his principalship, and was presented by them to the school on February 3rd, 1890. Gray hair and moustache, black suit. Reddish brown desk; rug prevailingly warm golden brown; golden brown background. Canvas, 78 x 52. Signed on base of desk, l.r.: "EAKINS 1890". Owned by the Board of Public Education, Philadelphia, and hung in the Philadelphia High School for Girls, Spring Garden and Seventeenth Streets.

241 DRAWING. For the program of the presentation exercises. At upper left is printed: "SOUVENIR". In black ink on a white tile, 8 inches square. In the possession of Ernest Lee Parker, Phila.

242 TALCOTT WILLIAMS
1849–1928. Well-known journalist; editorial writer on the *Philadelphia Press*, 1881–1912; director of the School of Journalism, Columbia University, 1912–1919. Head and bust, full-face, the head turned slightly left. Black hair, chestnut brown moustache, brown eyes; dark coat and tie, white collar. Canvas, 24½ x 20½. Unsigned. About 1890. Owned by his niece Mrs. L. H. Seelye, Beirut, Syria.

243 THE BOHEMIAN
Portrait of Franklin L. Schenck (1855–1926), painter, pupil of Eakins at the Art Students' League of Philadelphia, and its second curator. A poetic, unworldly temperament, he afterwards lived like a hermit on Long Island, raising all his own food and painting romantic landscapes suggestive of Blakelock's. He was fond of singing and playing the guitar. He appears in several other pictures (Nos. 244, 245, 247–250). Head and bust, turned slightly left. Abundant, disorderly auburn hair, moustache and beard; plain dark blue shirt; golden brown curtain in the background. The whole tone and mood are more romantic than usual with Eakins. Reproduced in the Met. Mus. Mem. Exh. catalogue, also in *Art in America*, February 1931, with an article on Schenck by Nelson C. White. Canvas, rebacked, 24 x 20. Signed, l. r.: "EAKINS", and on back: "T. E." About 1890. Owned by the Penna. Museum.

244 F. L. SCHENCK
 (See the preceding.) Head and bust, half
left, his left arm over the back of a chair, his
head tilted far to the right and supported by his
left hand. Most of his face is in shadow, the
light from the right catching only the salient
points. Leonine auburn hair, moustache and
beard, florid complexion; dark blue flannel
shirt, dark golden brown background. Canvas,
24 x 20. Unsigned. About 1890. From Schenck
it passed to his friend John Wright; now owned
by the latter's daughter, Mrs. Fred E. Man-
castroppa, Linwood, N. J.

245 F. L. SCHENCK (STUDY)
 Almost full-length, seated, legs crossed, his
body in profile left, his left arm over the back of
the chair, supporting his head, which is turned
slightly toward the spectator. The upper part of
the body is in the same attitude as in the pre-
ceding, but seen more in profile. Dark blue
shirt, gray trousers; golden brown background;
general golden tone. On the back is a sketch of
a man in a white suit. Oil on cardboard, 13¾ x
10¼. Unsigned. About 1890. Owned by
Frederic Newlin Price of the Ferargil Galler-
ies, New York.

246 THE FATHER OF F. L. SCHENCK
 Painted for F. L. Schenck, from a photo-
graph. Head and bust, slightly right of full-
face. Dark gray hair, gray moustache and beard;
blue coat buttoned up to his neck; warm ochre-
ish gray background. Canvas, 24 x 20. Signed
on back: "T. E." About 1890. Owned by Nel-
son C. White, Waterford, Conn.

247 HEAD OF A COWBOY
 Portrait of F. L. Schenck dressed in Eakins'
cowboy costume. Head and bust, half left; thick
auburn hair, moustache and beard; gray-blue
eyes; wide-brimmed sombrero on the back of
his head; dark green scarf around his neck, buff
leather cowboy shirt. Dark golden brown back-
ground; general golden tone. Canvas, 24 x 20.
Signed on back: "EAKINS". About 1890. Owned
by Mrs. Eakins.

248 HOME RANCH
 A cowboy playing the guitar and singing,
while another looks on. The model for the
singer is F. L. Schenck; full-length, seated, half

right, his legs crossed, the guitar across his lap,
his head thrown back; auburn hair, moustache
and beard; sombrero, red scarf, buff leather
shirt, brown chaps. The other man, in the right
background, is seated at a table holding a fork;
a black cat rubs against the table leg. Repro-
duced in the Met. Mus. Mem. Exh. catalogue.
Canvas, 24 x 20. Signed on side of table at
right: "EAKINS", and on back: "T. E." About
1890. Owned by the Penna. Museum.

249 COWBOY SINGING
 Similar to the preceding, except that Schenck
is playing a banjo instead of a guitar, and is
turned more toward the spectator, slightly right
of full-face; there is no other figure, and the
background is plain gray-brown. Reproduced
in the Met. Mus. Mem. Exh. catalogue. Water-
color on paper, 18 x 14. Signed l. r.: "EAKINS"
(covered by the mat). About 1890. Owned by
the Metropolitan Museum of Art, New York.

250 COWBOY SINGING
 Similar to the preceding, but turned half left.
Canvas, 24 x 20. Signed l. r.: "*Eakins*", and
on back: "EAKINS". About 1890. Owned by the
Penna. Museum.

251 THOMAS B. HARNED
 Lawyer; intimate friend of Walt Whitman
in his last years; one of his literary executors.
Head and bust, half right; moustache, dark gray
suit; dark brown background. Canvas, 24 x 20.
Unsigned. About 1890. Owned by his son,
Herbert S. Harned, New Haven, Conn.

252 DR. JOSEPH LEIDY, II
 1866–1932. Physician; specialist in internal
medicine; prominent in public hygiene work;
author of works on parasites, helminthology and
parasitology; editor of the writings of his uncle
Dr. Joseph Leidy. He is one of Dr. Agnew's
assistants in *The Agnew Clinic* (No. 235).
Three-quarters length, seated, half right, look-
ing at the spectator, his arms resting on the arms
of the chair. Brown hair, auburn moustache,
blue eyes, ruddy complexion; turned-down col-
lar, dark red necktie, black suit; old-fashioned
armchair with red plush upholstery; dark brown
background. Canvas, 39½ x 36. Signed l. r.:
"T. E. 1890". Owned by Mrs. Joseph Leidy,
Pennlyn, Pa.

253 DR. JOSEPH LEIDY, II (FIRST VERSION).
Unfinished. Canvas, 50 x 36. Squared off.
Signed l. r.: "*Eakins*", and on back: "т. е."
Owned by Mrs. Eakins.

254 WILLIAM H. MACDOWELL
(Plate 40)
Engraver; father of Mrs. Eakins. Eakins
painted him several times (see Nos. 260, 261,
262, 301, and 416). Long gray hair, gray
moustache and beard; black bow tie, black suit.
Deep mahogany-colored background. Canvas,
24 x 20. Signed l. r.: "т. е.", and on back:
"т. е." About 1890. Owned by Stephen C.
Clark, New York.

255 PHIDIAS STUDYING FOR THE FRIEZE
OF THE PARTHENON
Sketches for a composition never carried out,
of Phidias studying the movement of youths on
horses outdoors, for the frieze of the Parthe-
non. On one side of the panel, Phidias, at the
right, stands with two nude youths, pointing
toward two others on rearing horses in the mid-
dle distance; blue sky with white clouds, strong
sunlight. On the back, two nude youths on
prancing horses, in attitudes almost identical
with some in the Parthenon frieze; blue sky,
green earth. Wood, 10⅝ x 13¾. Unsigned.
About 1890. Owned by Mrs. Eakins.

256 THE RED SHAWL
Head and bust, half right, of a young mu-
latto woman wearing a bright red shawl with a
black and white design running through it.
Dark warm gray background. Reproduced in
the Met. Mus. Mem. Exh. catalogue. Canvas,
24 x 20. Signed on back:"EAKINS". About 1890.
Owned by the Penna. Museum.

257 FRANCIS J. ZIEGLER
Pupil of Eakins at the Art Students' League
of Philadelphia, and its secretary; later art critic
of the *Philadelphia Record*. Head and bust of
a young man, half left, looking down as if read-
ing; black hair, brown moustache, pince-nez;
black suit, high wing collar; dark brown back-
ground. Reproduced in the Penna. Acad. Mem.
Exh. catalogue. Canvas, 24 x 20. Inscribed on
back: "*To my friend Francis Ziegler, Thomas
Eakins*". About 1890. Owned by Francis J.
Ziegler, Phila.

258 THE ART STUDENT
Portrait of James Wright, painter, and pupil
of Eakins at the Art Students' League of Phila-
delphia. A young man, three-quarters length,
seated, half left, his knees crossed, his right arm
over the back of a chair, holding a corncob pipe
in his right hand, his left hand in his lap, hold-
ing a gray soft hat. Chestnut hair and small
moustache; blue shirt, flowing dark blue tie,
brown corduroy coat and trousers, red bandanna
in his breast pocket. Dark brown background.
Canvas, 42 x 32. Signed l. r.: "EAKINS", and
on back: "т. е." About 1890. Owned by James
Wright, Brooklyn, N. Y.; in the possession of
his nephew George Wright, Drexel Hill, Pa.

259 THE BLACK FAN
Portrait of Mrs. Talcott Williams, wife of
the well-known journalist (No. 242). Full-
length, standing, slightly left of full face, wear-
ing a white evening dress and holding a black
fan. Golden brown background. Not entirely
finished, as Mrs. Williams did not care for it
and would not continue the sittings. Repro-
duced in the Met. Mus. Mem. Exh. catalogue.
Canvas, 80¼ x 40. Unsigned. About 1891.
Owned by the Penna. Museum.

260 WILLIAM H. MACDOWELL
Engraver; father of Mrs. Eakins. Head and
bust, half left, head tilted a little to right, gaz-
ing downwards, his left arm over the back of a
chair, the hand (which is shown) hanging
down. Long gray hair, gray moustache and
beard; black bow tie, black suit, dark brown
background. Reproduced in the Penna. Acad.
Mem. Exh. catalogue, 2nd page of reproduc-
tions. Canvas, 24 x 20. Signed on back:
"EAKINS". About 1891. Owned by Mrs. Eakins.

261 WILLIAM H. MACDOWELL (STUDY)
Head and bust, full-face, eyes fixed on spec-
tator, his left hand resting on the back of his
chair. Long iron-gray hair, iron-gray mous-
tache and beard; brown eyes, black suit; ochre-
colored background. Painted loosely, with heavy
pigment. Reproduced in the Met. Mus. Mem.
Exh. catalogue, No. 36. Canvas, rebacked, 28 x
22. Signed on back: "*T. Eakins*". Squared off
with three faint lines. About 1891. Owned by
Mrs. Eakins.

262 WILLIAM H. MACDOWELL. Unfinished watercolor for which the preceding was a study. Paper on a stretcher, 30 x 25. Unsigned. Owned by Mrs. Eakins.

263 MISS AMELIA C. VAN BUREN
(Plate 41)

Artist; pupil of Eakins at the Pennsylvania Academy. She wears a salmon pink dress with white cuffs and a flowered white panel in front; her hair is black streaked with gray; the chair is mahogany upholstered in brownish red velvet, the background deep olive-brown. Reproduced in color as the frontispiece of *Creative Art*, July 1931. Canvas, 45 x 32. Unsigned. About 1891. Owned by the Phillips Memorial Gallery, Washington, D. C.

264 PROF. HENRY A. ROWLAND
(Plate 42)

1848–1901. Physicist; "one of the most brilliant men of science that America has produced." Professor of physics at Johns Hopkins University, where he carried on important experiments, using more exact methods than any before. Computed the accepted value of the mechanical equivalent of heat, and made a more nearly accurate determination of the value of the ohm than any previous investigator. To make more accurate diffraction gratings for spectrum analysis, he constructed a dividing engine which ruled 14,000 to 20,000 lines to the inch; also developed concave gratings. His gratings were used in physics laboratories the world over, and inaugurated the modern study of spectroscopy as an exact science. He photographically mapped the solar spectrum for the first time.

Eakins wrote about this portrait: "Professor Rowland is shown with a diffraction grating in his hand. His engine for ruling is beside him and in the background his assistant, Mr. Schneider, is working at his lathe. The frame is ornamented with lines of the spectrum and with coefficients and mathematical formulae relating to light and electricity, all original with Professor Rowland and selected by himself."

Canvas, 80 x 54. Inscribed on the floor, l. l.: "*Prof. Henry A. Rowland, Thomas Eakins, 1891*". Presented by Stephen C. Clark in 1931 to the Addison Gallery of American Art, Phillips Academy, Andover, Mass.

265 SKETCH. Canvas, 14¼ x 10. Unsigned. Squared off for enlarging. Owned by Mrs. Eakins.

266 THE CONCERT SINGER
(Plate 43)

Portrait of Weda Cook, well-known singer (now Mrs. Stanley Addicks); friend of Walt Whitman, and composer of music for his *O Captain! my Captain!* Mrs. Addicks tells me that she posed for the picture during two years, the first year fairly regularly. Each day before commencing, Eakins would ask her to sing *O rest in the Lord* from Mendelssohn's *Elijah* (also a favorite of Whitman), so that he could observe the action of mouth and throat. After two years she was unable to continue posing, and the right foot was painted from a slipper placed on the floor with the dress draped over it. The conductor's hand in the foreground was posed for by Charles M. Schmitz (1843–1915), conductor of the old Germania Orchestra, for forty years the leading Philadelphia orchestra.

The singer has dark brown hair and wears a light rose evening dress trimmed with white lace, and white slippers. A bouquet of pink roses lies on the stage; green palm leaves appear at the left. The background is a warm golden green. The color scheme is unusually poetic and mellow. Canvas, 75 x 54. Signed u. r.: "EAKINS 92". Owned by the Penna. Museum.

267 SKETCH. Canvas mounted on wood, 14⅜ x 10⅜. Unsigned. Owned by the Penna. Museum.

268 JOSHUA BALLINGER LIPPINCOTT

1816–1886. Publisher, founder of the house of J. B. Lippincott & Co. This portrait was a commission. Head and bust, half left; gray-brown hair, gray moustache and chin beard, gray eyes; dark suit; dark background. Canvas, 30 x 25. Signed l. l.: "T. E. 92"; inscribed on back: "Copied from a photograph". Owned by the sitter's granddaughter, Mrs. Stricker Coles, Bryn Mawr, Pa.

269 MISS BLANCHE HURLBURT

Head and bust, left profile; black hair done up on top of her head, light dress, light yellowish background. The light from the right strikes the side of the face but leaves most of the features in shadow. Unfinished. Canvas, re-

backed, 24 x 20¼. Signed, l. r.: "*Thomas Eakins*", and on back: "EAKINS". About 1892. Owned by the Penna. Museum.

o DR. JACOB M. DA COSTA

1833–1900. Well-known Philadelphia physician; professor of the practice of medicine in Jefferson Medical College; noted as a diagnostician; author of *Medical Diagnosis*; president of the College of Physicians of Philadelphia, 1884–6 and 1895–8. Eakins painted an earlier portrait of him, in 1892, but it was unsatisfactory to the Doctor and his friends, and the artist destroyed it and painted this one. Three-quarters length, seated, half right, his hands resting on his legs. Bald forehead, curly iron-gray hair and side-whiskers; black suit, wing collar; background light terracotta red. Canvas, 42 x 34. Signed l. r.: "EAKINS 1893". Owned by the Pennsylvania Hospital, Philadelphia, where Dr. Da Costa was attending physician for many years.

71 SKETCH. Canvas mounted on cardboard, 14½ x 10½. Signed l. r.: "*Sketch T. E.*" Owned by Mrs. Eakins.

72 GIRL WITH PUFF SLEEVES

Head and bust, half right, of a slender young woman wearing a greenish white dress with large puff sleeves and a round brown collar. Brown background. Unfinished. Canvas, 24 x 20. Unsigned. Date unknown. Owned by Mrs. Eakins.

73 FRANK HAMILTON CUSHING
(Plate 44)

1857–1900. Ethnologist; pioneer in the study of the American Indian. He lived for five years with the Indians of the Zuñi pueblo in New Mexico, being adopted into the tribe and initiated into the secret order of the "Priesthood of the Bow". Later he led an expedition which discovered and explored many ancient cities of the Southwest. The hardships he endured broke down his frail health, and he died comparatively young, having added much to the first-hand knowledge of Indian life, and leaving behind writings marked by imagination and unusual literary quality. The impression he made on all who knew him was extraordinary; more than one of his colleagues said: "He was a man of genius". Eakins, who met him when he was

under the care of Dr. William Pepper in Philadelphia, had a high regard for him, and he for Eakins. When this portrait was started they turned the studio into a replica of a room in a Zuñi house, with a pottery furnace and a ladder by which the Indians enter from the roof.

Cushing is shown in his costume as Priest of the Bow. His long hair and his moustache are auburn; a dark blue scarf is bound around his head; he wears a black shirt, buff deerskin trousers and leggings with silver buttons and scarlet garters; his shield on the wall is covered with Indian designs in bright warm colors. The floor and wall are light terracotta. Canvas, 90 x 60. Signed on wall, l. l.: "EAKINS". Late 1894 or 1895. Submitted to the Pennsylvania Academy exhibition of 1895–6, but rejected; never shown in a regular art exhibition. Eakins loaned it to the Archæological Museum of the University of Pennsylvania, of which Stewart Culin (No. 483) was director; when the latter went to the Brooklyn Museum, it was loaned to that institution, where it hung in the ethnological collection. Purchased by the Museum after Eakins' death, it is now in the department of paintings. Eakins designed for it a frame of plain wood bound together with leather thongs, but this has been discarded.

274 SKETCH. Canvas, 24 x 16. Squared off for enlarging. Unsigned. Owned by Mrs. Eakins.

275 MRS. FRANK HAMILTON CUSHING

A young woman, seated, seemingly lost in thought. Three-quarters length, half-left, her face almost in profile; dark hair, black evening dress with short puff sleeves; her bare arms resting in her lap. Reproduced in *The Arts*, December, 1923, p. 311. Canvas, 26 x 22. Signed l. r.: "T. E." About 1894 or 1895. Owned by the Penna. Museum.

276 JAMES MacALISTER (SKETCH)

The portrait for which this is a study has disappeared (No. 481). Three-quarters length, slightly left of full-face, his right hand holding the front of his black frock-coat, his left arm by his side. Blond hair and moustache, red necktie; dark brown background. Squared off for enlarging. On the back, a sketch of William L. MacLean, pupil of Eakins (see No. 207); and another of a man seated in the sunlight, with a

hat on. Canvas mounted on cardboard, 14½ x 10½. Unsigned. Owned by Mrs. Eakins.

277 WEDA COOK

Singer, who posed for the *Concert Singer* (now Mrs. Stanley Addicks). Head and bust, half right; dark hair; light rose evening gown; dark brown background. Canvas, 24 x 20. Signed l.r.: *"Eakins"*. About 1895. Owned by Stephen C. Clark, New York.

278 STANLEY ADDICKS

Pianist. Head and bust, slightly left of full-face, his head tilted to the left. Light, curly brown hair, blond moustache, ruddy complexion, blue eyes. Pink shirt, flowing light red necktie, loose-fitting brownish-gray coat, no vest. Gray-brown background. Canvas, 24 x 20. Unsigned. About 1895. Owned by Mrs. Eakins.

279 MAUD COOK

Cousin of Weda Cook. Head and bust of a slender young woman, her body slightly left of full-face, her head turned further left and tilted to the left; brown hair low on the neck and tied with a ribbon; brown eyes; low-necked pink dress. Dark greenish background. Canvas, 24 x 20. Inscribed on back: "TO HIS FRIEND MAUD COOK, THOMAS EAKINS. 1895". Owned by the sitter, now Mrs. Robert C. Reid, Oil City, Pa.

280 RITER FITZGERALD
(Plate 45)

Art and music critic of the *Philadelphia Item*, one of the city's most brilliant critics, and a friend and constant champion of Eakins; died in 1911. Grayed hair and moustache; bluish green smoking jacket, black vest and trousers. Red easy chair with a multi-colored fringe, rug of a prevailing light warm red, books of various colors. Canvas, 76 x 64. Signed on the base of the bookcase, l. l.: "EAKINS 95". Owned by the Whitney Museum of American Art, New York.

281 SKETCH. Canvas mounted on cardboard, 13 x 10½. Signed l. r.: *"T. Eakins"*. Owned by LeRoy Ireland, New York.

282 SKETCH. Canvas, about 24 x 20. Owned by the sitter's niece, Mrs. J. K. Spare, Moylan, Pa. No other information available.

283 MRS. HUBBARD (SKETCH)

Sister of Riter Fitzgerald. The portrait for which this is a study has been destroyed (No.

493). Full-length, seated, half left; golden hair, gray-blue evening dress, opera cloak trimmed with white ermine; grayed purple armchair, light gray background; strong light. Canvas mounted on cardboard, 14½ x 10½. Signed on back: "T. E." About 1895. Owned by Mrs. Eakins.

284 JOHN McLURE HAMILTON
(Plate 46)

Painter, well-known for his informal portraits of famous men. Born 1853 in Philadelphia; has lived much of his life in England. He wrote an appreciation of Eakins in the Metropolitan Museum *Bulletin* at the time of the Memorial Exhibition. Brown moustache and beard, white vest, light gray-brown coat, dark gray trousers, black shoes; floor light warm gray, fading into a warm gray-brown background. Canvas, 80 x 50¼. Inscribed on the floor: l. l.: *"To my friend Hamilton. Eakins, 95"*. Owned by Stephen C. Clark, New York.

285 SKETCH. Canvas mounted on cardboard, 14½ x 10½. Squared off for enlarging. Signed l. r.: *"Thomas Eakins"*. Owned by Samuel Murray, Phila.

286 MRS. CHARLES L. LEONARD (SKETCH)

The portrait for which this is a study is no longer in existence (No. 492). Three-quarters length, seated, half left, her hands joined in her lap; red dress with brown fur around the shoulders; dark brown background. Cardboard, 13¾ x 11. Squared off for enlarging. Signed, l. r.: "T. E." 1895. Owned by Mrs. Eakins.

287 MISS GERTRUDE MURRAY

Sister of Samuel Murray. Head and bust, slightly right of full-face, of a young woman with brown hair and blue eyes, wearing a pink silk dress with puff sleeves and high collar, trimmed with cream-colored lace. Golden brown background. Canvas, 24 x 20. Inscribed u. l.: *"To my pupil Samuel Murray, T. E., 1895"*. Owned by Samuel Murray, Phila.

288 CHARLES LINFORD

1846–1897. Landscape painter. Three-quarters length, seated, half right, gazing in front of him, hands on knees, palette on left hand. Bald brow, heavy nose, dark hair and moustache; black suit; dark gray background.

Unfinished. Canvas, 48 x 36. Signed on back: "т. е." About 1895. Owned by Mrs. Eakins.

9 CAPT. JOSEPH LAPSLEY WILSON
1844–1928. Captain of the First City Troop of Philadelphia. Head and bust, almost in profile left; dark brown hair, auburn moustache and full beard; dark blue uniform with gold epaulets, a gold and red sash across his chest; gray-brown background. Canvas, 30 x 22. Unsigned. About 1895. Owned by Mrs. Joseph Lapsley Wilson, Merion, Pa.

0 SKETCH. The head only. Canvas mounted on cardboard, 7¾ x 5¼. Unsigned. Owned by Mrs. Eakins.

1 THE 'CELLO PLAYER
(Plate 47)
Portrait of Rudolph Hennig (1845–1904), leading 'cellist of the Thomas Orchestra in the '70s, and for many years a member of the Mendelssohn Quintette. His hair and beard are dark brown, slightly grayed, he wears a black suit, the chair is reddish brown, and the background golden brown. Canvas, 64 x 48. Signed, l. r.: "*Eakins 96*". Purchased by the Pennsylvania Academy of the Fine Arts, the present owner, from their Temple Collection Fund, out of their 66th Annual Exhibition, February, 1897. Eakins gave Hennig half the purchase price for posing.

2 SKETCH. Canvas, 17½ x 14. Squared off for enlarging. Inscribed l. l.: "*To my dear pupil Samuel Murray, Thomas Eakins*". Owned by Samuel Murray, Phila.

3 MRS. JAMES MAPES DODGE
Wife of Eakins' friend James Mapes Dodge (1852–1915), prominent Philadelphia business man and friend of artists. Head and bust, almost in profile left, of a young woman with dark hair and ruddy, glowing complexion, wearing a light green velvet low-necked dress with large puff sleeves; she faces the light. Olive background, darker and warmer at the left. Canvas, 24¼ x 20¼. Signed l. r.: "*EAKINS 96 to his friend JAMES M. DODGE.*" Owned by Mrs. James Mapes Dodge, Germantown, Phila.

94 HARRISON S. MORRIS
Author; born 1856. As managing director of the Pennsylvania Academy, 1893–1905, he played an active part in the world of American art. A friend of Walt Whitman, he has written a biography of him, as well as poetry, novels and art criticism. An appreciation of Eakins by him appeared in the Metropolitan Museum *Bulletin* at the time of the Memorial Exhibition; and his recent book, *Confessions in Art*, gives an entertaining account of his relations with the artist. Three-quarters length, standing, body slightly left, head almost in profile left, his left hand in his trousers pocket, his right by his side. Red necktie, black coat, gray trousers. Warm light golden-brown background. Canvas, 54 x 36. Inscribed l. r.: "*To his friend Harrison Morris, Thomas Eakins, 1896*". Owned by Harrison S. Morris, Phila.

295 **SKETCH.** Canvas mounted on cardboard, 17½ x 13. Signed l. r.: "*Eakins*". Squared off for enlarging. Owned by Mrs. Eakins.

295A **PROF. WILLIAM WOOLSEY JOHNSON**
1841–1927. Mathematician; professor of mathematics at the U. S. Naval Academy, Annapolis; author of numerous textbooks, especially on calculus. Head and bust, half left; grayed moustache and beard; gray-blue eyes; wing collar, bow tie, dark suit; dark maroon background. Canvas, 24 x 20. Unsigned. About 1896. Owned by the sitter's son, Charles W. L. Johnson, Baltimore, Md.

296 **DR. CHARLES LESTER LEONARD**
1861–1913. Pioneer in Roentgenology, one of the earliest in this country to use the X-ray method of diagnosis, director of X-ray laboratories in various hospitals, president of the American Roentgen-Ray Society, founder of the Philadelphia Roentgen Society, author of many writings on the subject. His hands were burned by X-ray in the early days of his work, and after a vain battle against the invasion of the body, he died at the age of fifty-one, a martyr to his specialty. Head and bust, slightly left of full-face; broad, high forehead and long nose, black hair and long moustache, dark brown eyes fixed on the spectator, pince-nez; black suit. Canvas, 24 x 20. Signed on back: "EAKINS 97". Frame inscribed: "CAROLVS LESTER LEONARD MEDICVS QVI ARCANA BENEFICA VIRTVTIS ELECTRICAE CVIVS RADIOS SVBTILES ROENTGEN PRIVS DETEXERAT QVAERENDO PROPRIAM COMMVNI SALVTEM POSTPONENS PERIIT". Owned by Mrs. Eakins.

297 MRS. SAMUEL MURRAY

A slender young woman, three-quarters length, seated, full-face, her right hand on her hip, her left hand in her lap. Blond hair and complexion, gray-blue eyes fixed on the spectator, aquiline nose, slender hands; black dress trimmed with apple-green, with puff sleeves. Unfinished. Reproduced in *The Arts*, October, 1931, p. 41. Canvas, 40 x 30. Unsigned. About 1897. Owned by Mrs. Eakins.

298 MRS. SAMUEL MURRAY

Head and bust, in much the same position as the preceding, and wearing the same dress. Not entirely finished. Canvas, 24 x 20. Unsigned. Owned by Samuel Murray, Phila.

299 MISS LUCY LEWIS

Friend of the Eakinses. Head and bust, body half right, head almost full-face; dark hair, dark eyes, warm complexion, full lips; low-necked white dress with very full ruffle around shoulders; deep claret-colored background. Canvas, 22 x 27⅛. Unsigned. About 1897. Owned by Miss Lucy Lewis, Phila.

300 MISS ANNA LEWIS

Friend of the Eakinses; sister of Miss Lucy Lewis. Half-length, seated, half right, her hands joined in her lap, her head tilted slightly toward the right. Dark brown hair, blue eyes, round face; filmy white evening dress, with ruffle around the shoulders; dark brown background. Unfinished. Canvas, 33 x 27¾. Signed l. r.: "T. E." About 1898. Owned by Mrs. Eakins.

301 WILLIAM H. MACDOWELL WITH A HAT

Engraver: father of Mrs. Thomas Eakins. Head and bust, full-face, wearing a wide-brimmed black hat. Long gray hair, gray moustache and beard; dark suit. Deep brown background. Strong Rembrandtesque contrast of light and shade. Canvas, rebacked, 28 x 21½. Signed on back: "T. E." About 1898. Owned by Mrs. Thomas Eakins.

302 GEN. E. BURD GRUBB

Soldier, diplomat, and mine-owner. As volunteer in the Civil War, he rose from the rank of private to brevet Brigadier-General. For some years captain of the First City Troop,

Philadelphia. Republican candidate for Governor of New Jersey, 1888; defeated. From 1890–1892 United States Minister to Spain, where he negotiated the Reciprocity Treaty. Head and bust, half left; gray hair, moustache and side-whiskers; dark blue uniform, dark brown background. Unfinished, as the General, after one sitting, did not return. Reproduced in the Met. Mus. Mem. Exh. catalogue. Canvas, 30 x 22. Signed on back: "T. E." Probably about 1898. Owned by Reginald Marsh, Flushing, N. Y.

303 TAKING THE COUNT
(Plate 48)

The standing fighter, with a green sash, is Charlie McKeever; the kneeling one, with a red sash, is Joe Mack; the referee is H. Walter Schlichter. All the spectators are portraits. Also called *Counting Out*. Canvas, 96 x 84. Signed l. l.: "EAKINS 98". In the Whitney Collection of Sporting Art, presented in 1932 by Francis P. Garvan to Yale University, New Haven, Conn.

304 SKETCH. Study for the arrangement of the three figures. Canvas mounted on cardboard, 10 x 9¾. Unsigned. Owned by Mrs. Eakins.

305 SKETCH. Study for the arrangement of the three figures. Canvas, 24 x 18. Unsigned. Squared off for enlarging. Owned by Mrs. Eakins.

306 THE REFEREE (STUDY). Head and bust. Canvas, 20 x 16. Signed on back: "T. E." Owned by Mrs. Eakins.

307 MAYBELLE

Portrait of Mrs. Maybelle Schlichter, wife of the referee in *Taking the Count*. Head and bust, half right, looking in front of her; black hair; low-necked black dress leaving her shoulders bare; back of chair behind; olive-brown background. Reproduced in *The Arts*, October, 1929. Canvas, 24 x 18. Inscribed on back: "TO MY FRIEND MRS. SCHLICHTER, THOMAS EAKINS, 1898". Owned by Samuel Murray, Phila.

308 SKETCH. Canvas mounted on cardboard, 14 x 11. Unsigned. The sketch on the back is not by Eakins. Owned by Mrs. Eakins.

309 JOHN N. FORT

Music and art critic. He appears also in *Tak-

ing the Count, in the first row of the audience at the extreme right. Head and bust, body almost full-face, head turned slightly right, peering over his pince-nez; his right hand showing. Bald brow, grayish hair and moustache; black suit, dark brown background. Canvas, 24 x 20. Signed l. r.: *"To my friend J. N. Fort, Eakins, 98".* Owned by his son, Lee J. Fort, Phila.

o SALUTAT
(Plate 49)

The fighter is Billy Smith. In the audience can be recognized Samuel Murray, David Wilson Jordan and Clarence W. Cranmer. Canvas, rebacked, 50 x 40. Signed l. r.: "EAKINS 1898". On the original frame is carved: "DEXTRA VICTRICE CONCLAMANTES SALVTAT". Owned by the Addison Gallery of American Art, Phillips Academy, Andover, Mass.

1 STUDY. Canvas, 20 x 16. Inscribed on back: *"Dextra victrice Conclamantes Salutat. To his friend Sadakichi Hartmann, Thomas Eakins".* Owned by Mrs. Emil Carlsen, Falls Village, Conn.

2 BETWEEN ROUNDS
(Plate 50)

The fighter is Billy Smith; the second waving a towel is Billy McCarney; the one bending over is Ellwood McCloskey, "The Old War Horse"; the timer is Clarence W. Cranmer, newspaperman and friend of Eakins. All the spectators are portraits. The scene is the Arena at Broad and Cherry Streets, no longer in existence. Canvas, 50¼ x 40. Signed l. r.: "EAKINS 99". Owned by the Penna. Museum.

3 SKETCH. Study for the composition. On the back, a landscape sketch. Oil on cardboard, 4 x 5¾. Unsigned. Owned by Mrs. Eakins.

4 BILLY SMITH (SKETCH). Study of his whole figure. Canvas, 20 x 16. Signed on back: "T. E." Owned by the Penna. Museum.

5 BILLY SMITH (STUDY). Head, bust and part of arms, in the same position as in *Between Rounds.* Canvas, about 21 x 17. Inscribed at right: "BILLY SMITH FROM HIS FRIEND THOMAS EAKINS, 1898". Owned by William Smith, Upper Darby, Pa.

6 THE TIMER (STUDY). Reproduced in *The Arts,* October, 1929, p. 83. Canvas, 21 x 17. Inscribed across bottom: *"Souvenir. Clarence W. Cranmer from his friend Thomas Eakins".* Owned by Clarence W. Cranmer, Phila.

317 WRESTLERS

Two men wrestling, one lying on his right side, his head to the right, the other on top of him, trying to turn him on his back with a hold on his neck which the under man is trying to loosen with his left arm. The faces of both are red with exertion. Behind at the right appear the legs of two spectators, one in tweed knickerbockers, the other nude except for a breechcloth; further back at the left a nude man is seated at a rowing machine. Canvas, 48 x 60. Signed on wall, above right center: "EAKINS 1899". Owned by the National Academy of Design, New York, to whom Eakins gave it as his "diploma picture" on his election as Academician in 1902. Reproduced in the *Brooklyn Museum Quarterly,* April, 1932.

318 WRESTLERS (STUDY). Reproduced in the Met. Mus. Mem. Exh. catalogue. Canvas, 16 x 20. Signed l.r.: "T. E.", and on the back: "T.E." Owned by the Harrison Gallery, Los Angeles Museum.

319 WRESTLERS. An unfinished version, showing only the two wrestlers. Reproduced in *Artwork,* London, Autumn, 1930. Canvas, 40 x 50. Unsigned. Squared off. Owned by Fiske Kimball, Phila.

320 THE FAIRMAN ROGERS
FOUR-IN-HAND

Black and white version of No. 133, painted to be reproduced as the frontispiece of Fairman Rogers' book, *A Manual of Coaching,* published 1900. As in the case of the drawing of the *Gross Clinic,* Eakins, believing that a photograph falsified values, made this black-and-white copy. Oil on canvas, 24 x 36. Squared off in white chalk. 1899. Owned by Mrs. Eakins.

321 T. ELLWOOD POTTS

Lawyer, of the firm of Potts & Eberle, conveyancers, 524 Walnut Street, Philadelphia. He handled the legal work on Benjamin Eakins' real estate. Eakins painted his portrait between 1890 and 1900. He died about 1900, and the portrait was left in his office, where it was seen ten or more years ago. I have been unable to trace his family or the portrait.

322 MRS. T. ELLWOOD POTTS

Probably painted about the same time as the preceding. I have been unable to trace it.

323 MISS MARY ADELINE WILLIAMS

Childhood friend of Thomas and Margaret Eakins; lived with the Eakinses from 1900 on. The artist painted a later portrait of her (No. 333). Head and bust, turned slightly right; dark brown hair and eyes; high white collar and pleated black dress; strong light from left; dark brown background. Canvas, 24 x 20. Unsigned. 1899. Owned by Mrs. Eakins.

324 BENJAMIN EAKINS
(Plate 51)

Father of Thomas Eakins. Black suit; dark reddish-brown background. Canvas, 24 x 20. Unsigned. Painted about 1899, shortly before the sitter's death. Owned by the Penna. Museum.

325 MRS. THOMAS EAKINS

Head and bust, full-face, her head tilted somewhat to the left. She wears a black jacket with a high collar flaring out from the throat, a black scarf around her neck fastened in front with a green pin, and a light blue shirtwaist. Dark brown background. Canvas, 20 x 16. Unsigned. About 1899. Owned by Mrs. Eakins.

326 MRS. WILLIAM H. GREEN

Head, bust and arms, seen to the waist, of a young woman, slightly right of full-face. Curly dark hair, low on the forehead, dark eyes, dark complexion; black evening dress, collar of pearls around neck. Red-brown background; strong light, coming from the left. Painted from a photograph after the subject's death. Canvas, 27 x 22. Signed l. r.: "EAKINS 1899". Owned by Samuel Murray, Phila.

327 THE DEAN'S ROLL CALL
(Plate 52)

Portrait of Prof. James W. Holland (1849–1922), dean of the Jefferson Medical College for thirty years, professor of medical chemistry and toxicology, and a noted urologist. He is shown in the official robes of a doctor of medicine, calling the roll of candidates to receive degrees. Light hair and beard; gray-blue eyes; black gown trimmed with vivid green; warm gray background. Canvas, 84 x 42. Signed l. r.:

"*Eakins 1899*". Owned by Mrs. James W. Holland, Phila.

328 LOUIS HUSSON

1844–1923. Pioneer photographer and photo-engraver. Of French birth, he settled in Philadelphia in 1874 and became one of Eakins' closest friends. Head and bust, half right, gazing in front of him. Dark brown hair, moustache and beard; piercing hazel eyes; aquiline nose; dark blue double-breasted coat; dark brown background. Canvas, 24 x 20. Inscribed u. r.: "*To his friend Louis Husson, Thomas Eakins, 1899*", and on back: "TO KATY HUSSON FROM HER FRIEND THOMAS EAKINS". Owned by his daughter, Mrs. Simon M. Horstick (*née* Katharine Husson), Pleasantville, N. J.

329 DAVID WILSON JORDAN

Painter, particularly of landscape; born 1859. Pupil of Eakins at the Pennsylvania Academy, and later a close friend. Eakins also painted his sister (No. 222). Three-quarters length, standing, facing away toward the right, his back turned almost half toward the spectator; his head more in profile. Dark hair and beard, black suit; his right hand at his side, holding gray gloves. Dark greenish gray background. General reserved color scheme of grays, blacks and whites. Canvas, 60 x 28. Signed l. l.: "DAVID WILSON JORDAN FROM HIS FRIEND THOMAS EAKINS 1899". Owned by David Wilson Jordan, New York.

330 WILLIAM M. CHASE

1849–1916. Painter and teacher; for ten years president of the Society of American Artists; head of the schools of the Pennsylvania Academy from 1897 to 1909. Head and bust, almost in profile left. Brown, slightly grayed hair, moustache and pointed beard; pince-nez with black ribbon, black suit, white cravat with a gold pin; white gardenia in his button-hole. Plain brown background. Reproduced in the Met. Mus. Mem. Exh. catalogue. Canvas, 24 x 20. Inscribed on back: "TO MY FRIEND WILLIAM M. CHASE, THOMAS EAKINS". About 1899. Owned by John F. Braun, Merion, Pa.

331 THE THINKER
(Plate 53)

Portrait of Louis N. Kenton, husband of Mrs. Eakins' sister Elizabeth Macdowell Kenton.

Dark hair, black suit and shoes, dark red necktie, light golden gray background. Canvas, 82 x 42. Signed l. r.: *"Eakins 1900"*. Owned by the Metropolitan Museum of Art, New York.

32 SKETCH. Oil on cardboard mounted on wood, 13¾ x 10. Unsigned. Squared off for enlarging. On the back, a sketch for the portrait of Mgr. J. F. Loughlin (No. 365). Owned by David Wilson Jordan, New York.

33 ADDIE
(Plate 54)
Portrait of Miss Mary Adeline Williams (see No. 323). Dark brown hair and eyes; black dress striped with light red, light red ribbon around the neck, and smaller ones on each side; dark brown background. Oil on canvas, 24 x 18. Signed on back: "T. E." 1900. Owned by the Penna. Museum.

34 MRS. MARY ARTHUR
Mother of Robert Arthur, painter. Head and bust, half left, of an elderly white-haired woman, wearing spectacles, a black lace cap and black dress, looking down at her knitting, both hands showing. Dark background. Canvas, 24 x 20. Inscribed on back: *"To his dear friend Robert Arthur, Thomas Eakins, 1900"*. Owned by the sitter's granddaughter, Miss Mary Arthur Bates, Englewood, N. J.

35 ROBERT M. LINDSAY
Philadelphia art dealer and print collector, proprietor of Lindsay's Galleries at Eleventh and Walnut Streets; died about 1908. Full-length, seated, half left, in an armchair, looking at a print. Bald brow; moustache, beard, pince-nez; dark suit. A portfolio at the left; an Oriental rug on the floor; behind, print cabinets, and paintings on the wall. Also called *The Print Collector* and *The Book Collector*. Reproduced in *The Arts*, October 1929, p. 77. Canvas, re-backed, 24 x 20. Signed at right center: "EAKINS 1900". Owned by Ernest Lee Parker, Phila.

36 SKETCH. Wood, 11¾ x 10½. Unsigned. Owned by Ernest Lee Parker, Phila.

37 FRANK JAY ST. JOHN
Business man and inventor; died 1900. Full-length, seated in a mahogany armchair, half left, holding a soft black felt hat in his lap, wearing a black overcoat over a black business suit. Brown

hair and moustache, glasses, red necktie. Oriental rug on the floor. Canvas, 24½ x 20½. Signed right center: "EAKINS 1900". Owned by his daughter, Mrs. Benjamin F. Chappelle, Reno, Nevada.

338 MRS. WILLIAM D. FRISHMUTH
(Plate 55)
Collector of musical instruments, of which she gave a collection to the Museum of the University of Pennsylvania; also honorary curator of musical instruments for the Pennsylvania Museum, and prominent in museum affairs. She has brown hair and wears a black dress, with a light blue ribbon around her neck. The portrait was loaned by Eakins for a number of years to the University Museum, where it hung in the Frishmuth Collection. Canvas, 96 x 72. Signed l. r.: "EAKINS 1900". Owned by the Penna. Museum.

339 MRS. JOSEPH H. DREXEL
Donor of the Drexel collection of fans to the Museum of the University of Pennsylvania. Eakins began a portrait of her similar in type to that of Mrs. Frishmuth, showing her full-length, seated, a little left of full-face, holding two fans. She gave a few sittings but could not spare the time for more, and the portrait was abandoned when little more than sketched in. Canvas (unstretched), 72 x 53. Squared off in white chalk. Unsigned. 1900. Owned by Mrs. Eakins.

340 SKETCH. On the reverse, a study for a portrait of Mr. and Mrs. John D. Trask, never carried out. Oil on cardboard, 14½ x 10½. Unsigned. Owned by Mrs. Eakins.

341 CLARA
(Plate 56)
Portrait of Clara J. Mather. Dark hair, black dress, dark brown background. Canvas, 24 x 20. Signed l. r.: *"T. Eakins"*. About 1900. Presented by Mrs. Eakins in 1930 to the Pennsylvania Museum of Art, and presented by the latter in 1931 to the Musée du Louvre, Paris.

342 A WOMAN IN BLACK. Two sketches of Clara J. Mather, standing, in black evening dress; studies for a full-length portrait never carried out; instead Eakins painted the preceding. Wood, 26 x 7½. Unsigned. Owned by Mrs. Eakins.

343 ELIZABETH R. COFFIN

1850–1930. Painter, pupil of Eakins, and prominent in the Brooklyn Art Guild, where Eakins taught in the '90s. Head and bust, half left, the head high in the picture and tilted to the left, the eyes fixed on the spectator. Gray hair, black dress with narrow white collar, dark background. Reproduced in the Met. Mus. Mem. Exh. catalogue. Canvas, 24 x 20. Signed l. r.: "EAKINS". About 1900. Owned by the Coffin School, Nantucket, Mass.

344 DR. EDWARD J. NOLAN

1847–1921. Physician; for many years librarian and recording secretary of the Academy of Natural Sciences of Philadelphia; also prominent in the Art Club. Head and bust, half right; bald on top; gray hair, moustache and heavy beard; pince-nez; high white stand-up collar, black suit. Warm gray background. Canvas, 24 x 20. Signed l. r.: "EAKINS" and on back: "T. E." About 1900. Owned by the Penna. Museum.

345 HENRY O. TANNER

Painter of religious subjects; born 1859. Pupil of Eakins at the Pennsylvania Academy. Head and bust, half left, looking down; black hair, brown moustache and goatee, spectacles, dark suit; dark brown background. Reproduced in *The Arts*, December 1923, p. 317. Canvas, rebacked, 24⅛ x 20¼. Signed l. r.: "EAKINS", and on back: "*Thomas Eakins*". About 1900. Owned by Mrs. Eakins.

346 HON. JOHN A. THORNTON

One time postmaster of Philadelphia. Head and bust, in profile right, the head at the left of the picture; dark hair, clean-shaven, heavily built; dark brown background. Canvas, 24 x 20. Unsigned. Owned by the Hon. John A. Thornton; in the possession of Samuel Murray, Phila.

347 MGR. JAMES P. TURNER

1857–1929. Vicar-general of the archdiocese of Philadelphia, 1902–1910; Managing Editor of the *American Catholic Quarterly Review*, and prominent in Catholic charities. He was a close friend of Eakins in the later years of the artist's life. This portrait was painted about 1900, before he was a Monsignor, and was exhibited under the titles of *Portrait of a Clergyman* or *The Vicar-General*. Eakins

painted a later portrait of him (No. 438). Head and bust, half right, leaning his head on his left hand and looking at the spectator. Bald brow, dark brown hair, clean-shaven, pince-nez, black cassock, dark gray-brown background. Canvas, 24 x 20. Unsigned. Owned by his cousins, the Misses Anna A., Helen C., and Elizabeth A. King, Phila.

348 PROF. LESLIE W. MILLER
(Plate 57)

1848–1931. Painter and teacher of art; principal of the School of Industrial Art of the Pennsylvania Museum, 1880–1920, and a prominent figure in the Philadelphia art world. He is shown addressing an audience. His hair and beard are grizzled; he wears a dark gray suit, black necktie, black shoes. The screen is golden, the background in general warm gray. Awarded the Thomas R. Proctor Prize for the best portrait in the 80th Annual Exhibition of the National Academy of Design, New York, 1905; and the Second Prize at the 11th Annual International Exhibition of the Carnegie Institute, Pittsburgh, 1907. Canvas, 88⅛ x 44. Signed on the floor, l. r.: "*Eakins 1901*". Owned by Mrs. Edgar V. Seeler, Phila., and loaned to the Penna. Museum.

349 SKETCH. Oil on cardboard, 13¼ x 9½. Unsigned. Squared off for enlarging. Owned by the sitter's son, Percy Chase Miller, Oak Bluffs, Martha's Vineyard, Mass.

350 MRS. LESLIE W. MILLER

Head and bust, seated, half left, her left arm and hand showing. Grayish hair parted in the middle and brushed down simply on the sides; spectacles; plain dark dress with a high collar. Canvas, 24 x 20. Inscribed u. l.: "*To his friend Percy Chase Miller from Thomas Eakins*". 1901. Owned by Percy Chase Miller, Oak Bluffs, Martha's Vineyard, Mass.

351 MRS. ELIZABETH DUANE GILLESPIE

Prominent in the affairs of the Pennsylvania Museum and School of Industrial Art. Prof. Leslie W. Miller, principal of the school, wrote me: "Mrs. Gillespie refused to go near him [Eakins] again after he received her one blistering hot day in his studio up three or four flights of stairs, dressed only in an old pair of trousers and an undershirt. He wanted her to give him

one or two more sittings, but she not only refused them, but wanted me to destroy the portrait after it came into my possession—which of course I didn't do". Half-length, seated, slightly left of full-face, her hands clasped in front of her. Gray hair, parted in the middle and smoothed down tightly, ruddy complexion, piercing eyes. Black dress, with white trimming at the throat; dark brown background. The face and hands are practically finished; the rest broadly indicated. Canvas, 45 x 30. Inscribed on back: "UNFINISHED PORTRAIT OF MRS. E. D. GILLESPIE BY THOMAS EAKINS PRESENTED BY HIM TO THE PENNSYLVANIA SCHOOL OF INDUSTRIAL ART, 1901". Owned by the Pennsylvania Museum School of Industrial Art, Phila.

352 SKETCH. Canvas, 24 x 20. Squared off for enlarging. Owned by Mrs. Eakins.

353 GEORGE MORRIS
1828–1912. Merchant; hunting and boating companion of Benjamin and Thomas Eakins. This portrait was painted soon after the death of Benjamin Eakins. Head and bust, half right, seated in a high-backed chair. White hair and side-whiskers, spectacles, ruddy complexion, aquiline nose; dark gray suit; gray background. At the right center is a line drawing in red of a sailboat. Canvas, 24 x 20. Inscribed u. r.: "HANC EFFIGIEM CARISSIMI PATERNI AMORIS SOCII PINXIT BENIAMINI EAKINS FILIVS A.D. MCMI PHILADELPHIÆ". On back: "THIS PORTRAIT OF HIS FATHER BELONGS TO WILLIAM MORRIS". Owned by the sitter's granddaughter, Mrs. Clara Morris Bullock, Phila.

354 REV. PHILIP R. McDEVITT
Born 1858. Superintendent of parish schools, Philadelphia, 1899–1916. Bishop of Harrisburg since 1916. Head and bust, half left, looking to left; dark hair, moustache and beard; spectacles; black cassock. Reproduced in the Penna. Acad. Mem. Exh. catalogue. Canvas, 20 x 10. Unsigned. 1901. Owned by the Rt. Rev. Philip R. McDevitt, Harrisburg, Pa.; in the possession of his sister, Miss Mary McDevitt, Phila.

355 CHARLES F. HASELTINE
1840–1915. Philadelphia art dealer, who handled Eakins' work in early years, and at whose gallery the *Gross Clinic* and the *Agnew*

Clinic were first exhibited. Head and bust, half left; white hair and moustache, white necktie, black suit; red-brown background. Reproduced in the Met. Mus. Mem. Exh. catalogue. Canvas, 24 x 20. Signed on back: "EAKINS". About 1901. Owned by Mrs. Eakins.

356 ELBRIDGE AYER BURBANK
1858–1930. Painter, particularly of North American Indians. Eakins painted his portrait about 1901, and presented it to him. I have been unable to trace his family or the portrait.

357 ALFRED F. WATCH
Optician, formerly with Riggs & Brother of Philadelphia, later in business for himself; died about 1920. Portrait painted about 1901 and presented to him. I have been unable to trace his family or the portrait.

358 SELF-PORTRAIT
(Frontispiece)
Painted in 1902, when Eakins was in his fifty-eighth year, as his "diploma" portrait on the occasion of his election as Associate of the National Academy of Design. Grayed hair, gray-brown moustache and beard, dark iron-gray eyebrows, dark brown eyes. Black suit, black bow tie. Dark grayish brown background. Canvas, 30 x 25. Unsigned. (The inscription on the back, "Thomas Eakens by himself, 1893", is not in Eakins' handwriting and is incorrect as to date.) Owned by the National Academy of Design, New York.

359 COL. ALFRED REYNOLDS
1849–1926. Colonel in the 22nd Infantry, U. S. Army; graduate of West Point; took part in the Spanish-American War; retired 1914. Cousin of Mrs. Thomas Eakins. Head and bust, slightly right of full-face, his head tilted toward the left; blond hair and moustache; uniform of a major; dark background. Canvas, 24 x 16. Inscribed on back: "SIMVLACRVM PRÆFECTI COHORTIS REYNOLDS REM MANCIPI ELISABETHÆ REYNOLDS PINXIT THOMAS EAKINS AN MCMII". Owned by Mrs. Eakins' nephew Walter G. Macdowell, Roanoke, Va.

360 SIGNORA GOMEZ D'ARZA
(Plate 58)
Italian actress and wife of Enrico Gomez d'Arza, impresario of a small theatre in the

Italian quarter of Philadelphia. Eakins frequented this theatre, and the d'Arzas became good friends of the Eakinses. She has black hair, dark brown eyes, a swarthy complexion; wears red ear-rings, and a dress with dark blue sleeves and cream-colored cuffs and vest, trimmed with white lace. Warm golden-brown background. Canvas, 30 x 24. Signed on back: "T. E. 1902". Owned by the Metropolitan Museum of Art, New York.

361 HIS EMINENCE SEBASTIANO CARDINAL MARTINELLI

1848–1918. Second Apostolic Delegate to the United States, 1896–1902. Created Cardinal Archbishop of Ephesus, 1901. This portrait was painted in Washington at the Cardinal's residence in 1902, shortly before he returned to Rome. Full-length, seated in a carved highbacked armchair, almost in profile left, his hands resting on the arms of the chair. Black hair, dark complexion, clean-shaven. He wears the black robes of the Order of Hermits of St. Augustine, with a cardinal red skull-cap, and holds the cardinal red biretta in his left hand; the end of a red sash rests on his knee. On the floor is an Oriental rug; the background is golden brown panelled wood. In the upper left corner appears a coat-of-arms, the Augustinian Shield. Canvas, 79¼ x 60. Signed l. r.: "*Eakins 1902*". Inscribed on back: "EFFIGIES SEBASTIANI S R E CARDINALIS MARTINELLI QVI ANNOS VI IN STAT FOED AB MDCCCXCVI AD MCMII DELEGATI APOSTOLICI OFFICIO FVNCTVS"; below: "THOS. EAKINS PHILADELPHIEN A.D. MCMII PINXIT". Owned by the Catholic University of America, Washington, D. C.

362 VERY REV. JOHN J. FEDIGAN

1842–1908. Provincial of the Order of St. Augustine in the United States from 1898; built the new monastery and college buildings of Villanova College, whose president he had formerly been. Full-length, standing, slightly right of full-face, his left arm resting on a drawing-board with a picture of the new monastery. He has silvery gray hair, gray eyes, long, clean-shaven, kindly face, and wears the plain black robes of an Augustinian. Light warm gray wall behind. Canvas, 89½ x 50. Signed on base of drawing-board, l. r.: "EAKINS 1902". Pre-

sented by Eakins to Villanova College, Villanova, Pa., the present owner.

363 SKETCH. Canvas, 24 x 20. Squared off for enlarging. Unsigned. Owned by Mrs. Eakins.

364 THE TRANSLATOR
(Plate 59)

Portrait of the Rt. Rev. Mgr. Hugh T. Henry (born 1862), president of the Roman Catholic High School in Philadelphia, 1902–1919; professor at St. Charles Seminary, Overbrook, Pa.; author, translator, editor of *Church Music*; president of the American Catholic Historical Society for two terms; now professor of homiletics at the Catholic University of America, Washington. He is shown translating the *Poems, Charades, Inscriptions* of Leo XIII, whose portrait hangs on the wall; wearing the robes of a Doctor of Literature, black with a white stripe across the front. Canvas, 50 x 40. Inscribed on front of desk: "CYGNI VATICANI LEONIS XIII VOCEM CANORAM AURIBUS ANGLICIS ACCOMMODAVIT HUGO THOMAS HENRY E VIVO DEPINXIT THOMAS EAKINS A D MCMII". Mgr. Henry writes me: "You are doubtless aware that Mr. Eakins painted such portraits simply out of love of his art. . . . He asked me to sit for him, offered me the completed work as a gift, and only at my suggestion presented it to the American Catholic Historical Society, Philadelphia"—the present owner.

365 MGR. JAMES F. LOUGHLIN

1867–1911. Rector of the Church of the Nativity of the Blessed Virgin Mary, Philadelphia; editor of the *American Catholic Quarterly Review*. Full-length, standing, slightly left of full-face. Round face, reddish blond hair, gray-blue eyes, pince-nez; bare-headed; black cassock, with red buttons, purplish-red sash, long red cloak. His left hand holds the edge of the cloak. Behind, a secretary at the left, a brownish wall, and a chair at the right. Canvas, 90 x 45. Signed l. r.: "*Eakins 1902*". In bad condition, with several holes in it, when the writer examined it. After hanging for many years in the parish house of Mgr. Loughlin's church, it was moved in 1930 to St. Charles Seminary, Overbrook, Pa. For sketch see No. 332.

366 JOHN SEELY HART

1810–1877. Principal, 1842–1858, of the

Central High School of Philadelphia, of which Eakins was a pupil from 1857 to 1861. This portrait was commissioned in 1902 by John Story Jenks, an alumnus, and presented to the school on the occasion of the dedication of the new building in November, 1902. Painted from a photograph. Head and bust, half right; grayish blond hair, ruddy complexion, clean-shaven; black suit; dark warm gray background. Canvas, 30 x 25. Unsigned. Owned by the Central High School, Phila.

367 CHARLES E. DANA

1843–1914. Painter, writer, and professor of art at the University of Pennsylvania; president of the Philadelphia Watercolor Society and of the Fellowship of the Pennsylvania Academy. Three-quarters length, standing, half left, his left arm at his side, his right bent, holding a cigarette in a holder. A handsome, stylishly dressed figure, with gray hair and moustache, wearing a frock-coat, high wing collar, white tie. His coat of arms appears in the upper left corner. Brown background. Canvas, 50 x 30. Unsigned. Probably about 1902. Presented by Mrs. Charles E. Dana in 1913 to the Pennsylvania Academy of the Fine Arts, the present owner.

368 THE YOUNG MAN

Portrait of Kern Dodge (born 1880), son of James Mapes Dodge (see No. 293); now a consulting engineer and Director of Public Safety of Philadelphia. Three-quarters length, standing, almost in profile left, his left hand in his trousers pocket. Dark hair, clean-shaven; pince-nez; dark gray suit, no vest, white shirt and collar. Cool brown background. Unfinished, except for the head. Reproduced in the Met. Mus. Mem. Exh. catalogue. Canvas, 45 x 26. Signed l. r.: "*T. Eakins*", and on back: "T. E." About 1902. Owned by the Penna. Museum.

369 MISS MARY PERKINS (STUDY)

Head and bust of a young woman, slightly left of full-face; auburn hair, wide-brimmed black hat perched on top of her head, dark brown coat open in front, brown background. Unfinished. Canvas, 20 x 16. Signed on back: "T. E." About 1902. Owned by Mrs. Eakins.

370 GIRL WITH A FAN

Portrait of Miss Gutierrez. Head and bust, half right, of a young woman holding a gray fan to her face with her right hand. Black hair, dark brown eyes, gold ear-rings, white blouse; brown background. Strong light from the left. Canvas, 20 x 16. Signed on back: "T. E." About 1902. Owned by Mrs. Eakins.

371 ADAM S. BARE

Art dealer, connected for many years with the Haseltine Galleries in Philadelphia, Eakins' dealers. Head and bust, half left; grayish brown hair, moustache and beard; bald on top; ruddy complexion; gold-rimmed spectacles; black suit, high white collar. Canvas, 24 x 20. Signed on back (by Mrs. Eakins in 1929): "T. E. 1903". Owned by the sitter's daughter, Miss Florence Bare, Phila.

372 WALTER COPELAND BRYANT

Collector of American art. Half length, seated, half left, his left arm resting on the arm of his chair, his right hand on his chest. Chestnut hair, blue eyes, fair skin, clean-shaven; dark blue suit. Dark maroon background. "Mr. Eakins asked Mr. Bryant if he could take all the liberty he wanted to do a fine piece of work as a work of art rather than a likeness", writes Mrs. Bryant. "He thought Mr. Bryant too youthful looking and said in fifty years nobody would know . . . Hand painted for a 70 year old man at Mr. Eakins' request to do as he wished. Mr. Bryant was 50. . . . Day beard at Mr. Eakins' request. . . . Painted in three sittings, a total of ten hours". Canvas, 24 x 20. Signed u. l.: "EAKINS 1903". Owned by Mrs. Walter Copeland Bryant, Brockton, Mass.

373 DR. MATTHEW H. CRYER

1840–1921. Oral surgeon; first professor of oral surgery at the University of Pennsylvania; author of *Studies in the Internal Anatomy of the Human Face*. Head and bust, half left; high forehead, long nose, brown hair and auburn moustache and beard, slightly grayed; blue eyes; black suit. Dark brown background. Canvas, 24 x 20. Signed l. r.: "T. E. 1903". Owned by Mrs. Matthew H. Cryer, Bryn Mawr, Pa. In previous catalogues of Eakins' work this picture has been erroneously listed as "Dr. Ayer".

374 ARCHBISHOP WILLIAM HENRY ELDER
(Plate 60)

1819–1904. For many years Bishop of
Natchez; distinguished himself for his devotion,
courage and charity, especially during the Civil
War, when he was arrested for not using a form
of prayer for the President, convicted, but par-
doned. Became Archbishop of Cincinnati in
1883, and built up the archdiocese; was devoted
to his parishioners and they to him. White hair,
deep violet biretta and cassock, with red sash
and red buttons; golden brown background.
Canvas, 66½ x 45½. Signed l. r.: *"Eakins
1903"*. Awarded the Temple Gold Medal at
the Pennsylvania Academy, 1904. Owned by
Archbishop John T. McNicholas of Cincinnati,
and hung in the lobby of Mt. St. Mary Seminary,
Norwood, Ohio.

375 MOTHER PATRICIA WALDRON
(SKETCH)

Study for a portrait painted in 1903, present
whereabouts unknown (No. 487). An elderly
Sister of Mercy, in black and white robes, half-
length, seated, slightly left of full-face, her
hands clasped in front; brown background. Can-
vas mounted on cardboard, 14⅜ x 10½. Squared
off for enlarging. Unsigned. Owned by the
Penna. Museum.

376 BISHOP EDMOND F. PRENDERGAST
(SKETCH)

Study for a picture which has disappeared
(No. 495). This sketch has been cut in half, and
shows only the sitter's head and bust, slightly
left of full-face, with a chair-back behind. Can-
vas, 6½ x 10. Unsigned. The sketches on the
reverse are not by Eakins. Owned by Mrs.
Eakins.

377 JAMES A. FLAHERTY

Lawyer, and a prominent Catholic layman;
born 1853. Formerly Supreme Knight of the
Knights of Columbus. Head and bust, half left;
iron-gray hair and moustache; black suit; dark
red-brown background. Canvas, 27 x 22. Signed
u. r.: "T. E. 1903". Owned by the Knights of
Columbus Home, Phila.

378 WILLIAM B. KURTZ

1856–1925. Banker and broker; member of
the firm of Kurtz Brothers, Philadelphia; an

amateur athlete, and a friend of Eakins. Three-
quarters length, standing, full-face, looking
straight at the spectator, his body turned slightly
left, his hands thrust into the side pockets of his
coat, thumbs outside. Curly dark hair, slightly
grayed; clean-shaven; loose-fitting gray suit.
Dark gray-brown background. Canvas, 52 x 32.
Signed l. r.: "EAKINS 1903". Owned by his son,
William Fulton Kurtz, Phila.

379 MISS ALICE KURTZ

Daughter of William B. Kurtz. Head and
bust of a young woman of about twenty, slightly
left of full face, looking down to the left. Brown
hair, tanned face, bare throat and arms; low-
necked cream-colored dress, with a flounce of
deep lace around front and shoulders. Back-
ground dark olive-brown. Canvas, 24 x 20.
Signed l. r.: "EAKINS". Summer 1903. Owned
by the sitter, now Mrs. John B. Whiteman,
Greenfield, Mass.

380 MRS. MARY HALLOCK GREENEWALT
(Plate 61)

Pianist; born 1871. Piano soloist with the
Pittsburgh and Philadelphia symphony orches-
tras in tours; concertized in piano throughout
the country. The first to use a color lighting ac-
companiment shifting in sympathetic feeling
with every phase of a musical composition, and
inventor of basic patents dealing with this
method of expression. Eakins also made a bas-
relief of her (No. 515). She has black hair, and
wears a pale lilac evening dress trimmed with
white lace. Grayish brown background. Can-
vas, 36 x 24. Signed u. r.: "EAKINS 1903". In-
scribed on back: "MARIÆ HALLOCK EFFIGIEM
THOMAS EAKINS PHILADELPHIENSIS PINXIT AN
MCMIII". Owned by Mrs. Mary Hallock Greene-
walt, Phila.

381 DR. FRANK LINDSAY GREENEWALT

Head and bust, slightly left of full-face. Dark
hair, high collar, dark brown suit, brown back-
ground. Canvas, 24 x 20. Inscribed on back:
*"To his friend Dr. Greenewalt, Thomas Eakins,
1903"*. Owned by Mrs. Mary Hallock Greene-
walt, Phila.

382 MRS. ANNA A. KERSHAW

Mother of Mrs. Samuel Murray. Head and
bust, full-face; silvery gray hair in a pompadour,

gray silk dress striped horizontally with white, high collar, string of black beads. Canvas, 24 x 20. Inscribed on back: "JENNIE DEAN KERSHAW FROM THOMAS EAKINS 1903". Owned by Mrs. Samuel Murray, Phila.

383 RUTH

Portrait of Ruth Harding, niece of Mrs. Samuel Murray. Head and bust, half left, of a girl of about ten, sitting in an armchair; her golden hair, tied with a pink ribbon, falls in two strands down the front; she wears a white dress. Dark red brown background. Reproduced in the Met. Mus. Mem. Exh. catalogue. Canvas, 24 x 20. Inscribed on back: "LAURA K. HARDING FROM THOMAS EAKINS 1903". Owned by Mrs. Edward H. Harding, Phila.

384 AN ACTRESS

Portrait of Miss Suzanne Santje (Mrs. Keyser). Full-length, seated, half right, her head leaning back, her arms resting on the arms of the chair. Abundant brown hair, dark skin; cerise dress, short-sleeved, with a high flaring collar and a train. A paper-backed book and a letter lie on the floor. Behind, a fireplace, a wall with a man's portrait, and a doorway. Canvas, 80 x 59½. Signed on floor, l. l.: "Eakins 1903". Owned by the Penna. Museum.

385 SKETCH. Canvas mounted on cardboard, 14 x 10. Unsigned. The sketch on the back is not by Eakins. Owned by Mrs. Eakins.

386 MISS BETTY REYNOLDS

Daughter of Mrs. Eakins' cousin Col. Alfred Reynolds (No. 359). Head and bust, almost in profile right, of a girl of about fifteen, with tanned complexion and blond hair hanging in two braids down the front, wearing a loose pink robe and seated in a chair with a curved back. Light gray background. Canvas, 24 x 20. Unsigned. About 1903. Owned by Mrs. Eakins.

387 THE OBOE PLAYER

Portrait of Dr. Benjamin Sharp (1858–1915), physician, zoölogist and writer; professor of invertebrate zoölogy at the Academy of Natural Sciences of Philadelphia, and the University of Pennsylvania; corresponding secretary of the Academy, for which he made numerous expeditions to the tropics and the arctic regions. He played the oboe in the Philadelphia Amateur Orchestra. Half-length, seated in a chair, in profile right, playing the oboe, both hands showing. White hair, dark moustache and beard, black suit, gray background. Canvas, 36 x 24. Signed at left on back of chair: "EAKINS 1903". Owned by Mrs. Benjamin Sharp, Nantucket Island, Mass.

388 REAR-ADMIRAL CHARLES D. SIGSBEE

1845–1923. Captain of the Maine when she was blown up in Havana harbor in 1898; advanced three numbers in rank for extraordinary heroism on this occasion and during the war with Spain. Commandant of League Island Navy Yard, Philadelphia, 1903–1904. Inventor of new apparatus and methods in deep sea exploration. Head and bust, half-left, in uniform, wearing a blue and white naval cap with gold braid; moustache, spectacles. Dark background. Canvas, 26 x 21. Unsigned. 1903. Owned by his daughter, Mrs. Anton Otto Fischer, Kingston, N. Y.

389 MRS. M. S. STOKES

Mother of Frank W. Stokes, painter and pupil of Eakins. Head and bust, full-face, of an elderly woman with grayed dark hair, wearing a white blouse with a white bow around the neck, her pince-nez hanging from a pin in front. Brownish gray background. Canvas, 24 x 20. Unsigned. Summer 1903. Owned by Frank W. Stokes, New York.

390 MRS. RICHARD DAY

Head and bust, half left, of an elderly woman gazing slightly downward, with silvery hair and blue-gray eyes, wearing a black dress with a high collar, open at the throat and down the front, showing a gray silk blouse. Deep mahogany-colored background. Canvas, 24 x 20. Unsigned. About 1903. Owned by Mrs. Eakins.

391 MOTHER

Portrait of Mrs. Dallas T. Gandy, sister of Miss Mary Adeline Williams. Head and bust, half left, looking down, her head tilted somewhat toward the right. Dark brown hair, in two long braids down the front, dark brown eyes; loose-fitting grayish-yellow gown. Very dark brown background. Canvas, 24 x 20. Inscribed on back: "TO ADDIE FROM TOM OF ANNIE". About 1903. Owned by Miss Mary Adeline Williams, Phila.

392 MRS. HELEN MacKNIGHT

Friend of Mr. and Mrs. Eakins; sister of Mrs. Gish (No. 488). Head and bust, half left, of a slender elderly woman with grayed brown hair and pale, fine complexion, wearing a white shirtwaist with a high collar. Warm brown background. Reproduced in *The Arts*, October 1931, p. 31. Canvas, 20 x 16. Signed l. l.: "*T. Eakins*"; inscribed on back: "TO HELEN MACKNIGHT FROM THOMAS EAKINS". About 1903. Owned by the sitter's daughter, Mrs. Helen I. Montgomery, Washington, D. C.

393 FRANCESCO ROMANO

Young Italian living in Philadelphia; friend of Eakins. Portrait, head and bust, painted about 1903. I have been unable to trace the sitter or his family.

394 ROBERT C. OGDEN

1836–1913. Merchant; member of the firm of John Wanamaker, New York. This portrait was painted in the New York studio of Eakins' pupil Frederick W. Stokes, who introduced Eakins to Ogden. It failed to please the sitter, his family or friends; there was also a dispute about the price, $1,500. Ogden paid it, but offered to return the picture to the artist "with his compliments". Eakins refused to take it back. Full-length, seated, half right, his arms on the arms of the chair, his left leg crossed over his right. White hair and beard, clean-shaven upper lip; black suit, black shoes. An Oriental rug on the floor; a tapestry on the wall behind. Canvas, 72 x 48. Signed on floor, l. l.: "*Eakins 1904*". Owned by the sitter's daughter, Mrs. Alexander Purves, Hampton, Va. Eakins painted an earlier version, which has disappeared (No. 489).

395 J. CARROLL BECKWITH

1852–1917. Portrait-painter, prominent in the "New Movement" and the Society of American Artists; one of Eakins' close friends. He is shown painting a portrait of his wife; standing, full-length, half left, with palette and brush, looking at the spectator. Gray hair, grayed blond moustache and goatee, brown eyes; high white collar, black suit, shiny black shoes. On the easel to the left is the portrait, in a fashionable style. Oriental carpet; warm brown background with part of a picture showing on the wall. Re-

produced in the Met. Mus. Mem. Exh. catalogue. Canvas, 83 x 48. Signed on base of easel: "EAKINS 1904". Inscribed on back: "TO MRS. CARROLL BECKWITH FROM HER FRIEND THOMAS EAKINS, 1904". Owned by Mrs. Eakins.

396 CHARLES PERCIVAL BUCK

Head and bust of a young man, half left, his head inclined toward the left; black hair, dark brown moustache, dark brown eyes, ruddy complexion, a rather plump face; light gray suit. Plain gray background. Canvas, 24 x 20. Signed u. r.: "EAKINS 1904". In the possession of his sister-in-law Mrs. Helen I. Montgomery, Washington, D. C.

397 MRS. JAMES G. CARVILLE

Head and bust, half left, of a young woman with a mass of soft dark brown hair piled on top of her head, tanned complexion, dark brown eyes; wearing a white shirtwaist with a pale lilac collar. Light gray background. Canvas, 20 x 16. Signed u. l.: "T. E.", and on back: "TO HIS FRIEND HARRIET CARVILLE, THOMAS EAKINS, 1904". Owned by Mrs. James G. Carville, Phila.

398 MRS. KERN DODGE

(See No. 368). *Née* Helen Peterson Greene. Head and bust, half left, of a young woman of about twenty, her head turned slightly toward the spectator. Brown hair, white wash dress with a high collar, gray background. Canvas, 24 x 20. Signed u. r.: "EAKINS 1904". Owned by Mrs. Kern Dodge, Germantown, Phila.

399 MRS. KERN DODGE

Same position, dress, and general color scheme. Canvas, 24 x 20. Signed l. l.: "EAKINS 1904". Owned by Mrs. Kern Dodge, Germantown, Phila.

400 MISS BEATRICE FENTON

Sculptress, born in 1887; daughter of Dr. Thomas H. Fenton (No. 429). A girl of about seventeen, three-quarters length, seated, half left, looking down, holding a white fan in both hands on her lap; brown hair, brown eyes; white dress, long string of red coral. Dark brown background. Reproduced in *Creative Art*, February 1931, page sup. 55. Canvas, 43 x 31. Signed on back of chair: "EAKINS 1904", and on back: "T. E." Owned by Mrs. Eakins.

01 WILLIAM R. HALLOWELL

1832–1906. Friend and hunting companion of Benjamin and Thomas Eakins, member of an old Pennsylvania family, and an amateur artist. Head and bust, almost in profile left; gray hair and moustache, gold-rimmed spectacles, blue eyes, ruddy complexion. High stand-up collar, dark blue suit. Dark brown background. Canvas, 24 x 20. Inscribed on back: "TO HIS FRIEND WILLIAM R. HALLOWELL FROM THOMAS EAKINS, 1904". Owned by Mrs. William S. Hallowell, Germantown, Phila.

02 MUSIC
(Plate 62)

Portrait of Hedda van der Beemt, violinist, of the Philadelphia Orchestra, and Samuel Myers, pianist. Both wear black suits; the background is dark brown; the general color scheme is reserved but deep and mellow. A reproduction of Whistler's *Sarasate* hangs on the wall. Canvas, 39½ x 49¾. Signed l. l.: "EAKINS 1904". Owned by the Art Institute of Chicago.

03 SKETCH. The violinist only. Canvas mounted on cardboard, 13 x 15. Squared off for enlarging. Unsigned. Owned by the Penna. Museum.

04 THE VIOLINIST

Portrait of Hedda van der Beemt in the same position as in *Music*, but three-quarters length. Eakins started this after *Music*, intending to present it to the sitter as a return for his posing for the earlier picture, but as the violinist could give only a few sittings, it was never finished. Canvas, 50 x 39½. Unsigned. 1904. Owned by Mrs. Eakins.

05 SAMUEL MYERS

Pianist; he appears also in *Music*. Head and bust, slightly left of full-face; abundant curly dark brown hair, moustache, pince-nez (the side of the face refracted as seen through the lens), black coat, white vest; gray background. Canvas, 24 x 20. Signed u. r.: "EAKINS 1904". Owned by Samuel Myers, Phila.

06 FRANK B. A. LINTON

Portrait painter; born 1871. Pupil of Eakins at the Art Students' League of Philadelphia. Head and bust, body half left, head full-face, looking at the spectator. Bald brow; dark hair, moustache and beard, pince-nez; high white collar, white necktie, black suit; gray background. Reproduced in *The Arts*, October 1929. Canvas, 24 x 20. Signed u. l.: "EAKINS 1904", and on back: "TO MY PUPIL FRANK B. A. LINTON, THOMAS EAKINS, 1904". Owned by Frank B. A. Linton, Phila.

407 MRS. EDITH MAHON
(Plate 63)

Pianist, of English birth. Dark brown hair, black dress; dark gray background. Canvas, 20 x 16. Inscribed on back: "TO MY FRIEND EDITH MAHON, THOMAS EAKINS, 1904". Owned by the Smith College Museum of Art, Northampton, Mass.

408 REAR-ADMIRAL GEORGE W. MELVILLE

1841–1912. Engineer-in-chief of the U. S. Navy, and Chief of the Bureau of Steam Engineering. Member of three Arctic expeditions. Chief Engineer of the *Jeannette* expedition of 1879–1882, when the ship was caught in the ice for almost two years and finally crushed. He had charge of one of three small boats and brought his men safely to land; then returned to the Arctic to search for his shipmates, but found only their bodies. For his heroism he was awarded a gold medal by Congress and advanced fifteen numbers.

Eakins asked him to pose for this portrait. Three-quarters length, standing, half-left, his left hand in his belt, his right by his side. A leonine head: bald brow, long white hair, moustache and full beard. Dark blue naval uniform, with heavy gold epaulets; three medals on his left chest. Brown background. Canvas, 48 x 30. Signed l. r.: "EAKINS 1904". Inscribed on back: "REAR ADMIRAL GEORGE WALLACE MELVILLE, U. S. N. BORN NEW YORK CITY JANUARY 10 1841. ENTERED U. S. NAVY JULY 29, 1861. 1881 CHIEF ENGINEER. 1887 ENGINEER IN CHIEF. 1898 REAR ADMIRAL. 1904 RETIRED. MEMBER OF THE HALL RELIEF EXPEDITION 1873. CHIEF ENGINEER JEANNETTE EXPEDITION 1879–82. CHIEF ENGINEER GREELEY RELIEF EXPEDITION 1883. DEGREES, LL.D. (PA.) D.E. (STEVENS) M.A. (GEORGETOWN) M.E. (COLUMBIA)". Owned by the Penna. Museum. Eakins painted a second portrait of him (No. 420).

409 WILLIAM MURRAY

Father of Samuel Murray. Head and bust, full-face, of an elderly man, head tilted slightly to left; gray hair and moustache, ruddy complexion, black suit, red-brown background. Canvas, 20 x 16. Unsigned. About 1904. Owned by Samuel Murray, Phila.

410 MRS. MATILDA SEARIGHT

Head and bust, half left, of a middle-aged woman; black hair, slightly grayed; filmy white low-necked evening dress. Dark greenish background. Reproduced in *The Arts*, December 1923, p. 321. Canvas, 22 x 18. Inscribed on back: "TO HELEN F. SEARIGHT THIS PORTRAIT OF HER MOTHER WAS GIVEN BY THOMAS EAKINS WHO PAINTED IT, MCMIV". Owned by Mrs. Eakins.

411 EDWARD TAYLOR SNOW

1844–1913. Painter, collector, and a prominent figure in the Philadelphia art world. Head and bust, half left; iron-gray hair and moustache, aquiline nose; white wing collar, black coat, white vest. Deep red-brown background. Canvas, 24 x 20. Inscribed on back: "TO MY FRIEND E. TAYLOR SNOW, THOMAS EAKINS, 1904". Owned by his daughter, Mrs. Harry Harmstad, Phila. In previous catalogues of Eakins' work this has been incorrectly listed as "E. Taylor Suen".

412 B. J. BLOMMERS

1845–1914. Well-known Dutch painter of landscape, marines, genre, and particularly the life of fishermen. Eakins painted his portrait and another of his wife in 1904, when they were visiting E. Taylor Snow in Philadelphia. The portraits were taken back to Holland. I have been unable to trace them.

413 MRS. B. J. BLOMMERS

See the preceding.

414 CHARLES P. GRUPPE

Painter, particularly of landscape; born 1860. Head and bust, half left; brown hair and moustache, dark suit, no vest, red-brown necktie, reddish brown background. Canvas, 22 x 18. Inscribed on back: "TO HIS FRIEND C. P. GRUPPE, THOMAS EAKINS, 1904, PHILADELPHIA". Owned by Clarence W. Cranmer, Philadelphia.

415 JOSEPH R. WOODWELL

1842–1911. Painter and art patron, resident in Pittsburgh, where he was an original trustee of the Carnegie Institute and a member of its Fine Arts Committee from the beginning until his death, the last two years as its chairman. Head and bust, half left; brown hair and moustache, dark suit. Reproduced in *The Carnegie Magazine*, February 1931. Canvas, 24 x 20. Inscribed l. r.: "*To my friend Joseph R. Woodwell, Thomas Eakins, 1904*". Owned by the Carnegie Institute, Pittsburgh.

416 WILLIAM H. MACDOWELL
(Plate 64)

Engraver; father of Mrs. Thomas Eakins. The last portrait, two years before his death. Gray hair, moustache and beard; black bow tie, black suit; dark brown background. Canvas, 24 x 20. Signed on back: "T. E." About 1904. Owned by Mrs. Eakins.

417 WALTER MACDOWELL

Brother of Mrs. Eakins; auditor of the Norfolk and Western Railroad; died 1929. Head and bust, full-face, looking at the spectator; high forehead, brown hair and moustache, somewhat grayed; spectacles; high stand-up collar, red necktie, dark gray-brown suit; dark brown background. Canvas, 27 x 22. Unsigned. About 1904. Owned by Mrs. Eakins.

418 WILLIAM H. LIPPINCOTT

1849–1920. Painter of portraits, genre and landscapes; professor of painting at the National Academy of Design, New York; N. A., member of the American Water Color Society, Society of American Etchers, and Century Association. Eakins painted his portrait in late 1904 or early 1905, exhibited it at the Pennsylvania Academy in 1905, and presented it to Lippincott in April 1905. I have been unable to trace his family or the portrait.

419 EDWARD W. REDFIELD

Landscape painter; born 1869. This portrait was painted to be presented to the National Academy of Design on the occasion of the sitter's election as Associate. Half-length, seated, half left, his hands clasped in front of him, looking at the spectator. Black hair, long brown moustaches, bronzed complexion, brown eyes. Low

collar, dark blue necktie, dark blue suit. Gray background. Canvas, 30 x 26. Unsigned. Inscribed on back (not in Eakins' handwriting): "*Edward C. Redfield, A.N.A. Painted by Thomas Eakins, 1905*". Owned by the National Academy of Design, New York.

420 REAR-ADMIRAL GEORGE W. MELVILLE

(See No. 408.) Three-quarters length, standing, full-face, his hands clasped in front of him. Leonine head; bald brow, long white hair, moustache and full beard. Dark blue naval uniform; medal suspended around neck; brown background. Canvas, 40 x 27. Signed l. r.: "EAKINS", and on back: "T. E." 1905. Owned by Mrs. Eakins.

421 MRS. GEORGE MORRIS

1828–1914. (See No. 353.) Head and bust, half left; dark hair slightly grayed, gold-rimmed spectacles, black jacket, white shirtwaist; brown background. Canvas, 24 x 20. Inscribed on back: "ELIZABETH M. CORLIES FROM HER FRIEND THOMAS EAKINS, 1905". Owned by the sitter's granddaughter, Mrs. Clara Morris Bullock, Phila.

422 PROF. WILLIAM SMITH FORBES
(Plate 65)

1831–1905. Anatomist; professor of anatomy and clinical surgery at Jefferson Medical College. He drew up the Anatomical Act of Pennsylvania, passed in 1867, one of the best in the country, and the model for many similar acts. This portrait was presented to the College by the classes of 1905, 1906, 1907 and 1908. He is shown lecturing to his students, his left hand resting on a copy of the Act. He has white hair and moustache, and wears a black suit. Canvas, rebacked, 84 x 48. Signed l. r.: "*Eakins 1905*". Inscribed on the side of the amphitheatre, right center: "GVLIELMVS S. FORBES, M.D., QVI LEGEM NOVAM DE RE ANATOMICA GVBERNIO STATVS PENNSYLVANIÆ PROPOSVIT COMMENDAVIT DEFENSIONE STVDIOSA EX SENATVS CONSVLTV FERENDEM CVRAVIT". On the back the same inscription (garbled in copying when the canvas was rebacked), with these words added: "EFFIGEM PINXIT THOMAS EAKINS PHILADELPHIENSIS A.D. MCMV". Below, the names of the committee who presented it. Owned by the Jefferson Medical College, Phila.

423 CHARLES L. FUSSELL

About 1840–1909. Landscape painter. Friend of Eakins from his boyhood. He appears here as an old man with spectacles and a patriarchal white beard, three-quarters length, seated in a wooden armchair, slightly right of full-face, examining a print, with others spread over his knee. Black suit, light gray background. Reproduced in the catalogue of the 100th Anniversary Exhibition of the Pennsylvania Academy, 1905. Canvas, 50 x 40. Unsigned. About 1905. Owned by William Griscom, Phila.

424 MISS FLORENCE EINSTEIN

Teacher of art; for many years head of the department of design of the School of Design for Women, Philadelphia. Head and bust, almost in profile left. Black hair and eyebrows, dark brown eyes, rich coloring; low-necked greenish-white dress with a colored pattern; green scarab pin in front. Dark golden-brown background. Canvas, 24 x 20. Inscribed on back: "TO HIS FRIEND FLORENCE EINSTEIN, THOMAS EAKINS, 1905". Owned by the sitter's nephew, M. Edwin Arnold, Phila.

425 MGR. DIOMEDE FALCONIO
(Plate 66)

1842–1917. Third Apostolic Delegate to the United States, 1902–1911. Procurator-General of the Franciscan Order, 1889, Bishop of Lacedonia, 1892, Archbishop, 1895, first Apostolic Delegate to Canada, 1899. Created Cardinal in 1911. His robes are gray; he wears a red skull-cap; the rug is a general warm olive-green tone; the panelled background is dark red-brown. Canvas, 72 x 54⅜. Inscribed on back: "HANC EFFIGIEM ILLMI AC REVMI DIOMEDI FALCONIO ARCHLARISSENSIS ET DELEGATI APOSTOLICI IN STATIBVS FŒDERATIS AMERICÆ SEPTENTRIONALIS PINXIT THOMAS EAKINS WASHINGTONII MDCCCCV". Below: "EAKINS". Owned by Reginald Marsh, Flushing, N. Y.

426 JOHN B. GEST
(Plate 67)

1823–1907. Lawyer and trust company officer; president of the Fidelity Trust Company, 1890–1900; trustee of the University of Penn-

sylvania and of various business and charitable organizations. This portrait was commissioned by the Fidelity Trust Company. Gray hair and beard, blue-gray eyes, black suit, dark brown background. Canvas, 40 x 30. Signed l. r.: "EAKINS 1905". Owned by the Fidelity Philadelphia Trust Co., Phila.

427 A. W. LEE

A lean, middle-aged man, half-length, seated, half left, gazing straight ahead, his arms resting on the arms of his chair. Iron-gray hair, long face, clean-shaven, aquiline nose, gray-blue eyes. High stand-up collar, black suit. Black wooden chair, dark brown background. This portrait was a commission, but the sitter refused to accept it, paying for it but returning it to the artist. Canvas, 40 x 32. Unsigned. 1905. Owned by Mrs. Eakins.

428 MISS ELIZABETH L. BURTON

Three-quarters length figure of a young woman, standing, in a blue silk dress with large sleeves; under life-size. About 42 x 30. About 1905. Owned by the sitter, now Mrs. Alexander Johnston, Santa Barbara, Cal. Now in storage in Boston.

429 DR. THOMAS H. FENTON

1856–1929. Prominent ophthalmologist and art patron, secretary and later president of the Art Club of Philadelphia. Three-quarters length, standing, half left, his arms crossed; brown hair, clean-shaven; black frock-coat, high wing collar; warm dark brown background. Reproduced in the Met. Mus. Mem. Exh. catalogue. Canvas, 60 x 30. Signed on back: "T. E." About 1905. Owned by Mrs. Eakins.

430 MRS. LOUIS HUSSON

1851–1928. (See No. 328.) Née Annie C. Lochrey. Head and bust, slightly left of full-face, the head tilted a little to the left. Light brown hair in a pompadour, blue eyes fixed on the spectator, white shirtwaist with a high collar. Dark background. Canvas, 24 x 20. Signed u. r.: "T. E." Inscribed on back: "TO KITTY HUSSON FROM HER FRIEND THOMAS EAKINS". About 1905. Owned by her daughter Mrs. Simon M. Horstick (née Katharine Husson), Pleasantville, N. J.

431 MAURICE FEELEY

Painter; pupil of Eakins. Head and bust, slightly left of full-face, looking at the spectator; broad face, black hair, spectacles, clean-shaven; gray suit; grayish brown background. Not quite finished. Canvas, 24 x 20. Unsigned. About 1905. Owned by Mrs. Eakins.

432 GENJIRO YETO

Japanese artist. Portrait painted in 1906; unsigned; the sitter took it with him to Japan in 1907. I have been unable to trace him or the portrait.

433 A SINGER

Portrait of Mrs. W. H. Bowden. Head and bust, half left; auburn hair, Roman nose, brown eyes; low-necked evening dress. Unfinished. Canvas, 24 x 20. Unsigned. 1906. Owned by Mrs. Eakins.

434 A SINGER

Portrait of Mrs. Leigo. Head and bust, half left; brown hair in a pompadour; low-necked yellow evening dress; brown background. Canvas, 20 x 16. Unsigned. About 1906. Owned by Mrs. Eakins.

435 RICHARD WOOD

1833–1910. Iron manufacturer and merchant, director of the Provident Life and Trust Company of Philadelphia. This portrait was a commission. Head and bust, half left; bald brow, gray hair and side-whiskers, clean-shaven mouth and chin, gray eyes; black suit; light warm gray background. Canvas, 30 x 24. Signed l. r.: "T. E. 1906", and on back: "RICHARD WOOD by THOMAS EAKINS 1906". Owned by the estate of George Wood (the sitter's brother), and in the possession of the sitter's nephew Richard D. Wood, Phila.

436 MASTER ALFRED DOUTY

Son of Mr. and Mrs. Nicholas Douty (see No. 468). Head and bust of a boy seven years old, slightly left of full-face, with blond hair, wearing a white sailor suit with light blue lapels. Brown background. Canvas, 20 x 16. Inscribed on back: "TO MRS. NICHOLAS DOUTY FROM HER FRIEND THOMAS EAKINS 1906". Owned by Mrs. Nicholas Douty, Elkins Park, Pa.

437 A LITTLE GIRL
Head and bust, half left, of a girl about eight years old, with blond hair and rosy complexion; white ribbon in her hair, white dress; deep maroon background. Canvas, 16 x 12. Signed l. r.: "EAKINS" and on back: "T. E". About 1906. Owned by Mrs. Eakins.

438 MGR. JAMES P. TURNER
(See No. 347.) He is shown officiating at a service in the Cathedral of Sts. Peter and Paul, Philadelphia; full-length, standing, half left, his hands clasped in front holding a book, wearing a black and red biretta and red vestments with white lace sleeves. The high altar is in the background. Canvas, 88 x 42. Unsigned. About 1906. Owned by his cousins, the Misses Anna A., Helen C., and Elizabeth A. King, Phila.

439 SKETCH. On the back is a study for *William Rush and His Model* (see No. 454). Oil on cardboard, 14½ x 10½. Signed l. r.: "T. E." Owned by the Penna. Museum.

440 THOMAS J. EAGAN
Painter, pupil of Eakins, and one of those who left the Pennsylvania Academy to found the Art Students' League of Philadelphia. Head and bust, the body slightly left of full-face, the head turned a little more left. Thick brown hair, auburn moustache; spectacles; black suit, gray necktie; dark brown background. Canvas, 24 x 20. Inscribed at right center: "TO HIS FRIEND AND PUPIL. THOMAS EAKINS, 1907". Owned by Thomas J. Eagan, Conshohocken, Pa.

441 DR. ALBERT C. GETCHELL
Physician, born 1857, practising in Worcester, Mass. Head and bust, half left; hair low over forehead; moustache, pointed beard. Gray suit, gray necktie; reddish brown background. Canvas, 24 x 20. Inscribed on back: "TO EDITH LORING GETCHELL, THOMAS EAKINS, 1907". Owned by Mrs. Edith Loring Getchell, Worcester, Mass.

442 DR. WILLIAM THOMSON
(Plate 68)
1833–1907. Prominent ophthalmologist, connected for years with the Wills Eye Hospital in Philadelphia, and as a teacher with the Jefferson Medical College. White hair, moustache and goatee; tan shirt, red bow tie, brown suit, tan shoes and spats. Vari-colored Oriental rug, deep brown background. Canvas, 74 x 48. Signed on floor at right: "*Eakins 1907*". Presented by his family to the College of Physicians, Phila., the present owner.

443 DR. WILLIAM THOMSON. First version, unfinished. Reproduced in *The Arts*, December 1923, p. 316. Canvas, 68 x 48. Unsigned. Owned by Mrs. Eakins.

444 MAJOR MANUEL WALDTEUFEL
Alsatian, veteran of the Franco-Prussian War, later in the Foreign Legion; chevalier of the Legion of Honor. Cousin of the composer, and himself a violinist. Lived in Philadelphia the last years of his life and became a friend of Eakins; died in 1915. Head and bust, half left, holding a violin upright with his left hand. Bald brow; gray hair and moustache. Black suit, rosette in his buttonhole. Gray-brown background. Also called *The Violinist*. Canvas, 24 x 20. Signed l. r.: "T.E. 1907", and on back: "A SON AMI LE COMMANDANT WALDTEUFEL, THOMAS EAKINS". Owned by the French Benevolent Society, Phila.

445 WILLIAM RUSH CARVING HIS ALLEGORICAL FIGURE OF THE SCHUYLKILL RIVER
(Plate 69)
A later version of the theme which Eakins had painted in 1877 (No. 109). Canvas, 36x48. Signed on the scroll in the center: "EAKINS 1908". Owned by Mrs. Eakins.

446 SKETCH. An early study for the composition. Wood, 8¾ x 10 (sketch itself 4½ x 4¾). Unsigned. Owned by Mrs. Eakins.

447 SKETCH. Composition more developed, essentially the same as the finished picture. Wood, 6 x 8¾. Unsigned. Owned by Mrs. Eakins.

448 STUDIES OF RUSH. On one side of the panel, a sculptor with mallet and chisel, in modern clothes; painted over a sketch of a garden and buildings. On the reverse, two more studies of the figure. Wood, 14 x 10. Unsigned. Owned by Mrs. Eakins.

449 STUDY OF RUSH. Same attitude and costume as in finished picture. Canvas, 20 x 16. Unsigned. Squared off for enlarging. Owned by Mrs. Eakins.

450 STUDY OF THE NEGRESS. Canvas, 20x16. Unsigned. Squared off for enlarging. Owned by Mrs. Eakins.

451 WILLIAM RUSH AND HIS MODEL
(Plate 70)
The sculptor helping the model down from the stand. A large carved wooden scroll projects upwards in the foreground. Not entirely finished. Canvas, 36x48. Unsigned. 1908. Owned by Mrs. Eakins.

452 THE MODEL (STUDY). Canvas, 24 x 20. Unsigned. Measured off for enlarging. Owned by Mrs. Eakins.

453 WILLIAM RUSH AND HIS MODEL
A nude female model, slightly right of center, stepping down from the stand, in much the same attitude as in the preceding, but turned more toward the left. The figure is not quite finished; the rest of the canvas is blank. Canvas, 36 x 48. Unsigned. 1908. Owned by Mrs. Eakins.

454 THE MODEL (STUDY). The same model in the same position as in the preceding picture; and another nude female figure, to the left, standing below her, facing right, holding a white garment to put around her. (The same arrangement, with the additional figure of Rush at the right as in No. 451, appears in the sketch on the back of No. 439.) Evidently, in the preceding composition, Eakins intended to include not only the sculptor, but the model's attendant at the left. Canvas, 20 x 13¾. Unsigned. Owned by Mrs. Eakins.

455 MISS ELEANOR S. F. PUE
Head and bust, slightly left of full-face, of a young woman with black hair, wearing a low-necked gray dress which leaves her shoulders bare. Brown background. Canvas, 20 x 16. Unsigned. Inscribed on back (not in Eakins' handwriting): "Eleanor S. F. Pue by Thomas Eakins, 1908". Owned by the sitter, now Mrs. E. Farnum Lavell, Phila.

456 MISS REBECCA MACDOWELL
Mrs. Eakins' niece, daughter of Walter Macdowell (No. 417); now Mrs. John Randolph Garrett. Head and bust, half left, of a young woman with brown hair in a pompadour, gray-blue eyes, and tanned complexion, wearing a white shirt-waist with a high collar. Dark red-brown background. Canvas, 20 x 16. Unsigned. About 1908. Owned by Mrs. Eakins.

457 THE OLD-FASHIONED DRESS
(Plate 71)
Portrait of Miss Helen Parker. Light brown hair, light warm gray dress, brown chair, dark red-brown panelled wall behind. Also called Miss Parker. Canvas, rebacked, 60⅛ x 40¼. Signed l. r.: "T. E." About 1908. Owned by the Penna. Museum.

458 SKETCH. Cardboard, 11⅛ x 7. Squared off for enlarging. Unsigned. Owned by Mrs. Eakins.

459 STUDY. Canvas, 36 x 22. Squared off for enlarging. Unsigned. Owned by Mrs. Eakins.

460 MRS. LUCY LANGDON W. WILSON
Educator; born 1864. Head of the department of biology, Philadelphia Normal School, and principal of the Evening High School for Women, 1892–1915; principal of the Southern High School for Girls, Philadelphia, since 1915. Author of The New Schools of New Russia, 1928, and other works. Head and bust, full-face; dark hair, pince-nez, white shirt-waist; dark brown background. Canvas, 20 x 16. Unsigned. Summer 1908. Owned by Mrs. Lucy Langdon W. Wilson, Phila.

461 MRS. LUCY LANGDON W. WILSON
(See the preceding.) Head and bust, full-face; dark hair, pince-nez; black dress; chair-back shows behind; dark warm background. Canvas, 24 x 20. Inscribed on back: "MATRIS EFFIGIEM NATURAE PICTIS COLORIBUS SUA MANU REDDITAM FILIO AMANTISSIMO DAVID H. WILSON IN SIGNUM GRATI CORDIS AFFECTUS D D THOMAS EAKINS". Early 1909. Owned by Mrs. Lucy Langdon W. Wilson, Phila.

462 DR. WILLIAM P. WILSON
1844–1927. Scientist; director of the School of Biology of the University of Pennsylvania, 1890–1894. In 1893 he founded and became director of the Philadelphia Commercial Museum; was prominent in work on international trade relations. Husband of Mrs. Lucy Langdon W. Wilson. Half-length, seated, almost in profile left, his hands joined in his lap. Gray hair in a pompadour, gray moustache and beard, spectacles, winged collar, black suit. At the left is a terrestrial globe, with markers. Warm gray background. Canvas, 33 x 25. Unsigned. 1909. Owned by Mrs. Lucy Langdon W. Wilson, Phila.

463 DR. HENRY BEATES, JR.

1857–1926. Physician, prominent in improving medical education in Pennsylvania and in lengthening the required medical course; president of the State Board of Medical Examiners, 1899–1911. He was Eakins' physician in the last years of the artist's life. Standing, about three-quarters length, with a scroll in his hand. Canvas, about 50 x 30. 1909. Also called *The Medical Examiner*. Owned by Mrs. Henry Beates, c|o Mrs. George Carpenter, Auburndale, Mass. Stored in Phila. No other information available.

464 HENRY BEATES

Wholesale druggist, father of the preceding sitter, for whom Eakins painted this portrait from a photograph. Head and bust, full-face, of an elderly man with gray hair, deep wrinkles, clean-shaven upper lip, chin beard; wearing a dark suit. Canvas, about 24 x 20. Owned by Mrs. Henry Beates, c|o Mrs. George Carpenter, Auburndale, Mass. Stored in Phila. No other information available.

465 EDWARD A. SCHMIDT

Three-quarters length, standing, half left, hands clasped in front. Brown hair and moustache, black suit, dark brown background. Canvas, 53¾ x 30. Unsigned. About 1909. Owned by Edward A. Schmidt, Radnor, Pa.

466 REV. CORNELIUS J. O'NEILL

Assistant priest at the Church of the Annunciation of the Blessed Virgin Mary, Philadelphia; later Chaplain of St. Agnes' Hospital, Philadelphia. Head and bust, half left; clean-shaven. Canvas, about 30 x 24. About 1909. Given by Eakins to the sitter, who bequeathed it to a woman friend. I have been unable to discover her name or the present whereabouts of the picture.

467 JOHN J. BORIE

Architect. Full-length, standing, half right, leaning with his left arm on a drawing-board, his right hand on his hip. A handsome, slender young man, with light brown hair, small moustache, and ruddy complexion, wearing a black suit, high white collar, dark blue necktie, and black shoes. Plain gray-brown background. Not quite finished. Canvas, 80 x 42. Unsigned.

Given by Eakins to the sitter's cousin Adolphe Borie, Phila., the present owner.

468 MRS. NICHOLAS DOUTY

Née Frieda Schloss; writer, and editor of the *Musical Survey and Directory of Philadelphia*; wife of the tenor Nicholas Douty, close friend of Eakins. Head and bust, half left, of a young woman with black hair, wearing a light pink low-necked dress, cut square in the front. Brown background. Canvas, 24 x 18¾. Unsigned. 1910. Owned by Mrs. Nicholas Douty, Elkins Park, Pa.

469 DR. GILBERT LAFAYETTE PARKER

Physician; Civil War veteran, discharged as brevet Lieutenant-Colonel. Head and bust, slightly left of full-face, gazing in front of him; white hair, moustache and beard, dark gray suit, gray background. Reproduced in the Met. Mus. Mem. Exh. catalogue. Canvas, 24 x 20. Inscribed on back: "TO HIS FRIEND GILBERT S. PARKER, THOMAS EAKINS, 1910." Owned by the sitter's son, Ernest Lee Parker, Phila.

470 MRS. GILBERT LAFAYETTE PARKER

Head and bust, slightly left of full-face, gazing in front of her; dark hair, slightly grayed, black jacket with high collar, open at throat, dark brown background. Reproduced in the Met. Mus. Mem. Exh. catalogue. Canvas, 24 x 20. Inscribed on back: "TO HIS FRIEND MRS. PARKER, THOMAS EAKINS, 1910". Owned by the Museum of Fine Arts, Boston.

471 GILBERT SUNDERLAND PARKER

Curator of paintings, Pennsylvania Academy of the Fine Arts, and organizer of the Eakins Memorial Exhibition in that institution; died 1921. Son of Dr. and Mrs. Gilbert Lafayette Parker. Head and bust, almost in profile left; dark brown hair, lighter brown moustache and goatee; blue eyes, pince-nez; high turned-down collar, dark blue suit; dark reddish brown background. Canvas, 24 x 20. Signed l. l.: "EAKINS". Inscribed on back: "TO GILBERT S. PARKER BY & FROM HIS FRIEND THOMAS EAKINS 1910". Owned by the sitter's brother Ernest Lee Parker, Phila.

472 ERNEST LEE PARKER

Present curator of the Pennsylvania Academy of the Fine Arts; restorer and appraiser. Head

and bust, half left; dark brown hair, lighter moustache, pince-nez; high turned-down collar, dark suit; brown background. Not entirely finished. Canvas, 24 x 20. Signed l. r.: "T. E." Inscribed on back: "*To my friend Ernest Parker, 1910, Thomas Eakins*". Owned by Ernest Lee Parker, Phila.

473 PRESIDENT RUTHERFORD B. HAYES
1822–1893. Nineteenth President of the United States, 1877–1881. This portrait was commissioned through Thomas B. Clarke by Alexander Smith Cochran, who was forming a collection of portraits of the presidents, Eakins being known to have painted President Hayes from life (see No. 475). This second portrait was painted from a photograph, and was one of Eakins' last works. Head and bust, body half left, head a little left of full-face; brown hair, moustache and full beard; black suit. Brown background. Canvas, 29 x 24. Signed l. r.:

"EAKINS". 1912 or 1913. Now in the Alexander Smith Cochran Collection of Presidential Portraits, owned by the American Scenic and Historic Preservation Society, New York, and housed in Philipse Manor Hall, Yonkers, N. Y.

474 DR. EDWARD ANTHONY SPITZKA
1876–1922. Anatomist, criminologist, and brain specialist, professor of anatomy and director of the Daniel Baugh Institute of Anatomy of Jefferson Medical College. Especially noted for his work on the human brain. Full length, standing, half right, dressed in black, holding in both hands a cast of a human brain. Eakins started this portrait about 1913, when he was ill, and had great difficulty with it; finally he asked Mrs. Eakins to try her hand on the cast of the brain; this is the only finished part, as he was unable to continue. It was his last picture. Canvas, 84 x 43½. Unsigned. Owned by Mrs. Eakins.

PICTURES PROBABLY NO LONGER IN EXISTENCE

475 PRESIDENT RUTHERFORD B. HAYES
1822–1893. Nineteenth President of the United States, 1877–1881. In the spring of 1877 Eakins was commissioned to paint his portrait by the Union League of Philadelphia, the price being $400. He painted the sitter from life, in the White House in the summer of 1877. The portrait was at first refused by the League, then accepted, paid for, and hung; but later disappeared. In 1880, a portrait of the President by W. Gail Brown was presented to the League "by a number of gentlemen"; this still hangs in the clubhouse, but the League has no record of the Eakins portrait. Those who saw the latter remember it as life-size, about half-length, seated. Eakins painted a later portrait (No. 473).

476 JAMES L. WOOD
Painter; pupil of Eakins at the Art Students' League of Philadelphia; son of Dr. Horatio C. Wood (No. 239). About 1890 Eakins painted his portrait, which was in his possession but has since disappeared.

477 WILLIAM RUDOLF O'DONOVAN
1844–1920. Sculptor, known particularly for his portrait busts and soldiers' monuments; A. N. A., member of the Society of American Sculptors and the Architectural League. He

collaborated with Eakins on the figures of Lincoln and Grant for the Memorial Arch, Prospect Park, Brooklyn (No. 509). This portrait, painted in 1891 or early 1892, shows him modelling a bust of Eakins; about half-length, both hands shown. Exhibited at the National Academy of Design, 1892, and the World's Fair, Chicago, 1893. Present whereabouts unknown.

478 MISS EMILY SARTAIN (TWO STUDIES)
479 Portrait painter, mezzotint engraver, and for many years principal of the Philadelphia School of Design for Women; daughter of the engraver John Sartain, and sister of Eakins' lifelong friend William Sartain. Eakins painted two small portrait studies of her about the '90s, but her family has been unable to find them.

480 DR. HUGH A. CLARKE
1839–1927. Well-known musical teacher, writer, and composer; professor of the science of music at the University of Pennsylvania. This portrait, painted about 1893, disappeared some time ago, and Mrs. Clarke has been unable to discover it.

481 JAMES MacALISTER
1840–1913. Educator; first superintendent of Philadelphia public schools; first president

of Drexel Institute (where Eakins lectured on anatomy in 1895). Life-size, three-quarters length, standing, almost full-face, in a frock-coat (see sketch, No. 276). Probably about 1895. His daughter, Miss Mary T. MacAlister, informs me that it was stored at Drexel Institute, but cannot now be found.

2 CIRCUS PEOPLE (SKETCH)
Sketch for a composition never carried out, of circus performers behind scenes, one a woman with a baby. About 14 x 19. Painted before 1876. In the possession of Mrs. Eakins after the artist's death, but has since disappeared.

3 STEWART CULIN
1858–1929. Archæologist; curator of ethnology at the Museum of the University of Pennsylvania, 1892–1903, and at the Brooklyn Museum from 1903. An authority on costumes and games of primitive races. Friend of Eakins and of Frank Hamilton Cushing (No. 273). Eakins painted his portrait about 1899, life-size, full-length, seated, the body full-face, the head turned half left; various archæological objects on a table and floor—games, American Indian remains, etc. Dark hair and moustache. Canvas, about four or five feet square. Shown at the Carnegie Institute, Pittsburgh, in November, 1899, and at the Pennsylvania Academy in 1901. Mrs. Culin writes me that it was stolen some years ago and she has been unable to trace it.

4 DR. GEORGE B. WOOD
Physician: son of Dr. Horatio C. Wood (No. 239). Portrait painted about 1900, since disappeared.

5 RT. REV. MGR. PATRICK J. GARVEY
Rector of St. Charles Seminary, Overbrook, Pa.; died 1908. Eakins painted his portrait in the early 1900's; canvas, about 24 x 20. For some time it was at Overbrook, but the authorities there are unable to find it.

6 RT. REV. DENIS J. DOUGHERTY
Now His Eminence Denis Cardinal Dougherty, Archbishop of Philadelphia. In 1903, the year that this portrait was painted, he was consecrated Bishop of Nueva Segovia, P. I., and left for the Philippines, to be gone until 1915. He informs me that the portrait passed out of his hands at this time and that he does not know its

present whereabouts. It was exhibited at the Pennsylvania Academy in 1906, lent by Mrs. Patrick Dougherty.

487 MOTHER PATRICIA WALDRON
Mother Superior of the Convent of the Sisters of Mercy, Broad St. and Columbia Ave., Philadelphia, and of that at Merion, Pa.; died 1916. Eakins painted her portrait in 1903, about life-size (see sketch, No. 375). Although it was not a commission, she paid him a small sum and took the portrait. Several persons have told the writer that they saw it hanging in the Convent in Philadelphia as recently as fifteen years ago. On the other hand, the sisters of the Convent tell me that none of them have any memory of it or know of its present whereabouts.

488 MRS. MARGARET JANE GISH
Singer and teacher of music; sister of Mrs. Helen MacKnight (No. 392). Head and bust of a woman of about forty-eight, with brown hair, wearing a low-necked evening gown of black lace over silk; dark background. Canvas, about 24 x 20. Painted about 1903. Her niece, Mrs. Helen I. Montgomery, Washington, D.C., has been unable to find it.

489 ROBERT C. OGDEN
First version (see No. 394). This was at one time in the possession of the sitter's daughter Mrs. Crery, but was not found among her effects after her death.

490 DR. J. WILLIAM WHITE
1850–1916. Well-known surgeon; taught at the University of Pennsylvania for many years, in the beginning as assistant to Dr. D. Hayes Agnew (in which capacity he appears in the *Agnew Clinic*). Eakins started this portrait in the spring of 1904, but as the surgeon could not spare time for sufficient sittings and did not seem interested, it was never entirely finished.

Dr. White was a close friend of John Singer Sargent, who visited him in Philadelphia and painted his portrait. Eakins also was a friend of Sargent, and the two were to paint each other's portraits—a plan interrupted by Sargent's having to return to England. In 1906 Eakins presented his portrait of Dr. White to Sargent, receiving the following letter in acknowledgment: "My dear Eakins, I don't know how long

it is since your portrait of Dr. White has been here, nor how long my thanks have been overdue. Please accept them now that I have returned from a six months' absence and found the picture which gives me great pleasure. It is a capital likeness of a great friend and a specimen of your work which I am delighted to possess. I also bear in mind your kindness in wishing to offer it to me."

The picture has since disappeared. Miss Emily Sargent, the painter's sister, writes me that she has no knowledge of it, and Mr. Alexander Martin of Messrs. Christie, Manson & Woods, who made the inventory of Sargent's property after his death, can find no record of it.

491 ADOLPHE BORIE

Portrait-painter; born 1877. Portrait started about 1910, full-length, life-size; unfinished, most of the canvas being left bare. In the sitter's possession for several years, but has since disappeared.

PICTURES KNOWN TO BE NO LONGER IN EXISTENCE

492 MRS. CHARLES LESTER LEONARD

Wife of the eminent X-ray specialist (No. 296). Life-size, three-quarters length, seated (see sketch, No. 286). Painted in 1895. Her daughter writes me: "Unfortunately this portrait met with an accident and is no longer in existence."

493 MRS. HUBBARD

Sister of the critic Riter Fitzgerald (No. 280). Life-size portrait, full-length, seated, in evening dress and opera cloak (see sketch, No. 283). Painted about 1895. Destroyed by her daughter.

494 MRS. McKEEVER

Mother of the pugilist Charlie McKeever, who appears in *Taking the Count* (No. 303). Portrait painted in 1898 and presented to her. I am informed that it is no longer in existence.

495 BISHOP EDMOND F. PRENDERGAST

1843–1918. Auxiliary Bishop of Philadelphia, 1897–1911; Archbishop, 1911–1918. Life-size, about half-length, seated (see sketch, No. 376). Canvas, about 30 x 40. About 1903. I am informed that it is no longer in existence.

496 FRANK W. STOKES

Painter; pupil of Eakins at the Pennsylvania Academy; has specialized in Arctic and Antarctic scenes, and accompanied several expeditions to these regions. In the summer of 1903 Eakins painted his portrait (head and bust, about 24 x 20) and presented it to his family. Mr. Stokes tells me that he believes that it was later destroyed.

497 EDWARD S. BUCKLEY

Iron master; member of a prominent Philadelphia family. This portrait, painted in 1906, was not a commission. His daughter writes me: "It was so unsatisfactory that we destroyed it, not wishing his descendants to think of their grandfather as resembling such a portrait".

SCULPTURE

498 STUDIES FOR "WILLIAM RUSH"

(See No. 109.) Six small wax figures, consisting of the nude model, her head, Rush's head, and the three statues (the Allegorical Figure, Washington, and the reclining female figure). Mrs. Eakins owns the first; the five others are owned by the Penna. Museum.

499 THE MARE "JOSEPHINE"

One of Fairman Rogers' horses. Relief, in left profile. 22 x 28. Signed: "EAKINS 78". Plaster cast owned by Mrs. Eakins; bronze by the Penna. Museum. Eakins also made the following anatomical reliefs of this horse, all in profile left (Mrs. Eakins owns plaster casts of all three, the Penna. Museum owns bronzes of the first and third):

500 SKELETON. 11¼ x 14¼. Signed "EAKINS 78".

501 ECORCHÉ. 22 x 25. Unsigned.

502 ECORCHÉ. 22½ x 32. Signed: "EAKINS 1882".

503 STUDIES FOR "THE FAIRMAN ROGERS FOUR-IN-HAND"

(See No. 133.) Four small wax figures of horses. One reproduced in *The Arts*, October 1931. Owned by Mrs. Eakins.

504 SPINNING

High relief of a girl, full-length, seated on a stool at a spinning-wheel, in profile right, bending over, her right elbow resting on her knee, wearing an old-fashioned dress with low neck and short sleeves (attitude and costume similar to watercolor, No. 146). Oval, 19 x 15. Signed: "SPINNING. THOMAS EAKINS, 1881". This and the following were made on commission as chimney-piece decorations for the house of James P. Scott, Philadelphia, but were refused. Plaster casts of both owned by Mrs. Eakins (unsigned); bronzes by the Penna. Academy and the Penna. Museum. The date of both, according to Eakins' correspondence, should be late 1882 or early 1883.

505 KNITTING

(See the preceding.) High relief of a middle-aged woman knitting, seated, almost in profile left, wearing an old-fashioned dress (attitude and costume similar to watercolor *Seventy Years Ago*, No. 114). Tip-table at left; cat at lower right. Reproduced in *The Arts*, October 1931. Oval, 18¾ x 15. Signed: "KNITTING. THOMAS EAKINS, 1881".

506 ARCADIA

Relief of a group of idyllic figures listening to a nude youth playing the pipes. He is seated at the right; a dog sits in front of him; in processional order, right to left, appear the standing figures of a draped girl, a couple, an old man, and a nude youth. 12½ x 25. Signed: "EAKINS 1883". Plaster casts owned by the Penna. Museum and Mrs. Eakins: the latter also owns a bronze (erroneously dated 1888).

507 AN ARCADIAN

Relief of the figure of the girl in the preceding, standing in a pensive attitude, in profile right. 8¼ x 5. Owned in plaster and bronze by Mrs. Eakins (bronze signed: "THOMAS EAKINS").

508 A YOUTH PLAYING THE PIPES

Nude, standing, in profile left. Relief, 20½ x 11¼. Owned in plaster and bronze by Mrs. Eakins; plaster signed: "T. E. 1883"; bronze signed: "THOMAS EAKINS 1888" (date erroneous).

509 HORSES ON THE BROOKLYN MEMORIAL ARCH
(Plate 72)

Two horses for the equestrian statues of Lincoln and Grant on the Memorial Arch, Prospect Park, Brooklyn; riders modelled by William R. O'Donovan. The model for Lincoln's mount was Eakins' own "Billy"; for Grant's, "Clinker", belonging to A. J. Cassatt. Reproduced in *McClure's Magazine*, October, 1895, with an article on the statues. Bronze, life-size, in high relief, almost in the round. Signed: "W. R. O'DONOVAN AND THOMAS EAKINS, SCULPTORS, 1893–94."

510 "CLINKER". Small model, 6¼ x 6¼. Signed: "THOMAS EAKINS 1892". Owned in plaster and bronze by Mrs. Eakins.

511 "CLINKER". Model, 25 x 26. Squared off for enlarging. Inscribed u. l.: "*Clinker, charger belonging to A. J. Cassatt, Esq., Chesterbrook Farm, Berwyn, Penna.*". Owned in plaster by Mrs. Eakins, in bronze by the Penna. Museum.

512 "BILLY". Model, about 25 x 26. Squared off for enlarging. Plaster. Present whereabouts unknown.

513 THE AMERICAN ARMY CROSSING THE DELAWARE

Bronze relief on the base of the Trenton Battle Monument, Trenton, N. J. Boats filled with soldiers, being punted toward the right. In the left foreground, the bow of a boat, with three officers standing; at the right, the stern of a boat, with a helmsman. In the middle distance, Washington in a small rowboat. Reproduced in *The Arts*, December 1923, p. 304. About 1893.

514 THE BATTLE OF TRENTON

Bronze relief on the base of the Trenton Battle Monument, Trenton, N. J. In the foreground, American soldiers firing a cannon in the streets of Trenton; two officers on horses at the right. In the background, Hessian soldiers fleeing. About 1893.

515 MRS. MARY HALLOCK GREENEWALT

(See No. 380.) Relief; head and bust, in left profile. Plaster, 16½ x 12½. Inscribed: "MARY HALLOCK MCMV".

INDEX TO THE CATALOGUE

BIBLIOGRAPHY

NOTE: This bibliography does not attempt to list all the references to Eakins in books and periodicals, but only those of some extent and interest. It has been impossible to list more than a few of the many references in newspapers.

BOOKS, PAMPHLETS AND CATALOGUES

Art in America. By S. G. W. Benjamin. New York, 1880. P. 208.

Book of American Figure Painters. Philadelphia, 1886. Reproductions, accompanied by poems; introduction by M. G. Van Rensselaer. Eakins' *Lady with a Setter Dog* is reproduced, accompanied by Shakespeare's sonnet *Betwixt mine eye and heart a league is took*.

Animal Locomotion. The Muybridge Work at the University of Pennsylvania. The Method and the Result. Philadelphia, 1888. The description of Eakins' apparatus, pp. 9–14, was written by him.

History of the Life of D. Hayes Agnew, M.D. By J. Howe Adams, M.D. Philadelphia, 1892. Pp. 332–335, 341.

In Re Walt Whitman. Edited by Horace Traubel, Richard Maurice Bucke, and Thomas B. Harned. Philadelphia, 1893. Pp. 144, 195, 322, 389.

The Differential Action of Certain Muscles Passing More than one Joint. By Thomas Eakins. Reprinted from the Proceedings of the Academy of Natural Sciences of Philadelphia, 1894.

National Cyclopedia of American Biography, Vol. V. New York, 1894. P. 421.

Appleton's Cyclopedia of American Biography, Vol. II. New York, 1898. P. 288.

A History of American Art. By Sadakichi Hartmann. Boston, 1902. Vol. I, pp. 189, 200–207.

The History of American Painting. By Samuel Isham. New York, 1905 and 1927. Pp. 525–526.

With Walt Whitman in Camden. By Horace Traubel. 3 vols., 1906, 1908, and 1914.

The Story of American Painting. By Charles H. Caffin. New York, 1907. Pp. 230–233.

Catalogue of a Loan Exhibition of the Works of Thomas Eakins. The Metropolitan Museum of Art, New York, 1917. Introduction by Bryson Burroughs. 60 illustrations.

Catalogue of a Memorial Exhibition of the Works of the late Thomas Eakins. Pennsylvania Academy of the Fine Arts, 1917. Introduction by Gilbert Sunderland Parker. 80 illustrations, 2 portraits.

The Art Spirit. By Robert Henri. Philadelphia and New York, 1923. P. 86.

American Artists. By Royal Cortissoz. New York, 1923. "Thomas Eakins", pp. 77–82.

The Freeman Book. New York, 1924. "A Grand Provincial", by Walter Pach, pp. 256–261. (A reprint of an article in *The Freeman*, April 11, 1923.)

Biographical Sketches of American Artists. 5th Edition. Lansing: Michigan State Library, 1924.

The Adventures of an Illustrator. By Joseph Pennell. Boston, 1925. Pp. 50–52.

The Pageant of America. Vol. XII. *The American Spirit in Art*. By Frank Jewett Mather, Jr., Charles Rufus Morey, and William James Henderson. New Haven, 1927. Pp. 51, 57, 58, 96.

American Painters. Compiled by Charles B. Shaw. (Extension Bulletin of the North Carolina College for Women, Vol. 3, No. 2, July, 1927.) With a bibliography.

American Arts. By Rilla Evelyn Jackman, Chicago, 1928.

Ananias, or the False Artist. By Walter Pach. New York, 1928. Pp. 37, 249–251.

Art in America. By Suzanne LaFollette. New York, 1929. Pp. 184–190.

Dictionary of American Biography. Vol. V. New York, 1930. Pp. 590–592. "Thomas Eakins", by William Howe Downes.

Confessions in Art. By Harrison S. Morris. New York, 1930. Pp. 30–36.

Background with Figures. Autobiography of Cecilia Beaux. Boston and New York, 1930. Pp. 95–98.

Catalogue of the Sixth Loan Exhibition of the Museum of Modern Art, New York, May, 1930: Winslow Homer, Albert P. Ryder, Thomas Eakins. "In 1930", by Alfred H. Barr, Jr.; "Winslow Homer", by Frank Jewett Mather, Jr.; "Albert Pinkham Ryder", by Bryson Burroughs; "Thomas Eakins", by Lloyd Goodrich. 10 illustrations of Eakins' work.

Estimates in Art, Series II. By Frank Jewett Mather, Jr. New York, 1931. "Thomas Eakins",

pp. 201–231. (A reprint of an article in the *International Studio*, January, 1930.)

The Brown Decades. By Lewis Mumford. New York, 1931. Pp. 189–190, 210–220. (This section published in *Scribner's Magazine*, October, 1931.)

The History and Ideals of American Art. By Eugen Neuhaus. Stanford University, Calif., 1931. P. 174.

A Critical Introduction to American Painting. By Virgil Barker. New York, 1931. Pp. 34, 35.

PERIODICALS

Harper's New Monthly Magazine, Vol. LVIII, March, 1879. "Present Tendencies in American Art", by S. G. W. Benjamin.

Scribner's Monthly Illustrated Magazine, Vol. XVIII, No. 2, June, 1879. "The Art Season of 1878–9".

Scribner's Monthly Illustrated Magazine, Vol. XVIII, No. 5, September, 1879, pp. 737–750. "The Art Schools of Philadelphia", by William C. Brownell.

Scribner's Monthly Illustrated Magazine, Vol. XX, No. 1, May, 1880. "The Younger Painters of America", by William C. Brownell.

The Penn Monthly, Vol. XII, June, 1881. "The Schools of the Pennsylvania Academy of the Fine Arts", by Fairman Rogers.

Harper's New Monthly Magazine, Vol. LXIV, February, 1882. "A Clever Town Built by Quakers", by George Parsons Lathrop.

The Magazine of Art, Vol. 10, 1887, pp. 37–42. "Movements in American Painting. The Clarke Collection in New York", by Charles De Kay.

McClure's Magazine, Vol. V, No. 5, October, 1895, pp. 419–432. "Grant and Lincoln in Bronze", by Cleveland Moffett.

The Critic, Vol. XLIV, January, 1904. "Some American Portrait Painters", by Charles H. Caffin.

Putnam's Monthly and The Reader, Vol. IV, No. 6, September, 1908, pp. 707–710. "Two Portraits of Walt Whitman", by Annie Nathan Meyer.

The Old Penn Weekly Review, October 30, 1915. "The Unidentified Student in the Agnew Painting".

The Jeffersonian, published by Jefferson Medical College, Vol. XVII, No. 132, November, 1915. "The Collection of Portraits Belonging to the College", by Charles Frankenberger.

Philadelphia Press, February 13, 1916. "True Romance Revealed in Unique Bonds of Three Gifted Artists", by Hugh J. Harley. (The story of Eakins' reunion with Henry Humphreys Moore.)

Bulletin of the Metropolitan Museum of Art, Vol. XI, No. 6, June, 1916, p. 132. Under "Recent Accessions": "A Picture by Thomas Eakins" (*Pushing for Rail*), by B. B. (Bryson Burroughs).

Philadelphia Public Ledger, June 27, 1916. "Thomas Eakins, Noted Artist, Dies at Home in this City".

Philadelphia Inquirer, July 2, 1916. "Thomas Eakins, Dean of Artists" (obituary).

American Art News, July 15, 1916. "Thomas Eakins" (obituary).

Arts and Decoration, August, 1916, p. 477. (Obituary.)

Bulletin of the Metropolitan Museum of Art, Vol. XII, No. 8, August, 1917, p. 177. Under "Notes": "Coming Exhibitions of Paintings".

Bulletin of the Metropolitan Museum of Art, Vol. XII, No. 10, October, 1917, p. 198. "Thomas Eakins", by B. B. (The same as the Introduction to the catalogue of the Memorial Exhibition, omitting the biographical part. Reprinted in the *American Magazine of Art*, Vol. 9, January, 1918.)

Bulletin of the Metropolitan Museum of Art, Vol. XII, No. 11, November, 1917, p. 218. "Thomas Eakins: Two Appreciations", by John McLure Hamilton and Harrison S. Morris. (Reprinted in the *International Studio*, July, 1918.)

The New York Sun, November 4, 11, and 25, 1917. Reviews by Henry McBride of the Memorial Exhibition at the Metropolitan Museum.

The Outlook, Vol. 117, No. 12, November 21, 1917, p. 452. Under "This Week": "Thomas Eakins".

Current Opinion, Vol. LXIII, No. 6, December, 1917, pp. 411–413. "Thomas Eakins: Another Neglected Master of American Art".

Fine Arts Journal, Vol. XXXV, No. 12, December, 1917, pp. 46–51. Under "Exhibitions at New York Galleries", by Henry McBride.

Bulletin of the Metropolitan Museum of Art, Vol. XIII, No. 1, January, 1918, p. 25. Under "Recent Accessions": "Purchase of Two Paintings by Eakins", by B. B. (*The Writing Master* and *The Thinker*).

The Art World, Vol. 3, January, 1918, pp. 291–293. "Thomas Eakins", by William Sartain.

The Nation, Vol. 106, February 21, 1918, pp.

217–218. "The Thomas Eakins Exhibition", by N. N.

The Art World and Arts and Decoration, August, 1918, pp. 196 and 201. "The Chess Players by Thomas Eakins".

The Dial, Vol. LXXII, No. 2, February, 1922, pp. 221–223. Under "Modern Art," by Henry McBride.

The Arts, Vol. III, No. 3, March, 1923, pp. 185–189. "Thomas Eakins", by Alan Burroughs. 2 illustrations. Also p. 225, under "Comment".

The Freeman, Vol. 7, No. 161, April 11, 1923, pp. 112–114. "A Grand Provincial", by Walter Pach. (Reprinted in *The Freeman Book*, New York, 1924, pp. 256–261.)

The Dial, Vol. LXXIV, No. 5, May, 1923, pp. 529–531. Under "Modern Art", by Henry McBride.

The Arts, Vol. IV, No. 6, December, 1923, pp. 302–323. "Thomas Eakins, the Man", by Alan Burroughs. 22 illustrations.

Bulletin of the Metropolitan Museum of Art, Vol. XVIII, No. 12, December, 1923, p. 281. "Thomas Eakins", by B. B.

The Arts, Vol. V, No. 6, June, 1924, pp. 328–333. "Catalogue of Works by Thomas Eakins (1869–1916)", by Alan Burroughs.

The Arts, Vol. VIII, No. 6, December, 1925, pp. 345–347. Under "New York Exhibitions", by Lloyd Goodrich.

Arts and Decoration, January, 1926, p. 53. Under "New York Exhibitions from a Personal Angle", by Louis Kalonyme.

The Dial, Vol. LXXX, No. 1, January, 1926, pp. 77–78. Under "Modern Art", by Henry McBride.

Art and Archaeology, Vol. 21, No. 4, April–May, 1926, "Historic Philadelphia Number". "Events and Portents of Fifty Years", by Dorothy Grafly. P. 175.

The Brooklyn Museum Quarterly, Vol. XIV, No. 2, April, 1927, pp. 39–40. "Thomas Eakins", by Herbert B. Tschudy.

Bulletin of the Art Institute of Chicago, Vol. XXI, No. 8, November, 1927, pp. 101–102. " 'Music', by Thomas Eakins", by D.C.R.

Bulletin of the Metropolitan Museum of Art, Vol. XXIII, No. 1, January, 1928, p. 29. Under "Accessions and Notes": "A Portrait by Thomas Eakins", by J. M. L. (*Signora Gomez d'Arza*).

Bulletin of the Cleveland Museum of Art, 15th year, No. 1, January, 1928, pp. 7–9. "Memorial Exhibition of Paintings by Thomas Eakins, Albert P. Ryder, and J. Alden Weir", by W. M. M. (William M. Milliken).

The Arts, Vol. XVI, No. 2, October, 1929, pp. 72–83. "Thomas Eakins, Realist", by Lloyd Goodrich. 9 illustrations.

The New York Sun, November 16, 1929. "Thomas Eakins and His Art", by Walter Gutman.

International Studio, Vol. XCV, No. 392, January, 1930, pp. 44–49, 90, 92. "Thomas Eakins' Art in Retrospect", by Frank Jewett Mather, Jr. 8 illustrations. (Reprinted in his *Estimates in Art, Series II*, New York, 1931.)

Bulletin of the Worcester Art Museum, Vol. XX, No. 4, January, 1930, pp. 86–94. "Thomas Eakins, 1844–1916", by G. W. E. (George W. Eggers).

The Pennsylvania Museum Bulletin, Vol. XXV, No. 133, March, 1930. "Thomas Eakins, 1844–1916", consisting of "An Exhibition of Thomas Eakins' Work", by Henri Gabriel Marceau; "Thomas Eakins—An Appreciation", by Gilbert Sunderland Parker (a reprint of part of the introduction to the catalogue of the 1917 Memorial Exhibition at the Pennsylvania Academy); "Thomas Eakins, Realist", by Lloyd Goodrich (a reprint of part of the article in *The Arts* for October, 1929); and a "Catalogue of the Works of Thomas Eakins". 8 illustrations.

Parnassus, Vol. II, No. III, March, 1930, pp. 20–21, 43. "Thomas Eakins, Positivist", by Francis Henry Taylor.

The Arts, Vol. XVI, No. 8, April, 1930, pp. 563–567. Under "In the Galleries", by Forbes Watson: "The Growth of a Reputation".

The Arts, Vol. XVI, No. 9, May, 1930, pp. 630–634. Under "In the Galleries", by Forbes Watson: "Ryder, Eakins, Homer".

The New Yorker, May 17, 1930. "The Art Galleries", by Guy Pène du Bois.

The Literary Digest, June 7, 1930, pp. 19–20. "Our Veritable Old Masters".

Artwork: A Quarterly. London. No. 23, Autumn, 1930, pp. 196–199. "A Note on Thomas Eakins", by John Rothenstein.

Bulletin of the Detroit Institute of Arts, Vol. XII, No. 2, November, 1930, pp. 21–23. "A Portrait by Thomas Eakins", by Clyde H. Burroughs (*Portrait of Dr. Horatio C. Wood*).

The Arts, Vol. XVII, No. 4, January, 1931,

p. 272. Under "Exhibitions": "Thomas Eakins", by H. E. Schnakenberg.

The Pennsylvania Museum Bulletin, Vol. XXVI, No. 138, January, 1931, pp. 20–25. "The 'Fairman Rogers Four-in-Hand' ", by Henri Gabriel Marceau.

The Carnegie Magazine, Vol. IV, No. 9, February, 1931, pp. 280–281. Under "New Patrons Art Fund Paintings" (*Portrait of Joseph R. Woodwell*).

The Arts, Vol. XVII, No. 6, March, 1931, pp. 376–386. "Thomas Eakins as a Teacher", by Charles Bregler. 2 portraits.

The Arts, Vol. XVIII, No. 1, October, 1931, pp. 27–42. "Thomas Eakins as a Teacher: Part Two", by Charles Bregler. 11 illustrations.

Scribner's Magazine, Vol. XC, No. 4, October, 1931, pp. 366–369. "The Brown Decades: Art", by Lewis Mumford. Also appears in his *The Brown Decades*, New York, 1931.

INDEX TO THE ILLUSTRATIONS

ADDENDUM: *Taking the Count* (Plate No. 48) is now in the Whitney Collection of Sporting Art, presented by Francis P. Garvan to Yale University, New Haven.

PLATES

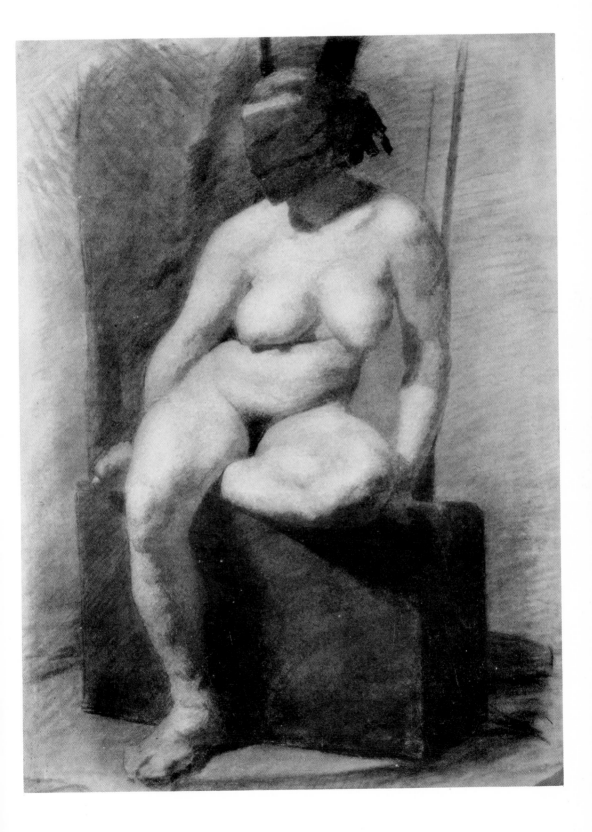

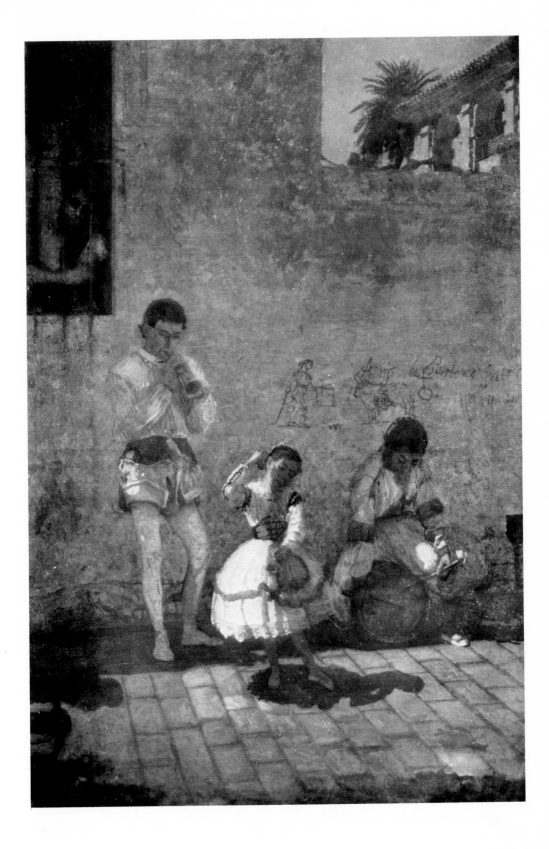

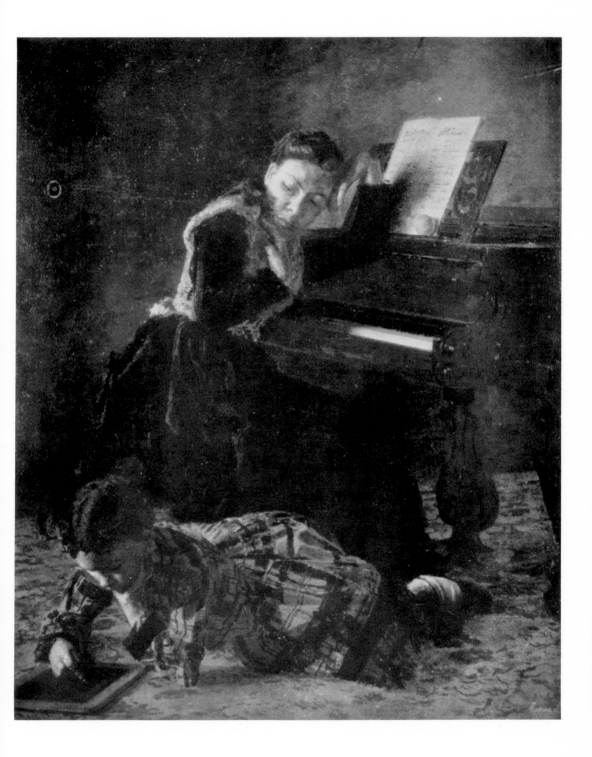

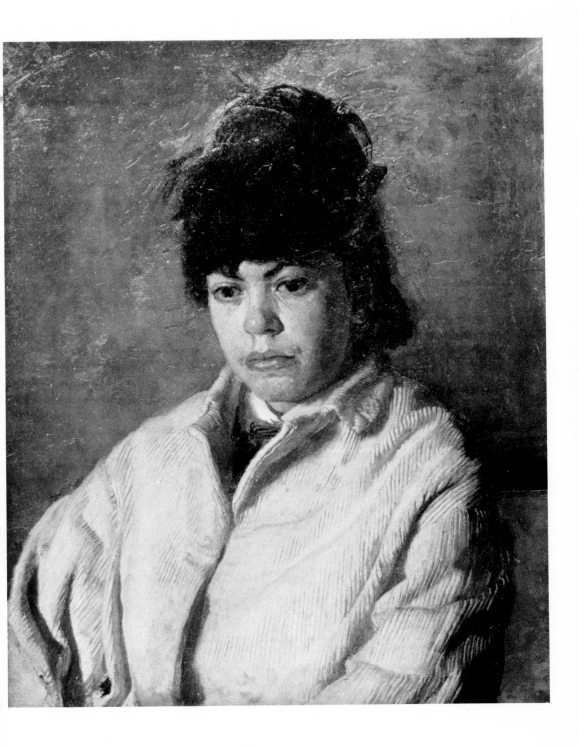

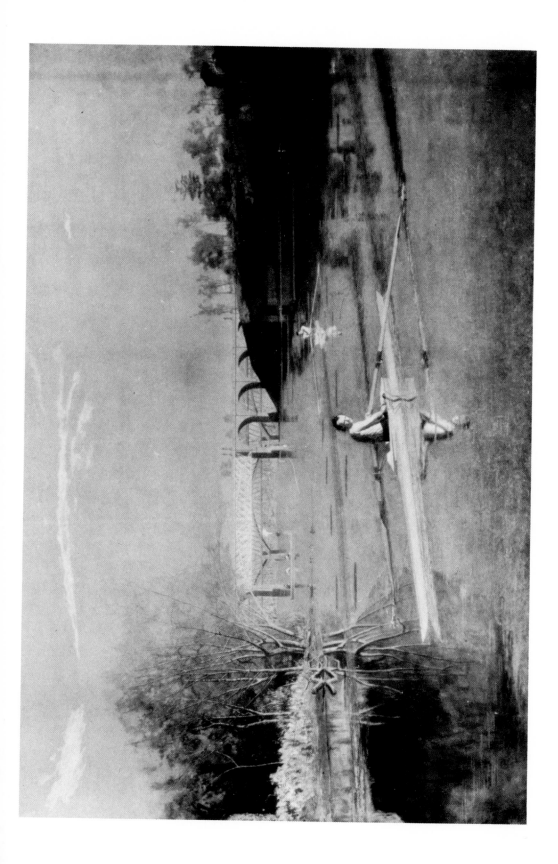

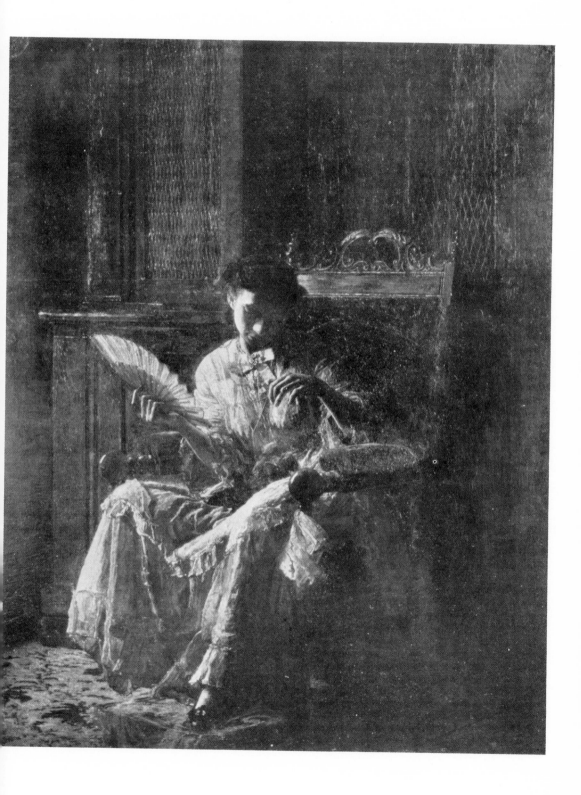

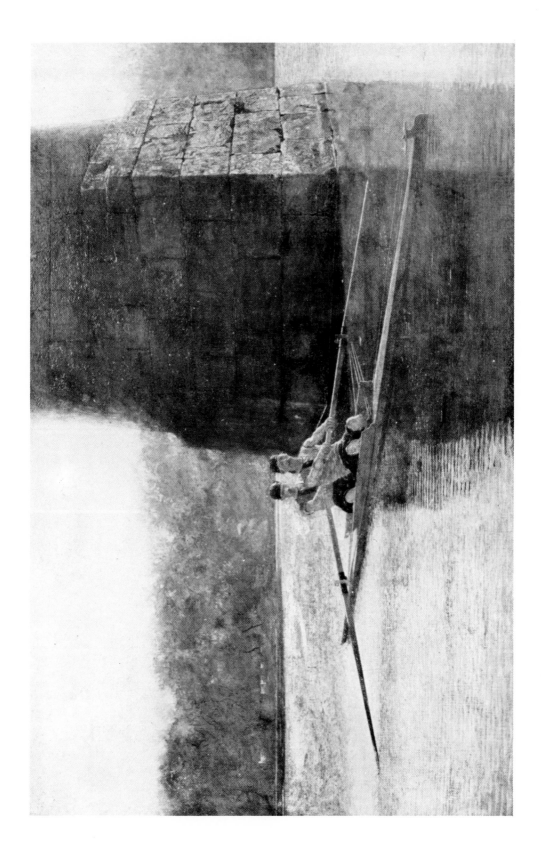

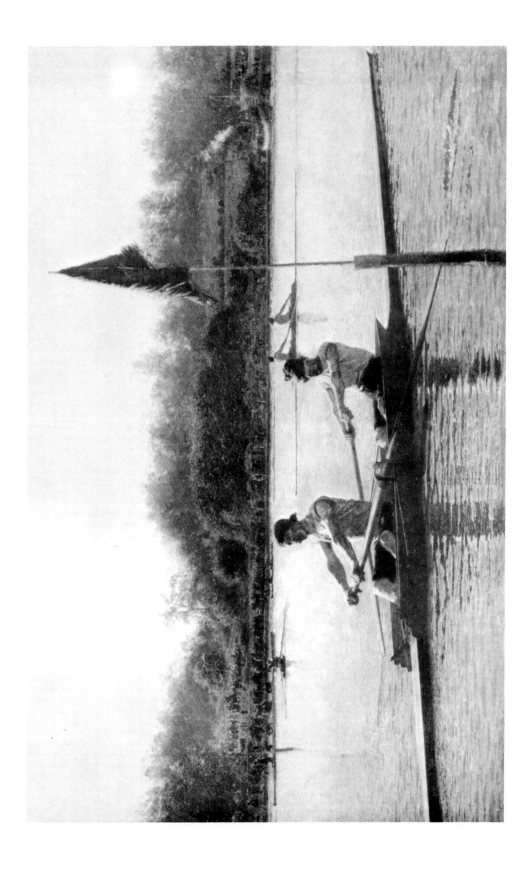

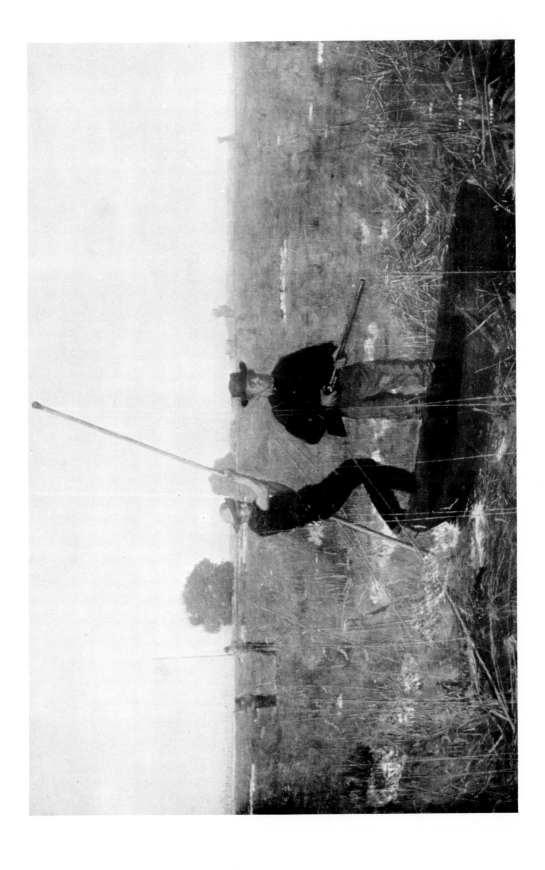

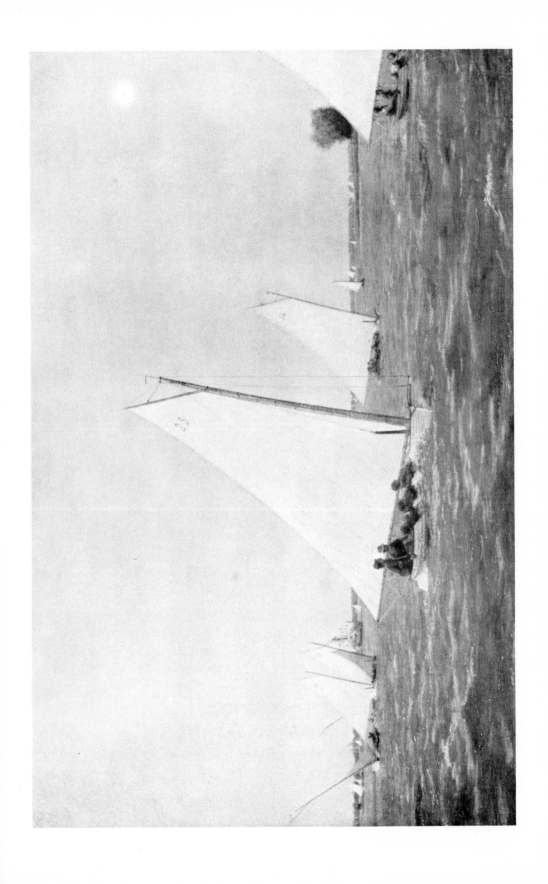

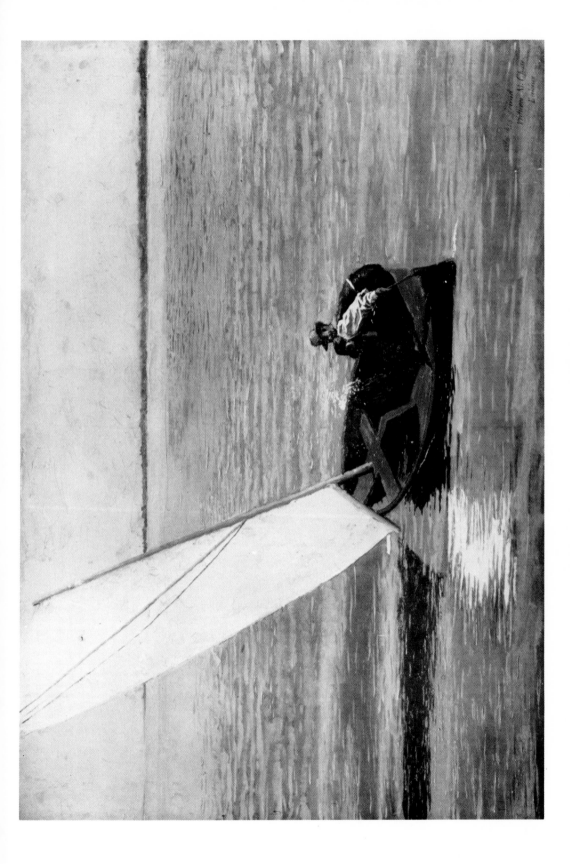

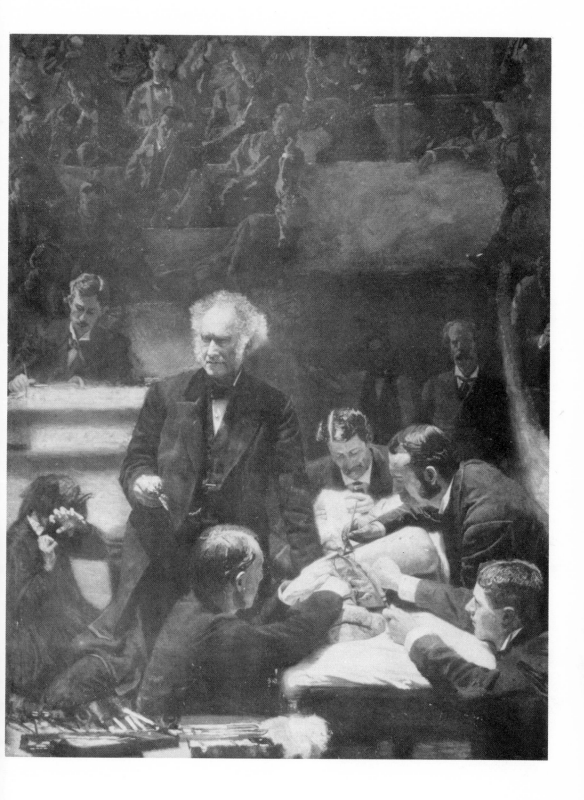

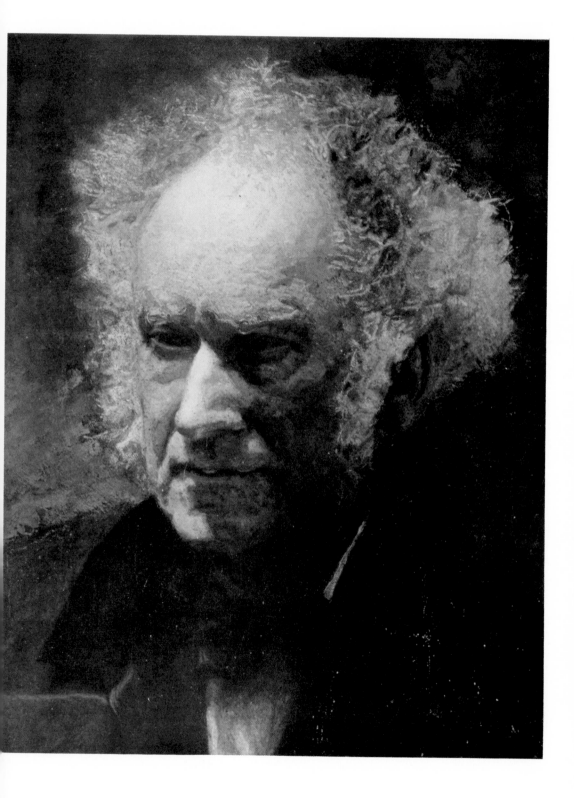

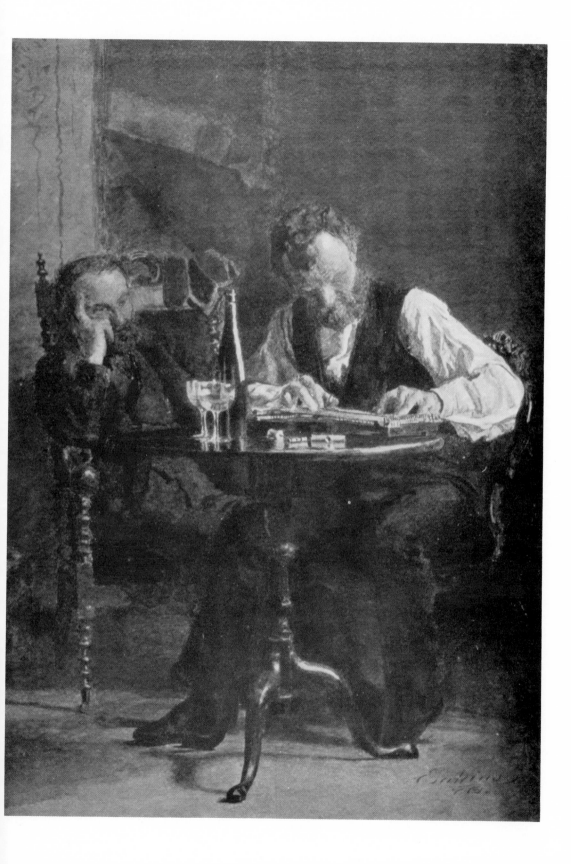

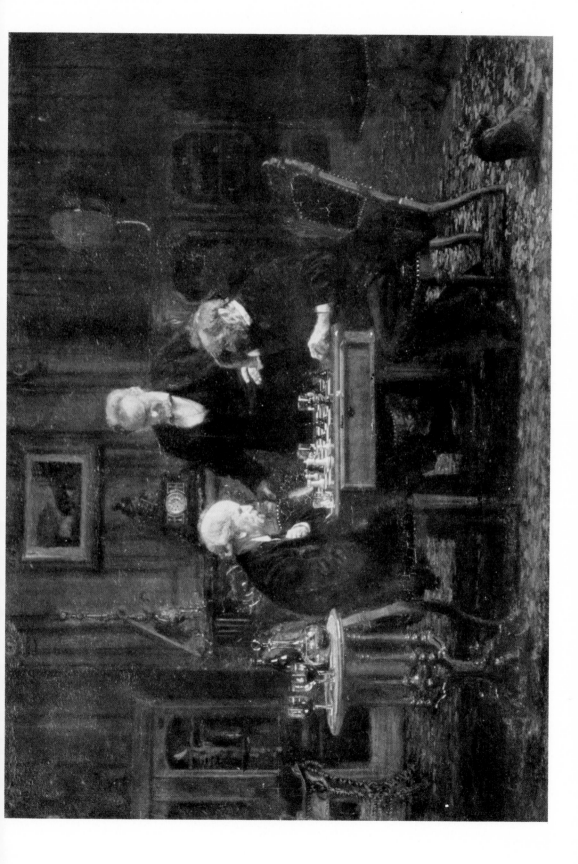

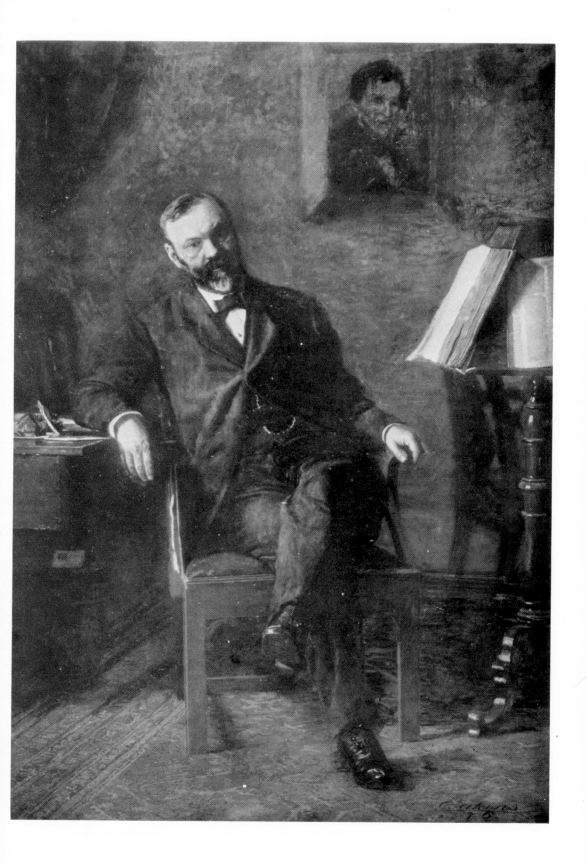

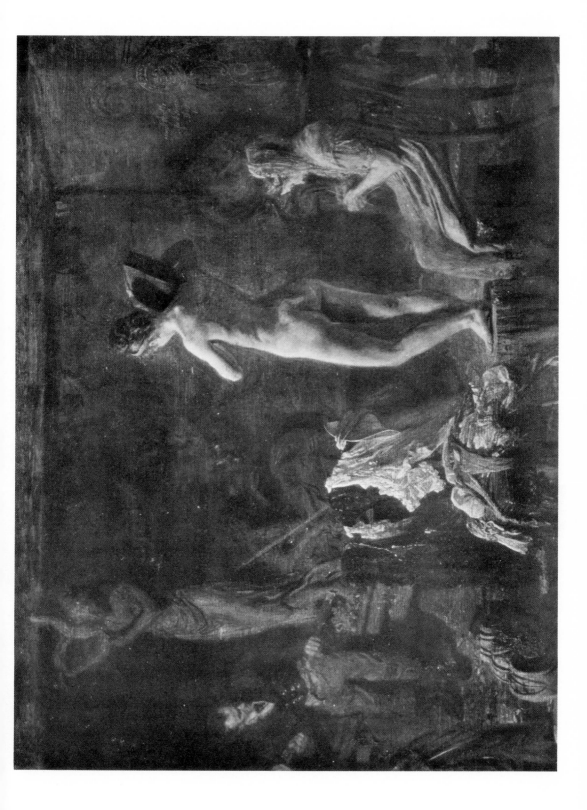

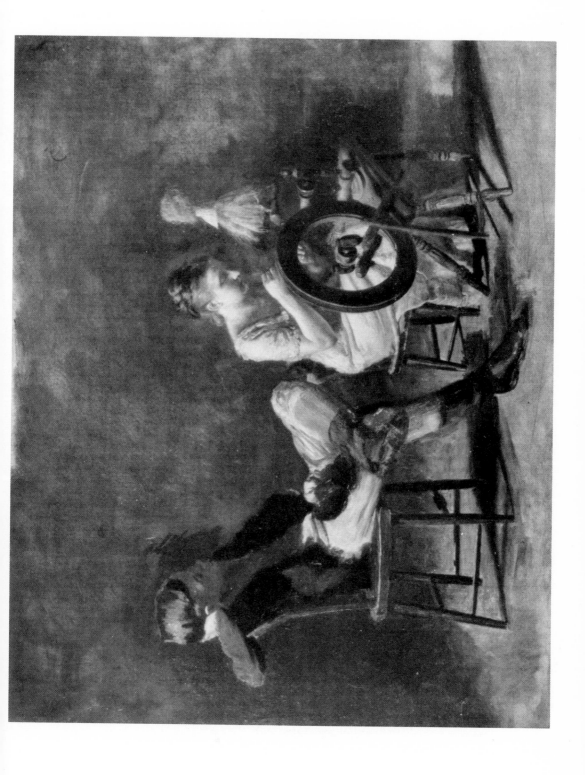

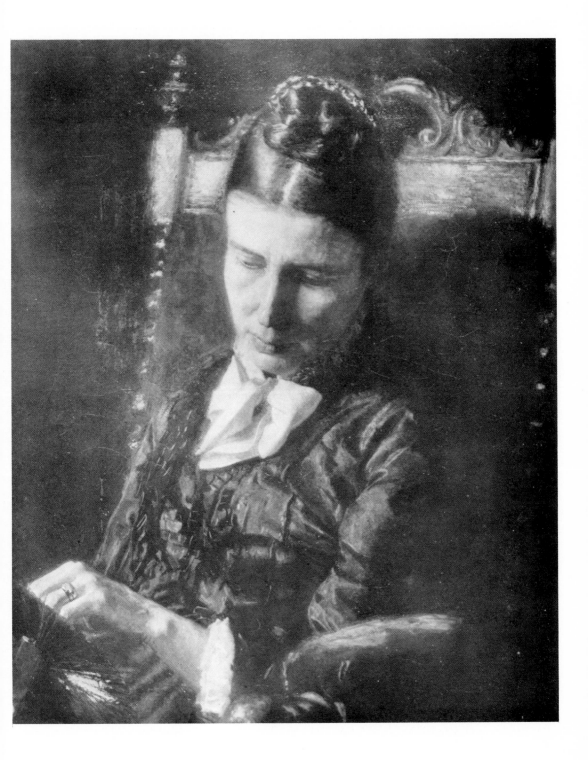

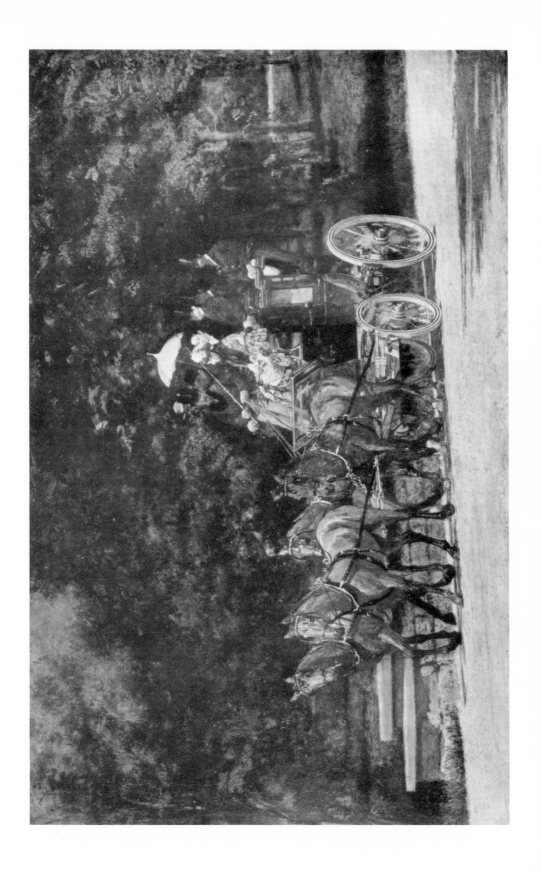

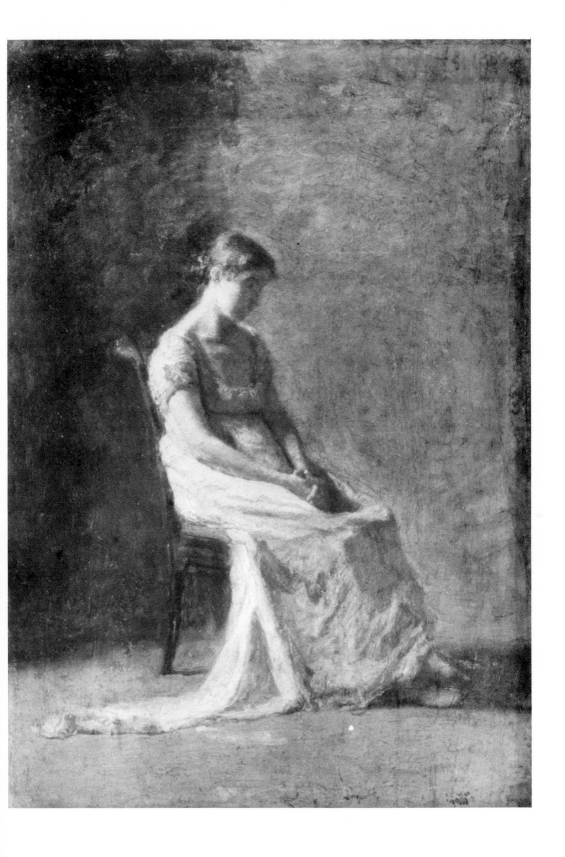

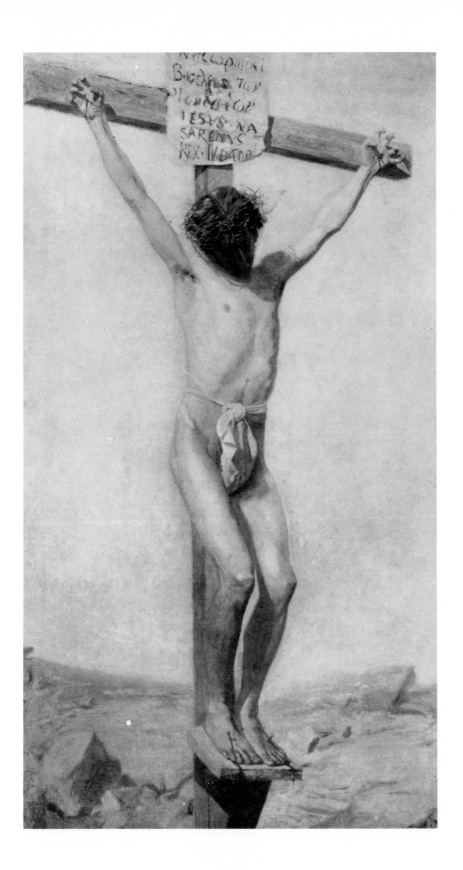

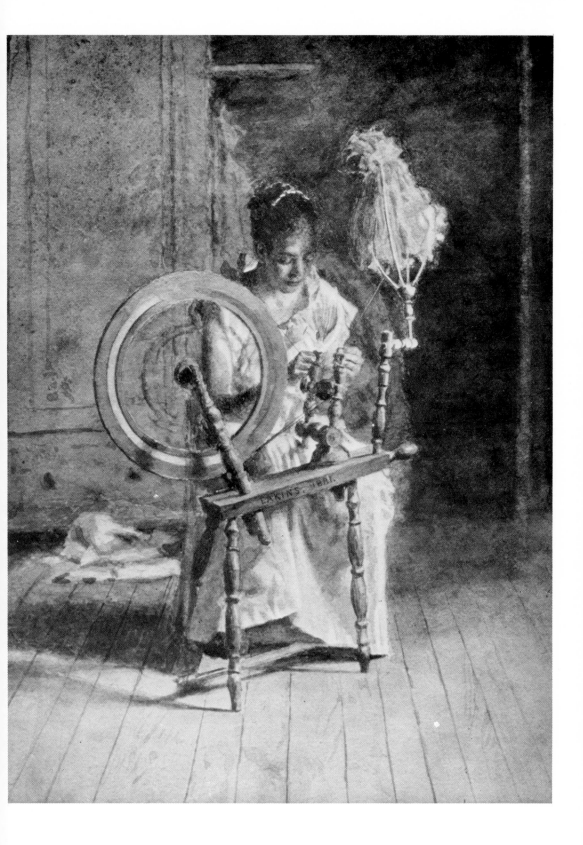

PLATE 24

THE PATHETIC SONG

OWNED BY THE CORCORAN GALLERY OF ART, WASHINGTON

1881. 45¼″ x 32½″. CATALOGUE NO. 148

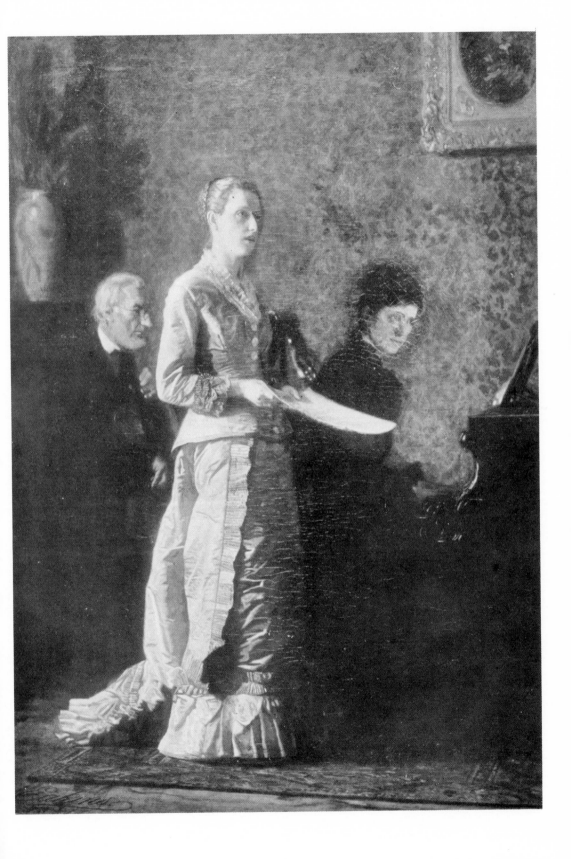

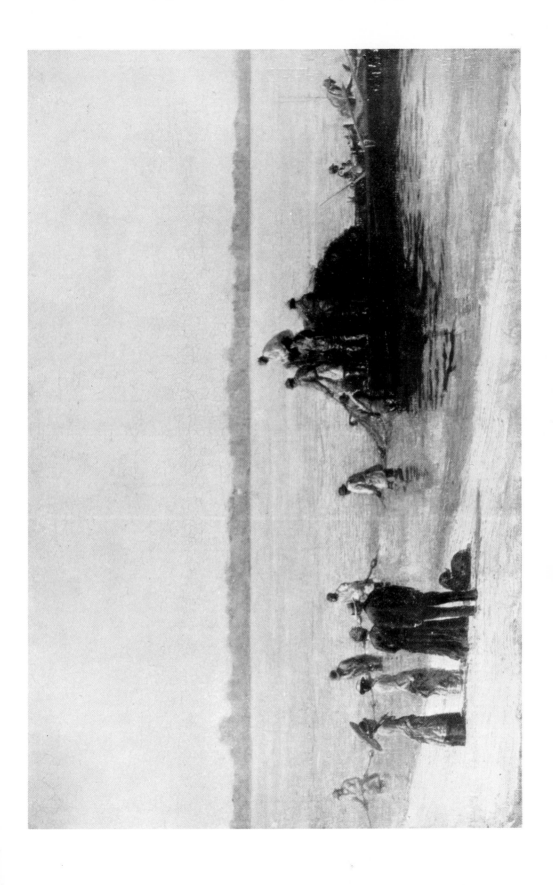

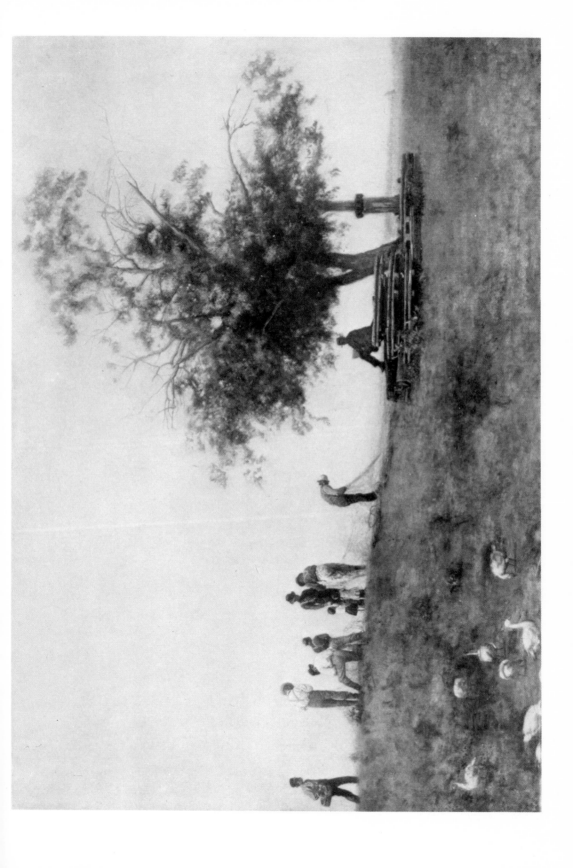

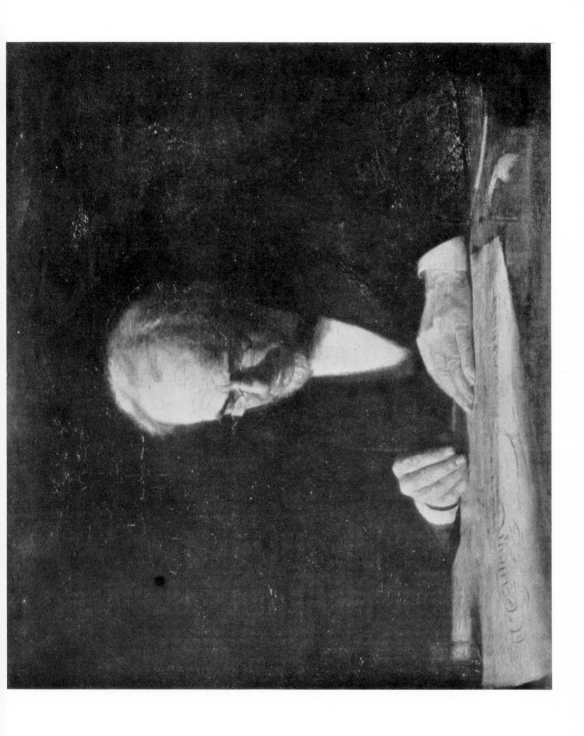

PLATE 28

THE SWIMMING HOLE

OWNED BY THE FORT WORTH MUSEUM OF ART, FORT WORTH, TEXAS

1883. 27″ x 36″. CATALOGUE NO. 190

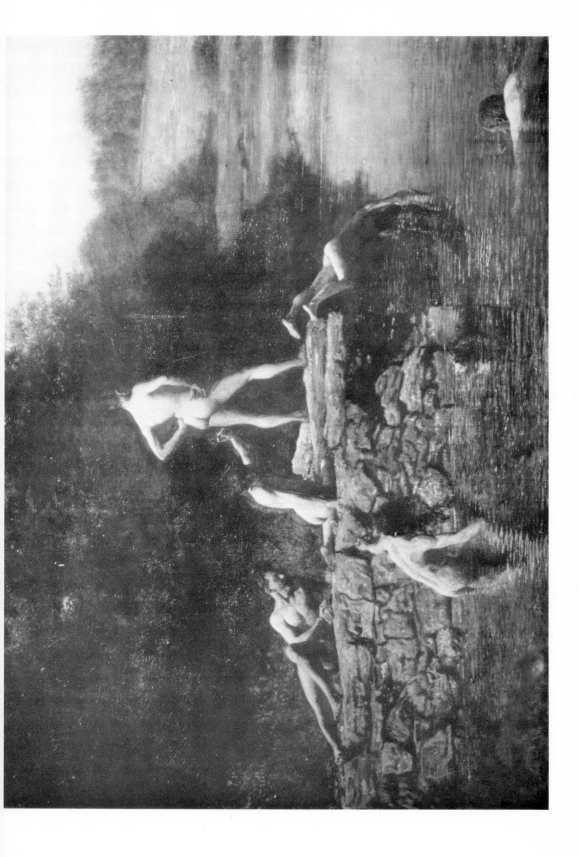

PLATE 29

THE VETERAN

OWNED BY HENRY SHEAFER, POTTSVILLE, PA.

ABOUT 1884. 23⅛″ x 17″. CATALOGUE NO. 211

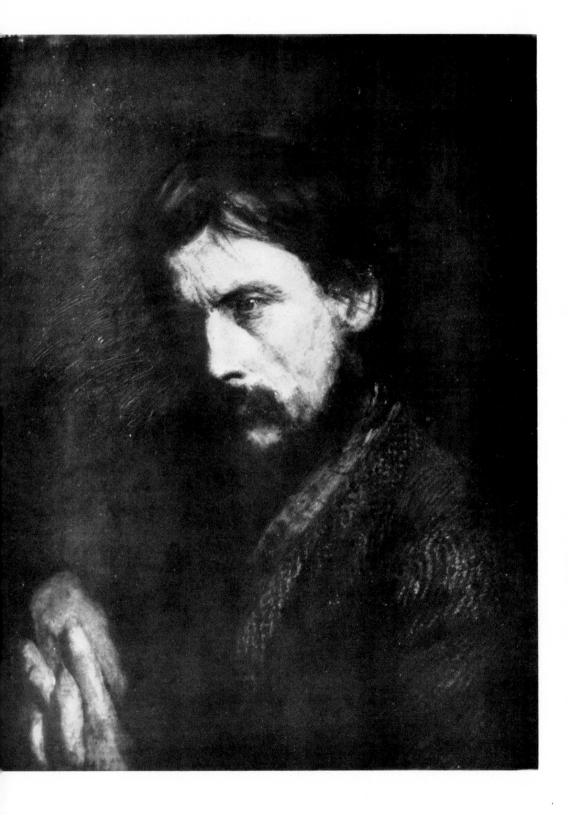

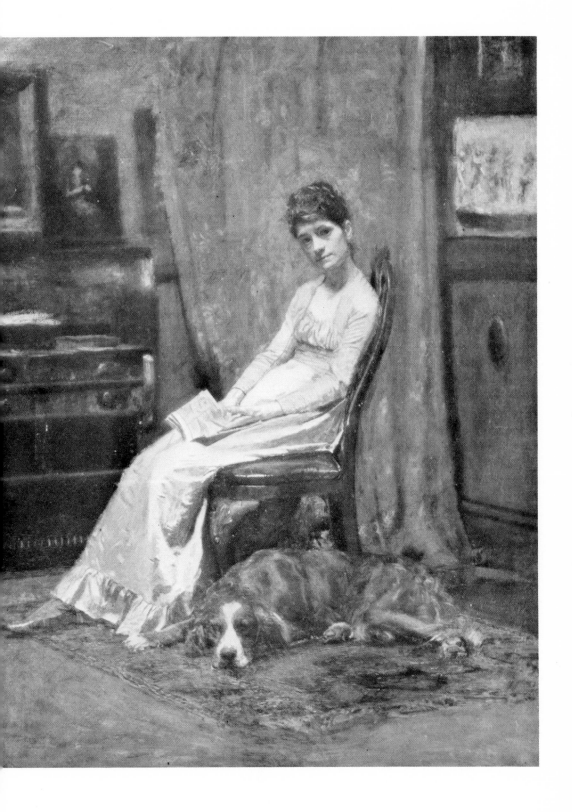

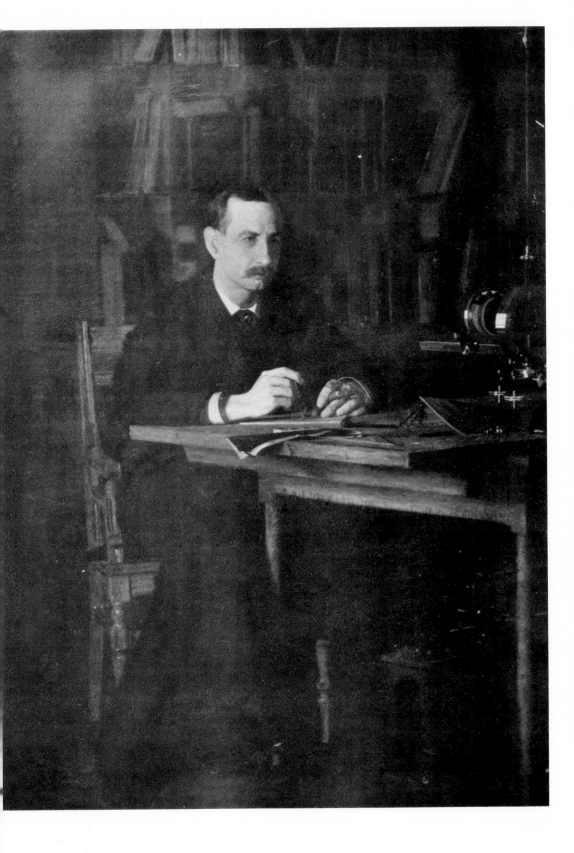

PLATE 32

WALT WHITMAN

OWNED BY THE PENNSYLVANIA ACADEMY OF THE FINE ARTS

1887–8. 30″ x 24″. CATALOGUE NO. 220

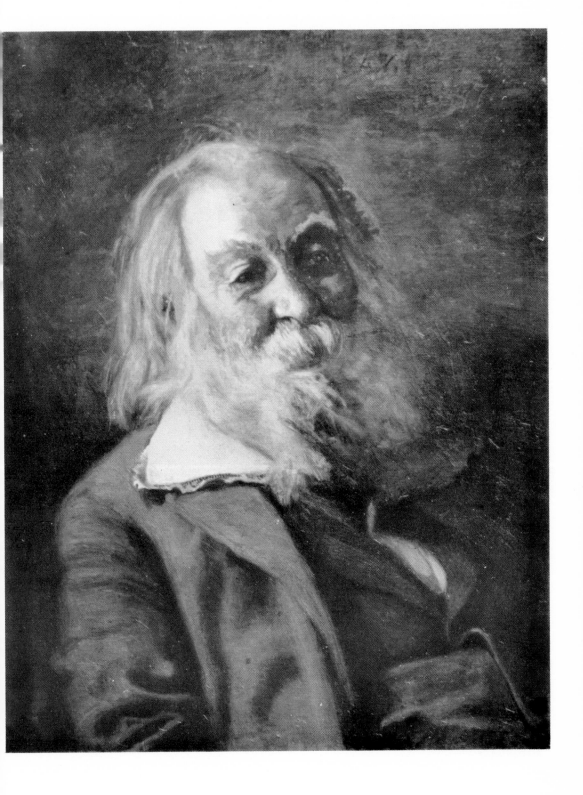

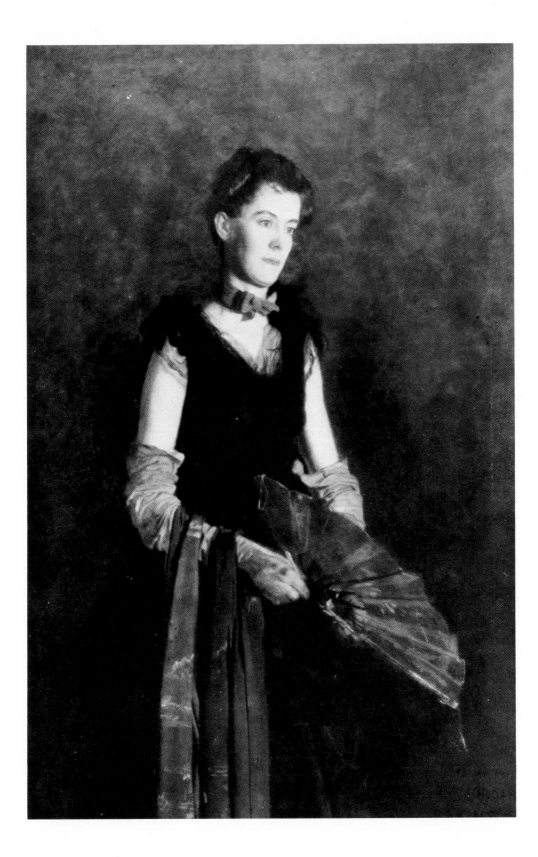

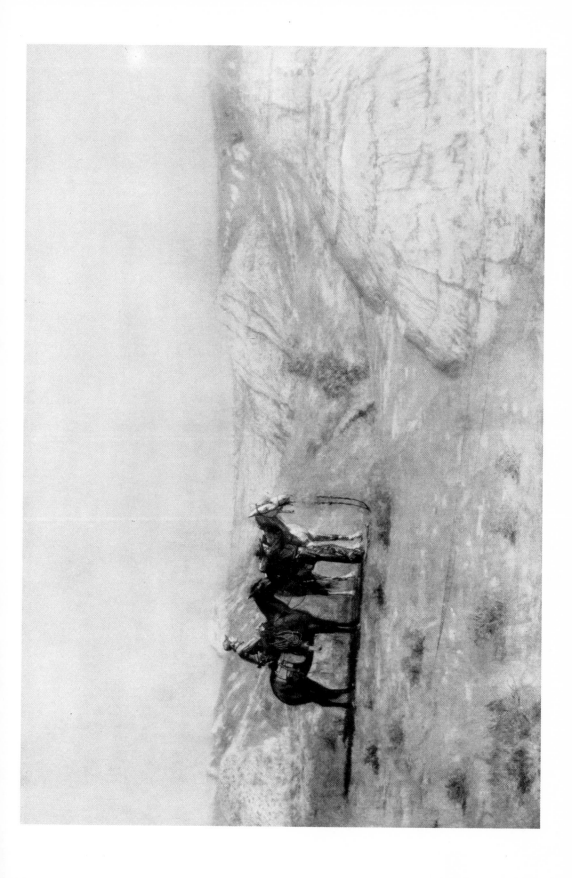

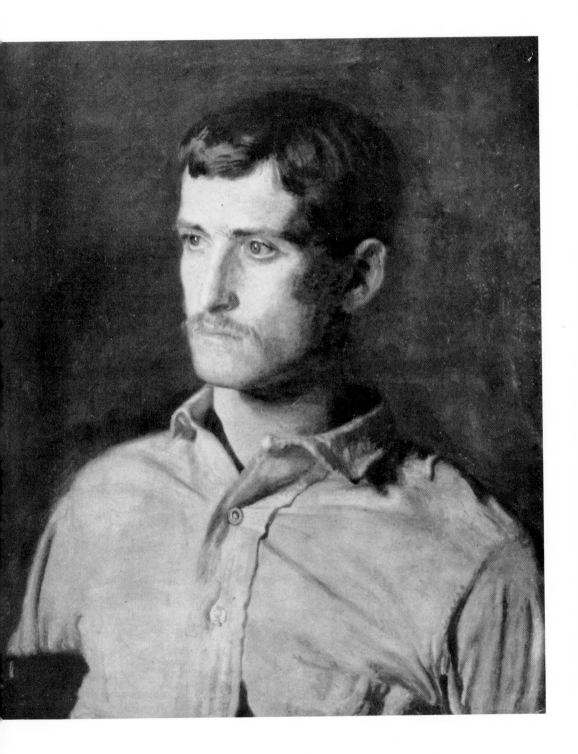

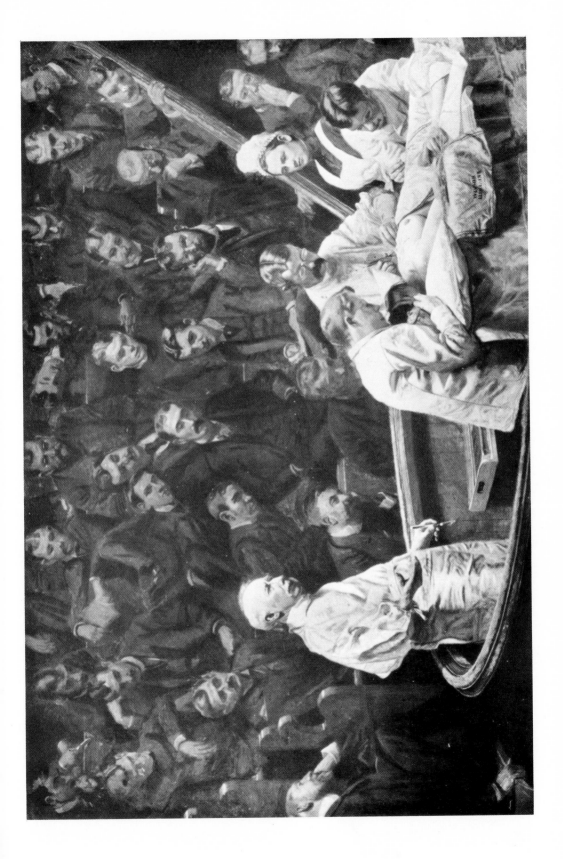

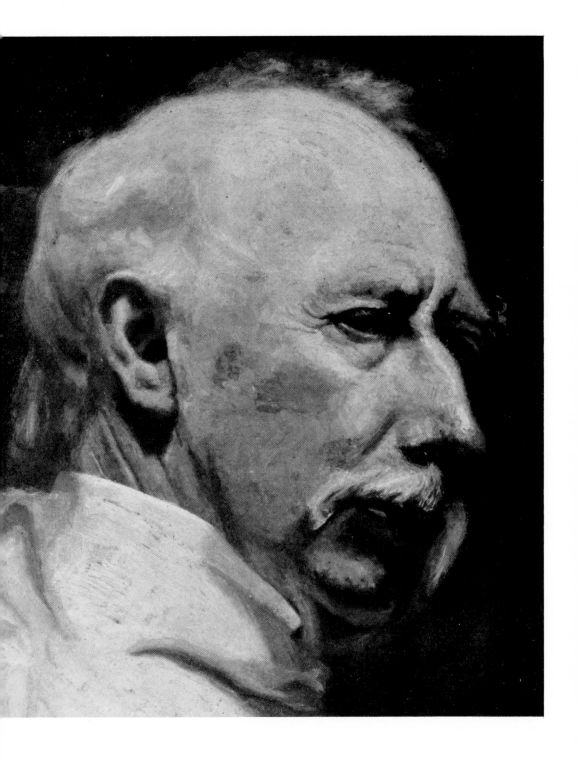

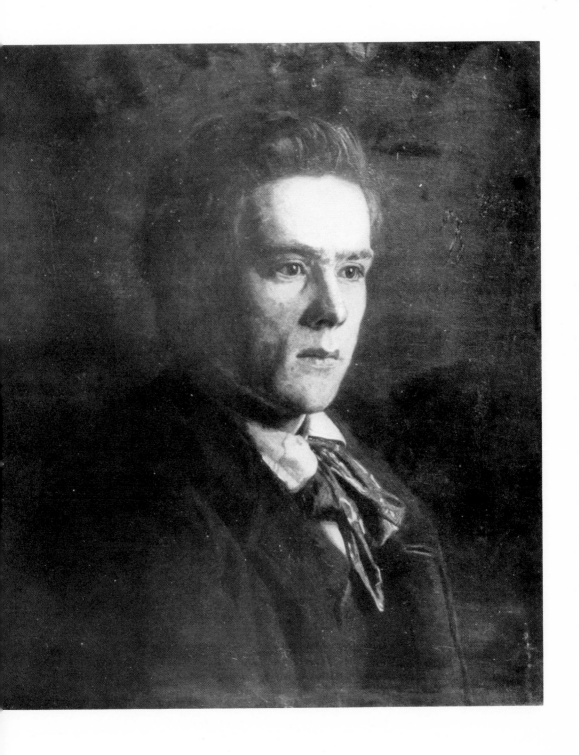

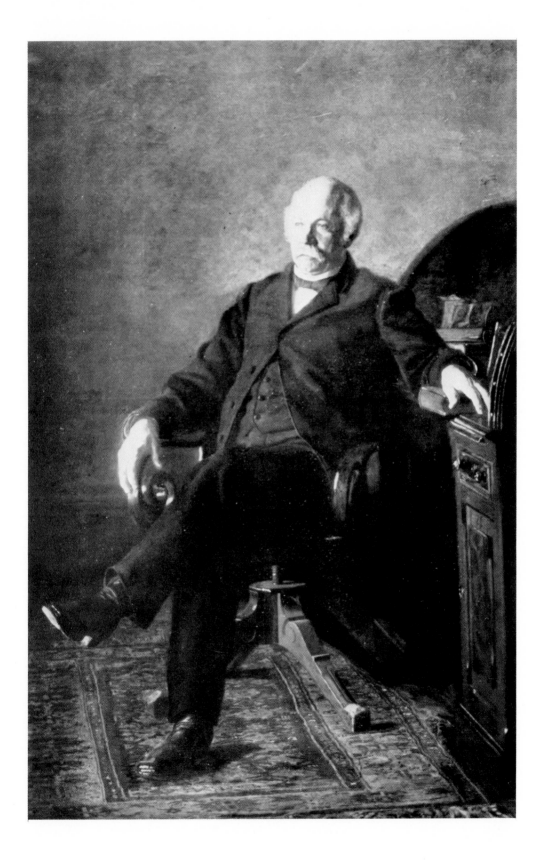

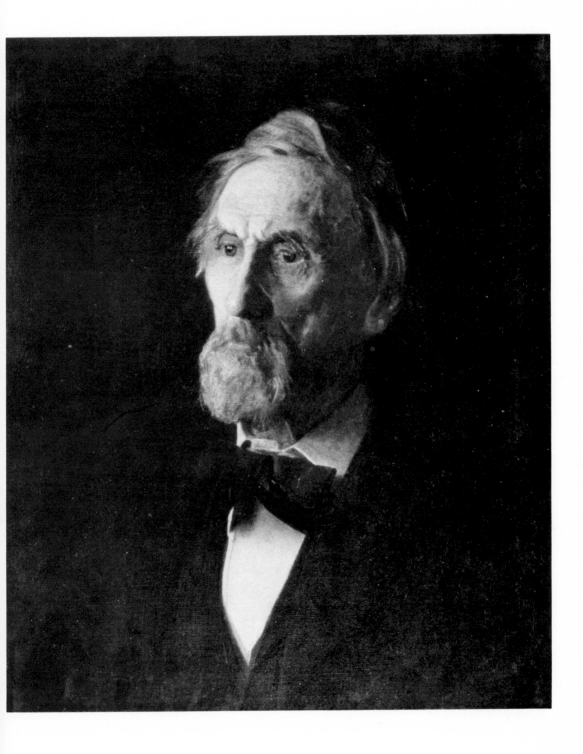

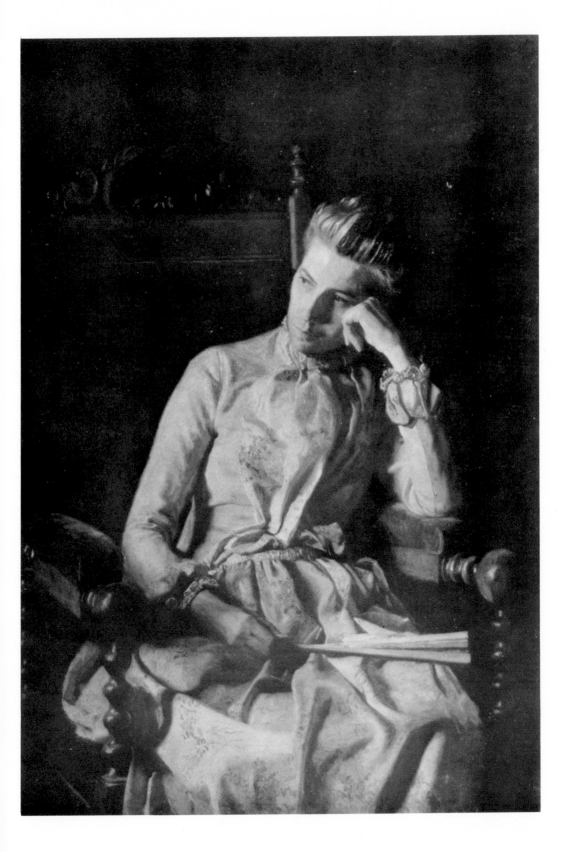

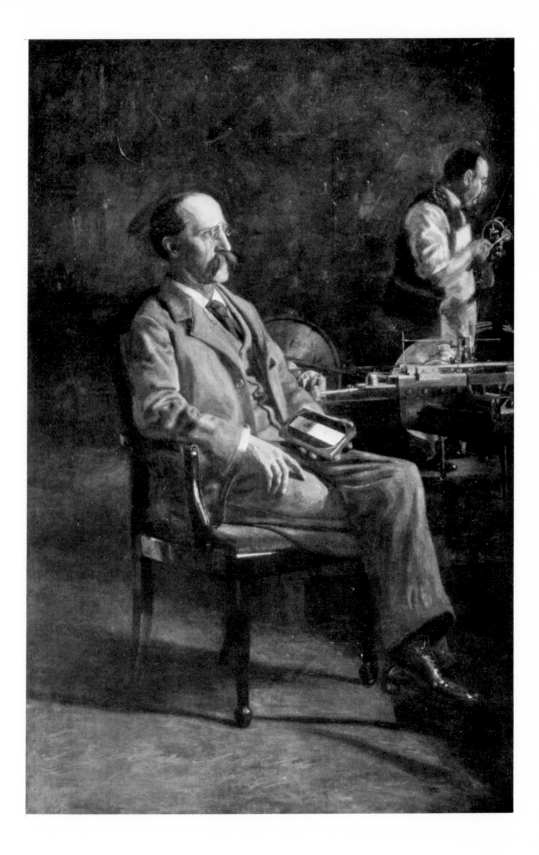

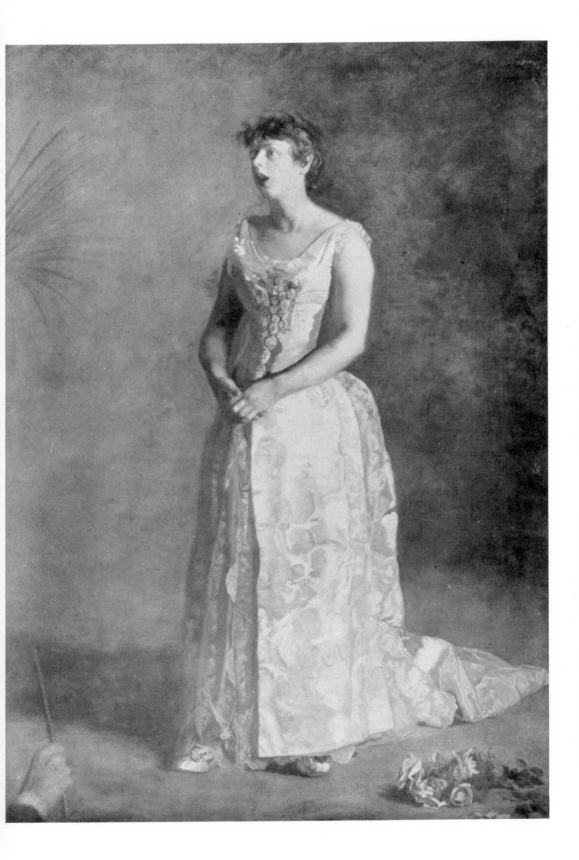

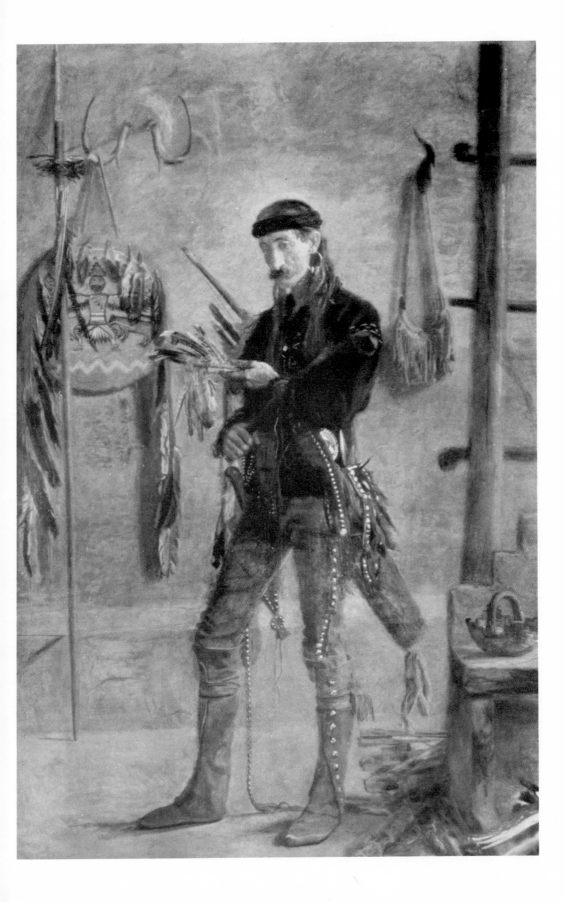

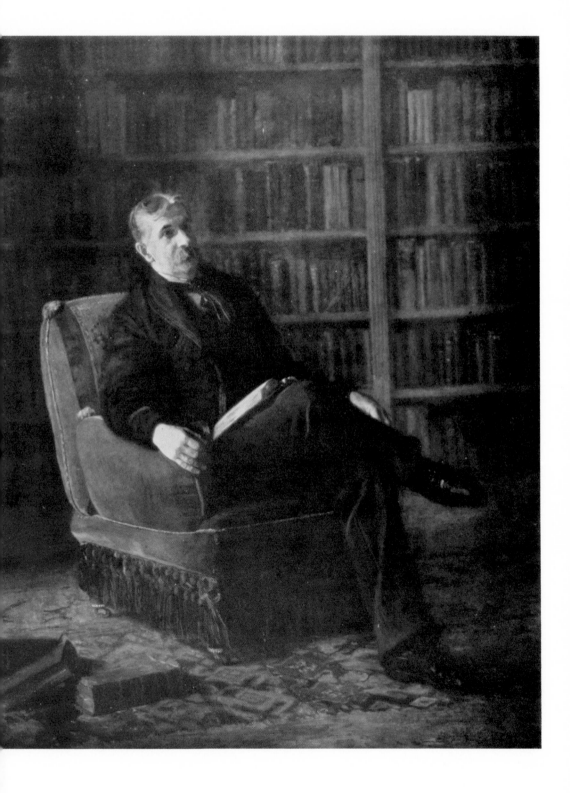

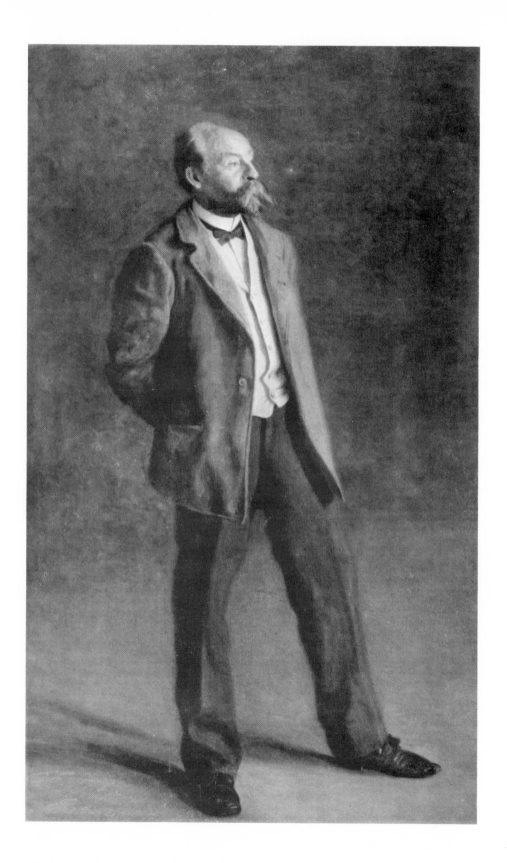

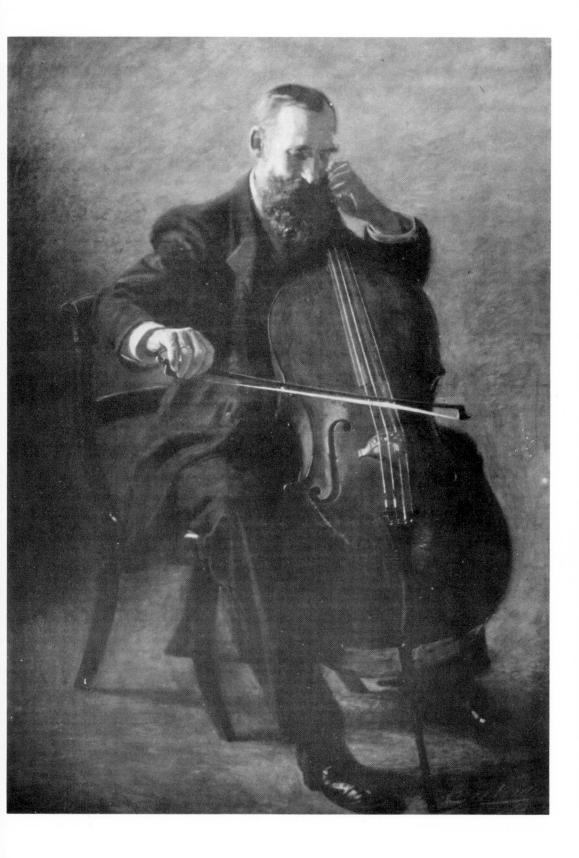

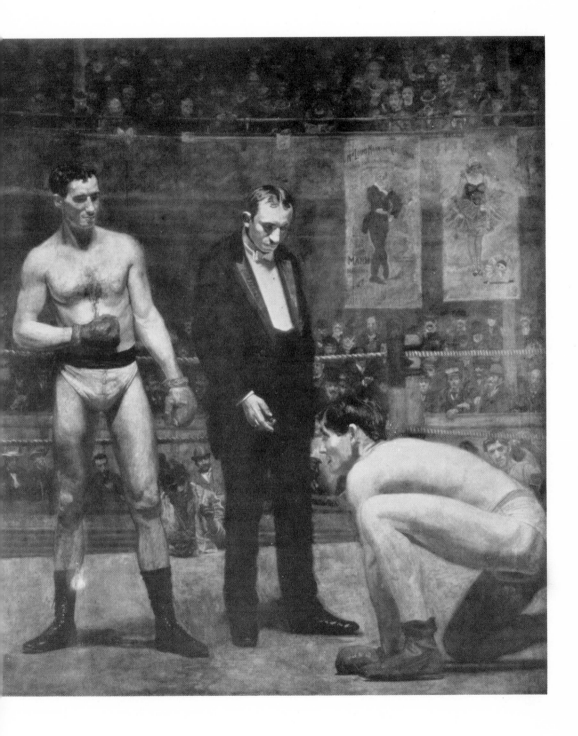

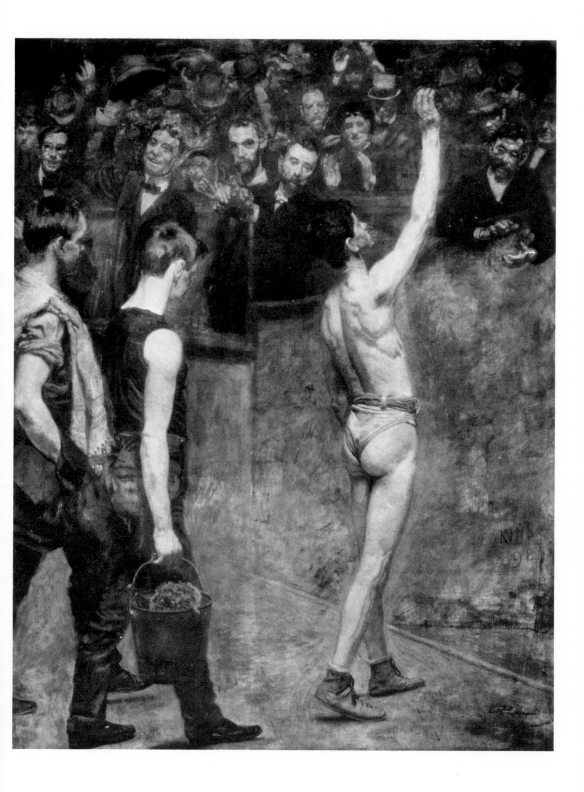

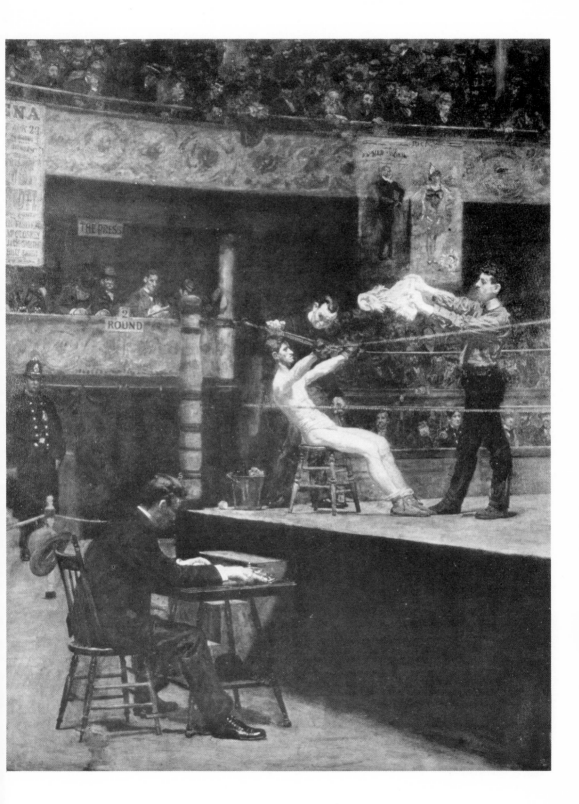

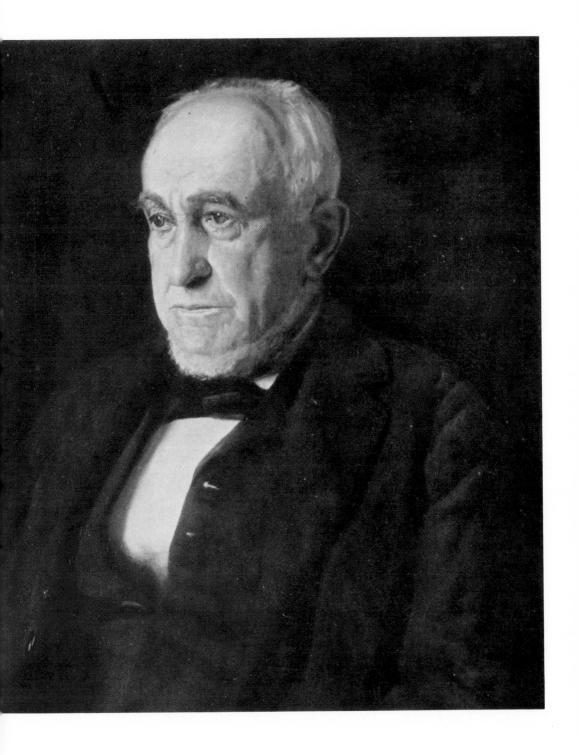

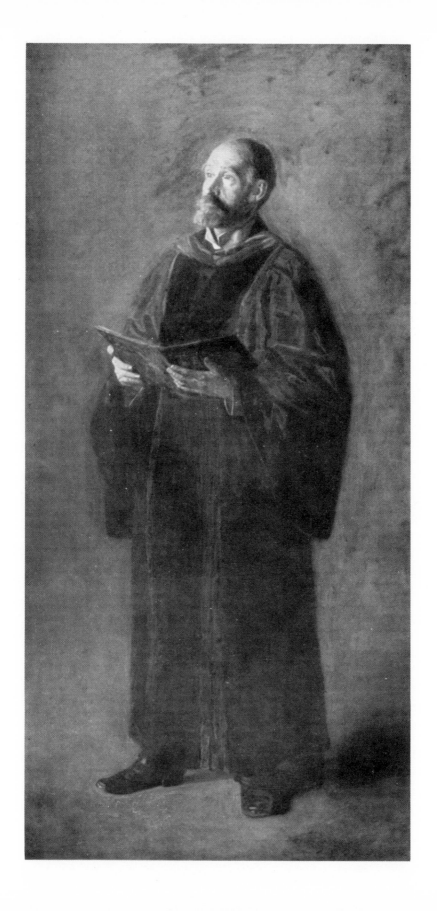

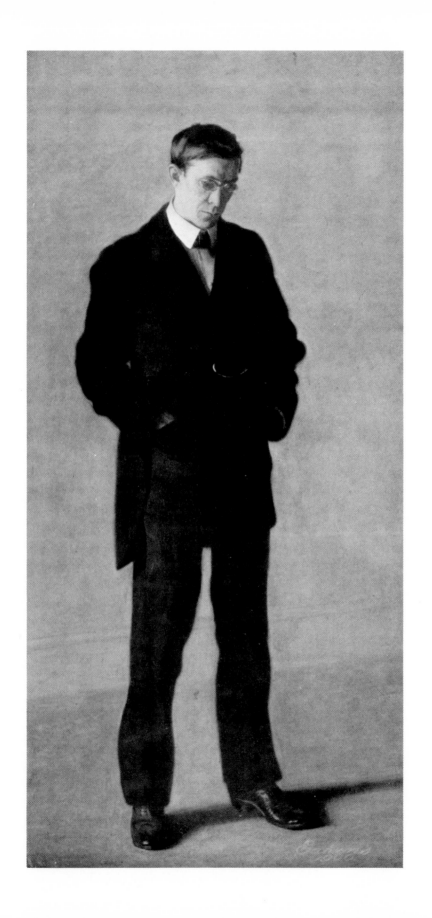

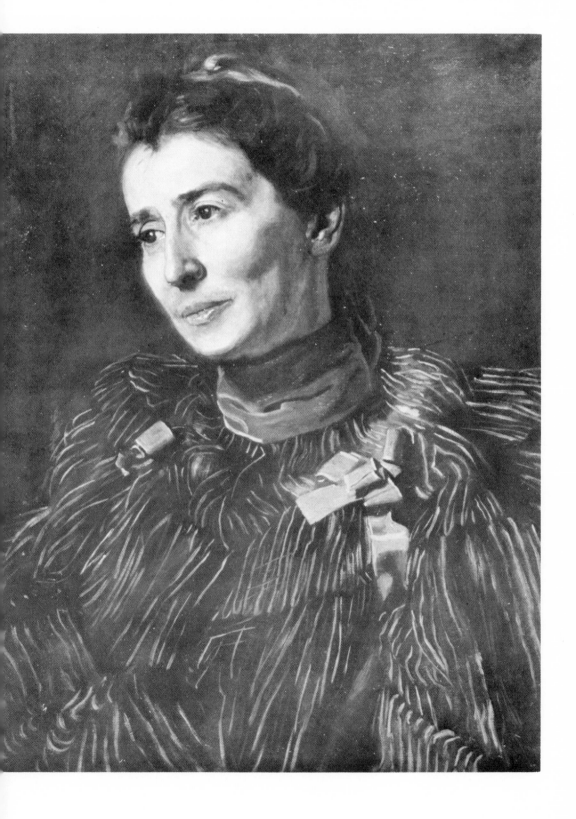

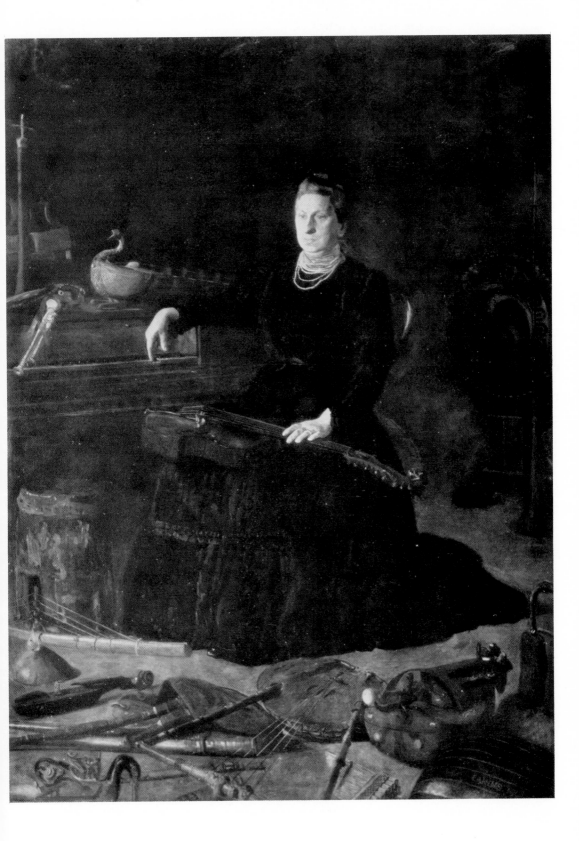

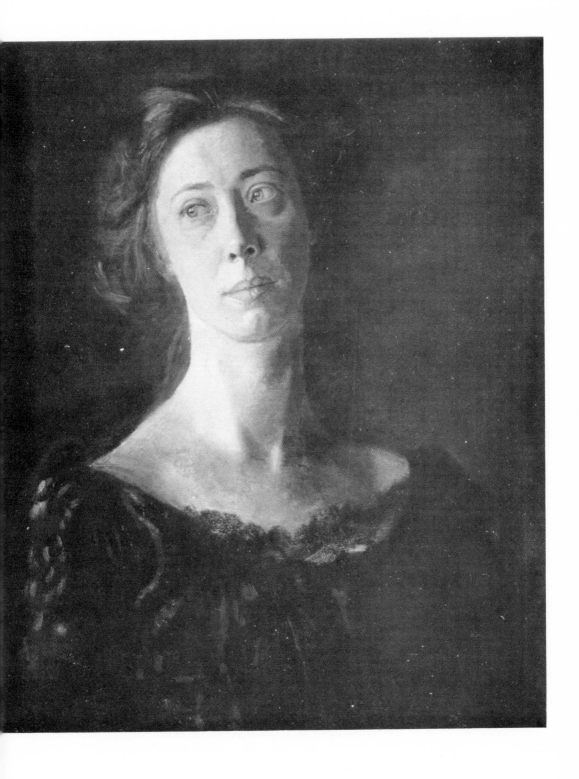

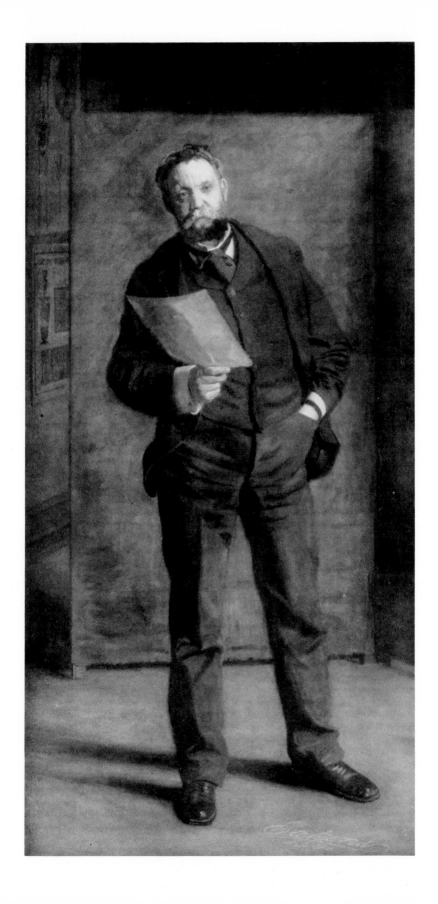

PLATE 58

SIGNORA GOMEZ D'ARZA

OWNED BY THE METROPOLITAN MUSEUM OF ART

1902. 30″ X 24″. CATALOGUE NO. 360

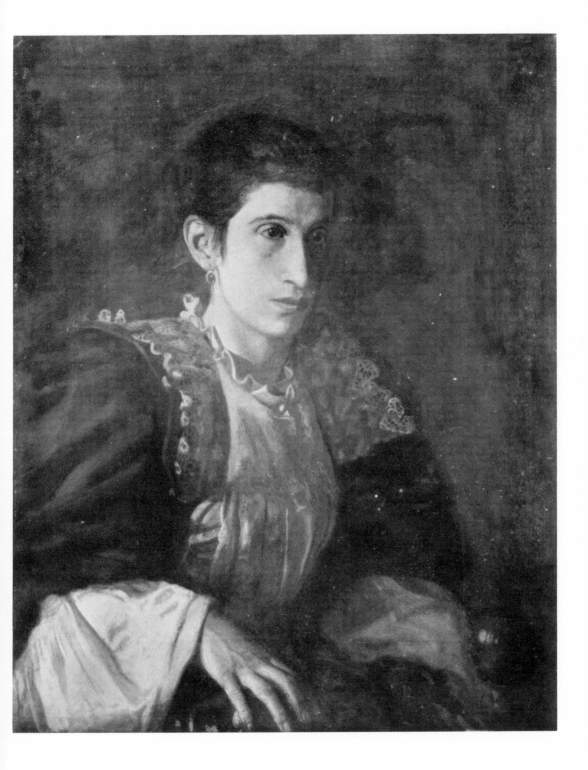

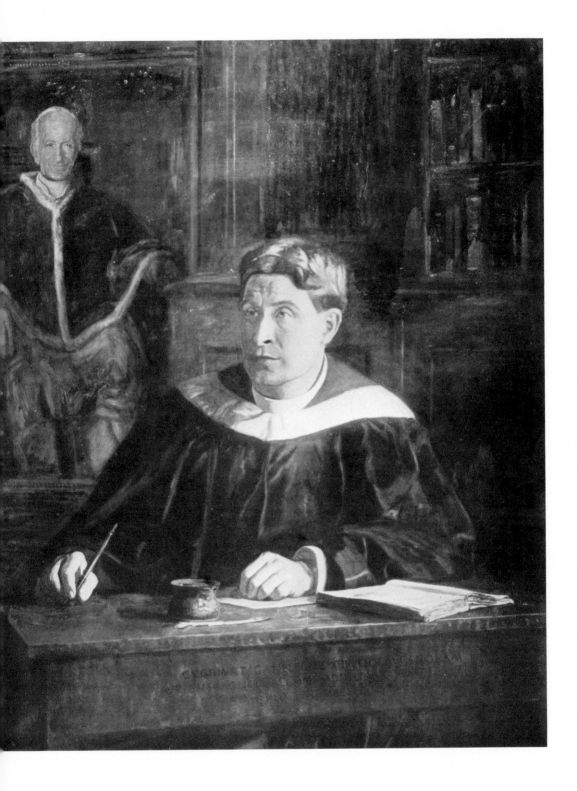

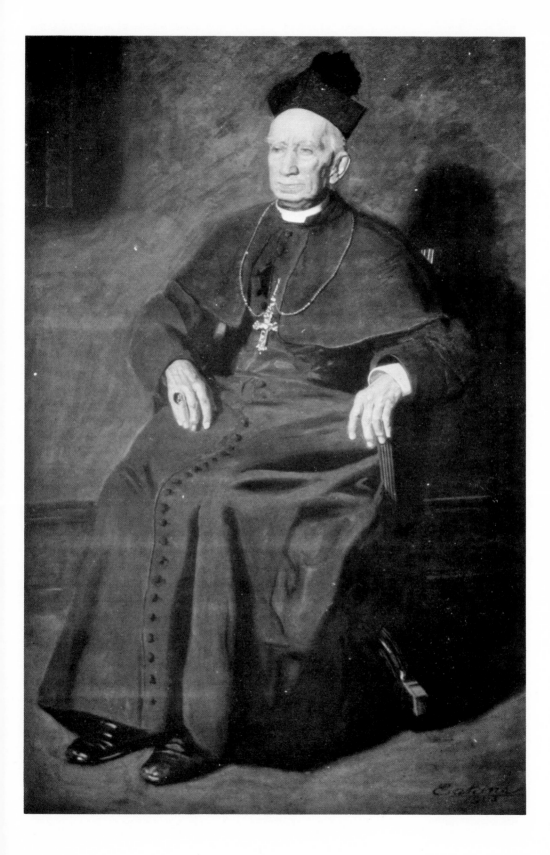

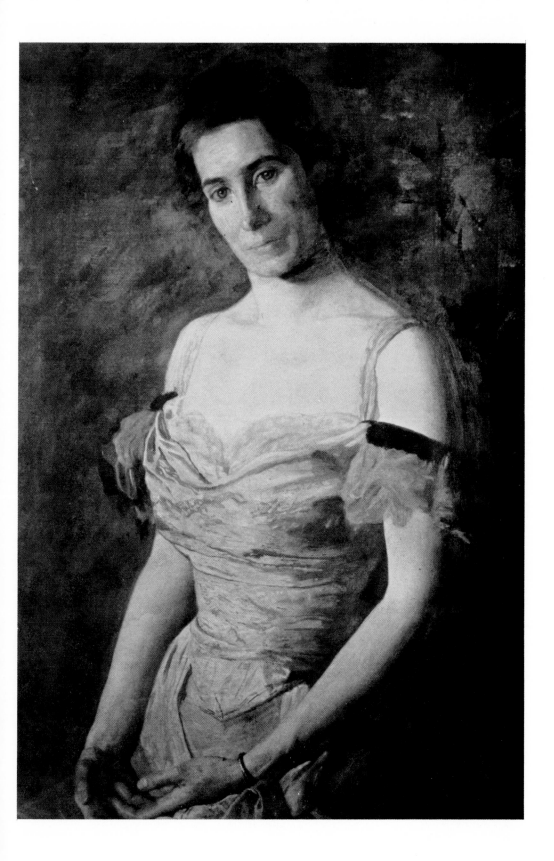

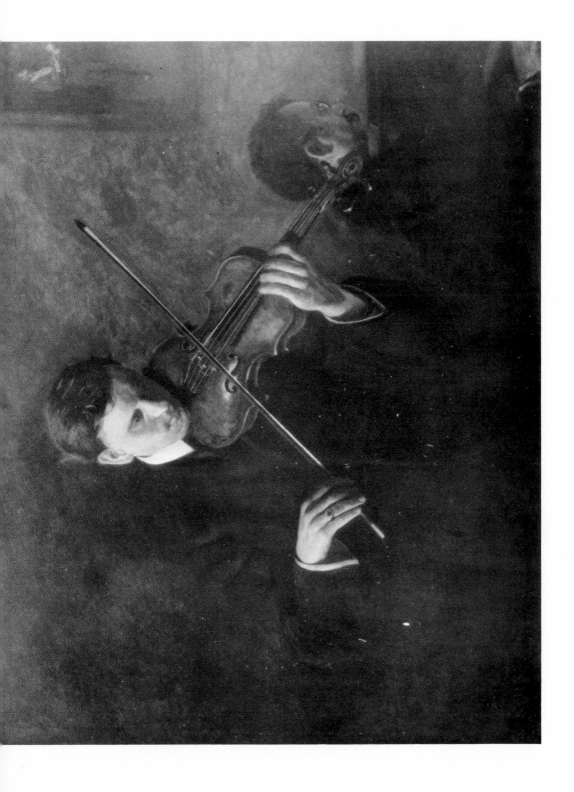

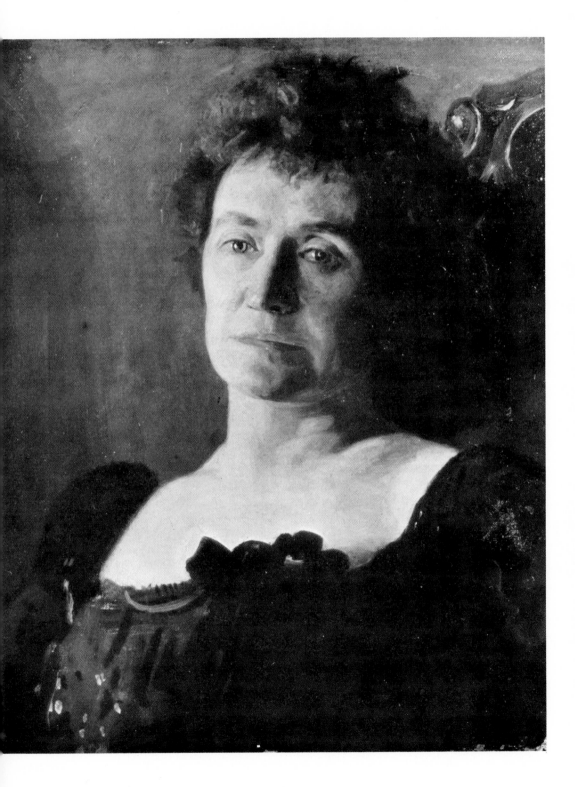

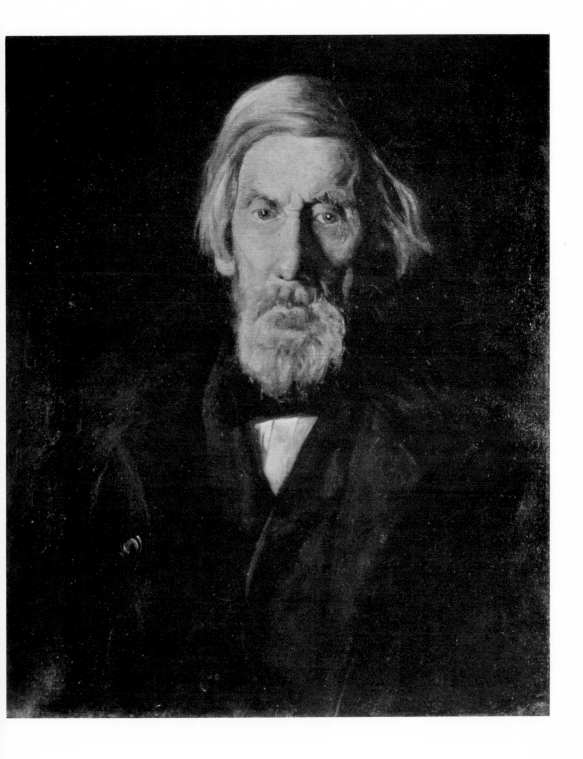

PLATE 65

PROFESSOR WILLIAM SMITH FORBES

OWNED BY THE JEFFERSON MEDICAL COLLEGE, PHILADELPHIA

1905. 84″ x 48″. CATALOGUE NO. 422

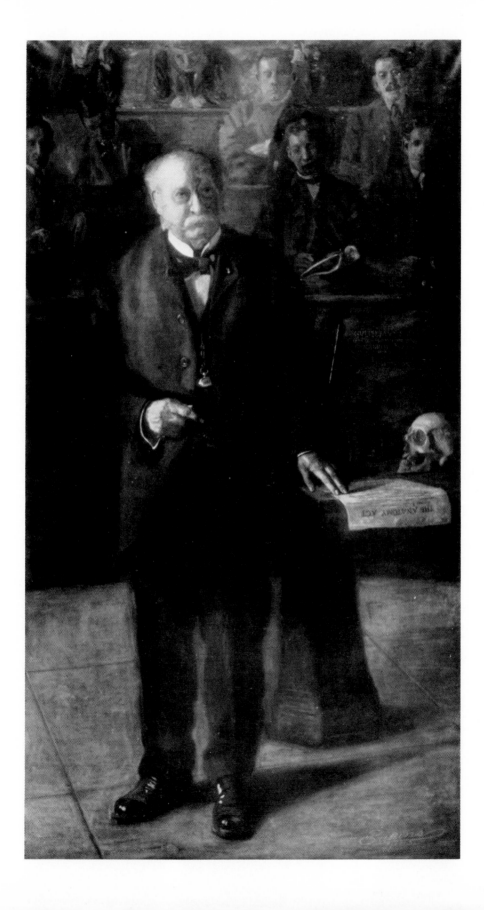

PLATE 66

MONSIGNOR DIOMEDE FALCONIO

OWNED BY REGINALD MARSH, FLUSHING, N. Y.

1905. 72″ x 54⅜″. CATALOGUE NO. 425

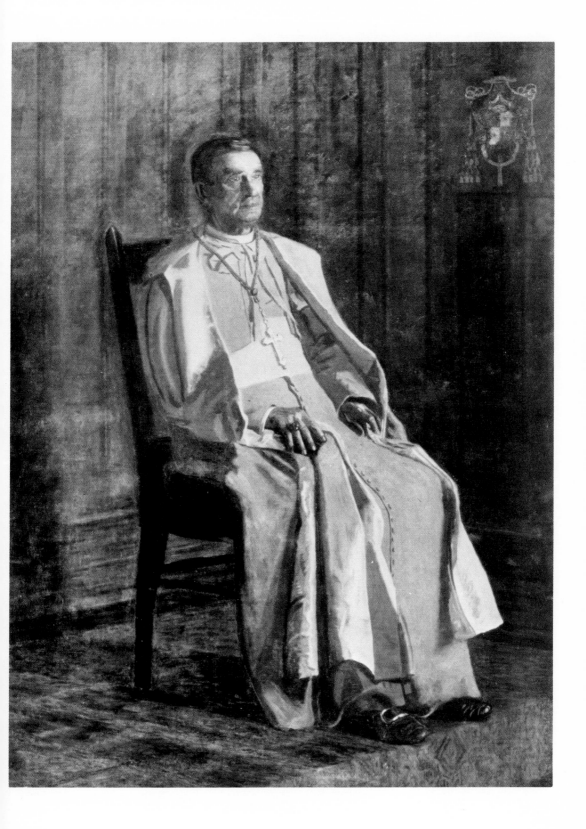

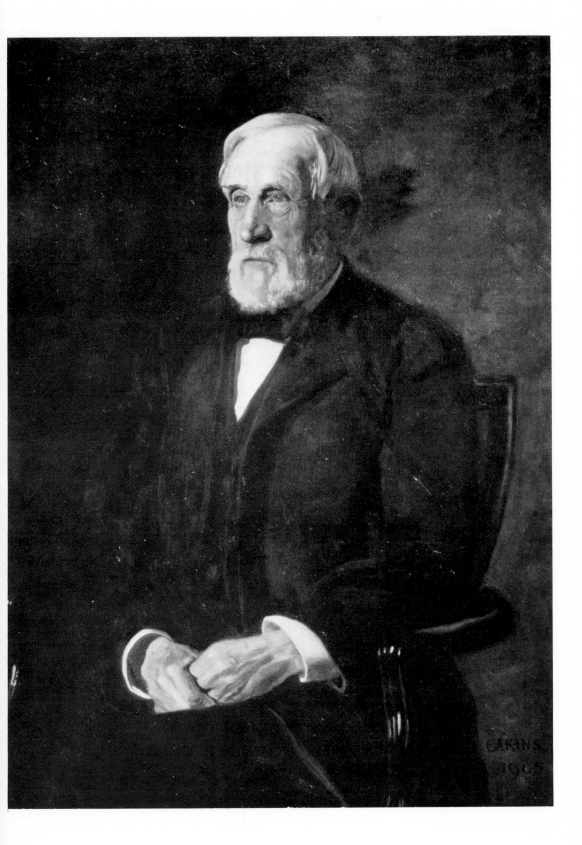

PLATE 68

DR. WILLIAM THOMSON

OWNED BY THE COLLEGE OF PHYSICIANS, PHILADELPHIA

1907. 74" x 48". CATALOGUE NO. 442

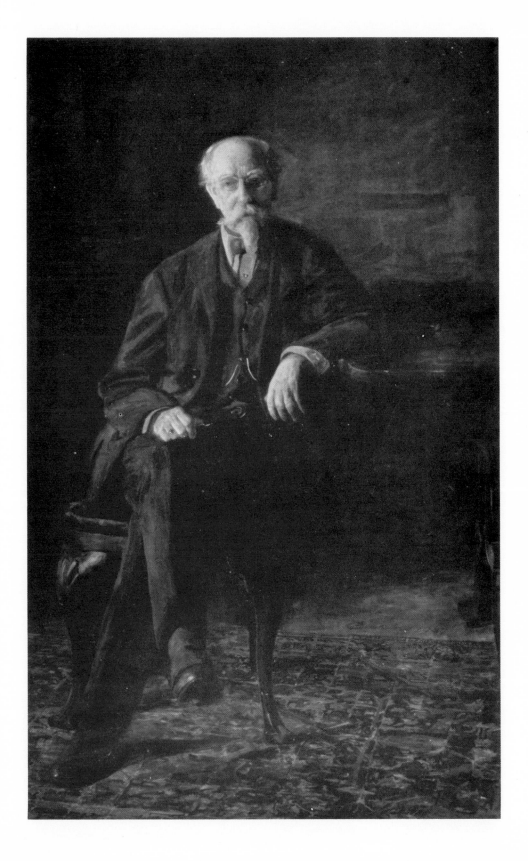

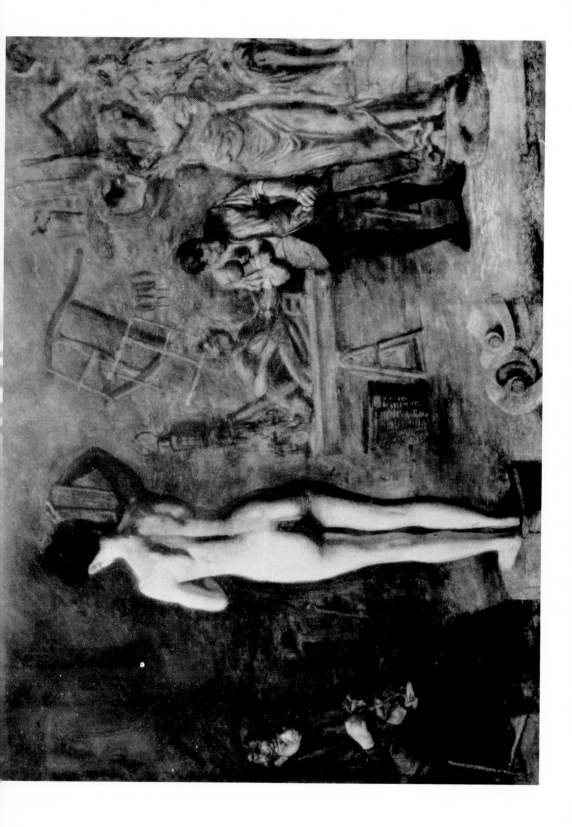

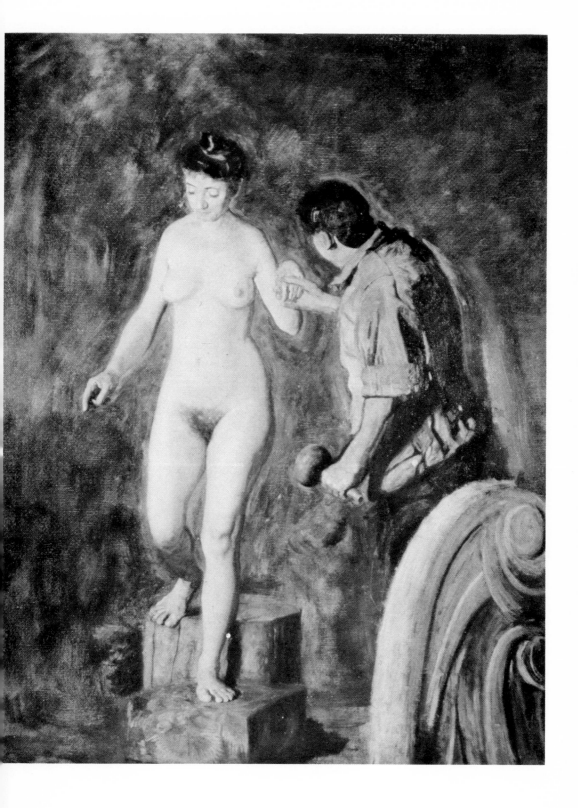

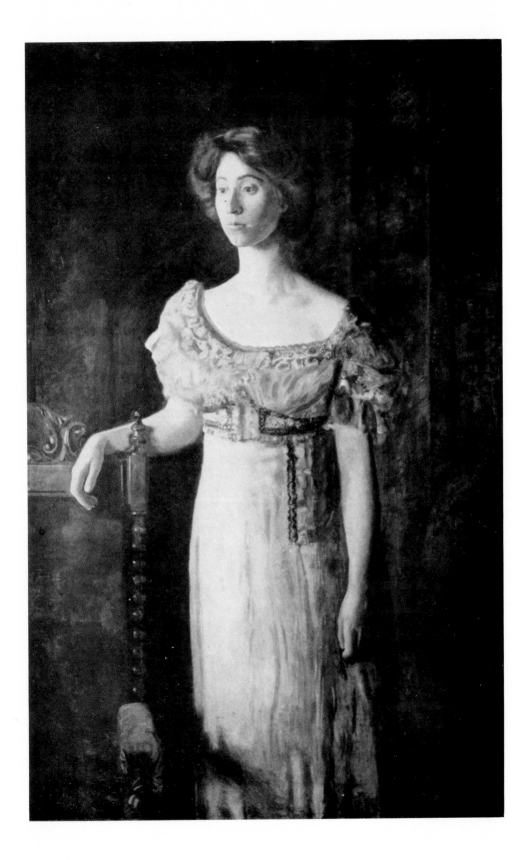

PLATE 72

GENERAL GRANT'S HORSE

PLASTER FOR THE BRONZE EQUESTRIAN STATUE OF GENERAL GRANT ON THE

MEMORIAL ARCH, PROSPECT PARK, BROOKLYN

1892. CATALOGUE NO. 509